MASTERF
THE MET
MUSEUM

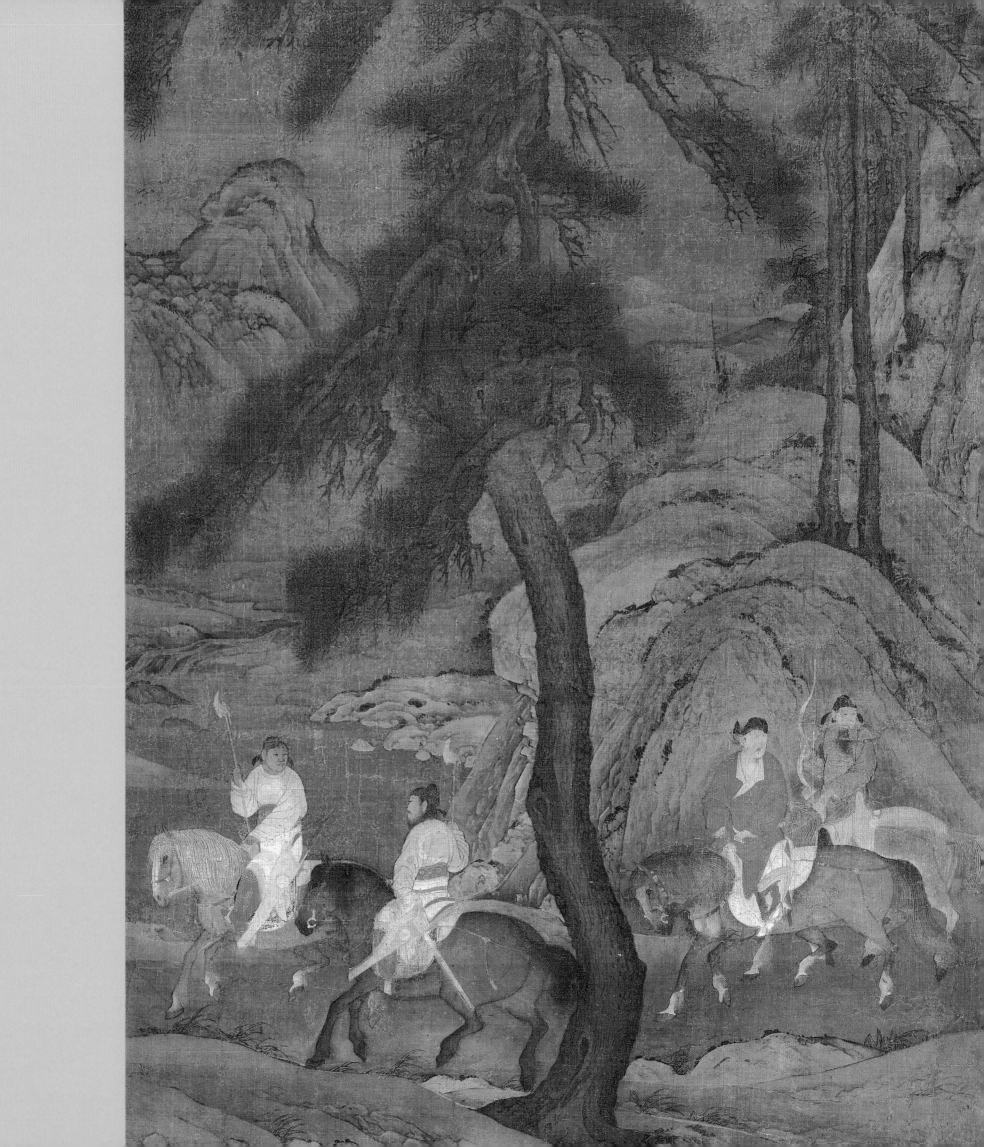

MASTERPIECES OF THE METROPOLITAN MUSEUM OF ART

Introduction by Philippe de Montebello

Edited by Barbara Burn

THE METROPOLITAN MUSEUM OF ART, NEW YORK

A BULFINCH PRESS BOOK / LITTLE, BROWN AND COMPANY
BOSTON • NEW YORK • TORONTO • LONDON

Copyright © 1993 by The Metropolitan Museum of Art

Produced by The Metropolitan Museum of Art, New York

Editor in Chief, John P. O'Neill
Project Coordinator / Editor, Barbara Burn, with the assistance of Ellisa Whitley
Designer, Abby Goldstein
Production Manager, Gwen Roginsky

LIBRARY OF CONGRESS CATALOGING-IN-PUBLICATION DATA

Masterpieces of the Metropolitan Museum of Art / introduction by
 Philippe de Montebello: edited by Barbara Burn.
 p. cm.
 Includes index.
 ISBN 0-87099-677-0.—ISBN 0-8212-2047-0 (Bulfinch)
 1. Art—New York (N.Y.)—Catalogs. 2. Metropolitan Museum of Art
(New York, N.Y.)—Catalogs. I. Burn, Barbara, 1940–
N610.A6742 1993
708.147′1—dc20 93-7966
 CIP

Bulfinch Press is an imprint and trademark of Little, Brown and Company (Inc.)
Published simultaneously in Canada by Little, Brown & Company (Canada) Limited

The chapter texts and captions for this book are the product of many hands, but the following
individuals in and outside the Museum were major contributors, and we are especially grateful
to them: Dorothea Arnold, Joan Aruz, Richard Barnhart, Peter Dorman, Kate Ezra, Everett Fahy,
Mark D. Greenberg, Prudence O. Harper, Frederick Hartt, Kathleen Howard, Julie Jones,
William Lieberman, J. Patrice Marandel, Joan Mertens, Douglas Newton, Josephine Novak,
Lucy A. O'Brian, John P. O'Neill, Oswaldo Rodriguez Roque, James Snyder, John T. Spike, and
Stuart Cary Welch. The editor is also grateful to Barbara Cavaliere, Joan Holt, Brian Hotchkiss,
Steffie Kaplan, Carol Judy Leslie, Helen Watt, and Eng Wong for their help.

The photographs in this volume were taken by The Photograph Studio, The Metropolitan Museum
of Art, with the exception of the following: pages 157, 192–93, Sheldan Collins; page 316 (above),
Mark Darley; pages 60, 175, Lynton Gardiner; pages 23, 37, 45, 51, 54 (below), 55, 78 (below left and
right), 86, 90–91, 109, 114, 173, 180, 187, 203, 213, 223, 224, 269, 272, 274, 277 (below), 281, Schecter Lee;
page 317, Neil Selkirk; frontispiece, pages 58, 175, 176–77, Malcolm Varon; page 249 (above and
below), Paul Warchol.

Cover: Peter Paul Rubens, Flemish, *Rubens, His Wife Helena Fourment, and Their Son Peter Paul,*
ca. 1639 (see pages 142–43)

Frontispiece: Detail of *Emperor Ming-huang's Flight to Shu,* Chinese, Southern Sung dynasty,
12th century (see pages 178–79)

Typeset by The Sarabande Press, New York
Printed and bound by Arnoldo Mondadori Editore S.p.A., Verona, Italy

Contents

Introduction

THE HISTORY OF The Metropolitan Museum of Art can be told in many ways—as the evolution of a vast cultural institution that has become New York City's most popular tourist attraction; as an architectural palimpsest that has grown and changed over the years to house its collections of nearly three million objects; as the story of personalities that have conspired, clashed, and cooperated with one other to establish the most comprehensive art museum in the Western Hemisphere. All of these stories make fascinating reading and have, in fact, been the basis of several publications.

The purpose of this book is not to retell history but to present in one volume a selection of the works of art that are, after all, the Museum's *raison d'être*. In 1905 the trustees issued a statement stipulating that in future the goal of the Metropolitan Museum would be "to group together the masterpieces of different countries and times in such relation and sequence as to illustrate the history of art in the broadest sense." It is in that spirit that this publication, the most recent in a long series of "masterpiece" books based on the Museum's holdings, is presented.

Selecting one tenth of one percent of the Museum's collection for this book was not an easy task, but it was a necessary one. A format designed to provide a pleasurable visual experience for the reader can accommodate only a few objects; anything more would be exhausting. Many visitors to the Museum realize that, after only two or three hours of intensive gazing, they simply cannot absorb another work of art.

In an institution as wide-ranging as the Metropolitan, it would have been easy to choose three hundred masterpieces from the Department of European Paintings alone. But such a publication, as beautiful as it might be, would ignore the resources of seventeen other departments in the Museum. The American Wing, for example, houses the world's most comprehensive collection of American paintings, sculpture, and decorative arts, including twenty-four period rooms. The Egyptian holdings in the adjoining wing are vast, thanks to the Museum's own archaeological expeditions, as well as generous gifts and discerning purchases, with about thirty-six thousand objects, including many treasures that have not even yet appeared in print. On the floor below the Egyptian galleries is the Costume Institute, a repository of many thousands of costumes that are stored in cabinets or lie carefully folded in drawers, seen only occasionally by scholars because of their fragility. The same precautions are taken with drawings, prints, photographs, and other works on paper that must be kept safe from the damaging effects of light, humidity, and other environmental conditions. These objects are occasionally put on public view, but only for brief periods of time and on a rotating basis.

I was tempted in preparing this book to choose masterpieces that are less well known to the general public, rather than the "warhorses" that the Museum's audience expects. How delightful it would be to reproduce for the first time in full color a magnificent watercolor by Delacroix or a tiny Assyrian cylinder seal. But that is a better idea for a second volume. Leaving out Goya's portrait of Don Manuel Osorio or Rembrandt's *Aristotle with a Bust of Homer* would both annoy and puzzle those who come regularly to the Museum to see those old favorites and would wish to have them in a book at home. And it is true that the works in this volume are among the greatest treasures we have.

Picking only two Vermeers from the Museum's five, when the oeuvre of the master includes fewer than forty paintings, is in fact a task more pleasurable than difficult.

A true measure of the Museum's scope is the fact that while this book does not present a complete and balanced history of art, nearly every culture and period are well represented by objects of the highest quality. We have not organized the book by curatorial departments, as we did the Museum's guide book, but by cultures, with the works arranged chronologically, so that the reader may be led logically through the history of human artistic accomplishment. Appearing alongside paintings and sculpture are works of decorative art, such as ceramics, tapestries, arms and armor, musical instruments, costumes, and great pieces of furniture.

Thousands of words of exacting scholarship have honored the works of art reproduced in this book, and the brief descriptions that appear here can only hint at what we know of them. But scholarship is a continuing process, and ideas about artists and the works they create are constantly being challenged and revised or replaced. The information presented in this book is the result of a vast collaborative effort on the part of the Museum's curatorial staff members, who have over the years studied, researched, and written about the objects in their care. I am grateful to them all for having reviewed yet again the material compiled to document the images you see here.

A final word of gratitude must go to those whose names you see on every page of this book in what we refer to as credit lines, which accompany each object. These are the names of the donors who have made possible the acquisition of the masterpieces in the Museum, either by having collected and donated the works or by having given funds for purchases. The incredible energy and drive that propelled these men and women to gather up the world's great works of art is honored in the subtext of our credit lines. The names of such individuals as J. P. Morgan, Benjamin Altman, Jules Bache, H. O. and Louisine Havemeyer, Stephen C. Clark, John D. Rockefeller, Jr., Philip and Robert Lehman, Nelson A. Rockefeller, C. Douglas Dillon, Charles and Jayne Wrightsman, and the Honorable Walter C. Annenberg tell the history of American collecting.

No less important to our history has been the long line of generous donors of funds that enable our curators to purchase objects for the Museum. Many of these individuals have been members of the Board of Trustees or staff members, collectors in their own right. A silver Cypriot bowl in the chapter on Greek and Roman art, for example, entered the Museum only four years after its founding, in 1874, from the collection of the Museum's first paid director, Louis P. di Cesnola. Others have been little known in the art world except for their financial support of the Museum. Jacob Rogers, a New Jersey businessman, established a fund in 1910 that continues to be an important resource today. The credit lines reading simply "Rogers Fund" are perhaps the most numerous in this book.

Although times are difficult today, and many of the incentives for donating works and funds to public institutions are less than compelling, there are still masterpieces to be found. It is a tribute to the energy and drive of the Museum's curatorial staff and to the unwavering support of its supporters that a number of works in this book are very recent additions to the Museum's holdings, such as a brilliant Turkish sword (page 78) and a major painting by Lucien Freud that entered the collection early in 1993.

But this book is not about the collectors or the curators or the history of the Museum's acquisitions. It is about the works of art, presented, as the trustees once dictated, "in such relation and sequence as to illustrate the history of art in the broadest sense." And it is with great pleasure that I let the works now speak for themselves.

<div align="right">

Philippe de Montebello
Director

</div>

THE ANCIENT WORLD

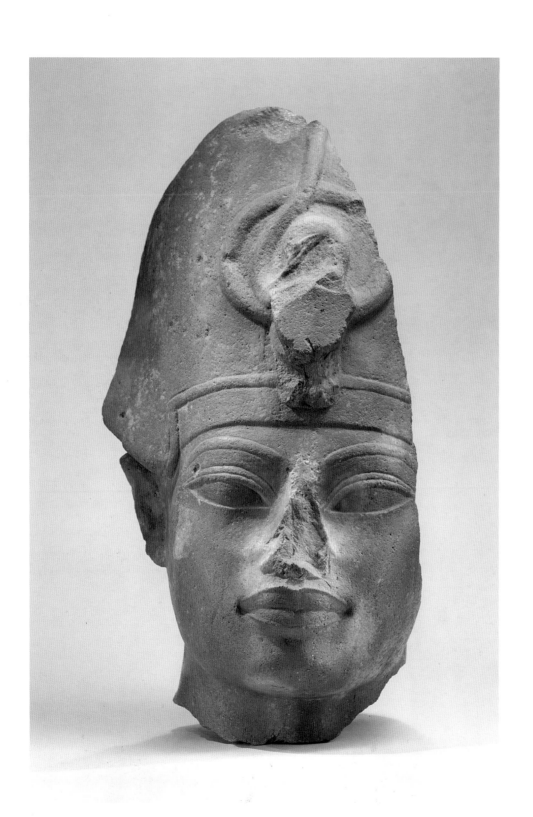

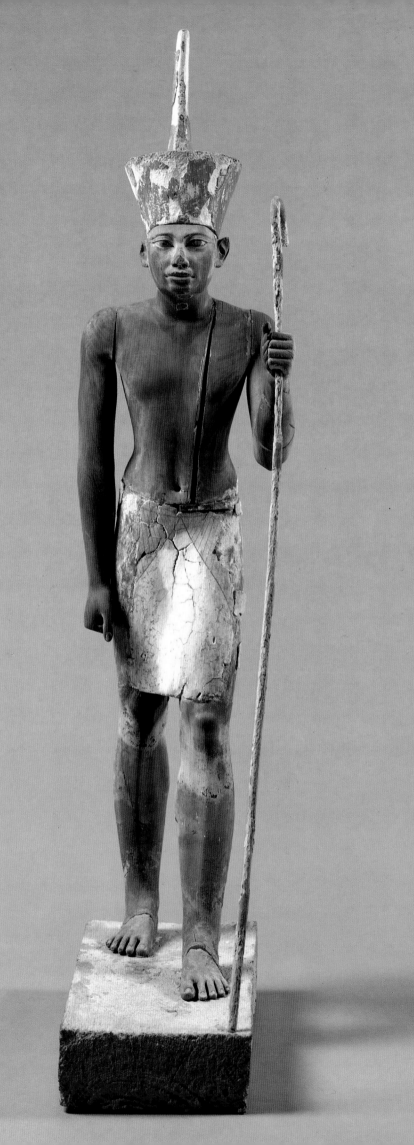

Egypt

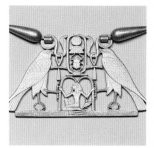

THE ANCIENT KINGDOMS OF Upper and Lower Egypt were unified about 3000 B.C. under Menes, the king from whom thirty dynasties of Egyptian monarchs would claim descent. The seat of royal power was located in the northern city of Memphis during the Old Kingdom, the period when the massive pyramids at Giza were built to enshrine the majesty of the deceased ruler. Owing to the disintegration of central authority and to economic crisis, the Old Kingdom collapsed in about 2130 B.C. There followed a time of political fragmentation, the First Intermediate Period, which lasted for about a hundred years, after which Mentuhotpe II of the Eleventh Dynasty reunified the kingdom from his capital at Thebes in the south. Egypt regained its prosperity during the Middle Kingdom (about 2040–1650 B.C.) under the powerful rulers of the Twelfth Dynasty (Amenemhat I, Senwosret I, Senwosret III, and Amenemhat III). During the Second Intermediate Period (about 1650–1550 B.C.), which followed the end of the Thirteenth Dynasty, Egypt was dominated by a group of foreign invaders. In about 1550 B.C. the foundation of the Eighteenth Dynasty inaugurated the New Kingdom, when Egypt entered the period of its greatest military strength, territorial expansion, and material prosperity. The last great pharaoh of the New Kingdom was Ramesses III (about 1184–1153 B.C.), but Egypt's military and economic decline had begun and by 1075 B.C. Egypt was effectively split in two. The Late Period (712–332 B.C.) saw a substantial influx of foreign settlers, including Syrians, Jews, and Greeks, and the Egyptians turned to their own past to revive earlier traditions in religion and the arts. In 332 B.C. Egypt was conquered by Alexander the Great, and when his short-lived empire came apart at his death in 323, Egypt was claimed by one of his generals, Ptolemy, who became the first of thirteen Ptolemaic kings. Ptolemaic Egypt became part of the Roman Empire after the Battle of Actium in 31 B.C., in spite of the opposition of Cleopatra VII.

The qualities that characterize the art of ancient Egypt—such as rigidity of pose and the use of contradictory perspectives in portraying the human figure—remained consistent for the greater part of Egyptian history. They originated in the Early Dynastic Period (about 3000 B.C.) and exerted a powerful influence long after the conquest of Egypt, first by Persia, then by Macedonia, and finally by Rome. Significant differences appear from period to period, but the reasons why a consistent aesthetic endured for some three thousand years lie in the Egyptian conceptions of time and space, which can be linked significantly with the physical setting that gave birth to one of the most splendid civilizations of the ancient world: the Nile Valley.

The annual succession of the agricultural seasons was marked by the slow progression of stars and constellations, punctuated by the movements of the sun and moon. Time moved in a never-ending, ever-renewing cycle. The conception of divine kingship, and the order it guaranteed, served as a counterpart to these recurrent natural patterns. In such a world, reassurance was found in the repetitiveness of life. The unusual or the unpredictable would introduce an unwelcome note of chaos into a well-ordered universe. In religion, art, politics, and social behavior, moderation and constancy were the supreme virtues, since these recalled the perfection of the world at "the time of the god," the moment of creation.

(OVERLEAF)

Dynasty 18, ca. 1391–1353 B.C.

AMENHOTPE III

———

Quartzite; H. 13¾ in. (35 cm)
Rogers Fund, 1956 (56.138)

———

This great example of New Kingdom sculpture emphasizes beautiful youth in a pharaoh who ruled Egypt at the pinnacle of its political power and economic prosperity and was a great builder and patron of the arts.

(OPPOSITE)

Dynasty 12, ca. 1920–1880 B.C.

RITUAL FIGURE

———

Gessoed and painted wood; H. 22⅞ in. (58.1 cm)
Rogers Fund and Edward S. Harkness Gift, 1914 (14.3.17)

———

This statuette, a masterpiece of ancient Egyptian wood carving, was found by the Museum's excavators in a high official's funerary precinct at Lisht, along with a companion piece now in Cairo. Both figures wear royal crowns and show the facial features of the reigning king.

(LEFT)

Dynasty 12, ca. 1890–1880 B.C.

PECTORAL OF SENWOSRET II

———

Gold, amethyst, turquoise, feldspar, carnelian, lapis lazuli, and garnet; H. 1¾ in. (4.5 cm)
Purchase, Rogers Fund, and Henry Walters Gift, 1916 (16.1.3)

———

This pectoral, found in the tomb of Princess Sithathoryunet, apparently the daughter of Senwosret II, is a masterpiece of goldworking and lapidary craftsmanship. The princess's treasure includes some of the finest pieces of royal jewelry preserved from the Middle Kingdom, a period of Egyptian history unsurpassed for its elegance and workmanship in the minor arts.

Egyptian art reflected and reinforced the attitudes of the Egyptians toward their physical and spiritual environment and was intimately related to the hieroglyphic system of writing, along with which it developed at an early period. The predominance of funerary objects may foster the misapprehension that the ancient Egyptians were obsessed with preparing for their burial and with the preservation of their bodies. In fact, this impression of a "morbid" concern with the afterlife is based on the great numbers of funerary objects that have survived. This endurance is largely an accident of Egypt's geography: the desert—where funerary monuments were erected—offers an ideal climate for the preservation of artifacts.

Egyptian art was by no means a monolithic tradition. The most dramatic innovations were made in the reign of Akhenaten (about 1353–1335 B.C.), who imposed his personal deity, the Aten, over all other gods in the Egyptian pantheon. The art of Akhenaten's reign illustrates, in a manner rarely demonstrated in other historical periods, the intimate correlation between Egyptian art and religion.

The Museum's collection of Egyptian art is one of the largest outside the Cairo Museum, and virtually all of its approximately thirty-six thousand objects are on permanent display. Many of the works were obtained by the Museum through its own extensive program of excavations, which began in 1906 and ended in 1936. After a hiatus of nearly fifty years, the department is once again excavating in Egypt.

Early Dynasty 12, ca. 1990 B.C.
MODEL OF A BOAT

Gessoed and painted wood; H. 14⅝ in. (37.1 cm)
Rogers Fund and Edward S. Harkness Gift, 1920 (20.3.1)

A 1920 expedition led by the Metropolitan Museum uncovered in Thebes in the tomb of Mekutra, a chancellor who served Mentuhotpe II and III and Amenemhat I, 23 painted wooden replicas of the chancellor's house and garden, the shops of his estate, his fleet of ships, his herd of cattle, and his servants bringing offerings to his tomb. All of these models were executed in miniature but with the utmost accuracy and attention to detail and were found in a state of almost perfect preservation. Probably no single find has contributed so graphically to our knowledge of the estates and other possessions of a wealthy Egyptian of the Middle Kingdom or provided us with such rich material for a general study of daily life in ancient Egypt.

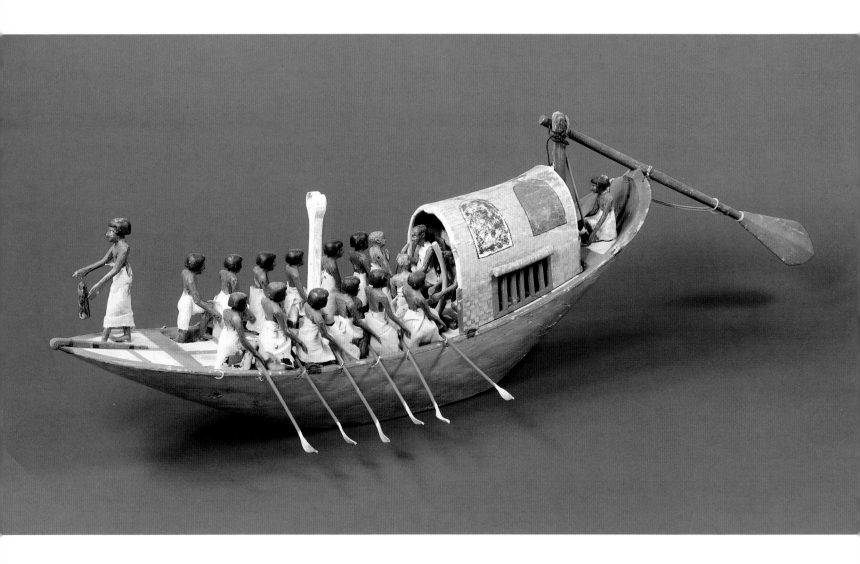

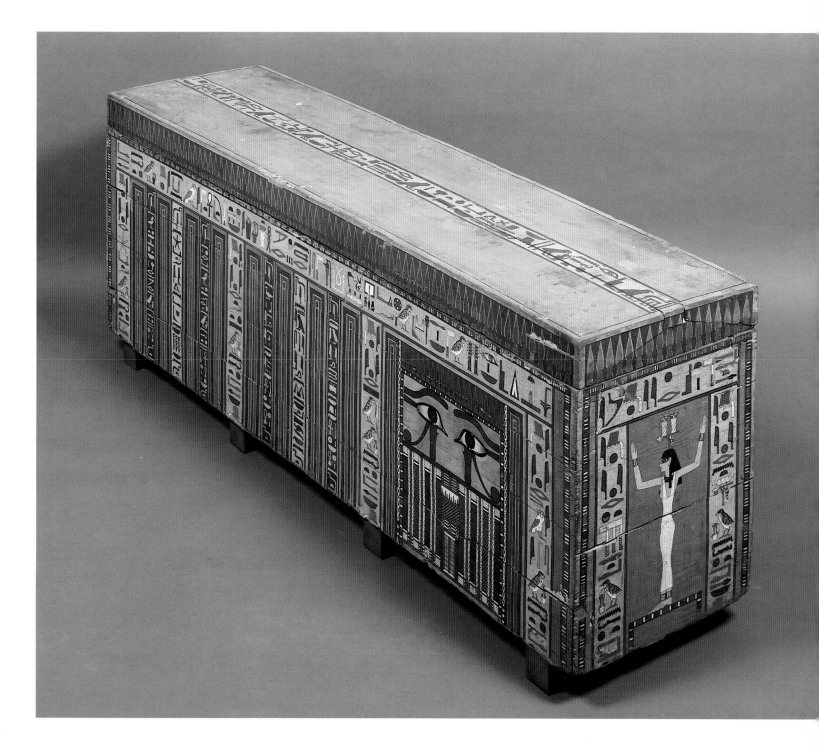

Dynasty 12, ca. 1900–1800 B.C.

COFFIN OF KHNUMNAKHT

Painted wood; L. 82 in. (208.3 cm)
Rogers Fund, 1915 (15.2.2)

The brilliantly painted exterior of the coffin of Khnumnakht, an individual unidentified except for his inscribed name, displays the multiplicity of texts and decorative panels characteristic of coffin decoration of the second half of Dynasty 12. It has at least one feature—the figure of a goddess on the head end—that is rare before the late Middle Kingdom. Painted at the end of one side is an architectural façade with a doorway for the passage of the soul, from which two eyes look forth onto the world of the living. The rest of the exterior is divided into panels framed between inscribed invocations to, and recitations by, various primeval deities and gods, particularly those associated with death and rebirth, such as Osiris, primary god of the dead, and Anubis, god of embalming.

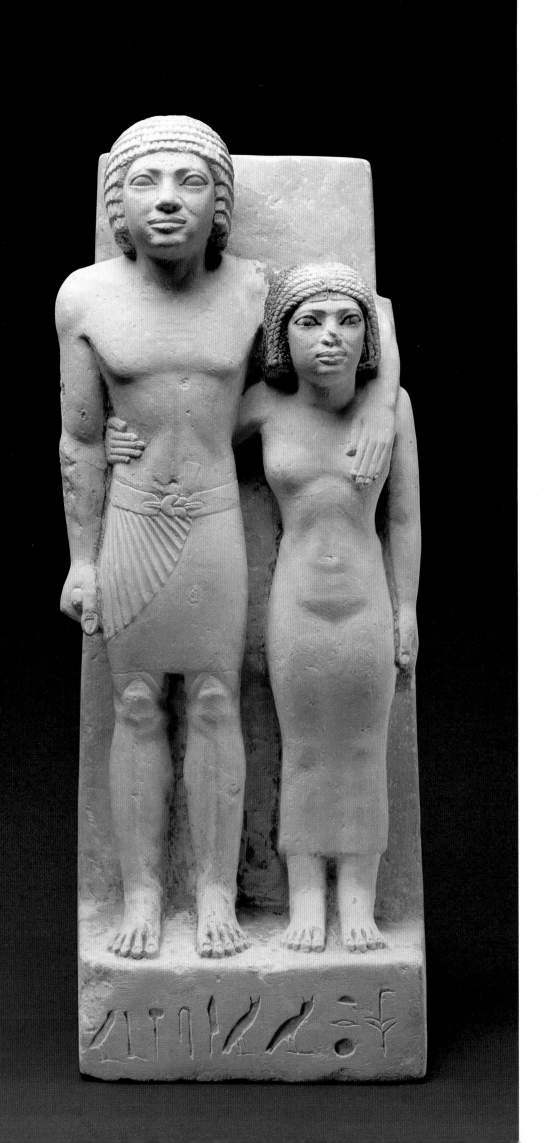

Dynasty 5, ca. 2350 B.C.

MEMISABU AND HIS WIFE

Painted limestone; H. 24⅜ in. (61.9 cm)
Rogers Fund, 1948 (48.111)

The statues placed in Egyptian tombs of the Old Kingdom provided habitations for the *ka*, or spirit, of the deceased. Customarily the wife is represented embracing her husband, but here Memisabu and his wife each embrace the other, which suggests that she—not her husband, a steward and keeper of the king's property—was the tomb's owner. This statue can be linked stylistically with monuments from the cemetery west of the great Pyramid of Khufu (Cheops) at Giza.

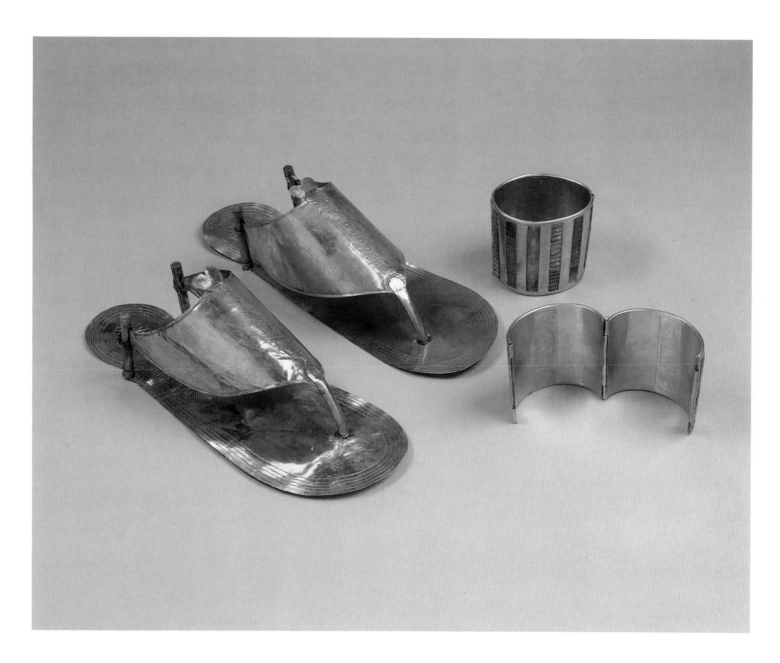

Dynasty 18, ca. 1479–1429 B.C.

SANDALS AND BRACELETS

Gold, carnelian, and turquoise glass; sandals:
L. 10 in. (25.4 cm); bracelets: Diam. 7¾ in.
(19.7 cm), 7⅝ in. (19.4 cm)
Fletcher Fund, 1926 (26.8.146ab; 26.8.125,127)

The treasure of the three minor wives of
Thutmosis III is the most spectacular group
of royal jewelry of Dynasty 18 before the
reign of Tutankhamun (ca. 1333–1323 B.C.).
Cut from sheet gold, the sandals closely
imitate tooled leatherwork, but their fragile
construction is typical of objects made to
adorn a mummy.

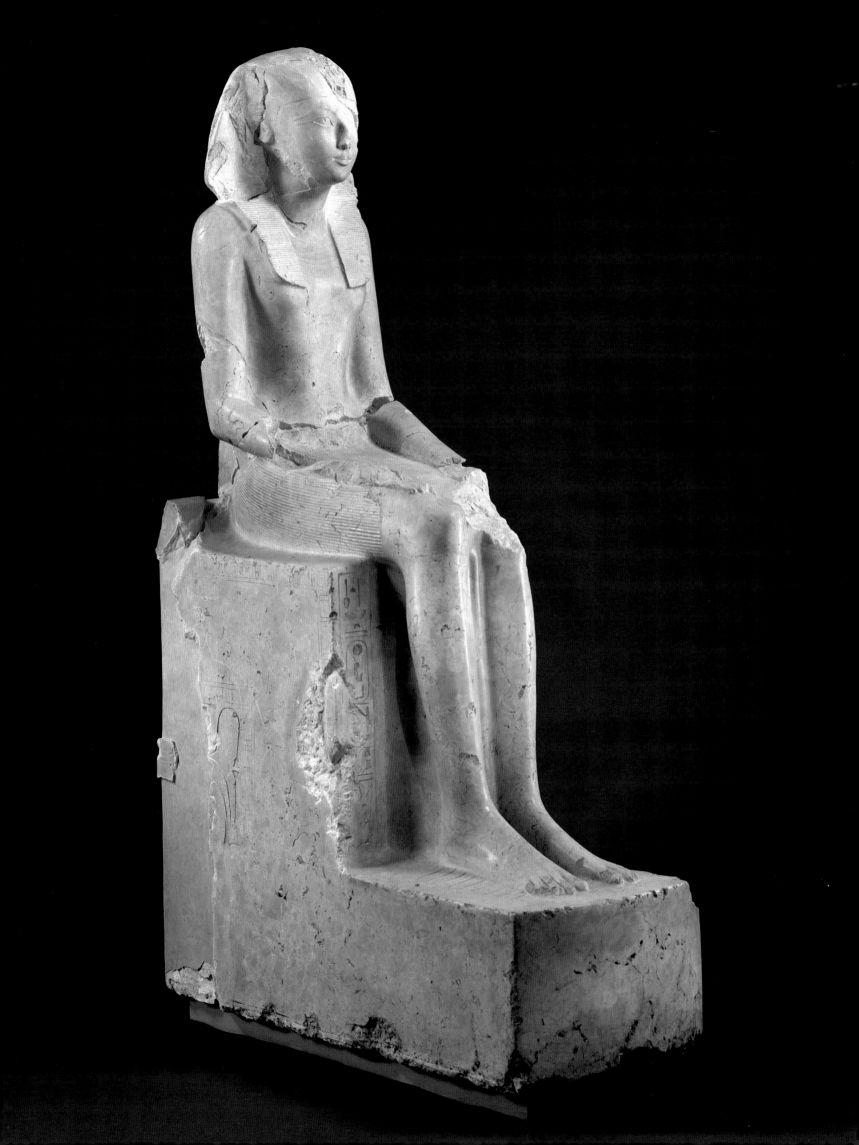

Dynasty 18, ca. 1473–1458 B.C.

QUEEN HATSHEPSUT

Painted indurated limestone; H. 76¾ in.
(194.9 cm)
Rogers Fund, 1929 (29.3.2)

With the ascension of King Thutmosis III
and Queen Hatshepsut, Egypt entered
upon what must be regarded as the most
glorious period in its long history—the
period of its greatest military strength,
territorial expansion, and material
prosperity. When Thutmosis II died, his
rightful heir, Thutmosis III, was still a child,
and so Hatshepsut, the boy's stepmother,
became regent. Within a few years, she had
contrived to have herself crowned king,
with full pharaonic powers. Her
magnificent funerary temple at Deir el
Bahri in western Thebes was intended both
to legitimize and commemorate her rule.
Statues of Hatshepsut were placed
throughout the temple, including this one
showing the great queen in masculine
guise. Not only the royal kilt and headdress,
but also the bare if admittedly soft torso, are
those of a man. Though certainly idealized,
the delicate face gives us one of the finest
representations of Hatshepsut extant. We
know her subjects were fully aware of the
anomaly of a female king; it is easy to
believe that the sculptor here tried, with
some success, to reconcile the political
myth with human reality.

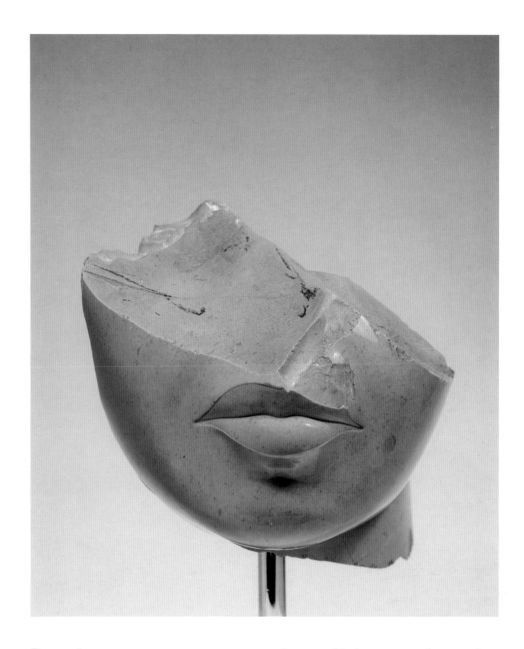

Dynasty 18, ca. 1391–1353 B.C.

FRAGMENTARY HEAD OF A QUEEN

Yellow jasper; H. 5½ in. (14 cm)
Purchase, Edward S. Harkness Gift, 1926
(26.7.1396)

This extraordinary fragment, polished to a
mirrorlike finish, is both sensual and elegant
in expression, reflecting the sophistication
of the court of Amenhotpe III, to whose
reign it can be assigned on stylistic grounds.
When complete, this head probably
belonged to a composite statue, in which
the exposed flesh parts were of jasper and
the remaining elements of other
appropriate permanent materials. The use
of yellow stone for the skin indicates that
the person represented is female; the scale
and superb quality of the work imply that
she is a goddess or a queen of Amenhotpe
III. The similarity of the full, curved lips
with down-turned corners to known
representations of the Great Royal Wife,
Tiye, suggest that it is she who is
depicted here.

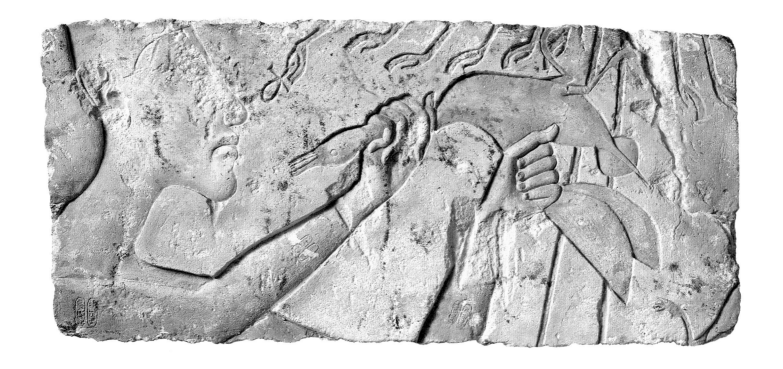

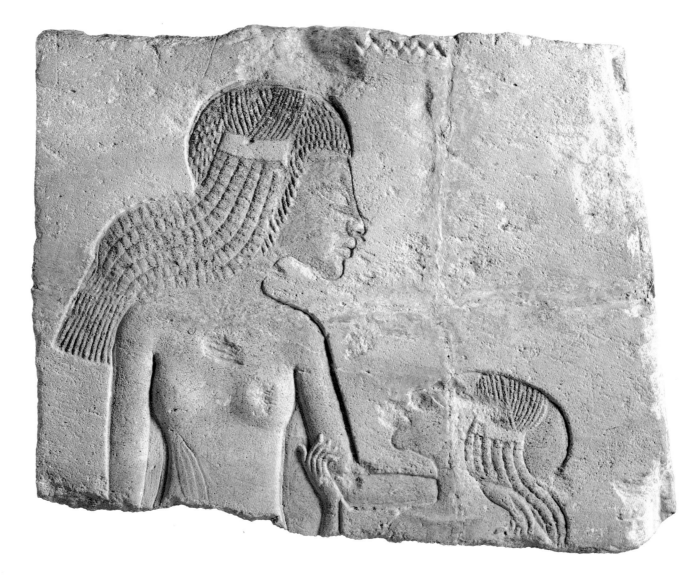

Amarna Painted Reliefs

Dynasty 18, ca. 1345–1335 B.C.

AKHENATEN PRESENTING A DUCK TO ATEN

Painted limestone; H. 9⅝ in. (24.4 cm)
Gift of Norbert Schimmel, 1985 (1985.328.2)

TWO PRINCESSES

Painted limestone; H. 8⅝ in. (22 cm)
Gift of Norbert Schimmel, 1985 (1985.328.6)

THE KING MAKING AN OFFERING

Painted limestone; H. 8¼ in. (21 cm)
Gift of Norbert Schimmel, 1985 (1985.328.3)

During his 17-year reign, Amenhotpe IV, who changed his name to Akhenaten, radically altered the official state religion by proscribing the worship of any god but Aten, the power embodied in the sun. Whatever may have motivated Akhenaten, Egypt's experiment in qualified mono-theism really impinged only upon the courtiers who surrounded the king, and at his death the traditional forms of worship reasserted themselves. For his unorthodoxy Akhenaten was to suffer the destruction of his monuments and his name at the hands of posterity. These relief blocks are carved in the mannered and expressive style peculiar to Akhenaten's reign. In the relief at the upper left the king is shown making an offering of a pintail duck to Aten, whose rays, ending in hands, stream down on him.

One of the hands holds an ankh—the symbol of life—to the king's nose. In the relief below the demonstration of affection between two of Akhenaten's daughters is typical of the intimacy allowed in representations of the royal family in the art of the Amarna Period. Although affectionate gestures are not entirely unknown in royal art of other eras, the naturalism of this pose and the frontal treatment of the torso of the older (larger) sister are unparalleled among royal figures and extremely rare in any type of representation in other periods of Egyptian art.

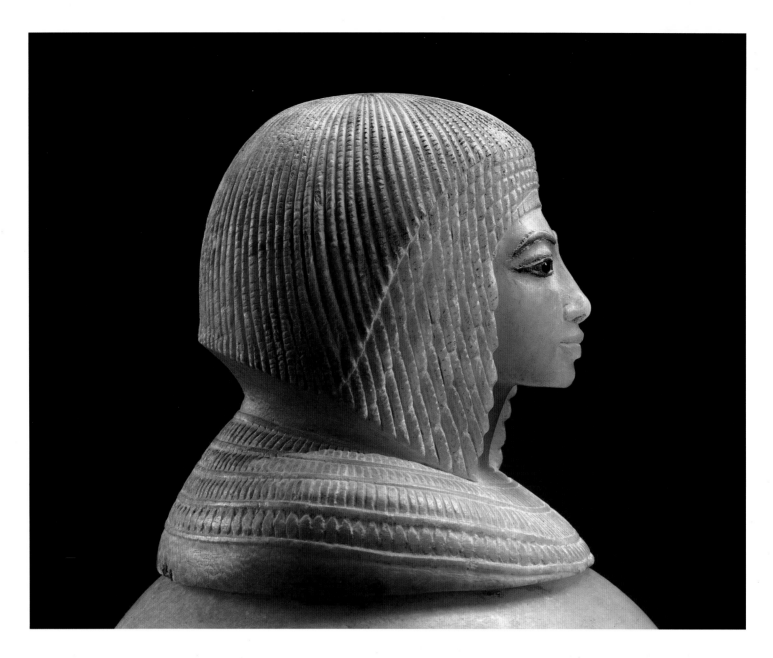

Dynasty 18, ca. 1340–1330 B.C.
CANOPIC JAR LID

Alabaster, obsidian, and blue paste; H. 7⅛ in.
(18.1 cm)
Theodore M. Davis Collection, Bequest of
Theodore M. Davis, 1915 (30.8.54)

Although the canopic jar to which this lid
belongs was designed for a practical
purpose (as a container for an embalmed
human organ), the lid is an unusually fine
representation of a royal woman that can be
dated to the reign of Akhenaten or shortly
thereafter. The massive wig of layered curls
is a headdress favored by Akhenaten's
queen, Nefertiti, their six daughters, and a
minor queen, Kiya. The jar was found in
Thebes in a tomb in the Valley of the Kings
that has aroused a great controversy
concerning the events surrounding
Akhenaten's death and succession.

Asyut, Early Dynasty 19, ca. 1290–1270 B.C.
STATUE OF YUNY

Painted indurated limestone; H. 50¾ in.
(129 cm)
Rogers Fund, 1933 (33.2.1)

The statue of Yuny—a beautiful example of
post-Amarna art—was found in the tomb of
his father, Amenhotpe, a chief physician.
Yuny's own titles indicate that he too
belonged to the medical profession. Here he
kneels, holding an elaborately carved shrine
containing a small figure of the god Osiris.
The necklace of lenticular beads was a
decoration given by the king for
distinguished service. Yuny's eyes and
eyebrows, once inlaid with semiprecious
stones, were gouged out by an ancient thief.

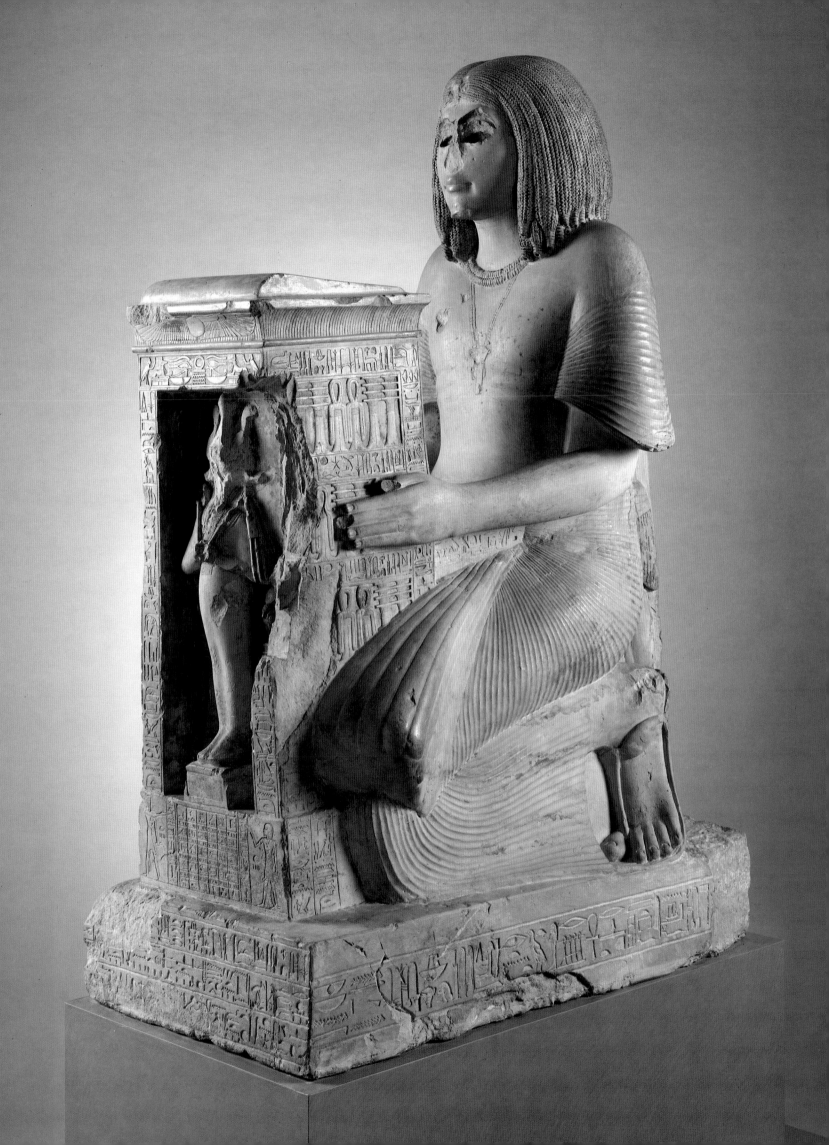

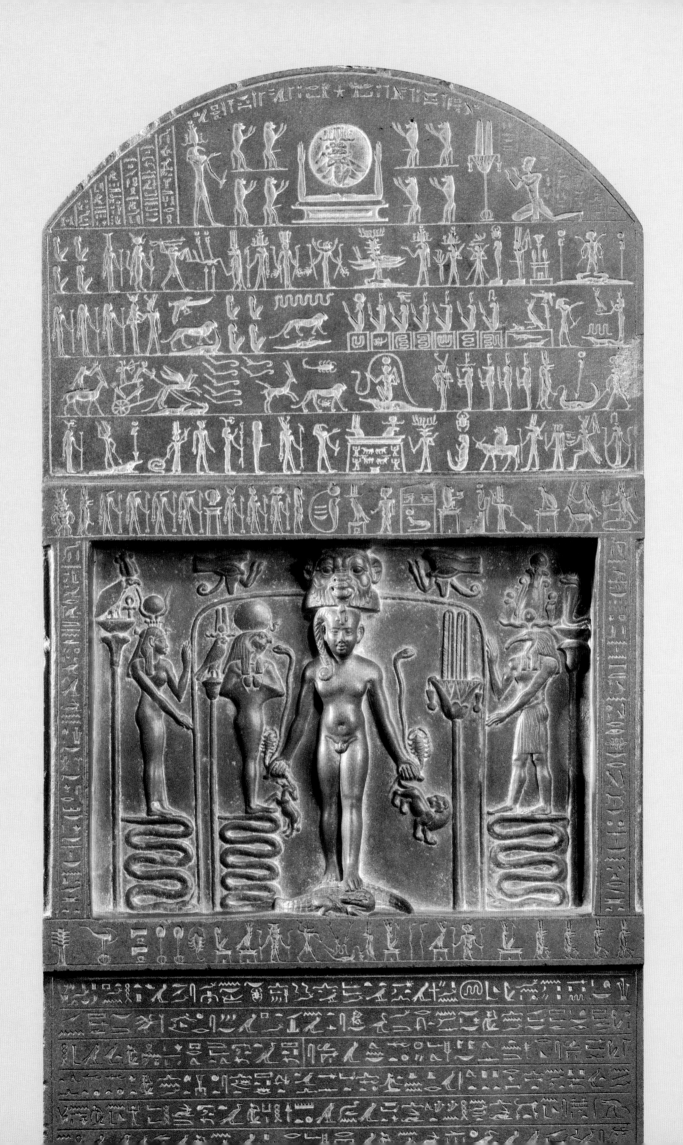

Dynasty 30, 360–343 B.C.

THE METTERNICH STELA

Graywacke; H. 32⅞ in. (83.5 cm)
Fletcher Fund, 1950 (50.85)

The kings of Dynasty 30 were the last native
Egyptian rulers. This stela is dated to the
reign of the last king of this dynasty,
Nectanebo II. Carved of graywacke by a
master of hard-stone sculpture, it is the
finest and most elaborate example of
Egyptian magical stelae. The child Horus
standing on two crocodiles is the dominant
motif. Above him are representations
of the sun's nightly journey through the
netherworld. The inscriptions are a set of 13
spells against poison and illness. These were
designed to be said by a physician treating a
patient, but their effectiveness could also be
absorbed by drinking water that was
poured over the stela. The inscription
around the base contains part of the myth
of Isis and Osiris, describing how the infant
Horus was cured of poison by Thoth in the
delta marshes. Thus Horus serves as the
divine prototype for this sort of cure. The
stela was made by the priest Esatum to be
erected in a necropolis of sacred bulls. In
1828 the stela was presented by Muhammad
Ali to the Austrian chancellor, Prince
Metternich.

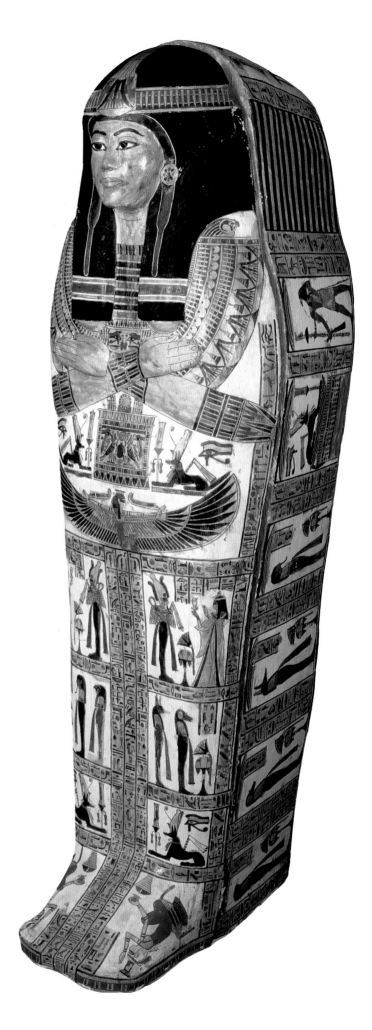

Dynasty 21, ca. 1070–945 B.C.

OUTER COFFIN OF HENETTAWY

Gessoed and painted wood; L. 79⅞ in.
(202.9 cm)
Rogers Fund, 1925 (25.3.182)

During the Third Intermediate Period, an
unsettled time, the individual private tomb
was abandoned in favor of family shafts (or
caches) that could be more easily guarded
from thieves; often tombs that had already
been robbed were reused for this purpose.
Henettawy, a mistress of the house and
chantress of Amen-Ra, was buried in such a
tomb. Since her burial chamber, like most
others of the time, was undecorated, the
paintings on her coffin, with their emphasis
on elaborate religious symbolism and
imagery, replaced the wall decorations of
previous periods and reflect a style and
iconography developed during the last years
of the New Kingdom.

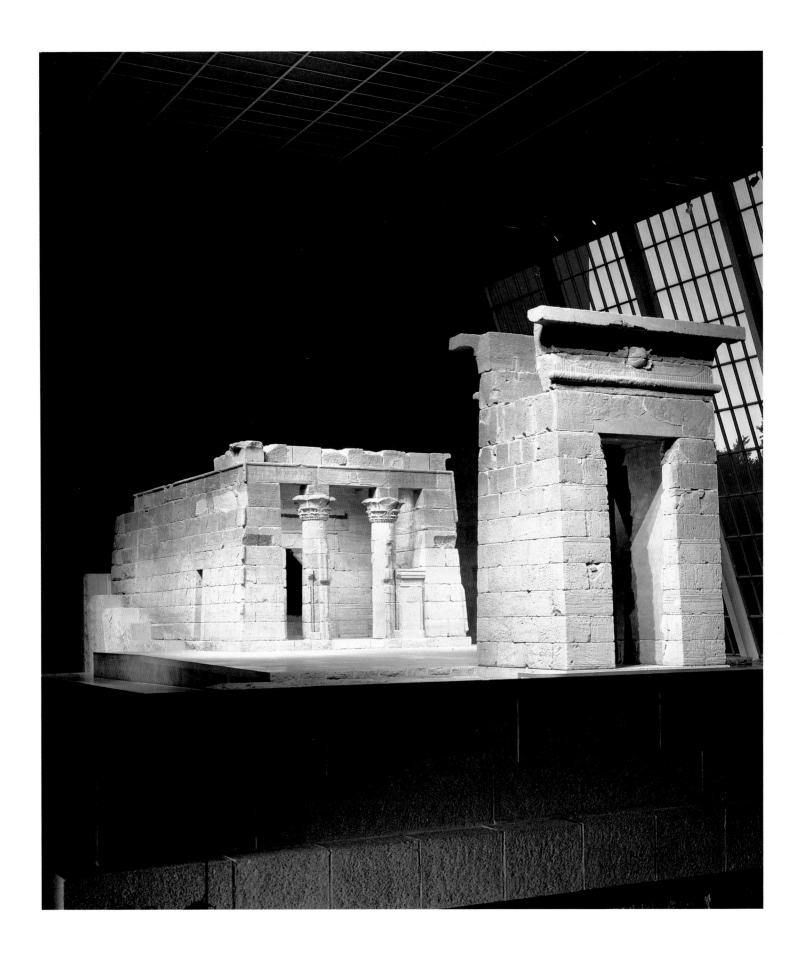

Early Roman Period, ca. 15 B.C.

TEMPLE OF DENDUR

Aeolian sandstone; L. of gateway and temple
82 ft. (25 m)
Given to the United States by Egypt in 1965,
awarded to The Metropolitan Museum of Art
in 1967, and installed in The Sackler Wing in
1978 (68.154)

This Egyptian monument, originally
erected in Nubia, would have been
completely submerged as a result of the
construction of the Aswan High Dam,
begun in 1960. Instead, the temple was
given to the United States in recognition of
the American contribution to the
international campaign to save the ancient
Nubian monuments. The temple was built
by the Roman emperor Augustus and
honors the goddess Isis and two deified sons
of a local Nubian chieftain. The complex,
reassembled as it appeared on the banks of
the Nile, is a simplified version of the
standard Egyptian cult temple.

Ptolemaic Period, 304–30 B.C.

COFFIN FOR A SACRED CAT

Bronze; H. 11 in. (27.9 cm)
Harris Brisbane Dick Fund, 1956 (56.16.1)

Since the beginning of Egyptian history,
many deities were represented in the form
of animals or as human figures with animal
heads. The cat was understood to be the
sacred animal of Bastet, a goddess
worshiped in the eastern delta town of
Bubastis. In the fifth century B.C., the Greek
historian Herodotus described the great
annual festival of Bastet and her beautiful
temple, near which mummified cats were
interred in large cemeteries. This hollow
figure, a fine example of the ancient
Egyptian art of bronze casting, served as a
coffin for a mummified cat.

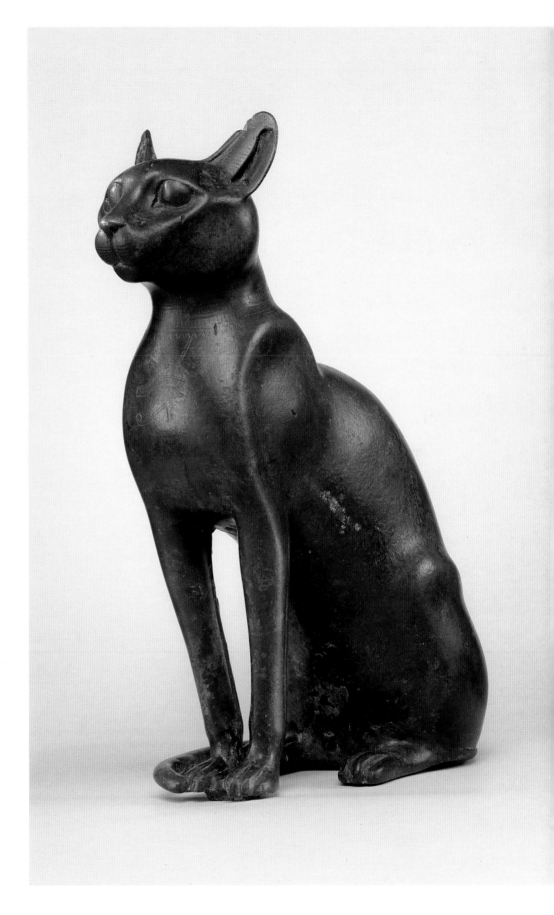

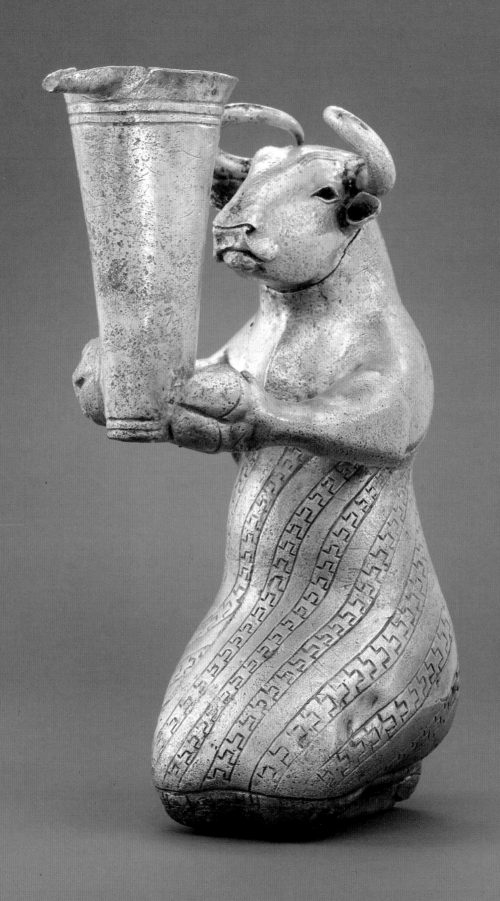

The Ancient Near East

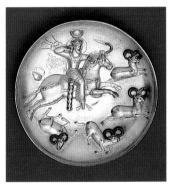

THE ORIGIN OF MANY features of Western civilization lies in the lands of the Near East, where small villages of hunters, gatherers, and farmers evolved into the first true cities. "Ancient Near East" is a general term that embraces both an enormous geographical territory and a long chronological span. The Museum's holdings of ancient Near Eastern art represent cultures from western Turkey east to the valley of the Indus River and from the Caucasus Mountains as far south as the Gulf of Aden. From this enormous geographic area come works of art that date from the late Neolithic period of the seventh millennium B.C. to the Islamic conquest in the middle of the seventh century A.D.

Mesopotamia, which lay between the Tigris and the Euphrates rivers, was the heart of the ancient Near East. As early as the seventh millennium B.C., these great rivers were major routes of communication, connecting distant regions. They were the source of water that, through irrigation, transformed the arid plains into fertile soil suitable for grazing and for growing crops. Urban civilization began in southern Mesopotamia during the fourth millennium B.C. Specialized full-time occupations, such as architect, artist, scribe, craftsman, farmer, and institutions such as the priesthood and kingship came into existence. The people responsible for this urban revolution, as it has been called, were the Sumerians, who are thought to have developed the first known script, a system of pictographs that later evolved into wedge-shaped cuneiform signs.

The Sumerians were succeeded by the Akkadians, a Semitic people who had entered southern Mesopotamia, probably from the west, during the centuries of Sumerian control. This dynasty was founded by Sargon of Akkad (2334–2279 B.C.), who was the first Mesopotamian ruler to have truly imperial aspirations. In 2154, however, the empire collapsed under invasions of tribesmen from western Iran. The period that followed is called Neo-Sumerian because the rulers and priests consciously returned to pre-Akkadian artistic forms and to the use of the Sumerian language. By the beginning of the second millennium, the kings of Assyria began to consolidate their power in northern Mesopotamia and within a few centuries dominated vast territories in the Near East.

The first millennium B.C. was a period of great empires, first in Assyria and later in Babylonia and Achaemenid Iran. The imperial palaces constructed in the Assyrian cities of Nimrud, Nineveh, Khorsabad, and Ashur were lavishly decorated. During the three decades of its development, the art of the Assyrian Empire reflected an increasing concern with secular themes, which elaborated and glorified the royal image.

Ancient Anatolia (modern Turkey) was an area with an abundance of metal resources and a trading center for merchants from Mesopotamia and Syria in the early second millennium B.C. During this period the Hittites entered the region and gained control of the Anatolian plateau. In the period of their empire (15th–13th century B.C.) the Hittites produced monumental architecture and sculpture and fine metalwork and ceramics. After the Hittite collapse at the turn of the millennium, a number of smaller kingdoms gained power in the region, notably Urartu, centered around Lake Van in eastern Anatolia, and Phrygia, known best from the site of Gordion in central Anatolia.

(OPPOSITE)

Iranian, Proto-Elamite, ca. 2900 B.C.
KNEELING BULL HOLDING A VASE

Silver; H. 6⅜ in. (16.2 cm)
Purchase, Joseph Pulitzer Bequest, 1966
(66.173)

This small silver bull from southwestern Iran is of exceptional technical quality and is composed of many parts carefully fitted together. The figure shows a curious blend of human and animal traits: the large neck meets distinctly human shoulders, which taper into arms that end in hooves. Animals in human posture are known in Iranian Proto-Elamite sculpture and can be seen engraved on contemporary cylinder seals. The purpose and meaning of this small masterpiece remain enigmatic, although it is thought that the bull acting like a human is drawn from a contemporary religious myth. Traces of cloth found affixed to the figure suggest that it was wrapped and intentionally buried, perhaps as part of a ritual or ceremony.

(LEFT)

Iranian, Sasanian,
late 5th–early 6th century A.D.
PLATE WITH PEROZ OR KAVAD I HUNTING RAMS

Silver with mercury gilding and niello;
H. 1¾ in. (4.5 cm)
Fletcher Fund, 1934 (34.33)

Many vessels made of silver survive from the Sasanian Empire (A.D. 224–642) and attest to the great wealth of the royal court. One of the finest examples is this silver plate, which shows a king in full ceremonial dress hunting a pair of rams. The raised design is made from a number of separate pieces fitted into lips that have been cut up from the background of the plate. The theme of the king as hunter symbolized the prowess of Sasanian rulers and was often used to decorate royal plates sent as gifts to neighboring courts.

The artist who carved this powerful sculpture, which represents a type of wild sheep native to the highland regions of the Near East, has achieved a realistic rendering of an animal at rest. The animal's head, now partially broken away, is held upward and turned slightly to the right, creating a naturalistic impression of alertness. The entire body is contained within a single unbroken outline. This combination of closed outline with broadly modeled masses and a minimum of incised detail is characteristic of animal sculpture from this period in the art of the Indus River valley.

During the seventh century B.C., before the Achaemenid Persian conquest that reached into western Anatolia, Scythian invaders to this area, as well as Mesopotamia and Iran, brought with them a distinctive style and repertory of designs featuring stags, panthers, birds of prey, and griffins.

Syria, to the south of Anatolia and west of Mesopotamia, was a crossroads between the great civilizations of the ancient world and was often disputed by rival powers. Despite the continuous presence of foreigners, the art of the region had its own distinctive character. At times during the second and first millennia B.C., however, truly international styles developed in this region. Motifs and designs from Egypt and the Mediterranean world were adopted and, in time, passed from Syria into Mesopotamia.

Southwestern Iran, known as Elam in antiquity, was Mesopotamia's closest neighbor, both geographically and politically. Contacts with lands as far to the north and east as the area known today as Afghanistan, and with the peoples living in the valley of the Indus, exposed the artists of Iran to cultures that were unfamiliar to their Mesopotamian neighbors, and this is reflected in the character and appearance of their works of art.

By the middle of the first millennium B.C., Mesopotamia and Iran, under the rule of Achaemenid kings, were part of an empire that exceeded in its geographical extent any political entity that had come before. Influences from lands throughout the empire, including Assyria, Babylonia, Egypt, and Greece, are apparent in both the style and iconography of the art of the Achaemenid court. The Greek conquest of the Achaemenid Empire in 334 B.C. under Alexander the Great interrupted the cultural development of the Near East and altered the course of civilization in that region. For the next thousand years, in times of peace and war, the kingdoms of the Near East and the Roman and Byzantine empires in the West maintained political and economic ties as well as common cultural traditions.

An abundance of fine painted pottery has survived from ancient Iran, and this ovoid storage vessel is a particularly good example. The dark brown geometric decorations divide the upper part of the jar into three panels that contain the stylized figure of an ibex. Each animal is shown in profile against the buff-colored background to highlight the great arch of its exaggerated horns.

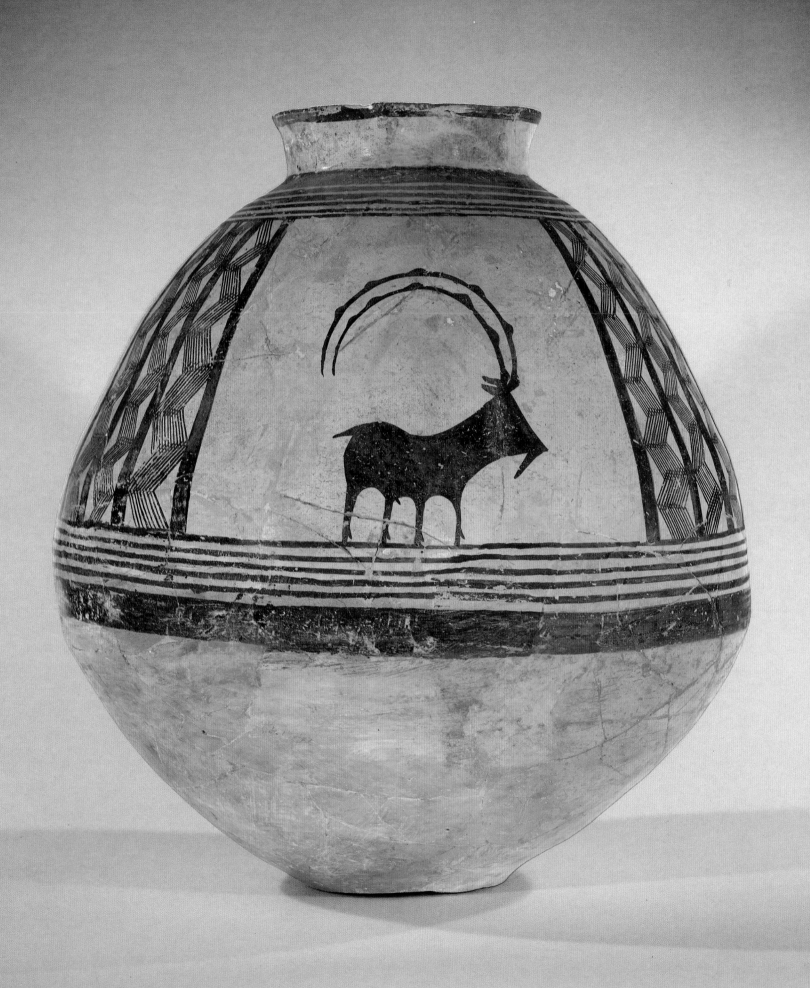

A reassertion of a Near Eastern identity, an Iranian renaissance, is apparent in the arts of the beginning of the first century B.C., and it developed under the Parthian and Sasanian dynasties. From the last centuries before Christ to the coming of Islam, the history of the ancient Near East was one of almost continual warfare as the great empires of Byzantium and Iran battled and ultimately exhausted their resources in the effort to control the rich trade routes and cities of Anatolia and Syria.

The Museum's collection of ancient Near Eastern art has been acquired by gift and purchase and by participation in excavations in the Near East. Its strengths include Sumerian stone sculptures, Anatolian ivories and metalwork, Iranian bronzes, and Achaemenid and Sasanian works in silver and gold. An extraordinary group of Assyrian reliefs and statues from the palace of Ashurnasirpal II at Nimrud, as well as fine stamp and cylinder seals and ivories, can be seen in the Assyrian art galleries.

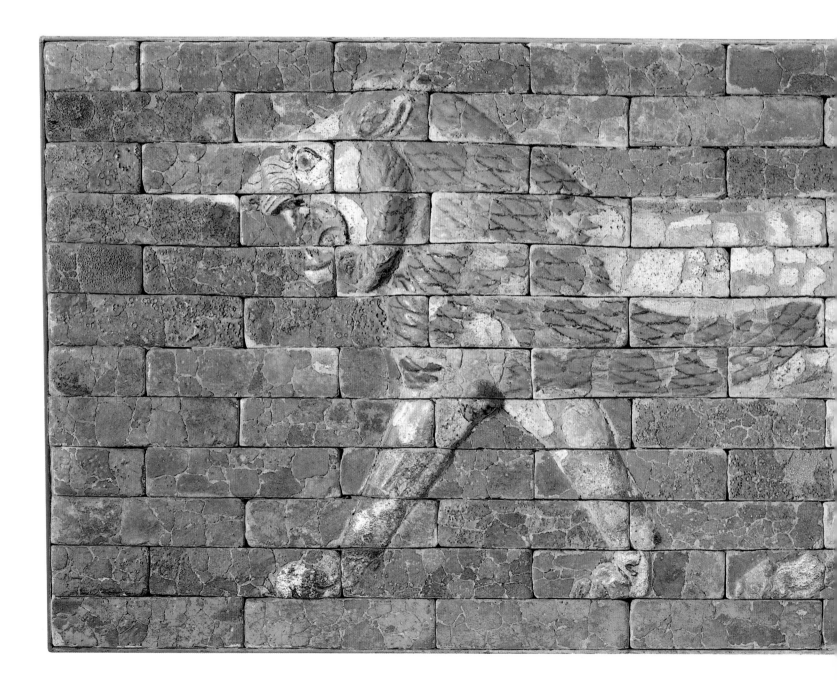

Mesopotamian (Babylon), Neo-Babylonian,
ca. 605–562 B.C.

PANEL WITH STRIDING LION

Glazed brick; 38¼ × 89½ in. (97.2 × 227.3 cm)
Fletcher Fund, 1931 (31.13.1)

During the reign of Nebuchadnezzar (605–562 B.C.), the Neo-Babylonian Empire reached its peak. This was largely due to his ability as a statesman and a general. He maintained friendly relations with the Medes in the east while vying successfully with Egypt for the control of trade on the eastern Mediterranean coast. During this period a tremendous amount of building took place, and Babylon became the city of splendor described by Herodotus and the Old Testament Book of Daniel. Because stone is rare in southern Mesopotamia, molded glazed bricks were used to decorate buildings, and Babylon became a city of brilliant color. The most important street in Babylon was the Processional Way, leading from the inner city through the Ishtar Gate to the *Bit Akitu*, or House of the Near Year's Festival. This relief of a striding lion is one of many from friezes that covered the walls of the Processional Way. The lion, symbol of Ishtar, goddess of war, served to direct the ritual procession from the city to the temple.

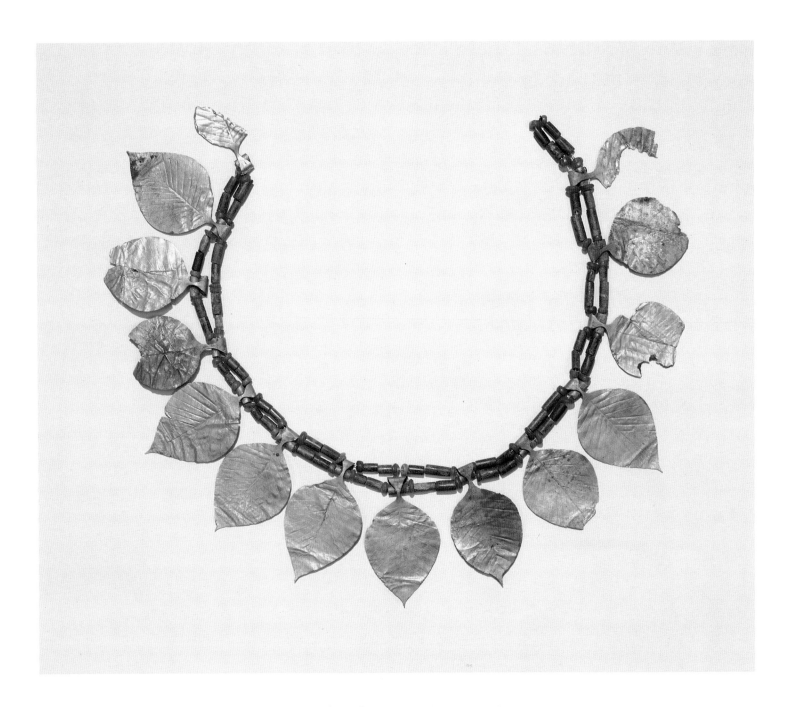

Mesopotamian, ca. 2600–2500 B.C.

CHAPLET OF GOLD LEAVES

Gold, lapis lazuli, carnelian; L. 15⅛ in.
(38.4 cm)
Dodge Fund, 1933 (33.35.3)

This wreath of gold beech leaves, suspended
from strings of lapis lazuli and carnelian
beads, encircled the crown of the head. It
was part of an important collection of
Sumerian jewelry found in one of the
richest graves in the Royal Cemetery at Ur,
which was excavated in 1927–28 by Sir
Leonard Woolley. The headdress adorned
the forehead of one of the female attendants
in the so-called King's Tomb. She also wore
two necklaces of gold and lapis lazuli, gold
hair ribbons, and two silver hair rings. Since
gold, silver, lapis lazuli, and carnelian are
not found in Mesopotamia, their presence
in the royal tombs attests both to the wealth
of the Early Dynastic Sumerians and to the
existence of a complex system of trade that
extended far beyond the Mesopotamian
river valley.

Anatolian, Hittite Empire Period,
ca. 15th–13th century B.C.
VESSEL IN THE FORM OF A STAG

Silver with gold inlay; H. 7⅛ in. (18.1 cm)
Gift of Norbert Schimmel Trust, 1989
(1989.281.10)

Anatolia is rich in metal ore, and the consummate skill of Hittite metalworkers is amply demonstrated by this fine silver rhyton, which is thought to be a rare example of art produced by court workshops. Of particular interest is the frieze depicting a religious ceremony that decorates the rim of the cup section. Although the precise meaning of the frieze remains a matter of conjecture, it is possible that the vessel was intended as a dedication to or the personal property of the stag god.

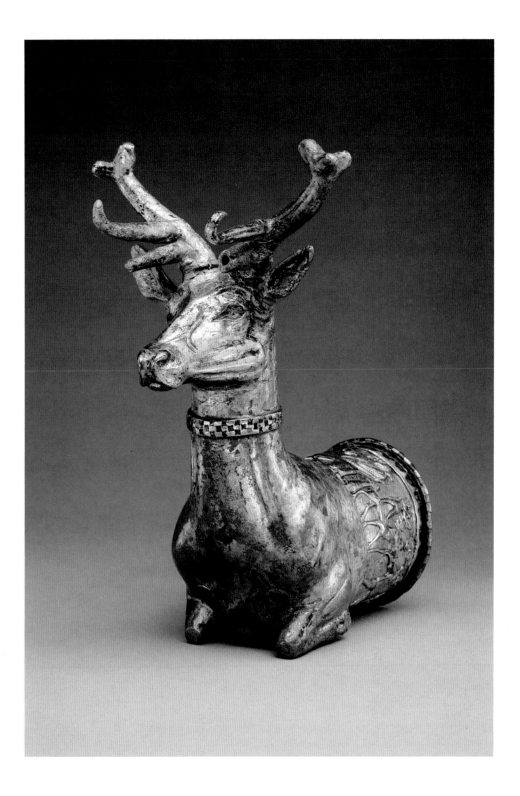

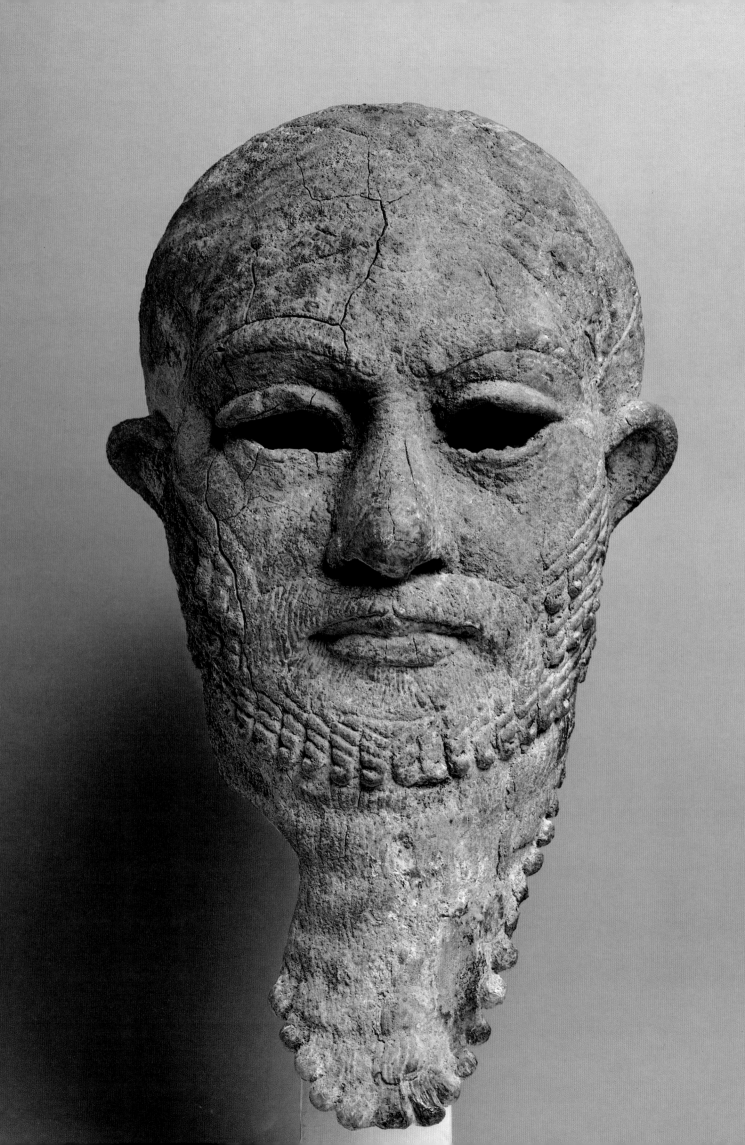

Iranian?, ca. 2000 B.C.

HEAD OF A DIGNITARY

Arsenical copper; H. 13½ in. (34.3 cm)
Rogers Fund, 1947 (47.100.80)

———

This magnificent copper head is reminiscent of the head of an Akkadian ruler found at Nineveh in northern Mesopotamia. Hollow cast, a dowel on the plate at the base of the neck presumably served to join the head to the body. The heavy-lidded eyes, the prominent but unexaggerated nose, the full lips, and enlarged ears all suggest that this is a naturalistic portrait of a real person, a rare phenomenon in the art of the ancient Near East. Its costly material and impressive workmanship, size, and appearance are all indications that this is a representation of a ruler whose identity remains unknown. In any case, the head is one of the great works of art preserved from the ancient Near East.

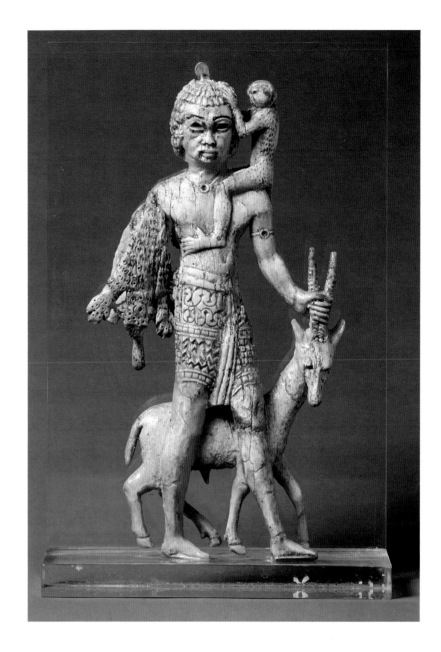

Mesopotamian (Nimrud), Neo-Assyrian,
8th century B.C.

NUBIAN TRIBUTE BEARER

———

Ivory; H. 5¼ (13.3 cm)
Rogers Fund, 1960 (60.145.11)

———

In contrast to the grand stylized reliefs that flanked the walls of the palace of Ashurnasirpal II at Nimrud (see page 39) are the delicate ornamental ivories that once adorned the royal furniture. Ivory, prized throughout the ancient world, was carved in rich detail and decorated with colorful inlays and gold. The ivories found at Nimrud were executed in several styles that reflected regional differences. This beautiful example has traits of the Phoenician style, characterized by the slender form of the tribute bearer and his animal gifts, the precision of the carving and intricacy of detail, and the distinct Egyptian flavor of both pose and features.

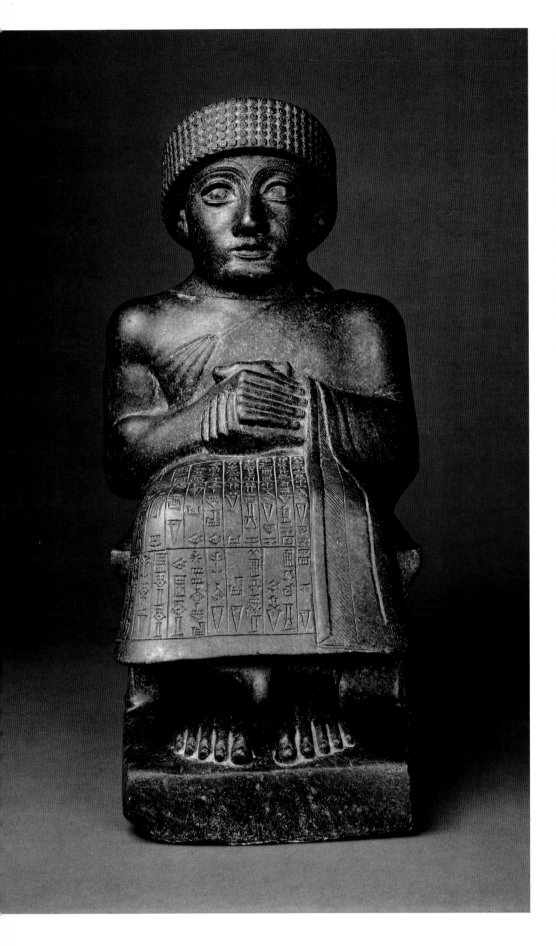

Mesopotamian, Neo-Sumerian, ca. 2100 B.C.

SEATED GUDEA

Diorite; H. 17⅜ in. (44.1 cm)
Harris Brisbane Dick Fund, 1959 (59.2)

At the end of the 22nd century B.C., the city-state of Lagash in the extreme south of Mesopotamia experienced a cultural renaissance under the leadership of the Sumerian governor Gudea and his son Ur Ningirsu. The works of art produced by this Neo-Sumerian culture are pervaded by a sense of pious reserve and calm, beautifully exemplified by this image of the ruler. It is thought that this statue was originally placed in a temple, as the inscription in cuneiform along the front of his robe reads: "Gudea, the man who built the temple, may it make his life long." Although there are many extant statues of Gudea, this is the only complete example in the United States.

Iranian, ca. 1000 B.C.

CUP WITH FOUR GAZELLES

Gold; H. 2½ in. (6.4 cm)
Rogers Fund, 1962 (62.84)

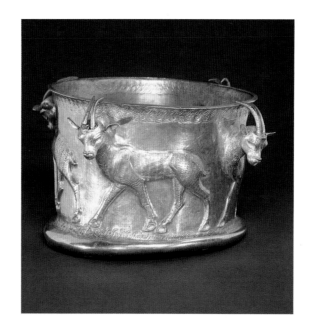

The tradition of making vessels decorated with animals whose turned heads project in relief has a long history in the Near East. This exquisite cup probably comes from northern Iran, near the Elburz Mountains. The four gazelles walk in procession to the left, framed by guilloche bands. The bodies are fashioned by repoussé and details of body hair and muscles are clearly defined by finely chased lines. The heads, ears, and horns were made separately and fastened in place by colloid hard-soldering, a process much practiced in Iran involving copper salt and glue.

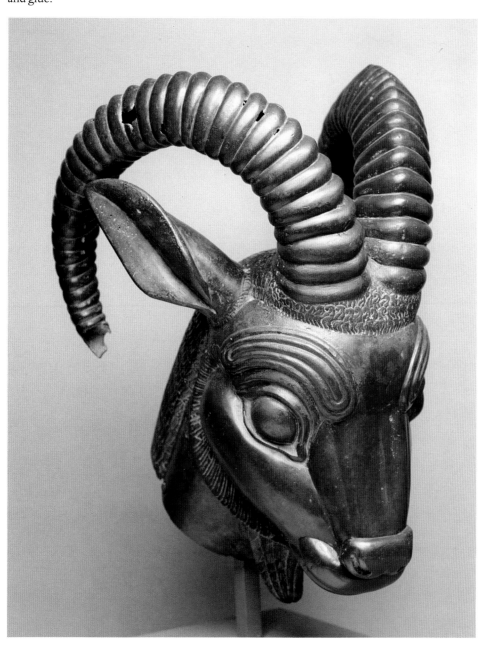

Iranian, Achaemenid, 6th–5th century B.C.

HEAD OF A HORNED ANIMAL

Bronze; H. 13⅜ in. (34 cm)
Fletcher Fund, 1956 (56.45)

This stylized rendering of a mythical animal—part goat, part sheep—is an eloquent example of Iranian art of the Achaemenid period, still untouched by the influence of classical Greece. Cast of bronze by the lost-wax process, it is made of five separate pieces joined by fusion welding. The angle of the neck suggests that the head was not attached to an animal body but was perhaps joined to a support as an element of furniture or architectural decoration.

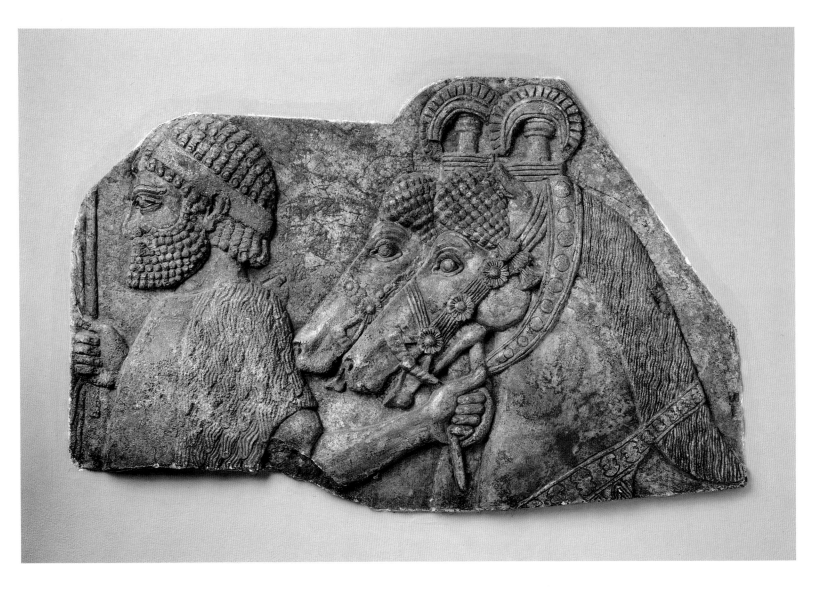

Mesopotamian (Khorsabad), Neo-Assyrian,
late 8th century B.C.
MAN LEADING HORSES

————

Limestone; 20 × 32 in. (50.8 × 81.3 cm)
Gift of John D. Rockefeller, Jr., 1933 (33.16.1)

————

From the ninth to the seventh century B.C.,
the kings of Assyria ruled over a vast
empire. Assyrian sculptors often depicted
the victories of their monarchs in war and in
the chase. Richly detailed and full of vitality,
these scenes expressing regal power and
triumph are among the masterworks of
Assyrian art. This fragment, which comes
from the palace of the king Sargon II
(721–705 B.C.) at Khorsabad, shows a
mountaineer, probably from Iran, bringing
two handsomely caparisoned horses as
tribute to the king.

Mesopotamian (Nimrud), Neo-Assyrian,
ca. 883–859 B.C.
HUMAN-HEADED WINGED LION

————

Limestone; H. 122½ in. (311.2 cm)
Gift of John D. Rockefeller, Jr., 1932 (32.143.2)

————

During the ninth century B.C. the great
Assyrian king Ashurnasirpal II built a new
capital at Nimrud, where the palace was
decorated with large stone slabs
ornamented with low-relief carvings and
with sculptural figures guarding the
doorways. The Neo-Assyrian sculptor of
this limestone guardian gave the beast five
legs so that it stands firmly in place when
seen from the front, but appears to stride
forward when seen from the side. The
horned cap attests to the creature's divinity
and the belt signifies its power.

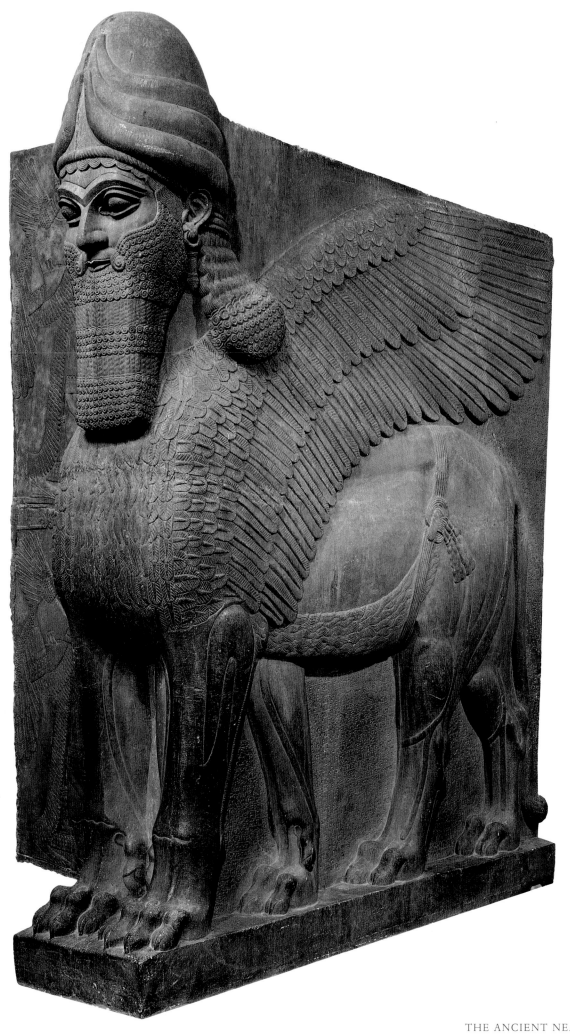

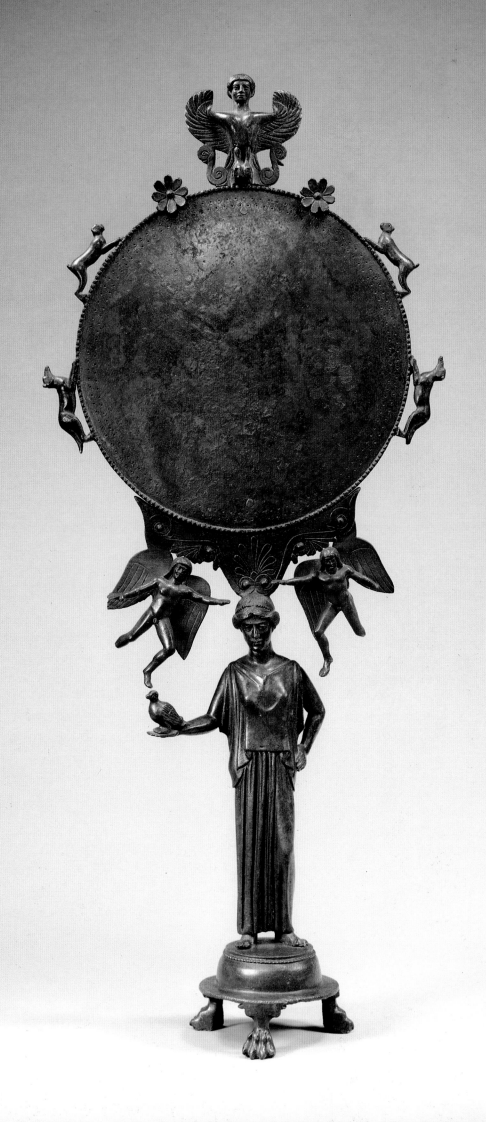

Greece and Rome

 THE BEGINNINGS OF CLASSICAL art may be discerned long before the people known as Greeks settled the lands bearing their name. Datable as far back as the sixth millennium B.C., the remains of cultures found in Thessaly, central Greece, the Peloponnesos, Crete, the Cycladic Islands, and Cyprus are sparse, but they include figural representations that can be seen as antecedents of Greek art. From the very outset, clay and marble were the preferred materials for artistic creativity, human figures were the preferred subjects, and a pronounced sense of measure governed the forms that were produced.

Consideration of the earliest cultures in Greece from a purely artistic standpoint entails a more selective field of vision than would a balanced, archaeological inquiry into the rich record of the region as a whole that is now coming to light. It was in the Cycladic Islands that the first great flowering of marble sculpture took place during the third millennium B.C. For much of the second millennium, between about 2000 and 1400 B.C., the Minoan culture developed and flourished in great palace complexes on the island of Crete.

The Mycenaean civilization, named after its preeminent center on the Greek mainland, reached a height during the fourteenth and thirteenth centuries B.C. The martial spirit of the Mycenaeans, so foreign to the Minoans, appears in the extent to which skilled craftsmanship was applied to objects of war or representations of warriors. Widespread cultural and political upheaval led to the downfall of the Mycenaean civilization and to a period of some three hundred years during which artistic activity diminished significantly. The renewal, which began about 1000 B.C., took place in mainland Greece, principally Athens. Its artistic manifestation is the Geometric style, a term derived from the curvilinear and rectilinear shapes that are used either as decorative motifs or as components in the depiction of more complex subjects, i.e., figures.

During the eighth century, renewed contacts with and imports from the east began to broaden the Greek repertoire of subjects, and by the end of the seventh century the oriental stimulus had been assimilated. The Archaic period (about 700–480 B.C.) saw an efflorescence of all the arts throughout Greece. Perhaps the single most important development was the emergence of monumental stone sculpture, in the round and in relief. Compared with Geometric renderings, the body is lifelike, becoming ever more so as sculptors acquired the ability to render not only how it looked but also how it moved.

If the Archaic manner of representation depicted the appearance of a subject with maximum clarity, artists of the Classic period (480–323 B.C.) began to introduce the realities of space, time, and character. The medium of sculpture reached its most exalted expression in the friezes, metopes, and pediments of the Parthenon in Athens. The aspects of human activity that Classic artists favored were those emphasizing human strengths: nobility in victory, valor in battle, restraint in mourning. It is in the succeeding, Hellenistic phase of Greek art (323–31 B.C.) that individual features—such as the characterization of a person, the marks of old age, a detail of deformity—acquire unprecedented importance.

(OPPOSITE)

Argos, mid-5th century B.C.

MIRROR

Bronze; H. 16 in. (40.6 cm)
Bequest of Walter C. Baker, 1971 (1972.118.78)

One of the achievements of sculptors of the Classic period is the successful integration of every component part into a whole. The diverse elements in this mirror have been composed into a magnificent utensil and unified by the perfectly balanced composition of the supporting figure. Inserted into the crown of her head is a palmette ornament that supports the mirror disk. Along the beaded border of the disk two hounds each pursue a hare. At the top, the siren constitutes a presence that is at once fearsome, with her lion claws and deployed wings, and feminine, with a coiffure and physiognomy corresponding to those of the caryatid below. This object of exceptional quality was made for the toilette of a lady of means.

(LEFT)

Detail from the Euphronios krater (see page 47)

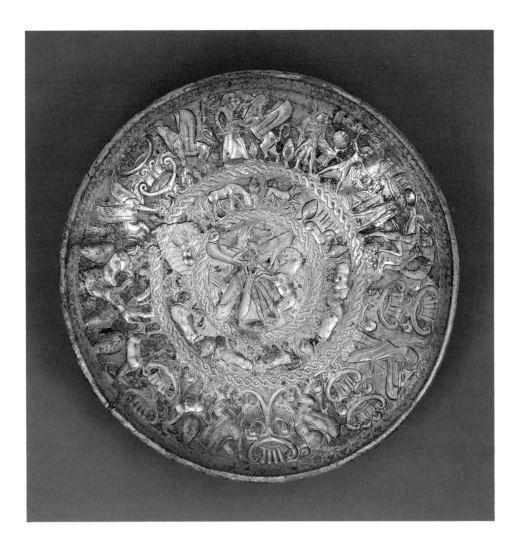

With the rise of Macedon under Philip II and Alexander the Great, the Hellenistic period saw the fields of creative energy displaced from the Greek heartland—Attica and the Peloponnesos—to the periphery, including southern Italy and Asia Minor. The great age of Athens was past. When the Romans conquered and destroyed Corinth in 146 B.C., the transfer of primacy was consummated.

During the Republic, the expansion of Rome over Italy, Spain, North Africa, and Asia subjugated cultures upon which the Greeks had left their mark. By the time the empire was established under Augustus (27 B.C.), Rome had achieved the power and organization to administer a realm whose greatest extent, under Trajan (A.D. 53–117), reached from Britain to Mesopotamia. The qualities and capacities of each successive ruler influenced not only the political but also the artistic world. Through architecture, sculpture, and coinage, the Roman presence was asserted in far-flung regions. Edward Gibbon observed that the hallmarks of civilization are art, law, and manners. It was the Roman achievement to hold its vast and diverse domains by a formal system of laws. Moreover, by endowing the symbols of its jurisdiction with the qualities so ardently assimilated from the Greek world, they became an integral part of what is called Western civilization.

Although the Department of Greek and Roman Art was not formally established until 1909, the first accessioned object in the Museum was a Roman sarcophagus from Tarsus, donated in 1870. Today the strengths of the vast collection include Cypriot sculpture, painted Greek vases, Roman portrait busts, and Roman wall paintings. The department's holdings in glass and silver are among the finest in the world, and the collection of Archaic Attic sculpture is second only to that in Athens.

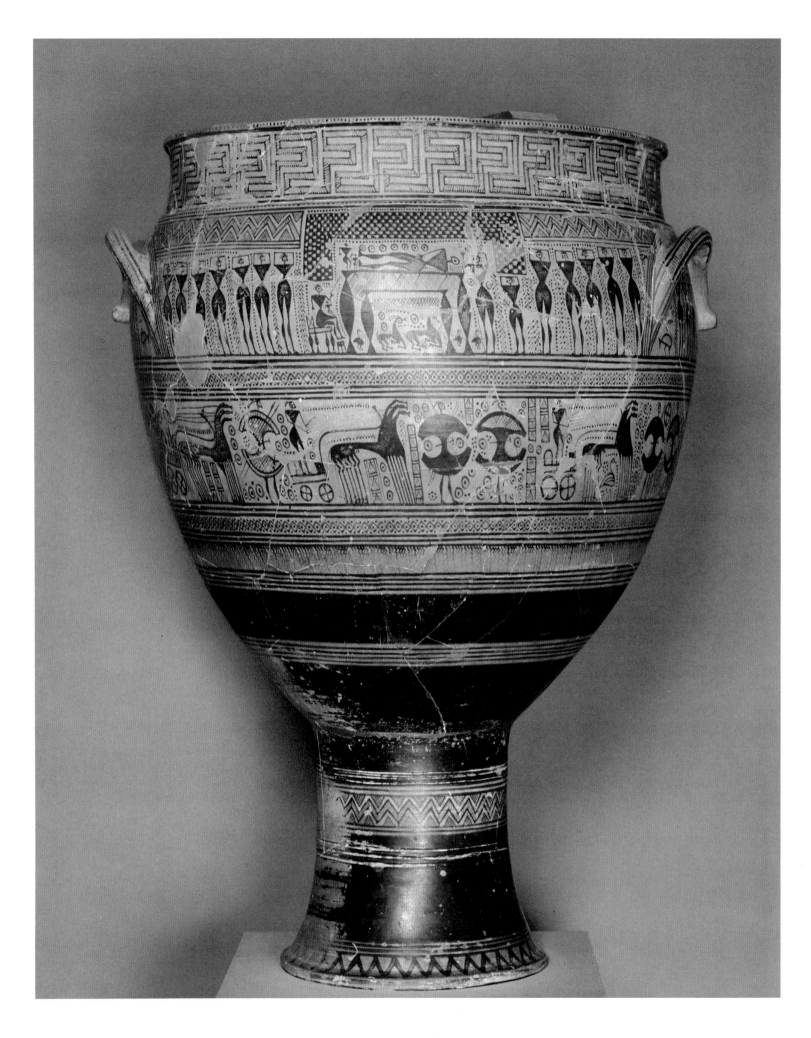

Attic, second half of 8th century B.C.

FUNERARY VASE

Terracotta; H. 42⅝ in. (108.3 cm)
Rogers Fund, 1914 (14.130.14)

This large vase, which was originally a grave marker, is a superb example of work of the Geometric period in Greek art (ca. 1000–700 B.C.) and a precious source of information about early Greek funerary rituals. At the broadest part of the vase, framed by the handles, the deceased is represented lying on a bier surrounded by mourners. In the zone below warriors in chariots alternate with foot soldiers carrying great figure-eight shields. Although the decoration is schematic, Geometric art from Attica and its center, Athens, shows extraordinary inventiveness and often monumentality.

Attic, ca. 610–600 B.C.

KOUROS

Marble; H. 76 in. (193 cm)
Fletcher Fund, 1932 (32.11.1)

The tradition of large scale in Geometric funerary vases continues into both vases and sculpture of the seventh and sixth centuries B.C. One of the most important types of freestanding statue is that of the kouros (youth), which served as a funerary monument or as a dedication in a sanctuary. The figure stands in perfect balance with absolute serenity. There is no attribute or detail to introduce any narrative or episodic dimension. Such sculptures, which were made through the sixth century B.C., are the point of departure for the progressive mastery of the human figure in Greek art. By about 500 B.C., when artists became interested in showing "active" movement, bronze was increasingly used for monumental works.

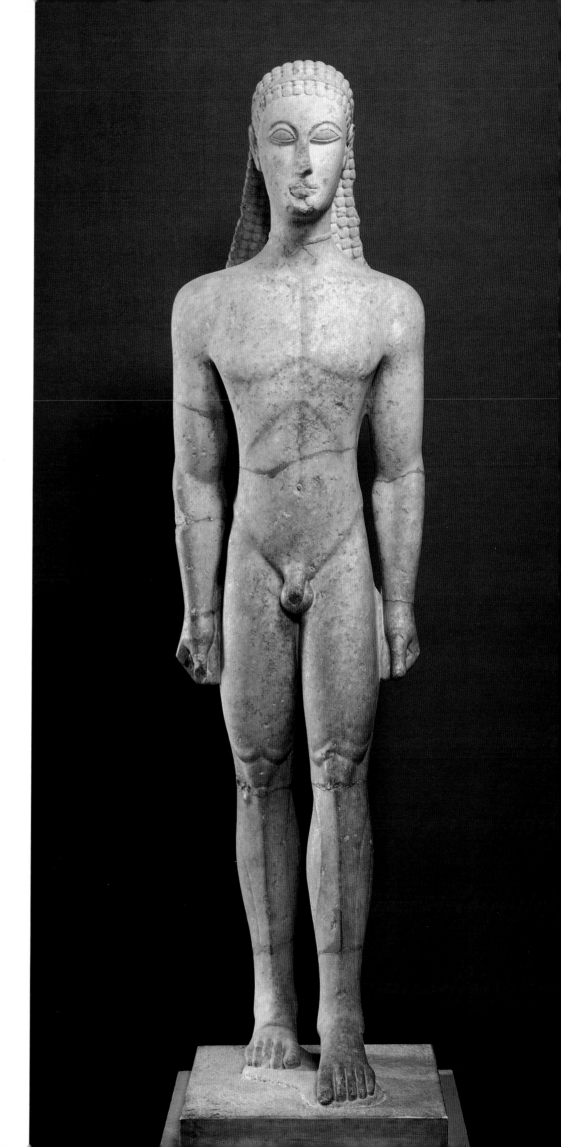

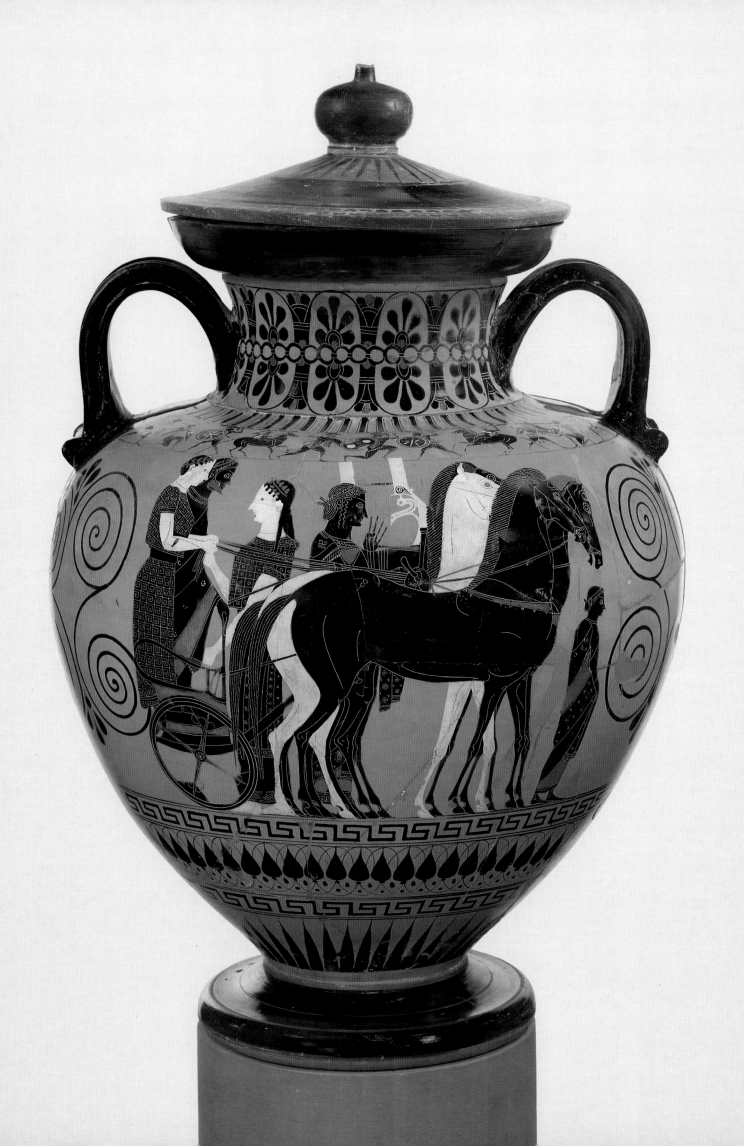

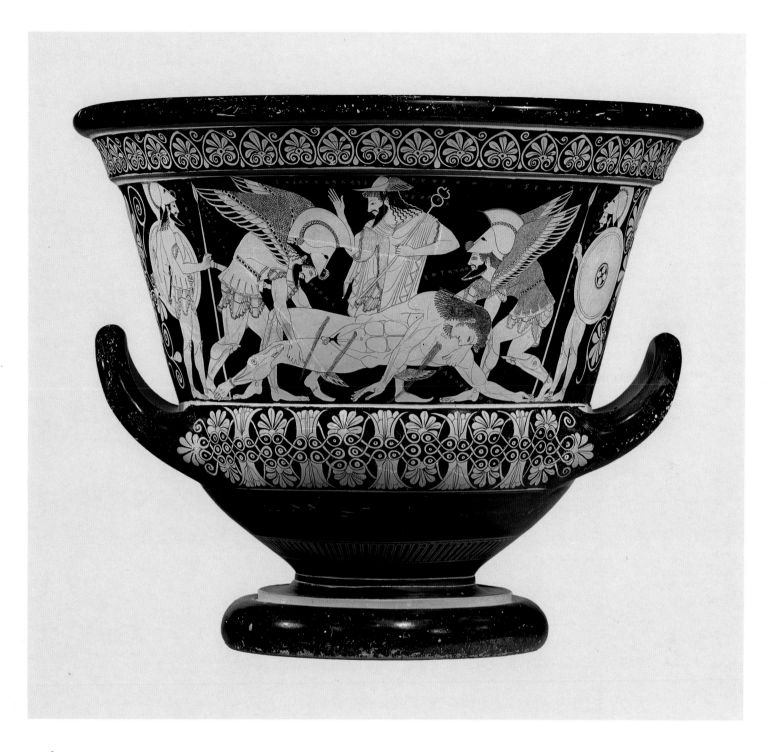

Exekias (painter)

Attic, ca. 540 B.C.

NECK AMPHORA

———

Terracotta; H. 21¾ in. (55.2 cm)
Rogers Fund, 1917 (17.230.14)

Exekias is perhaps the greatest of all black-figure vase-painters, and this is one of his finest works. He has covered the entire surface of this neck amphora, a storage jar, with decoration, and yet the effect is one of great order. The scene shows a wedded pair in the chariot being greeted by a woman or a goddess while a youth, perhaps Apollo, plays the kithara. The floral and geometric bands on the neck and body emphasize the measured cadence of the action and the shape of the pot itself.

Euphronios (painter) and *Euxitheos* (potter)

Attic, ca. 515 B.C.

CALYX KRATER

———

Terracotta; H. 18 in. (45.7 cm)
Purchase, Bequest of Joseph H. Durkee, Gift of Darius Ogden Mills and Gift of C. Ruxton Love, by exchange, 1972 (1972.11.10)

This krater is a masterpiece of composition and a superb example of the red-figure technique by two of the most prominent Athenian artists of the late sixth century B.C. Depicted here is an episode of the Trojan War in which Sarpedon, a son of Zeus and leader of the Trojans' allies, has just been slain by Achilles' friend Patroklos. Sleep and Death, under the direction of Hermes, are in the process of bearing off the fallen hero to Lycia, his native land, for burial.

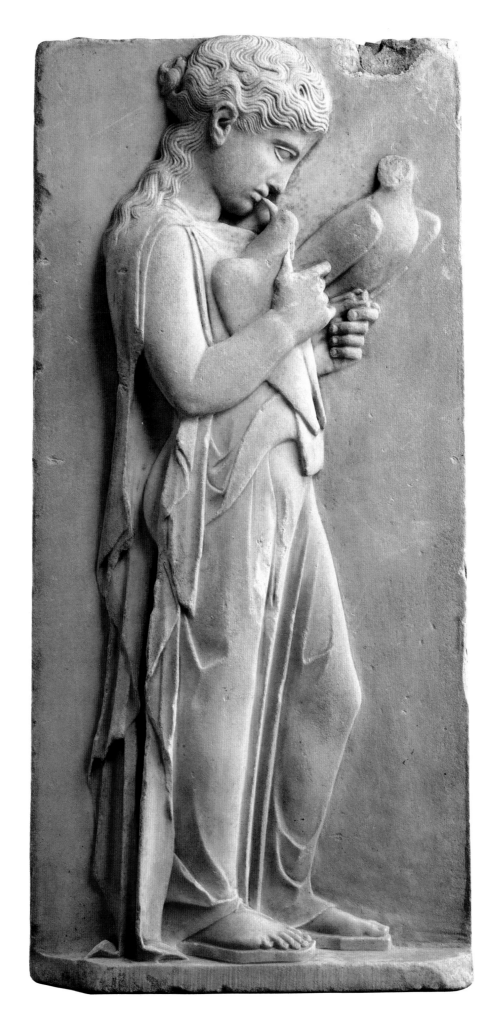

Greek (Alexandria?),
late 3rd–early 2nd century B.C.
VEILED AND MASKED DANCER

———
Bronze; H. 8⅛ in. (20.6 cm)
Bequest of Walter C. Baker, 1971 (1972.118.95)
———

The expressive possibilities of drapery, which Greek artists pursued most extensively in the female figure, reach a high point in this statuette of a dancing woman. The subject has been identified as one of the professional entertainers—a combination of mime and dancer—for which the city of Alexandria was famous in antiquity. Although the virtuosic conception, composition, and technical execution place this work in a special category, the figure represents as much of an innovation in Greek art as the deformed, infirm, and realistically rendered genre subjects that Hellenistic Alexandria established in the iconographic repertoire.

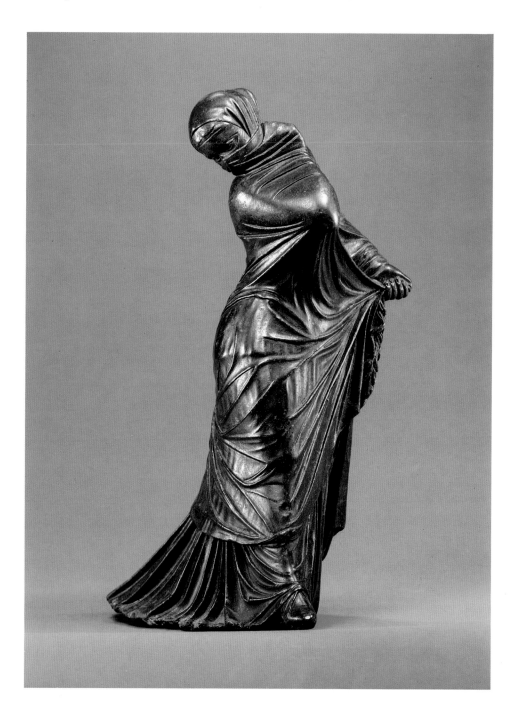

Greek, ca. 450–440 B.C.
GRAVE RELIEF: GIRL WITH DOVES

———
Marble; H. 31½ in. (80 cm)
Fletcher Fund, 1927 (27.45)
———

In ancient Greece gravestones were set up for children as well as adults; boys and girls were shown engaged in activities by which their parents wished them to be remembered. This work was found on the island of Paros, one of the main sources in antiquity for marble that was used in sculpture. The sculptor, probably a local artist, conveys the youth of the child through the pudgy body and limbs as well as her affection for her pet doves; the serious expression—well beyond her years—emphasizes the poignancy of her early death.

Etruscan, late 6th century B.C.

CHARIOT

Bronze; H. 51½ in. (130.8 cm)
Rogers Fund, 1903 (03.23.1)

In the sixth century B.C. chariots were no longer used in warfare. Found in a tomb in Monteleone, Italy, this example was probably put to limited ceremonial use before being included in the burial. The richness and quality of the decoration are exceptional. The pole issues from the head of a boar and ends in the head of a beaked bird. The principal subjects on the three parts of the chariot box refer to the life of a hero, probably Achilles. In the central panel (right) he is receiving his armor from his mother, Thetis. While the style and the subject are from Greek sources, the inflated appearance of the figures and the predilection for winged creatures are distinctly Etruscan.

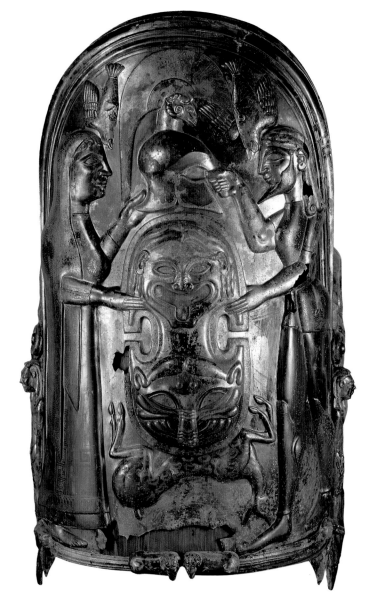

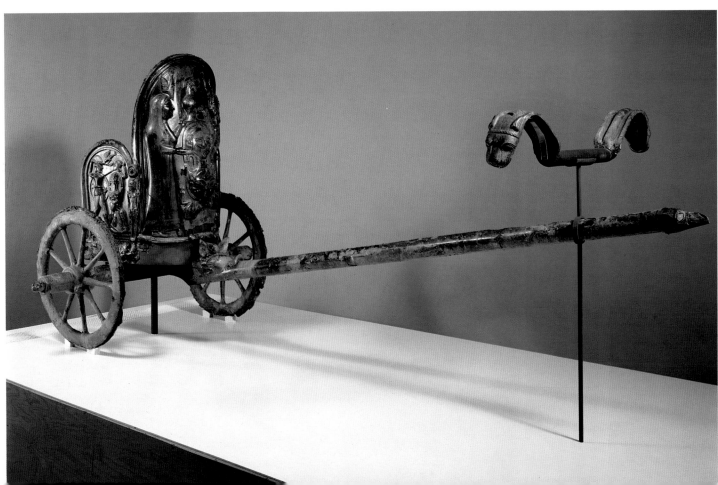

Augustan, ca. 10 B.C.–A.D. 4

PORTRAIT STATUE, PERHAPS OF
LUCIUS CAESAR

Bronze; H. 48½ in. (123.2 cm)
Rogers Fund, 1914 (14.130.1)

One of the Metropolitan's finest bronzes
from antiquity, this portrait beautifully
presents the mixed nature of adolescence,
combining the body of a boy with the
demeanor of a self-possessed young man.
The statue was found on the island of
Rhodes and is thought to depict one of the
grandsons of the emperor Augustus,
probably Lucius Caesar (17 B.C.–A.D. 2),
who, with his brother, Gaius, was given a
classical education on Rhodes by Greek
teachers until he was ready for military
service. The richly decorated pallium he
wears is a mark of status, and his hands
probably once held objects connected with
a religious ceremony. Although the work is
a specific characterization, the graceful
classical features and modeling are typical of
Augustan portraiture.

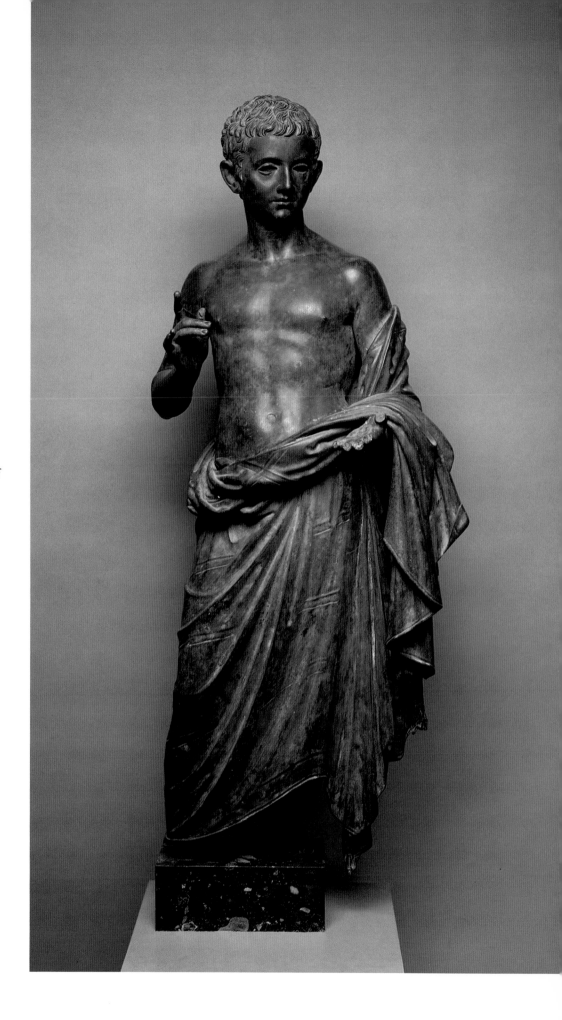

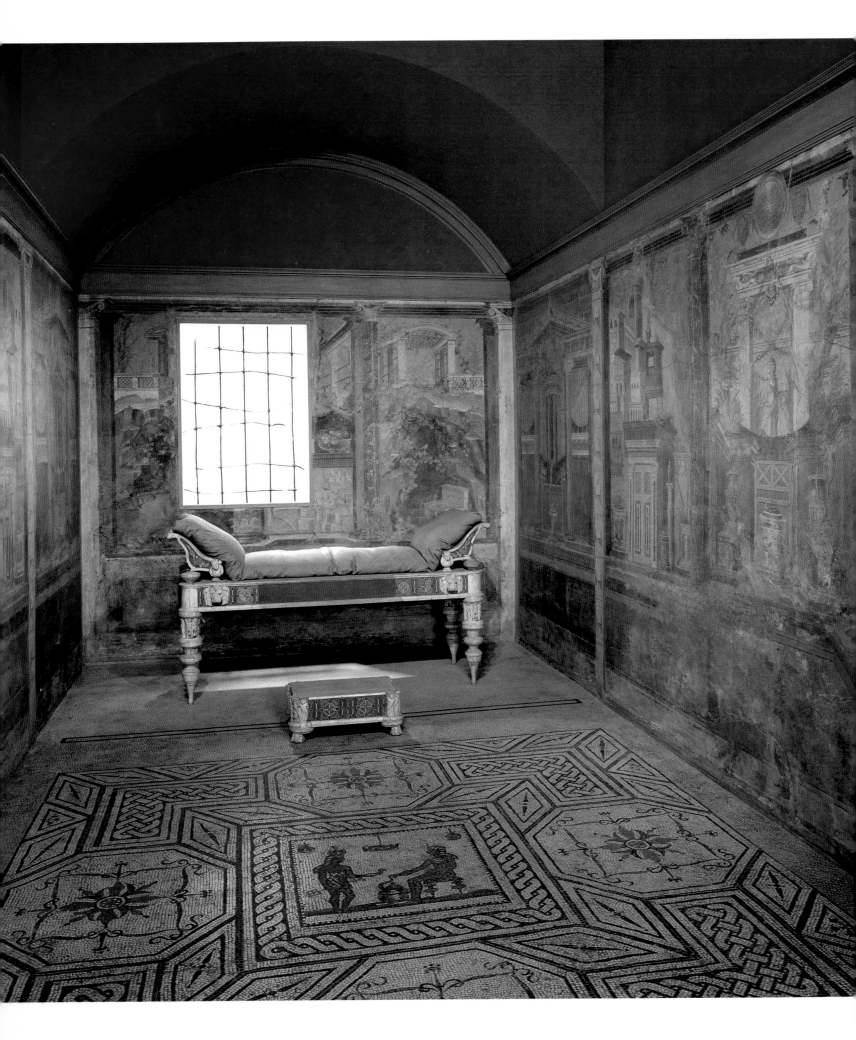

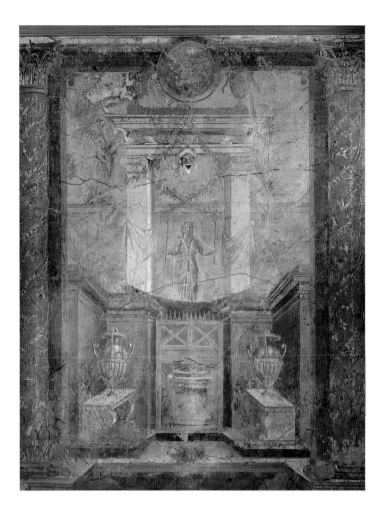

Roman, 40–30 B.C.

CUBICULUM FROM BOSCOREALE

Rogers Fund, 1903 (03.14.13)

The Metropolitan Museum owns two superlative groups of Roman wall paintings. One, from a villa near Boscoreale, about a mile north of Pompeii, includes a virtually complete bedroom (cubiculum). Like Pompeii, the villa was buried by the eruption of Mount Vesuvius in A.D. 79, and it is for this reason that the paintings are so well preserved. The bedroom (now furnished with a couch made of bone) is decorated with complex architectural vistas and various kinds of garden scenes. The detail above depicts a religious precinct with a statue of Hecate. The scene below shows an agglomeration of buildings with a remarkable variety of verandas and porticoes.

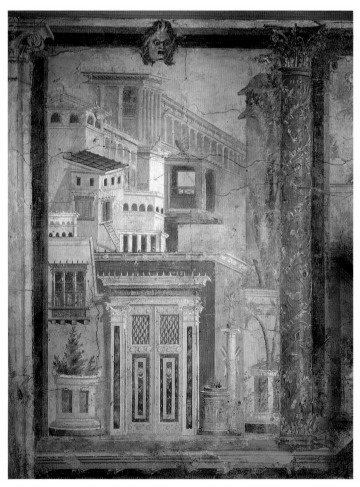

Roman, A.D. 260–270

THE SEASONS SARCOPHAGUS

Marble; H. 35 in. (88.9 cm), L. 87¾ in.
(222.9 cm)
Joseph Pulitzer Bequest, 1955 (55.11.5)

Sarcophagi were used in burials throughout
antiquity. This superb example shows the
wine god, Bacchus, riding a panther in the
company of his followers, the satyrs and
maenads, as well as the four seasons. The
last appear as four youths, each bearing
appropriate attributes. While the wine god
and his retinue begin in Greek mythology,
the presentation here exemplifies Roman
art at its best. The density of the figures
perfectly ordered within a shallow space,
the carving of the forms in extraordinarily
high relief, and the restless play of light and
dark over the surface generate an energy
that gives vibrancy to the entire work.

Roman Imperial, first century A.D.

STATUE OF PAN

Marble; H. 26⅝ in. (67.6 cm)
Classical Purchase Fund, 1992 (1992.11.71)

This splendid example of ancient high
baroque sculpture is unique in the
Museum's collection. The bravura carving
and the high quality of the workmanship
are typical, however, of many Roman
interpretations of Hellenistic baroque
sculpture. Pan, the goat god, is shown
braced against a tree trunk, bent forward
under the weight of an object once carried
on his back. A hole drilled through the
statue suggests that it was designed to be
part of a fountain complex.

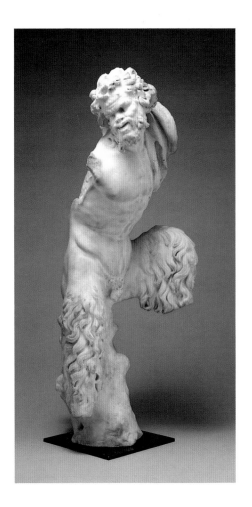

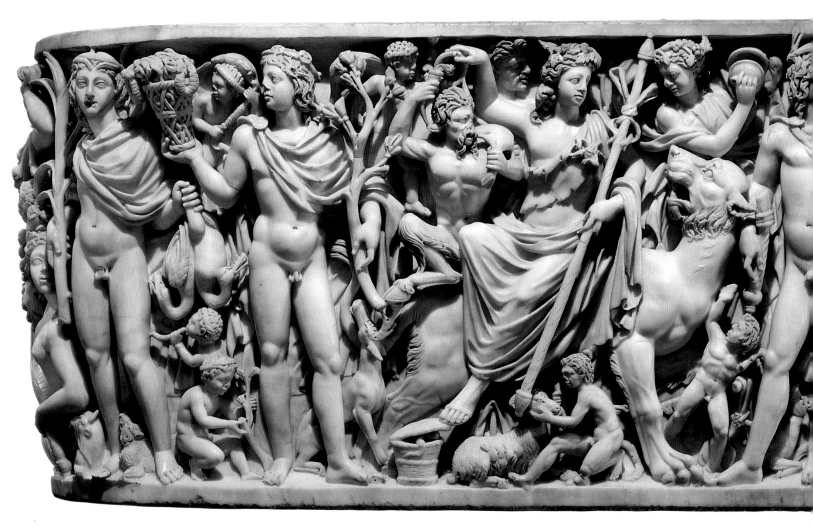

Roman, ca. A.D. 325

PORTRAIT OF THE EMPEROR
CONSTANTINE I

Marble; H. 37½ in. (95.3 cm)
Bequest of Mary Clark Thompson, 1923
(26.229)

The third century A.D. was a period of
turmoil and strife within the Roman
Empire that manifested itself artistically
in a diversity of concurrent styles and a
predisposition for representing spiritual
states of being rather than physical
verisimilitude. Christianity emerged as a
significant force at this time and was
decisively strengthened by the conversion of
the emperor Constantine in A.D. 312. This
portrait of Constantine, which originally
surmounted a colossal seated statue,
documents the transfer of ultimate
authority from the mortal ruler to his
savior.

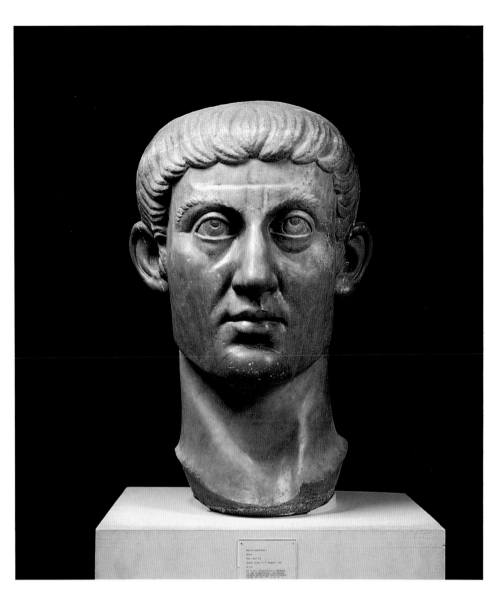

THE MIDDLE AGES

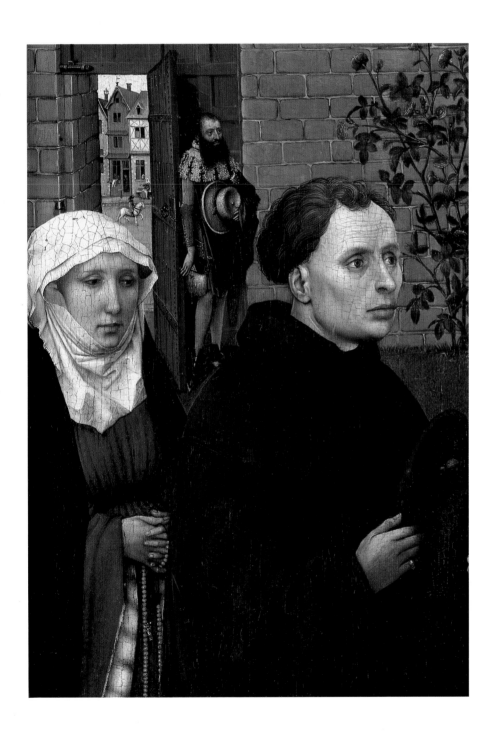

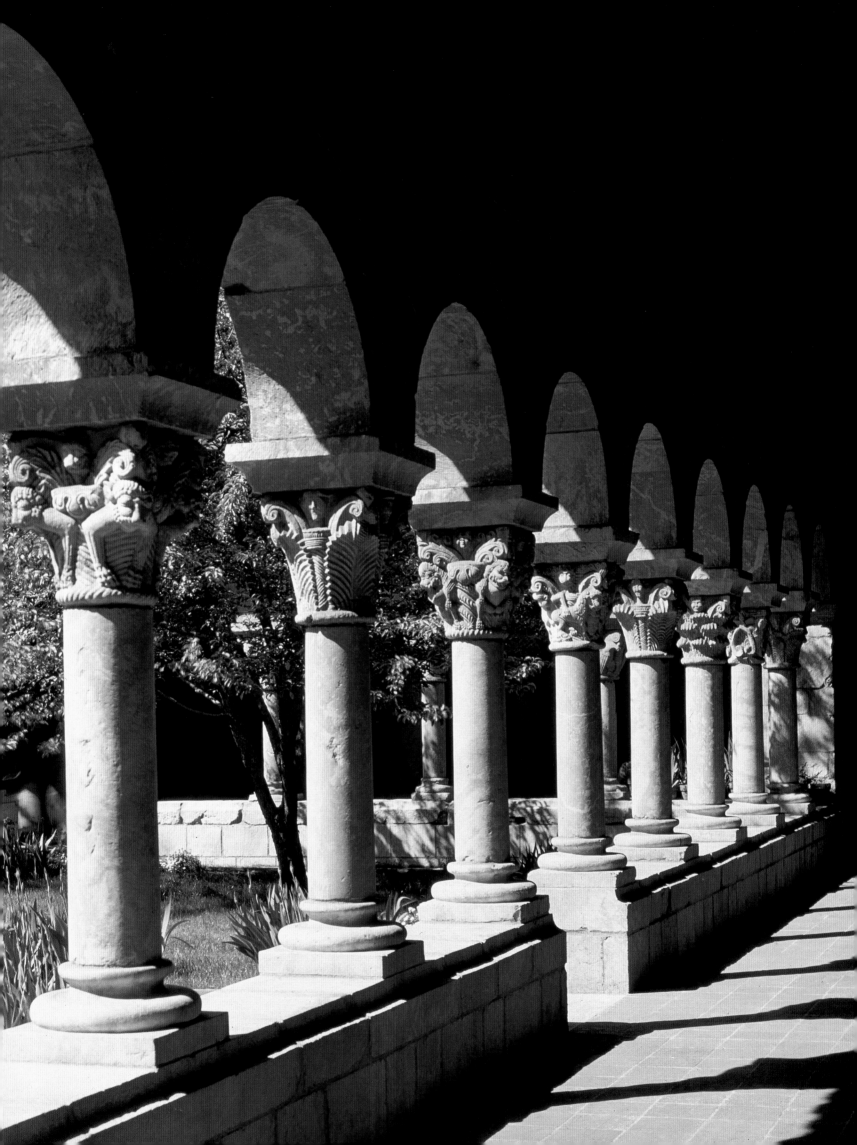

Medieval Europe

THE CHRISTIAN ART THAT emerged from the Greco-Roman world is one of the most important achievements of Western civilization. With the Edict of Milan in 313 the emperor Constantine the Great (reigned 306–337) formally recognized Christianity. Although this was a critical turning point, the transition from classical to Christian art was not abrupt, since for several hundred years both cultures coexisted and competed with each other. Christianity had its roots in Judaism and shared with it a proscription against images. Christians also resisted images because of their association with pagan religious practices. These factors impeded the development of a pictorial language appropriate to the new religion. Gradually, however, the power of the image became important to the promotion of Christianity and to conveying its message.

Since the reign of Constantine, Byzantium had increasingly become the center of the Roman Empire, while barbarian invasions disrupted the political and cultural fabric of the West. By the sixth century the eastern capital of Constantinople became the nucleus of a brilliant civilization. The emperor Justinian (reigned 527–565) inaugurated a dazzling building campaign of churches and public structures throughout the empire. The aesthetic aims of the Golden Age of Byzantium influenced all art forms and can be witnessed in portraits, ivories, and jewelry. Implements for the celebration of the Mass—gold and silver chalices, patens, ewers—essentially continued Roman forms of construction and design but were adapted to new functions.

The most distinctive local art of the Mediterranean developed in Egypt, where Coptic Christianity evolved. Essentially decorative in character, Coptic art ultimately was one of the bases of Islamic art. The rise of Islam permanently transformed the civilization of the eastern Mediterranean, and a violent dispute erupted in 726 over the permissibility of images, which led to the wholesale destruction of all representations by the "icon smashers," as they were called. Simultaneously, the northern European communities, especially the Frankish kingdoms, began to emerge artistically. During this critical stage, a truly medieval art was formed.

The barbarian invasions had permanently transformed the classical world and led to the rise of the Western civilizations of Europe. Following a nomadic life, the barbarians carried their wealth with them, usually in the form of jewelry. Two principal styles dominate the artistic forms of the migrating peoples: the polychrome style, associated with the Goths, Vandals, and Huns, and the animal style that originated in Scandinavia and northern Germany.

The Franks, who established the only lasting political power in Roman Gaul and converted to Christianity under Clovis I (reigned 481–511), ultimately founded the Carolingian Empire, which unified much of Europe. The essential qualities of barbaric art—its abstract, nonnarrative, geometric elements—were inappropriate for expressing the revival of the western Roman Empire. A cultural revival was therefore begun by Charlemagne, who was crowned in 774, and continued by Otto the Great, who in the tenth century inaugurated the Christianization of central Europe.

The identification of the term Romanesque with architecture is due to the great explosion of building activity through Europe in the late eleventh and twelfth centuries,

(OVERLEAF)

Detail of the Annunciation triptych (see page 74)

(OPPOSITE)

Pyrenees (Roussilon), ca. 1130–40
THE CUXA CLOISTER

Marble
The Cloisters Collection, 1925

This is a view of the west arcade of the cloister from the Benedictine monastery of Saint-Michel-de-Cuxa, located in the northeastern Pyrenees. The French closed the monastery in 1791 and much of the stonework was dispersed. The portion of the cloister installed here is remarkable for the variety of its sculptured capitals, which range from simple block forms to intricately carved animals, decorative elements, and motifs from popular fables.

(LEFT)

Anglo-Saxon (Kent), early 7th century
BROOCH

Gold, silver, garnets, gold wire; Diam. 1⅞ in. (4.8 cm)
Purchase, Joseph Pulitzer Bequest, 1987 (1987.90.1)

The geometric decorative and accomplished metalworking technique seen in early clasps like this handsome pin were an important legacy of the nonclassical tradition in the formulation of later medieval art.

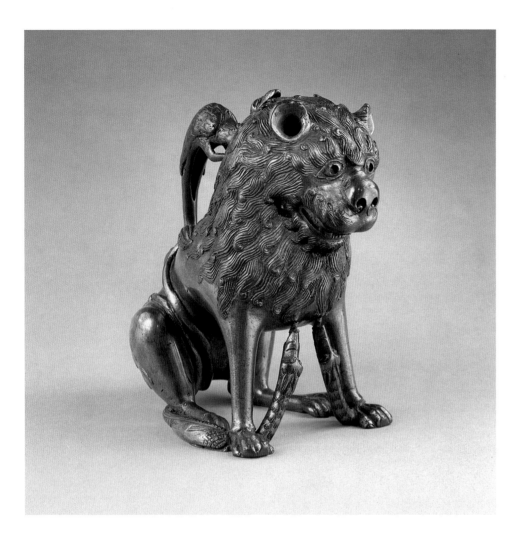

as the Church became the principal patron of the arts. Romanesque art, whether it is
monumental church sculpture, manuscript illumination, or the sumptuary arts, is a
synthesis of the preceding epochs, striving for orderly systematization of ideas and
images. Although in some areas the Romanesque survived into the thirteenth century,
its increasing exposure to classicizing forms (mainly as a result of Byzantine influences)
led to its eclipse and to the rise of the Gothic.

Between 1140 and 1270 the Gothic style emerged in France, and it would dominate
the artistic landscape of northern Europe for nearly four hundred years. The principal
catalyst for the miraculous rise of the great cathedrals was the rebirth of the cities,
where new political, commercial, and ecclesiastical wealth was concentrated.

The Late Gothic period, characterized by an increased secularity, gave rise to an
urban middle class as the Church's political power declined. In this tumultuous
environment, artistic and intellectual achievement advanced with astonishing inven-
tiveness and expressiveness, its fast pace halted only by the onslaught of the Black Death
in 1348. Recurrent economic recession brought on extremes of poverty and wealth, and
lavish objects of every description were produced in unprecedented quantities. About
1400 the International Style swept Europe. This brief phenomenon produced elon-
gated, elegant figures draped in flowing curvilinear folds, which hint at the anatomical
forms and impart a mystical lyricism to the human image.

If the fourteenth century can be said to have been dominated by sculpture and the
three-dimensional arts, the fifteenth century was one in which the two-dimensional art
of painting flourished along with the decorative arts, including great tapestries—the
mural paintings of the north—and elaborate gold ecclesiastical and secular objects. The
humanistic recognition of individual artistic expression heralded the end of the Middle

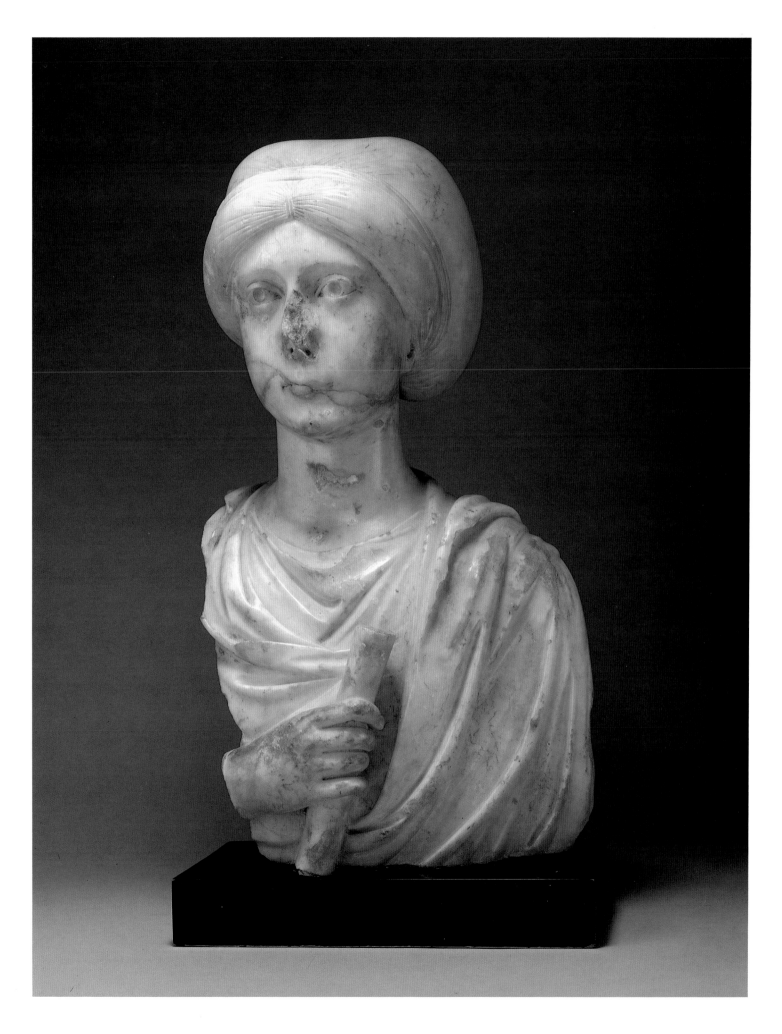

Ages in Italy in the early fifteenth century, but in the north it was not until 1500 that the lingering indifference to the Italian Renaissance began to fade.

The core of the Museum's collection of medieval art was formed by a major gift of J. Pierpont Morgan in 1917 and now numbers over four thousand pieces, which are in the Museum's main building. Among the strengths of the collection are Early Christian and Byzantine silver, enamels, glass, and ivories; Migration jewelry; Romanesque and Gothic metalwork, stained glass, sculpture, enamels, and ivories; and Gothic tapestries. The Cloisters, located in northern Manhattan overlooking the Hudson River, incorporates architectural elements of five medieval cloisters. John D. Rockefeller, Jr., provided the grounds and the building to house the works he had acquired from George Grey Barnard for the Museum in 1925, as well as works from his own collection. Known particularly for its Romanesque and Gothic architectural sculpture, the Cloisters collection also includes illuminated manuscripts, stained glass, metalwork, enamels, ivories, and paintings. Among its tapestries is the renowned Unicorn series.

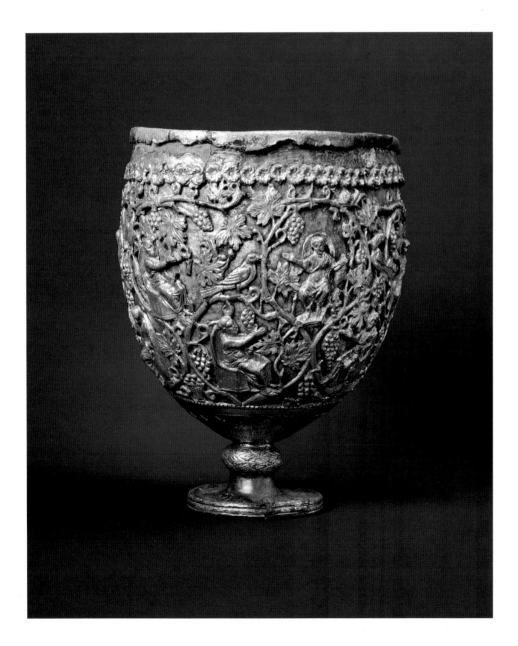

Syrian? (Kaper Koraon), Early Byzantine, 6th century
THE "ANTIOCH CHALICE"

Silver, silver gilt; H. 7½ in. (19.1 cm)
The Cloisters Collection, 1950 (50.4)

The plain silver cup that is the core of this vessel is encased in an elaborate openwork container of silver gilt. Recent research has identified the vessel as part of a large horde of Early Christian liturgical silver, probably from the village of Kaper Koraon in Syria. It has been suggested that the vessel was never a chalice at all but a standing oil lamp. In its densely inhabited grapevine Christ appears twice—seated with a scroll and seated by a lamb above an eagle with outspread wings. The other seated figures acclaim Christ, perhaps in reference to "I am the light."

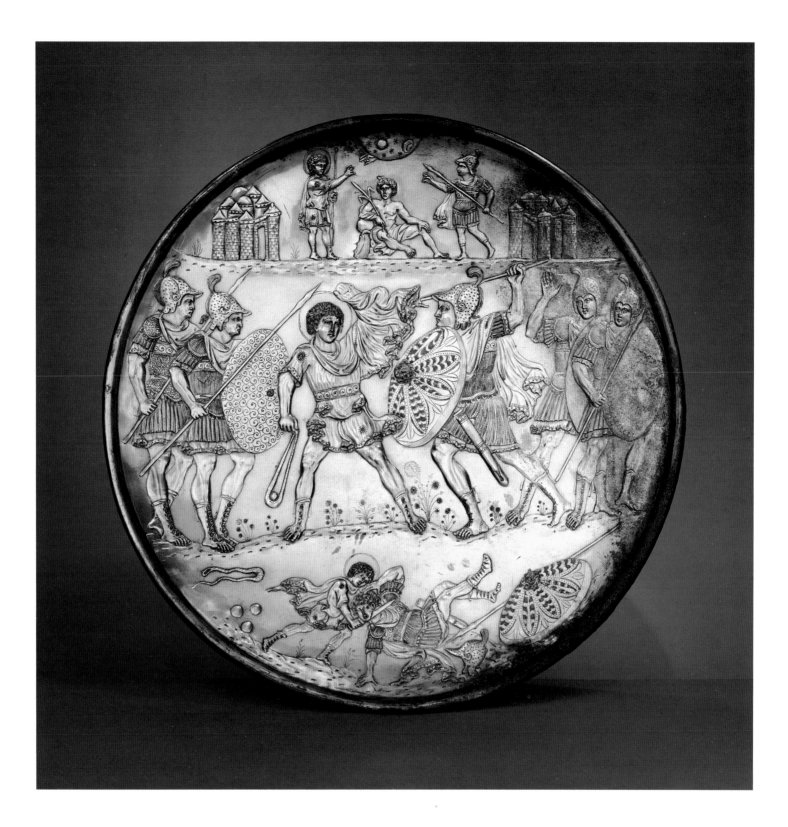

Early Byzantine (Constantinople), 628–630
DAVID AND GOLIATH

Silver; Diam. 19½ in. (49.5 cm)
Gift of J. Pierpont Morgan, 1917 (17.190.396)

This silver plate is the largest of a set of nine illustrating scenes from the life of the Hebrew king David that was uncovered in 1902 in Cyprus. This episode shows David slaying the Philistine warrior Goliath: at the top of the plate David curses Goliath; in the center Goliath lunges at him; at the bottom David beheads the fallen giant. Because the relief decoration makes these plates unsuitable for practical use, it is likely that they were intended for ceremonial display. They were produced during the reign of the emperor Heraclius, perhaps to commemorate his victory over the Persian general Razatis in 627. Each plate is made of a solid piece of silver, and the extraordinarily rich imagery is chased by hand, making these among the most spectacular works of Byzantine art in existence.

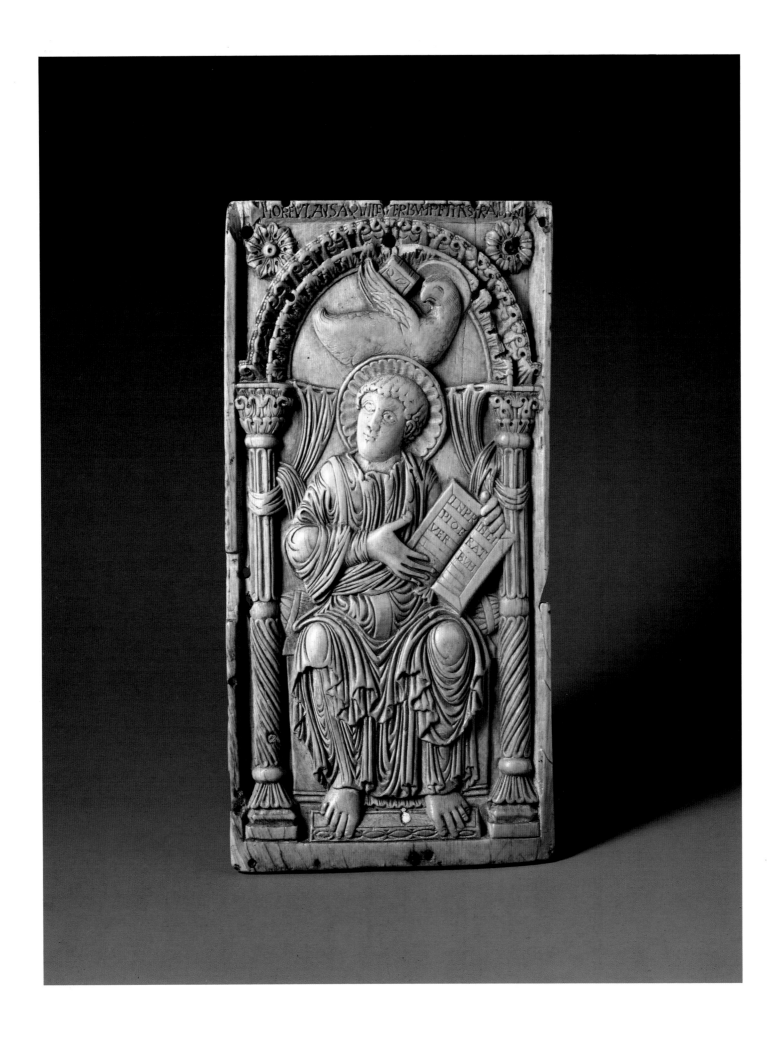

Carolingian, early 9th century

PLAQUE WITH SEATED SAINT JOHN
THE EVANGELIST

Ivory; 7½ × 3⅝ in. (19.1 × 9.2 cm)
The Cloisters Collection, 1977 (1977.421)

After Charlemagne was crowned Holy
Roman Emperor in the year 800, he sought
to reassert the grandeur of the first
Christian emperors, and the arts played an
important part in this renaissance. This
plaque representing Saint John the
Evangelist probably decorated the wing of
a triptych that may have been made in
Charlemagne's court school. The saint,
accompanied by his symbol, the eagle,
displays the opening text of his gospel: "In
the beginning was the word." The deep
layering of the drapery and the architectural
setting reflect Classical imagery.

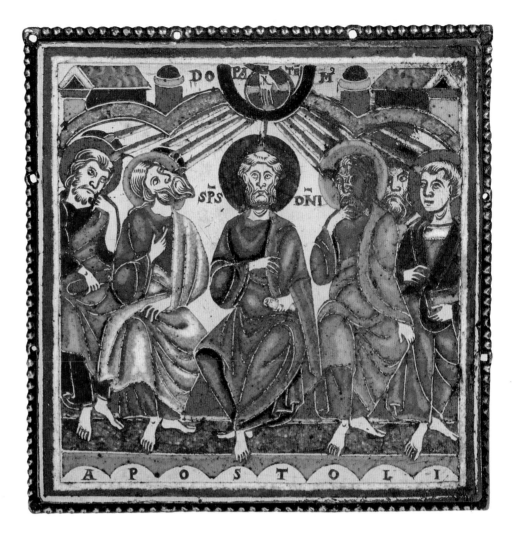

Mosan, third quarter of 12th century

PLAQUE SHOWING THE
PENTECOST

Champlevé enamel on copper gilt;
4½ × 4½ in. (11.4 × 11.4 cm)
The Cloisters Collection, 1965 (65.105)

Artists of the Meuse valley (in modern-day
France and Belgium) were traditionally
renowned for their beautiful works in
champlevé enamel. This jewel-like plaque is
the crowning piece of a number of Mosan
enamels in the Museum's collection, part of
an extensive series that once decorated a
large object, perhaps an altarpiece or foot of
a cross. The plaque illustrates the descent of
the Holy Sprit on the disciples of Christ at
the Pentecost. This event became viewed as
the birth of the Christian Church.

French (Troyes), ca. 1170–80
PANEL WITH CENSING ANGELS

Pot-metal glass; 18½ × 17⅜ in.
(47 × 44.1 cm)
Gift of Ella Brummer, in memory of her
husband, Ernest Brummer, 1977 (1977.346.1)

The stained glass produced in the city of
Troyes during the late 12th century
represents a major development in the
transition from the Romanesque to the
Gothic style. This panel, probably from the
church of Saint-Étienne, is from a window
of connected semicircles whose overall
subject was the Dormition of the Virgin. Its
meticulous painting style is unlike that
usually found in stained glass of this period
but bears a resemblance to techniques used
in Mosan enamelwork and manuscript
illuminations from Champagne.

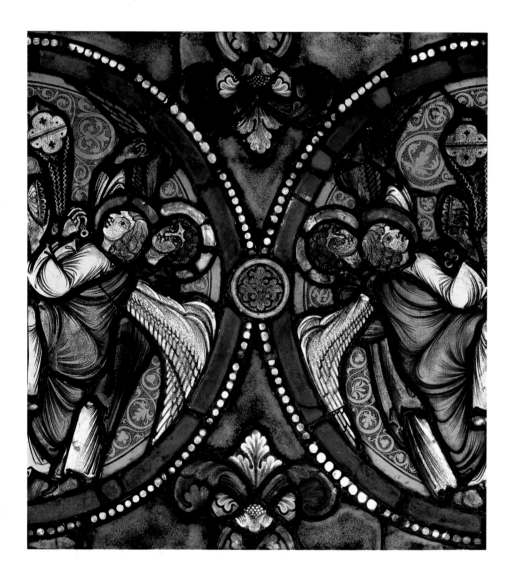

English (Bury Saint Edmunds?), ca. 1150–60
ALTAR CROSS

Walrus ivory with traces of polychromy;
22⅝ × 14¼ in.
(57.5 × 36.2 cm)
The Cloisters Collection, 1963 (63.12)

This extraordinary ivory cross is assembled
from seven pieces of walrus ivory and is
carved on both sides with more than 100
figures and 60 inscriptions in Latin and
Greek. Its complex imagery centers on the
promise of salvation through Christ's
sacrifice; this front view shows the cross as
the Tree of Life, with holes still visible
where the hands and feet of the missing
body of Christ were originally attached.
The sophistication of style and theological
imagery suggest that the cross, among the
finest in Romanesque art, was probably
produced at the Abbey of Bury Saint
Edmunds in eastern England, a thriving
monastic center in the 12th century.

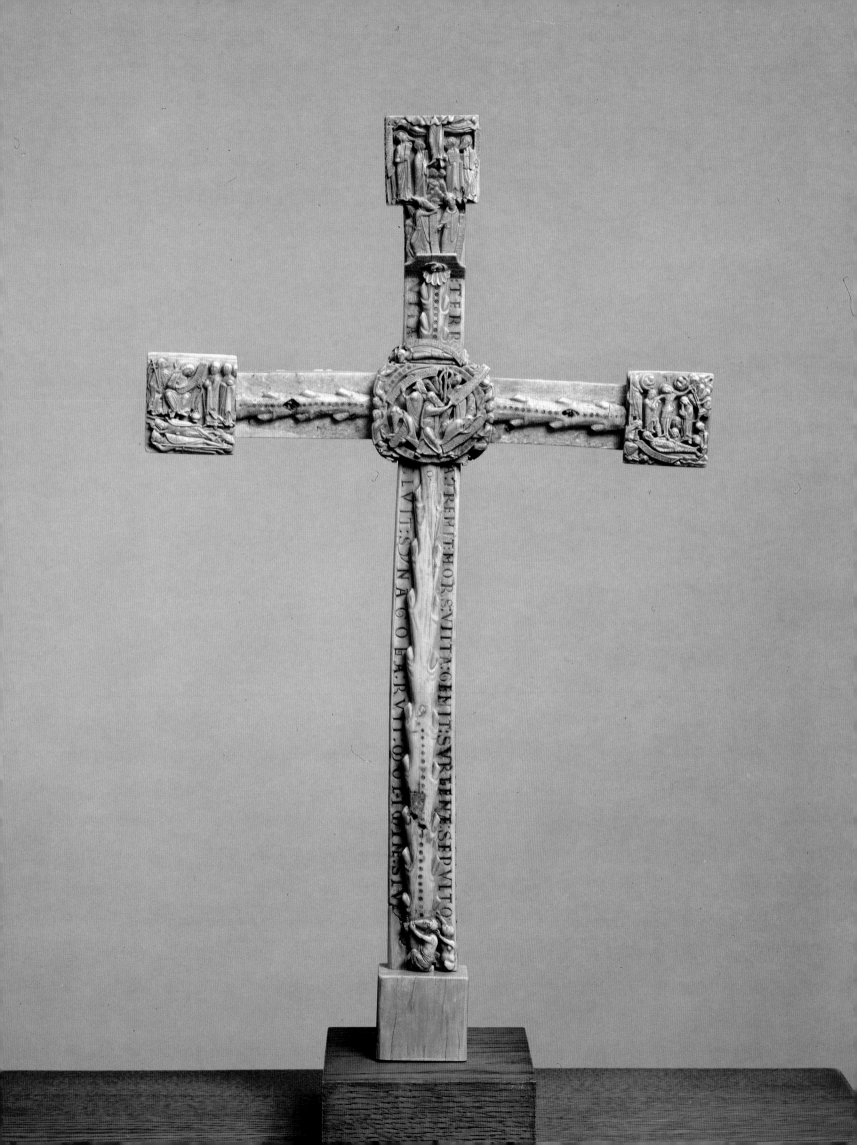

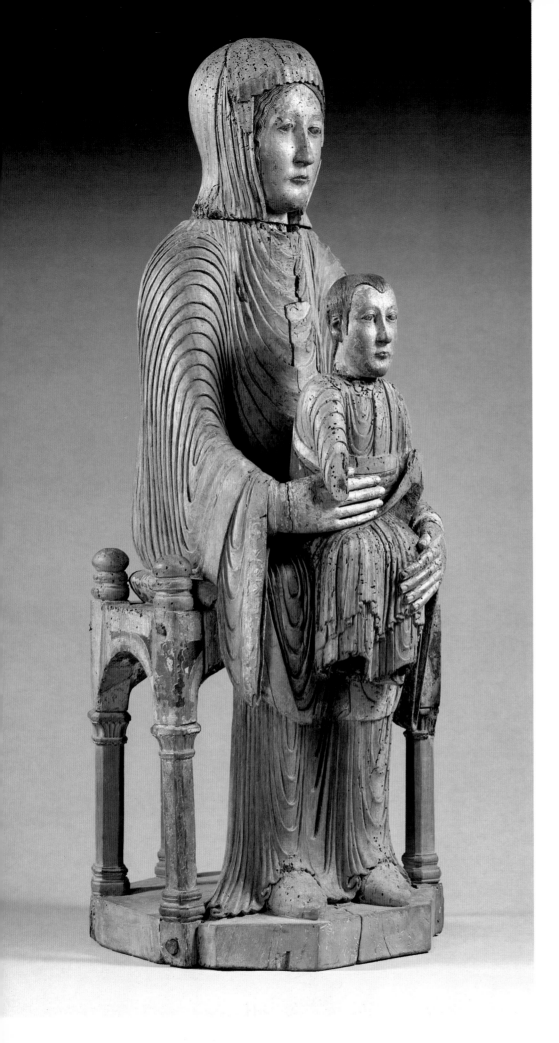

French (Auvergne), 1150–1200
VIRGIN AND CHILD
———
Oak with polychromy; H. 31 in. (78.7 cm)
Gift of J. Pierpont Morgan, 1916 (16.32.194)
———
This majestic sculpture of the Virgin and
Child enthroned probably served as an
object of devotion on an altar and perhaps
also in processions. The Virgin represents
the Throne of Old Testament Wisdom, and
the figure of Christ, which would originally
have held a scroll or book, imparts the
knowledge of the Word of God as continued
in the New Testament. The abstract hieratic
nature of the piece is effectively reinforced
by the rigid, frontal poses, the stern,
expressionless faces, and the calligraphic
pattern of the crisply chiseled drapery folds.

Spanish (Palencia), 1150–1200
CRUCIFIX
———
White oak and pine with polychromy,
gilding, and applied stones; H. 102⅜ in.
(260 cm)
The Cloisters Collection, 1935 (35.36ab)
———
According to tradition, this crucifix hung in
the convent of Santa Clara near Palencia in
northern Spain. The figure of Christ,
crowned as King of Heaven, is made of
white oak; the cross is of pine. It was
probably intended to be hung high above
the altar in front of the choir. Although the
triumphant Christ is indicated by the open
eyes and golden crown, the expression is
one of profound pathos. Its great size, the
strong face, and the preservation of much of
the original polychromy and cross establish
this as one of the most beautiful and
important crucifixes of the Romanesque
period.

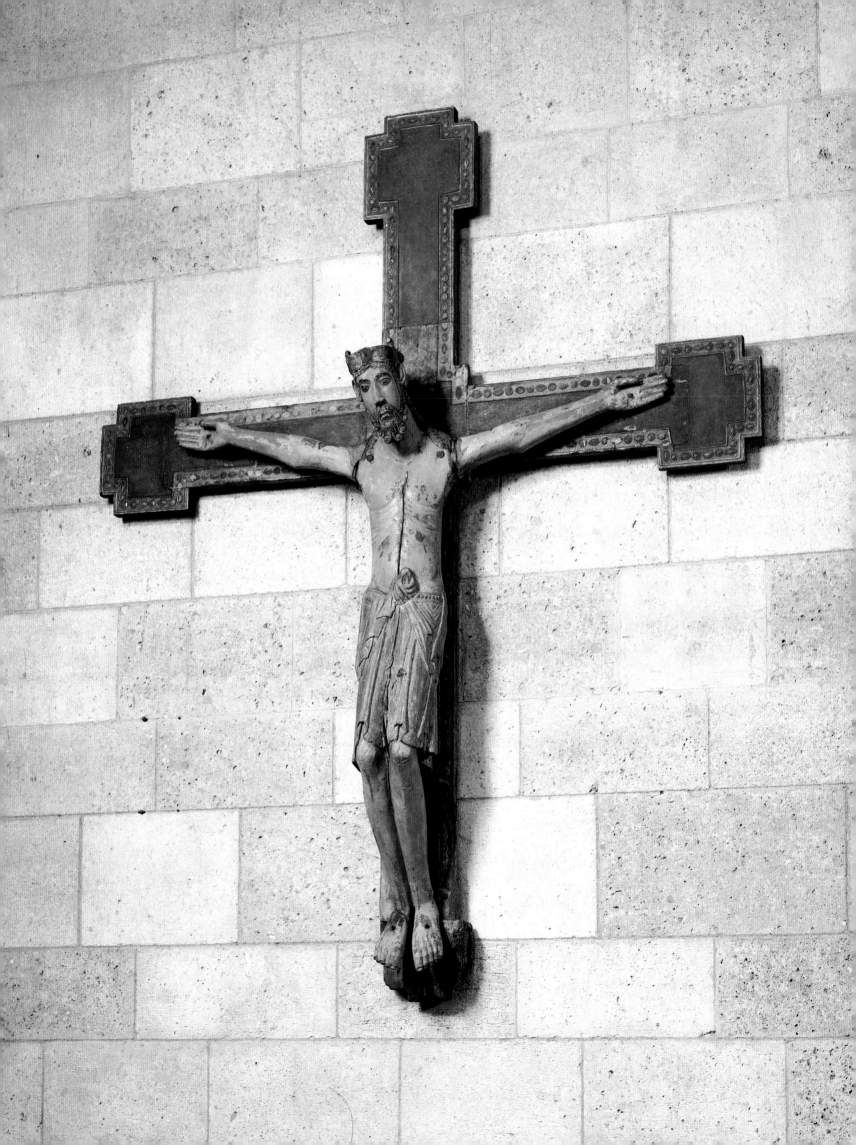

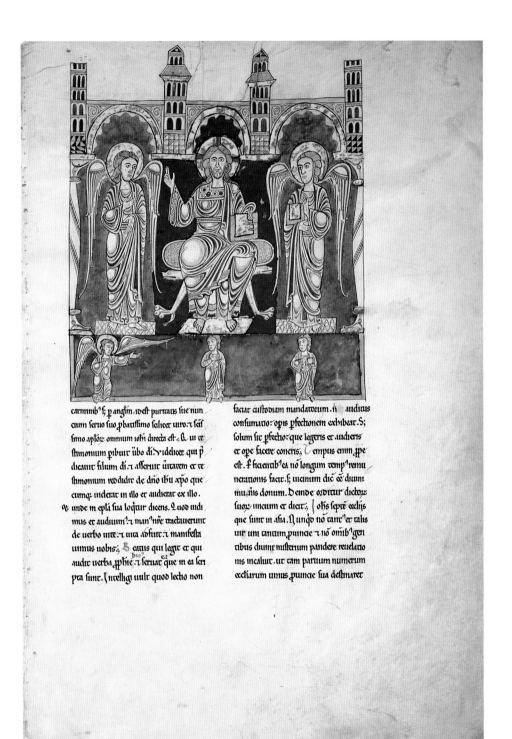

carmmib' f; p anglin. ioeft purtairs fue nun
cum feruo fuo pbanffimo falicer uiro .1 fei
fimo apfoz omnium ioih direcla eft. Cl ui ce
ftimoniuin pibuir ubo di. Y idelicer qui p
dicaiir filum di. r affernir iiirarem er re
ftimonium reodidir de dno ihu xpo que
cumq; uideair in illo er audierar ex illo.
Ct unde in epla fua loquir dicens. Quod uidi
mus er audiuim' r man'nie traclauerunt
de uerbo uire. r uira adfuir. r manifefta
uimus nobis. B earus qui legir er qui
audir uerba pphie. r feruar que in ea fcri
pra funr. Intelligi uulr quod lectio non

faciar cuftodiam mandaroum. n audiris
confumatio opis pfectionem exhibear. S;
folum fir pfectio que legeris er audieris
er ope facere coneris. Tempus enim ppe
eft. f fiaeiiiab'ea no longum remp'renu
nerationis facir. f; uicinum die cf diuini
muneris donum. Deinde orditur dictoz
fuoz incium er dicar. I ohs fepre eclefiis
que fim in afia. R unqo no taint'er talis
uir uni tanium puince r no omib'gen
tibus diume mifterium pandere reuelatio
nis incaluir. ur tam partium numerum
eclefiarum uirus puince fua deftinaret

Spanish, late 12th century

LEAF FROM A BEATUS MANUSCRIPT: CHRIST IN MAJESTY WITH ANGELS

———

Tempera, gold, and ink on parchment;
17⅝ × 11¾ in. (44.8 × 29.8 cm)
Purchase, The Cloisters Collection, Rogers,
and Harris Brisbane Dick Funds, and Joseph
Pulitzer Bequest, 1991 (1991.232.3 recto)

———

About 776 a Spanish monk, Beatus of Liébana, compiled passages from the Apocalypse with his interpretations cast as Christian allegories. Beatus manuscripts were as important in Spain as gospels and bibles were elsewhere in Europe throughout the Romanesque period. This leaf and 13 others now in the Metropolitan came from a manuscript made in the Benedictine monastery of San Pedro de Cardeña; the manuscript was broken up in the 1870s and divided between museums in Madrid and Gerona. The pictorial style is notable for vibrant and dramatic color contrasts with refined linear treatment of figures and their draperies.

Rhenish (Boppard-on-Rhine), 1440–47

WINDOWS WITH SAINTS

———

Pot-metal, white glass, silver stain; H. of
entire panel: 148½ in. (377.2 cm), W. of each
window: 28⅝ in. (72.7 cm)
The Cloisters Collection, 1937 (37.52.4–6)

These three windows of stained glass from the Carmelite church of Saint Severinus at Boppard-on-Rhine are part of an ensemble of six that were originally installed three over three to form a single tall window. After Napoleon invaded the Rhineland and secularized its monasteries, the stained glass of the church was removed and dispersed. The Cloisters panels constitute the only complete window of the extensive cycle at Boppard to have survived intact. Saint Catherine of Alexandria is depicted with the wheel and sword of her martyrdom in the panel at the left; Saint Dorothea receives a basket of roses from the Christ Child in the center; and at the right Saint Barbara holds the tower in which she was imprisoned. These lancets are one of the most brilliant ensembles of Late Gothic stained glass in the United States.

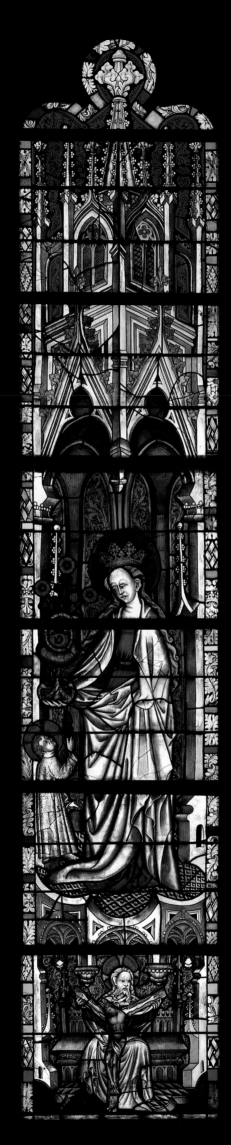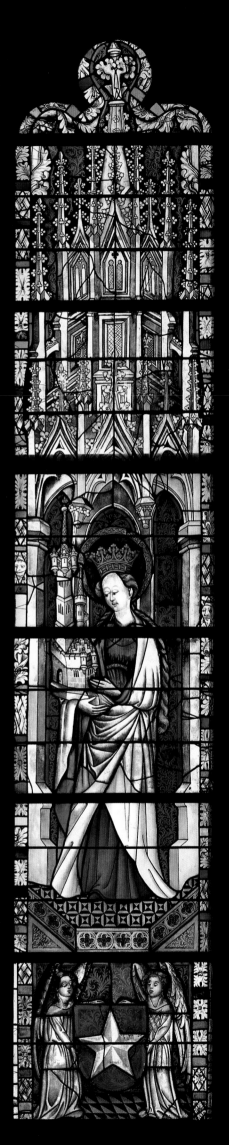

Sanc̄ paul' p̄m̄ h̄emita fruiēc̄ p̄ſecucōc dc
aj uiſo q̄ x̄p̄ianus quidā m̄c̄ amcia ligat̄ cc̄
ab ip̄udica titat̄ linguā abſadit ct m̄ci facicm̄
ſpuit ut tc̄mp̄ta͠ōnc dlo͠z fug͠aicc.rom̄a fug͠!

Pol, *Jean*, and *Herman de Limbourg*

French, active ca. 1400–1416

THE BELLES HEURES OF JEAN,
DUKE OF BERRY

———

Tempera and gold leaf on parchment;
9⅜ × 6⅞ in. (23.9 × 16.8 cm)
The Cloisters Collection, 1954
(54.1.1.fol. 191 recto)

Jean, duke of Berry, was one of the greatest
art patrons of the Middle Ages, and he
commissioned this exquisite book of hours
from Pol de Limbourg and his brothers,
who worked exclusively for him. The duke
demanded exceptionally high quality, as
seen in the perfect vellum, the unusual and
elaborate decoration, and above all in the
luminous, vibrant paintings. The book has
94 full-page miniatures, and many smaller
ones, including calendar vignettes and
border illuminations. The Limbourgs' style
is characterized by meticulous detail,
beautiful color, and masterful narration.
This scene shows Saint Paul the Hermit
watching a young Christian tempted by a
lewd woman, an episode that so horrified
Paul he abandoned the world and fled to
the desert.

Southern Netherlandish (Brussels), 1475–1500

THE UNICORN TAPESTRIES:
THE UNICORN IN CAPTIVITY

———

Wool, silk, metallic threads; 12 × 8 ft. 3 in.
(366 × 251.6 cm)
The Cloisters Collection, Gift of John D.
Rockefeller, Jr., 1937 (37.80.6)

This tapestry, showing the unicorn enclosed
in a garden fence under a pomegranate
tree, is the seventh in a series of seven
representing the Hunt of the Unicorn. The
legend of the unicorn, in which it is
captured as it rests its head in the lap of a
virgin, parallels the Passion of Christ, who
surrendered his divine nature and became
human through the Virgin. This scene
shows the resurrected unicorn after the
hunt is over. The mingling of Christian
symbolism, popular legends, and flora and
fauna associated with love and fertility
suggests that the tapestries may have been
designed to celebrate a marriage.

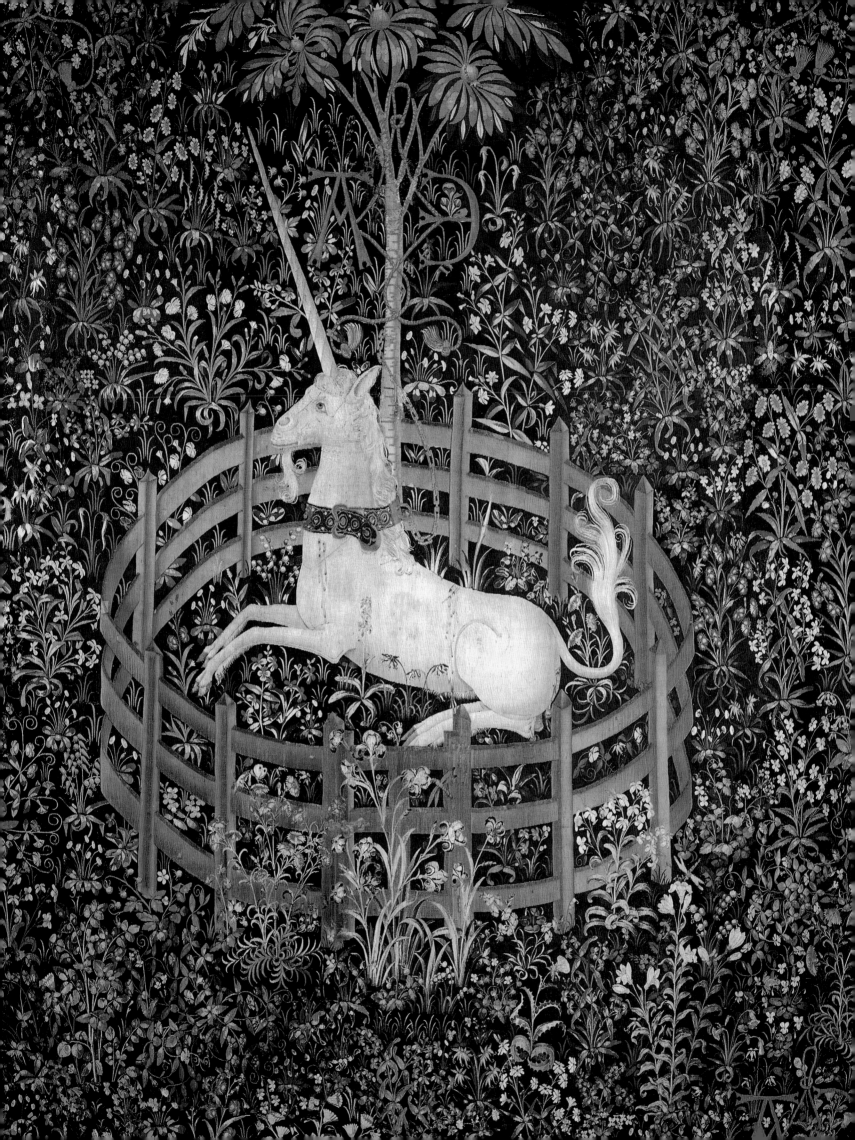

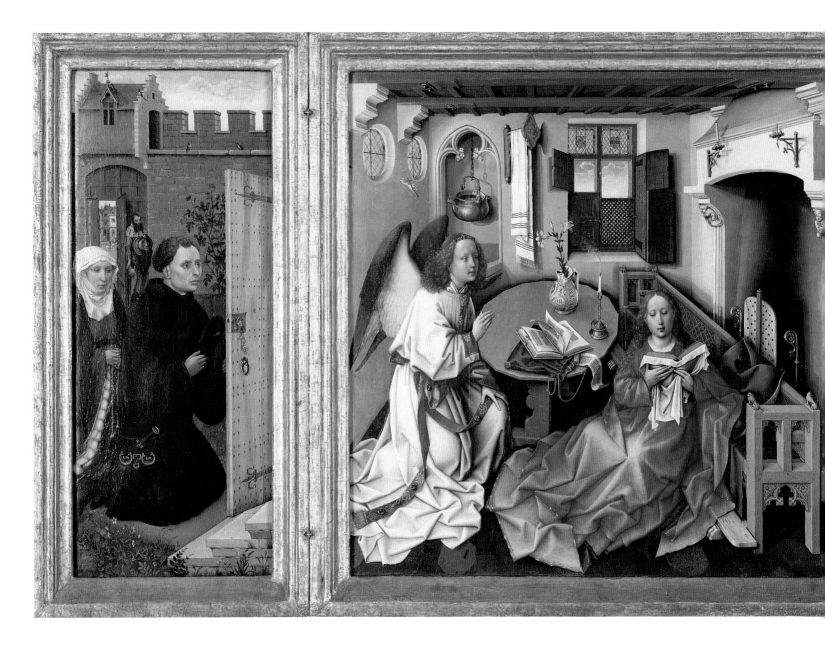

Robert Campin

South Netherlandish (Tournai), ca. 1378–1444

TRIPTYCH WITH THE
ANNUNCIATION

Oil on wood; central panel:
25¼ × 24⅞ in. (64.1 × 63.2 cm); each wing:
25⅜ × 10¾ in. (64.5 × 27.3 cm)
The Cloisters Collection, 1956 (56.70)

This small triptych dates from about 1425
and is innovative in showing the
Annunciation not in a portico or
ecclesiastical setting but in a middle-class
room of the patron's own time. In the
center panel the archangel Gabriel
announces to the Virgin Mary that she will
miraculously conceive Jesus Christ; her
spouse, Joseph, toils in his workshop in the
right panel. The patron and his wife appear
kneeling in the panel at the left. Although
the artist, using the then-new technique of
painting in oil on wooden panels, clearly
delighted in his ability to paint objects of the
real world with an emphasis on their form
and texture, he also exploited their symbolic
implication. The brass basin and the
Madonna lily in the vase, for example,
signify Mary's purity. The candle is a symbol
of Christ and the candlestick represents the
Virgin who bore him. This altarpiece was
painted at about the same time as *The
Crucifixion* and *The Last Judgment* by Jan van
Eyck, which are the first masterpieces
reproduced in the chapter on Renaissance
art in Northern Europe. This Annunciation
should perhaps also be considered a
Renaissance work, but as it is in the
collection of The Cloisters and is viewed by
many as a great example of Late Gothic
painting, we present it here.

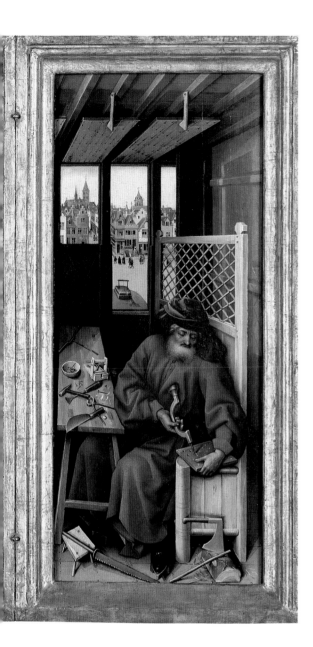

German (Nuremberg), ca. 1500

EWER WITH WILD MAN FINIAL

Silver, silver gilt, and enamel; H. 25 in.
(63.5 cm)
The Cloisters Collection, 1953 (53.20.2)

This ewer with a wild man finial is one of a pair in the Museum's collection. Holding the traditional attributes of a club and an armorial shield, the wild man announced and protected the ewer's ownership, possibly that of Hartmann von Stockheim, German master of the Order of Teutonic Knights, a powerful force in Germany at the turn of the 16th century. The wild man was a mythical woodland creature, once regarded as brutish but by this time perceived as the embodiment of Germanic strength and endurance. Such a standard would have been appropriate for an order that was martial in origin.

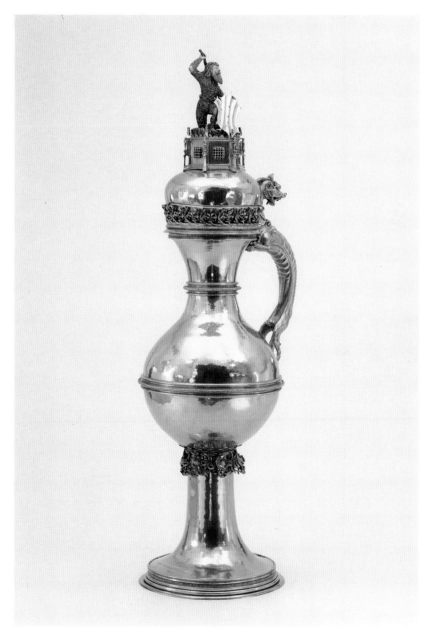

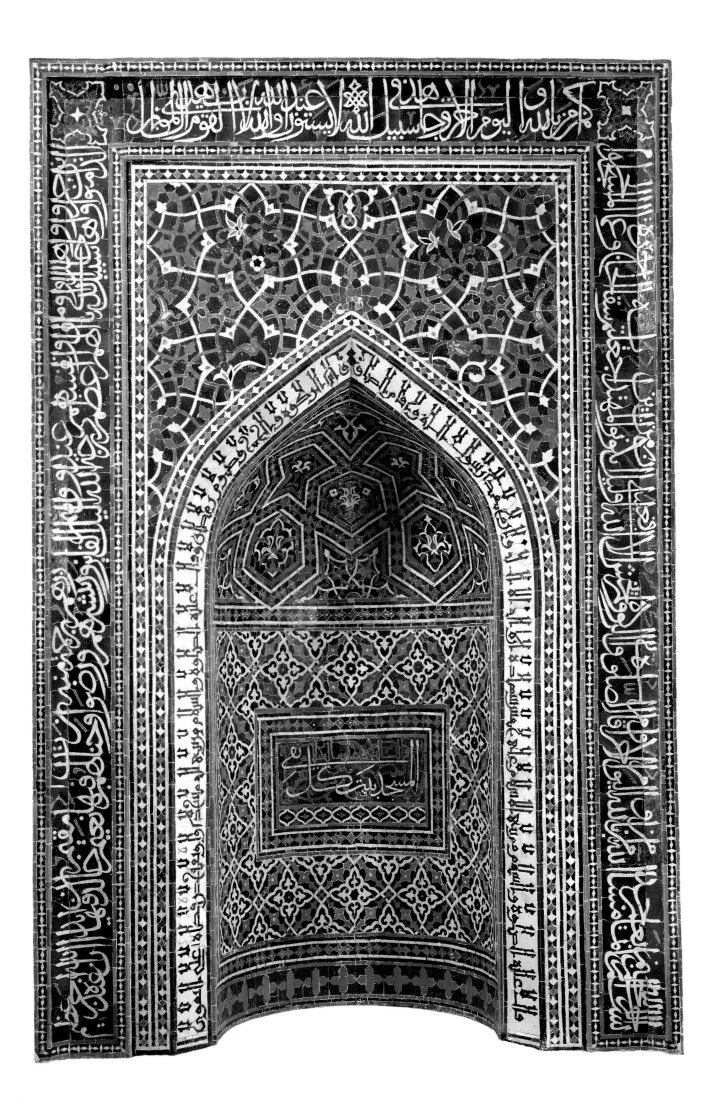

The Islamic World

WORKS OF ISLAMIC ART range in style from the purely abstract to the naturalistic, and their materials from humble clay to jeweled gold. Some are strikingly immediate, their appeal almost unapproachably refined and subtle. Among them are delightfully vital yet serious characterizations of extraordinary people and of bounding and roaring animals. However luxuriously ornamental and worldly, many of these pictures and objects take spiritual flight. Their provenances—from Spain to India and far beyond—are as disparate as their styles and moods; yet they come together harmoniously, unified by a touch of divine fire—Islam.

Islam ("submission to God") began in Arabia, a starkly beautiful land of scrub and desert, of endless horizons and starry skies, a land where survival was hard and required discipline and order but that inspired poetry and thought. The seeds of Islamic art are found in the life and teachings of Muhammad the Prophet, born in sixth-century Mecca, who experienced at the age of forty a profound revelation of Allah, the one and unique God, as both creator of the world and its judge. The Qur'an, Islam's holy book, is the living word of God as revealed to his prophet Muhammad. Islam was soon established not only as a world religion but as a rapidly expanding community with its own system of government, laws, and institutions.

By 732 the Muslim world included all of Arabia as well as Persia, Mesopotamia, Sind, Egypt, and the rest of North Africa and Spain. Cultures as disparate as those of Transoxiana, North Africa and Spain, Turkey, Persia, and India were transformed by the new faith and in turn contributed to its character.

The importance of the mosque in extending vital patronage and guidance to Muslim architects, calligraphers, and artist-craftsmen cannot be overestimated. Although mosques vary in style according to time and place, all include certain essentials, such as the mihrab, the niche indicating the direction of Mecca.

Mosques also contain smaller, movable objects that often influenced and were influenced by the techniques, patterns, and styles of comparable articles for secular use. Among these are the hanging lamps of glass often decorated with colorful enamels and donated by rulers or wealthy patrons. Equally appealing to the eye, and therefore desirable for palaces and homes, are the rugs stretched over the floor.

Clearly linked to the organic, meandering forms of vegetal arabesque are the geometric patterns upon which Islamic designers and artist-craftsmen composed infinite variations. Compelling in perfection of proportion and intricacy of rhythms, these crystalline configurations have affinities to scientific and mathematical speculation, perhaps Islam's greatest contribution to human knowledge.

The Museum's collection of Islamic art, which dates from the seventh to the nineteenth century, reflects the diversity and range of Islamic culture. In 1891 the Museum received its first major group of Islamic objects, a bequest of Edward C. Moore. Since then the collection has grown through gifts, bequests, and purchases; it has also received important artifacts from the Museum-sponsored excavations at Nishapur, Iran, in 1935–39 and 1947. The Museum now offers perhaps the most comprehensive exhibition of Islamic art on permanent view anywhere in the world. Outstanding holdings include the collections of glass and metalwork from Egypt, Syria, and Mesopotamia, ceramics and tiles from Persia and Turkey, royal miniatures from the courts of Persia and Mughal India, and carpets from the sixteenth and seventeenth centuries.

(OPPOSITE)

Iranian, ca. 1354

PRAYER NICHE (MIHRAB)

———

Composite body, glazed; 11 ft. 3 in. × 7 ft. 6 in. (3.43 × 2.88 m)
Harris Brisbane Dick Fund, 1939 (39.20)

———

This superb prayer niche, which comes from a theological school in Isfahan, is extraordinary not only for the beauty of its tile work but also for its variegated inscriptions. The mihrab, which now shows some areas of restoration, is composed of small pieces of ceramic fired at temperatures high enough to bring out the brilliance of the glaze and then fitted together to form geometric and floral patterns and inscriptions. The inscription in the outer panel contains a Koranic saying that speaks of the duties of the faithful and the heavenly recompense of those who build mosques. The inscription in the niche states that "the mosque is the house of every pious person."

(LEFT)

Iranian, 11th century

ROUNDEL

———

Gold; Diam. 2¹³⁄₁₆ in. (7.2 cm)
The Alice and Nasli Heeramaneck Collection, Gift of Alice Heeramaneck, 1980 (1980.344)

———

This gold roundel, an object of marvelous delicacy and beauty, combines features associated with both Iran and the Syro-Egyptian region, thus enlarging our understanding of the nature of medieval Islamic jewelry. The filigree construction laid on a backing of narrow strips of gold is typically Syro-Egyptian, but the solid sheet-constructed back and the concentric rings of narrow sheet separating front from back are Iranian. The original function of the roundel is not known.

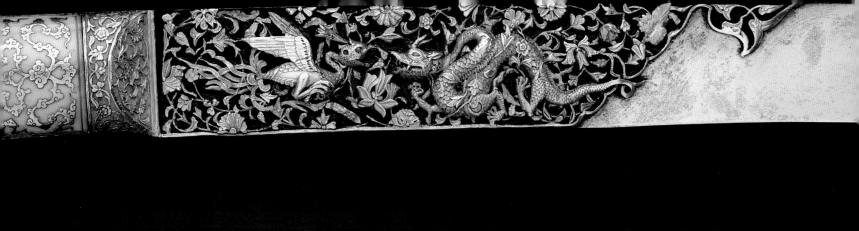

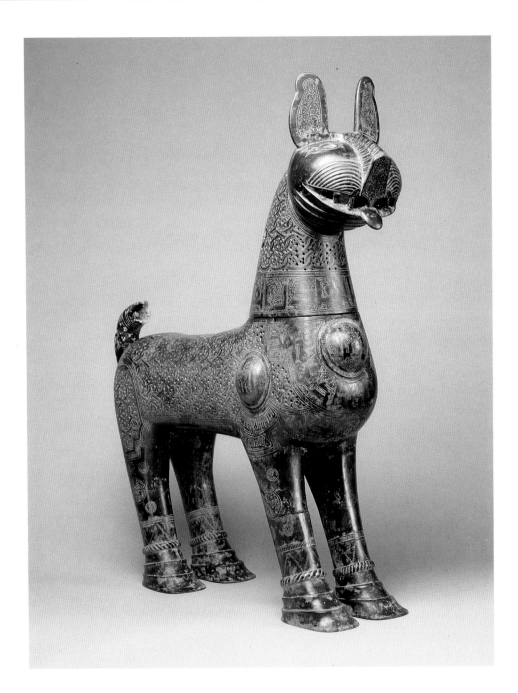

Iranian, Seljuk period, 1182

INCENSE BURNER IN FELINE FORM

Bronze; 36 in. (91.4 cm)
Rogers Fund, 1951 (51.56)

One of the largest and stateliest of all Islamic bronze animals, this incense burner is imbued with vitality and humor. The Seljuks were a dynamic Turkish people from inner Asia who gained control of Khorasan in 1034. The head, body, and limbs of the feline are abstracted into sleek static forms, powerful but not threatening. A guardian rather than an attacker, this noble beast has exquisitely proportioned ears, eyes, tongue, and streamlined whiskerlike ridges. The pierced body, mask, and tail are adorned with elegant arabesques, and the Kufic letters bear the name of the patron, the date, and wishes for happiness and blessings. This incense burner probably took pride of place in the center of a Seljuk prince's banquet hall.

(OPPOSITE)

Turkish (Istanbul), ca. 1525–30
SWORD (JATAGAN)

———————

Steel, walrus ivory, gold, silver, rubies, turquoise, pearl; L. 23⅜ in. (59.4 cm)
Purchase, Lila Acheson Wallace Gift, 1993 (1993.14)

———————

This sword, one of the earliest known *jatagans*—a Turkish short-sword with a distinctive double-curved blade—is a stellar example of Ottoman goldsmiths' work at the court of Sultan Suleyman the Magnificent (r. 1520–66). The sword presents a rich variety of precious materials that elegantly demonstrates the virtuoso talents of the bladesmith, ivory carver, goldsmith, and jeweler. The grip of walrus ivory is inlaid with gold cloud bands, and the pommel is embellished with gold flowers studded with turquoise and rubies. Each side of the blade is thickly encrusted in gold with scenes of combat between a dragon and a phoenix. The relief is minutely detailed; the eyes of the creatures are set with rubies and the dragon's teeth are of silver. Like the cloud bands, the dragon-and-phoenix motif is of central Asian origin and was adopted by Persian artists, eventually passing into Turkish art. This sword can be attributed to the Istanbul workshop of Ahmed Tekelü, a jeweler of reputed Persian origin who signed a very similar *jatagan* made for Suleyman in 1526 (Topkapi Palace Collection, Istanbul).

Indian, Deccan, early 17th century
ROUNDEL

———————

Sandstone; Diam. 18½ in. (47 cm)
Edward Pearce Casey Fund, 1985 (1985.240.1)

———————

This sandstone roundel clearly shows the consummate skill of both the calligrapher and the stonecutter. It repeats the Arabic invocation *Ya 'aziz* "O Mighty!" (one of the 99 Most Beautiful Names of God) eight times in mirrored Thuluth script. The calligraphy is reminiscent of the inscriptions in the Ibrahim Rauza, the mausoleum of Sultan Ibrahim 'Adilshah (r. 1580–1627) in Bijapur. The number eight, in addition to its geometrical qualities, points also to eternal bliss and the eight paradises of which Islamic tradition speaks.

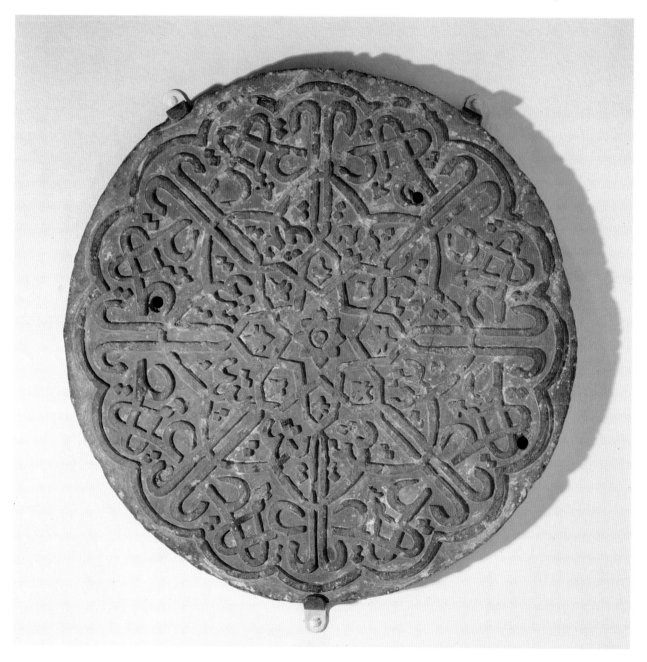

Spanish, 11th century
PLAQUE

Ivory; 4¼ × 8 in. (10.8 × 20.3 cm)
John Stewart Kennedy Fund, 1913 (13.141)

This charming plaque belongs to a group of ivories made in Islamic Spain during the reign of the Umayyads (756–1031). Because of this dynasty's Syrian roots, many motifs found in these ivories can be traced back to that area. The leaf arabesques here are a stylized version of the vine-and-acanthus scroll popular in late antique ornament, and prototypes for the animated figures can be found in early Islamic (Syrian or Egyptian) textiles, where birds, animals, and human beings of similar character are also paired on either side of stylized trees. The influence of textiles can be seen in the way the pattern in the overall design is repeated without change.

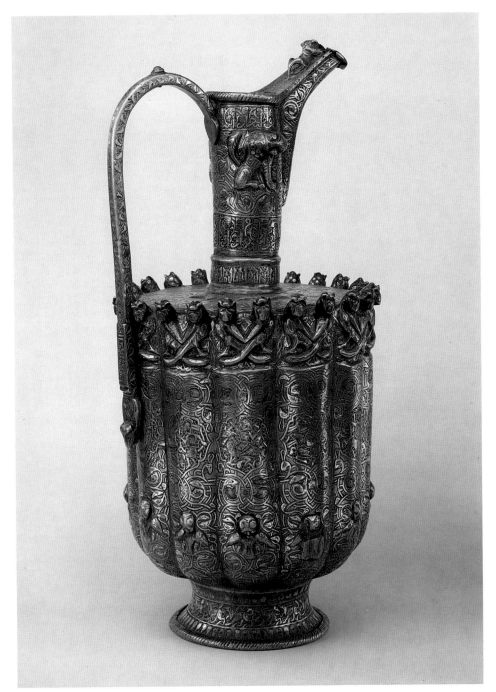

Iranian (Khorasan),
late 12th–early 13th century
EWER

Brass, incised and inlaid with silver; H. 15½ in. (39.4 cm)
Rogers Fund, 1944 (44.15)

The exquisitely inlaid surface of this elegant ewer, used for ablutions, carries a variety of subtle decoration. Arabic inscriptions on the neck and shoulder in Kufic and human-headed Naskh scripts express blessings and good wishes to the unnamed owner. The 12 flutes of the body are decorated with bands of animal-headed scrolls, which surround medallions that contain signs of the zodiac accompanied by a ruling planet. The flutes are topped by a row of harpies in relief, and near the bottom of the ewer is a row of repoussé birds. A frieze of coursing animals is located on the foot.

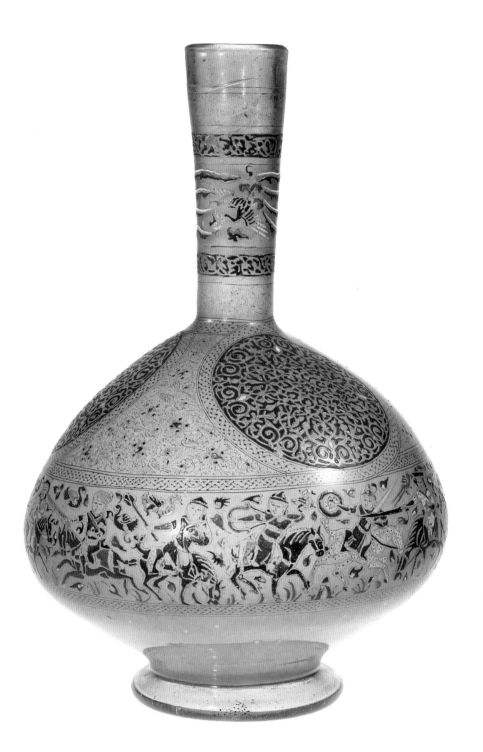

Syrian or Egyptian, 14th century
MAMLUK GLASS BOTTLE

Glass; H. 17⅛ in. (43.5 cm)
Rogers Fund, 1941 (41.150)

"Mamluk glass" is almost synonymous with the magnificent enamel-painted mosque lamps that were produced in profusion during the rule of the Mamluk dynasty in Syria and Egypt. But the artists of that period fashioned other glass objects, such as this graceful bottle with its elegant shape and surpassingly rich and varied decoration exhibiting foreign artistic influences and innovations. Although the Mamluks were enemies of the Mongol dynasty ruling in Greater Iran, related to the Yüan rulers in China, they were not impervious to Chinese and Persian influences. The linear drawing of the dense leafy patterns on the bottle's sloping shoulders is indebted to Chinese art, and the frieze of mounted warriors is related to contemporary Persian miniature painting.

North African, ca. 1300

PAGE FROM A QUR'AN
———
Ink, colors, and gold on vellum; 21 × 22 in.
(53.3 × 55.9 cm)
Rogers Fund, 1942 (42.63)

This beautiful sheet from a Qur'an made in
North Africa is written in the Magribi (or
"Western") style of Arabic script. This is
easily recognizable by its rather thin, high
letters, which sometimes end in buttonlike
rounds, and also by the long, swinging
endings of certain letters. On this page, two
round designs at the margin mark verses,
and a leaf-shaped decoration bears the word
khams (five), which occurs throughout the
suras (chapters) of the Qur'an to mark every
fifth verse of a decade. In this case, it marks
the fifth verse of Sura 39, or the Sura of the
Companies.

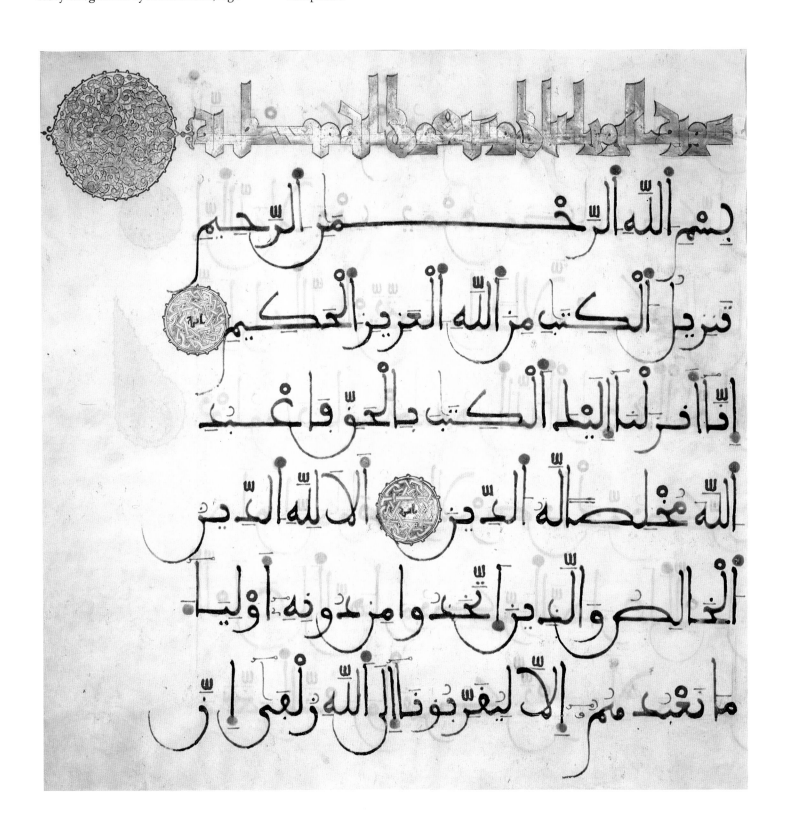

Turkish, mid-16th century
TUGHRA OF SULTAN SULEYMAN
THE MAGNIFICENT

Opaque watercolor and gold on paper;
20½ × 25⅜ in. (52.1 × 64.5 cm)
Rogers Fund, 1938 (38.149.1)

The Ottoman tughra (calligraphic emblem)
became largely standardized in general
appearance at least as early as the 15th
century, and—as this sumptuous example
demonstrates—it allowed calligraphers and
illuminators to display their talents to great
effect. Almost all of the orthographically
functional lines of this tughra are
concentrated in the area of dense activity at
the lower right, which gives the name and
patronymic of the sultan as well as the
formulaic "ever victorious." The
exaggerated verticals with their descending,
swaying appendages are essentially
decorative, as are the elaborate, sweeping
curves that form the large loops to the left
and their extensions to the right. All
imperial decrees were headed by the
sultan's tughra. The remainder of the
document is missing here.

Iranian or Transoxianan, 10th century
BOWL

Earthenware, slip-painted, incised, and
glazed; Diam. 18 in. (45.7 cm)
Rogers Fund, 1965 (65.106.2)

Perhaps the most outstanding examples of
the use of calligraphy on pottery are to be
found among wares from Nishapur and
Samarkand. In the tenth century Nishapur
was one of the great centers of Islamic art,
and its finest ceramics were slip-painted
wares on which elegantly painted Arabic
inscriptions are the principal and frequently
the only decoration. This bowl—the largest
and perhaps the most important Islamic
ceramic bowl in the Metropolitan
Museum—bears an inscription in Kufic
script stating: "Planning before protects you
from regret; prosperity and peace." The
elegance of the design and of the potting in
combination with the size of the bowl
makes this a true tour de force of the
potter's art.

Iranian (Tabriz) Safavid period, ca. 1520–22

THE FEAST OF SADEH

———

Leaf from the *Shah-nameh* of Shah Tahmasp,
attributed to Sultan Muhammad
Ink, colors, and gold on paper; 9½ × 9⅛ in.
(24.1 × 23.2 cm)
Gift of Arthur A. Houghton, Jr., 1970
(1970.301.2)

———

Sultan Muhammad painted this humorous
but visionary picture for the first Safavid
ruler, Shah Isma'il (r. 1502–24) and his young
son, Prince (later Shah) Tahmasp (r. 1524–
76). It comes from the grandest of all royal
copies of the *Shah-nameh* (Book of the
Kings). The Feast of Sadeh celebrates the
discovery of fire by one of the legendary
early kings, Hushang, who sighted a
hideous apparition and hurled a rock at it.
The creature vanished, but the royal missile
struck a boulder. Sparks flashed, so
impressing Hushang that he initiated fire
worship. That evening he assembled his
courtiers and their animals, discoursed on
the potential of fire, and—using the newly
discovered fire for cooking—celebrated the
feast known ever since as Sadeh.

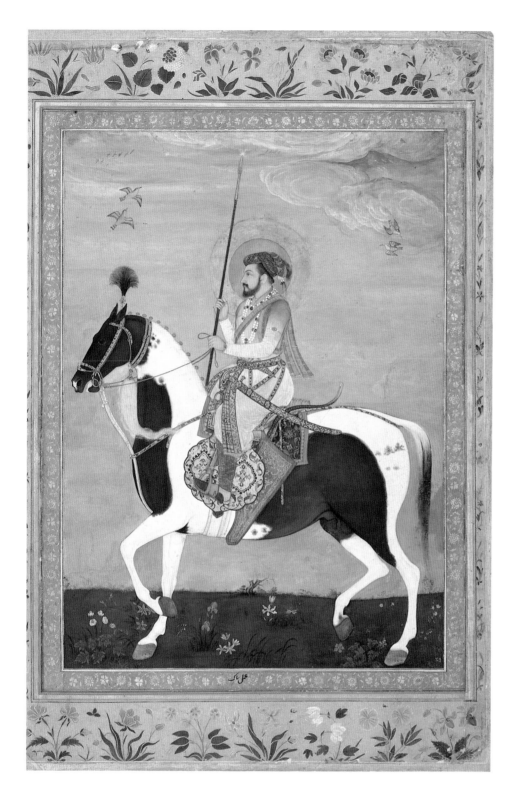

Indian, Mughal period, ca. 1645
SHAH JAHAN ON HORSEBACK

Ink, colors, and gold on paper; 15⅝ × 10⅛ in.
(38.9 × 25.7 cm)
Purchase, Rogers Fund and The Kevorkian
Foundation Gift, 1955 (55.121.10.21v)

This magnificent equestrian portrait of
Shah Jahan (1592–1666), a leaf from the Shah
Jahan Album, is attributed to the artist
Payag. The image of the emperor
epitomizes the imperial splendor of the
"Grand Mogul," an epithet commonly used
by Europeans when referring to the ruler of
the Mughal dynasty. The richness and
refinement of the saddle, the saddlecloth,
and the emperor's costume and arms, as
well as the nobility of his mount, are in
perfect harmony with the regal grandeur of
the emperor's face. He was the fifth
emperor of the Mughal dynasty and the son
of Jahangir, against whom he rebelled.
During Jahan's reign Mughal power reached
its apogee, and it was also the golden period
of Islamic architecture in India. Shah Jahan
built the Taj Mahal at Agra as a memorial to
his wife, Mumtaz Mahall ("the ornament of
the palace"), and he also erected the Pearl
Mosque in Agra Fort.

(DETAIL)

Iranian (probably Herat), mid-16th century
THE EMPEROR'S CARPET

Silk warp and weft, wool pile;
24 ft. 8 in. × 10 ft. 10 in. (7.52 × 3.3 m)
Rogers Fund, 1943 (43.121.1)

Court artists, designers, skilled weavers and
dyers, and ancillary helpers cooperated to
make this carpet one of the glories of
weaving. Its design combines refined
arabesques and scrolling vines with cloud
bands, and floral wonders with dynamic
representations of fabulous beasts and
animals and pairs of pheasantlike birds. In
the center four large palmettes in a lozenge-
shaped formation guide the underlying
system of dark-blue spirals, regulating the
placement, direction, and size of the
complex floral and leaf elements. Certain
symbolic aspects of the carpet's design have
been noted by scholars, especially the
comparison to a springtime garden with its
allusion to the Garden of Paradise. It is
called the Emperor's Carpet because it is
supposed to have been in the collection of
the Hapsburg emperors.

Turkish (Bursa or Istanbul), late 16th century
PRAYER RUG

Silk warp and weft, wool and cotton pile;
5 ft. 5 in. × 4 ft. 2 in. (1.65 × 1.27 m)
The James F. Ballard Collection, Gift of James
F. Ballard, 1922 (22.100.51)

The Ballard prayer rug is the most
outstanding example of its kind in the
Metropolitan's collection. The field of the
rug shows a portico with three pointed
arches that rest on columns decorated with
overlapping chevrons whose octagonal
bases are placed on small plinths. A mosque
lamp adorns the central and widest arch,
the lamp alluding to the Sura of Light (24.
verse 35). A row of crenellations framing
domed pavilions or tomb towers rises above
the spandrels, which are decorated with
typical Ottoman blossoms and arabesques.
Bouquets of naturalistic flowers taken from
a typical Ottoman repertoire—including
tulips, carnations, anemones, and roses—
decorate the spaces between the bases along
the floor line of the portico.

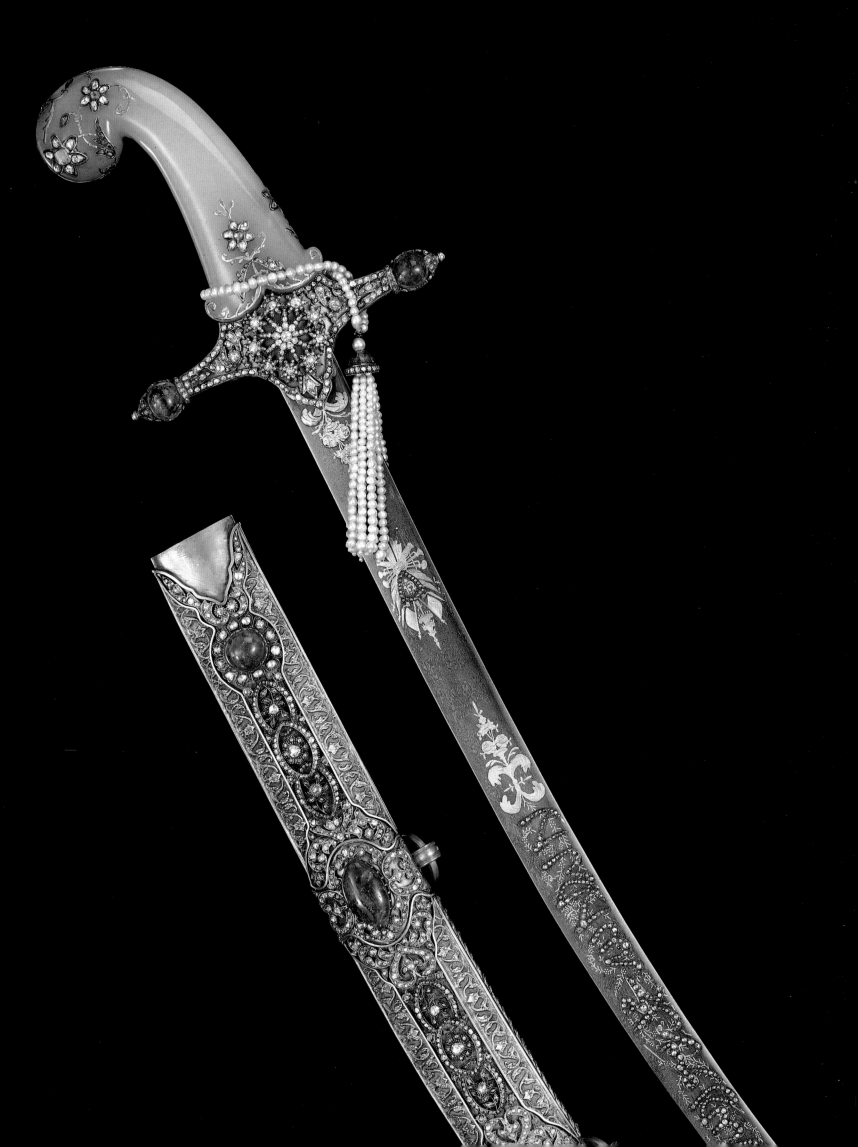

(Detail)

Blade: *Persian,* 17th century
Grip: *Indian,* 18th century
Mount: *Turkish,* 19th century

SABER AND SCABBARD

Steel, gold, gilt brass, jade, diamonds, emeralds, and pearls; saber: L. 39¾ in. (101 cm)
Gift of Giulia P. Morosini, in memory of her father, Giovanni P. Morosini, 1923 (23.232.2ab)

This extraordinarily ornate saber and its scabbard form an intriguing composite of elements from three important Islamic centers. The blade of watered steel was forged in Persia and is dated 1688. The grip of pale green jade, inlaid with sprays of jeweled flowers, was fashioned in 18th-century Mughal India. According to tradition, the guard and scabbard mountings of gilt metal studded with emeralds and diamonds, as well as the matching jeweled tassel of pearls, were made in Istanbul in 1876, when the elements were assembled to create the ceremonial weapon intended for use at the enthronement of Sultan Murad V.

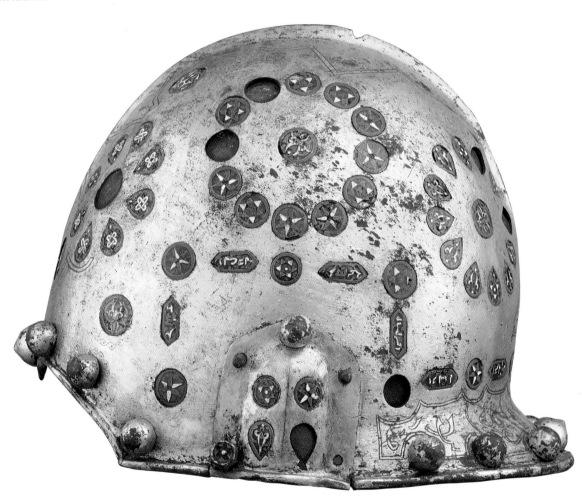

Spanish, Nasrid period, late 15th century

PARADE HELMET

Steel, overlaid with gold and silver and inlaid with cloisonné enamels; H. 7⅞ in. (20 cm)
From the Lord Astor of Hever Collection, Purchase, The Vincent Astor Foundation Gift, 1983 (1983.413)

This helmet is a rare surviving example of Nasrid armor. The shape of the helmet is that of a Spanish or Italian sallet, but the decoration is decidedly un-European. The steel surface is covered with gold and silver leaf tooled with geometric designs and stylized Arabic inscriptions and is set with cloisonné enamels, a type of decoration that has close parallels with sword fittings and jewelry of the late Nasrid period. The lavish decoration and the fact that the bowl is pierced to receive the enamels indicates that the helmet was intended exclusively for parade use. The Nasrids ruled from Granada over the last Muslim kingdom of Spain, and today they are chiefly remembered for having built the palaces that constitute the Alhambra.

Syrian, 1707

THE NUR AD-DIN ROOM

Gift of The Hagop Kevorkian Fund, 1970
(1970.170)

This elegantly decorated room from Damascus, Syria, served as a reception area for the patriarch of the family and his male guests. It is divided into two areas: a small anteroom, where the guests left their shoes (in photograph below) and a raised, high, narrow room (opposite), where the visitors reclined on cushions and partook of refreshments. The fountain in the entrance reinforced the importance of water in the life of the household. The sound of falling water, the subdued light filtered through the colored glass in the windows, and the comfortable atmosphere created a soothing calm for all gatherings. Open niches held books and favored objects. The walls and cornice panels inscribed in Arabic contain poetry and a eulogy to the Prophet Muhammad.

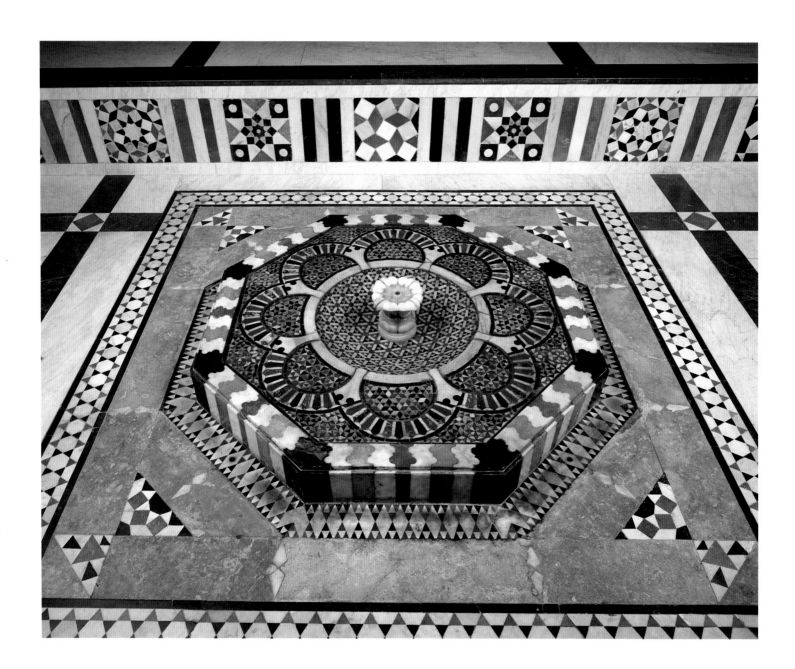

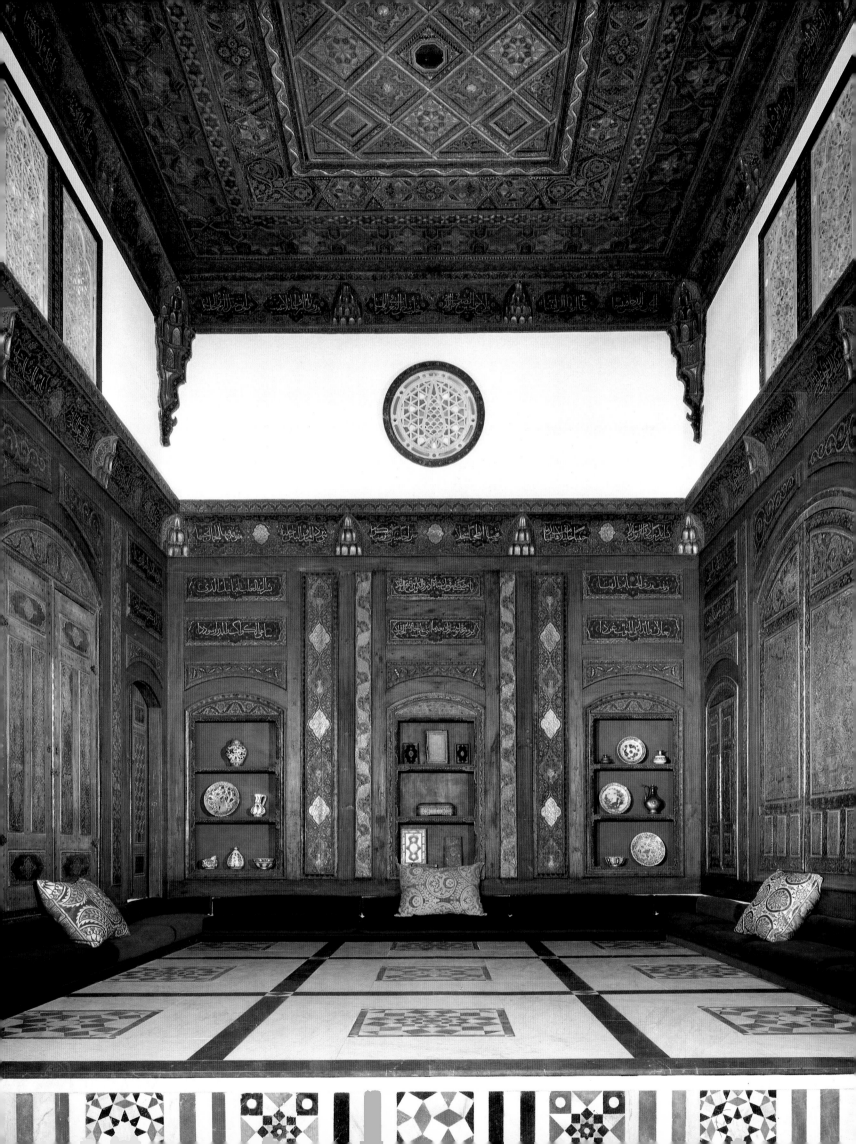

THE RENAISSANCE

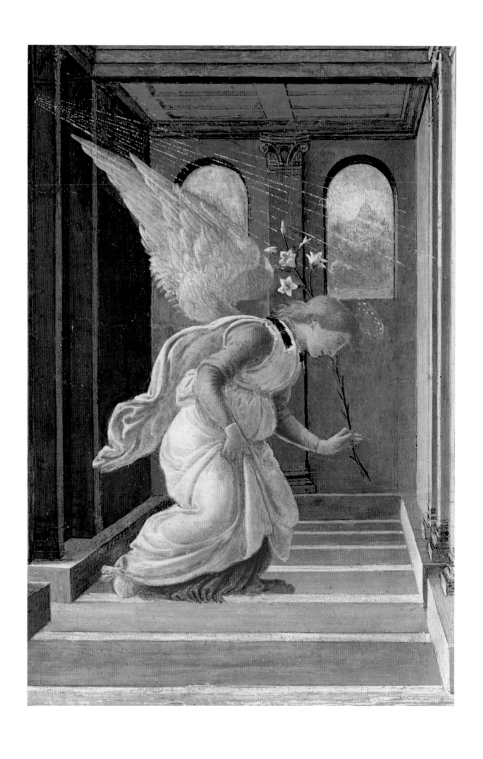

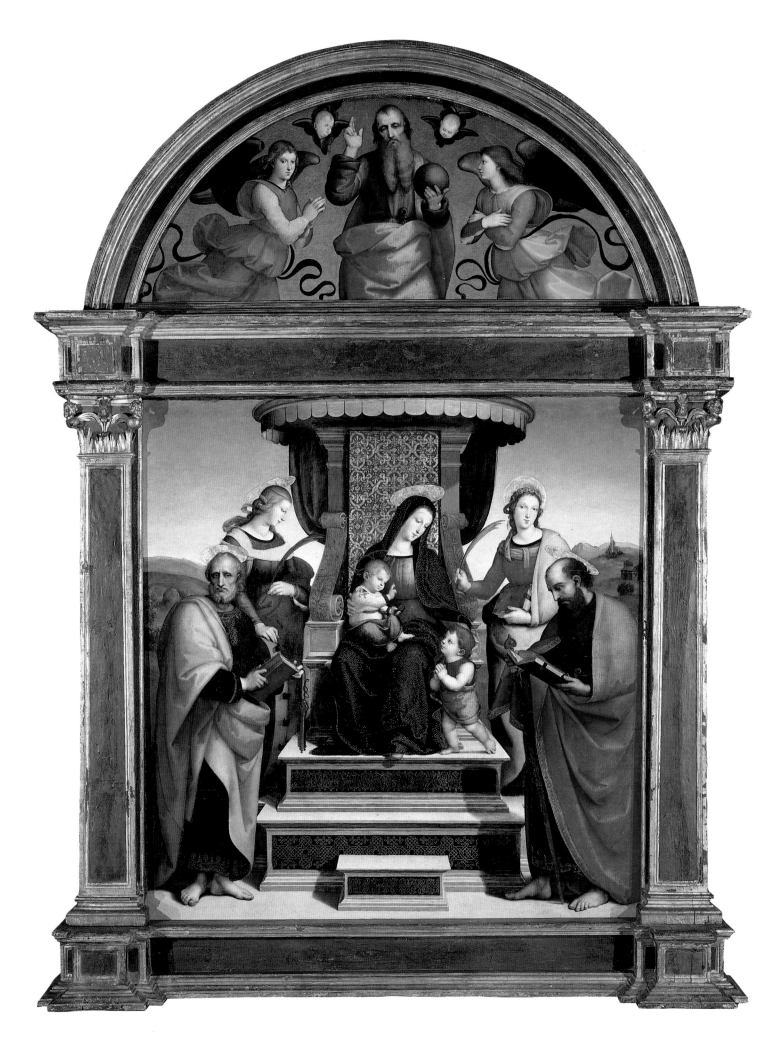

Southern Europe

MEDIEVAL ART HAD LARGELY been commissioned by monarchs, by nobles, and—above all—by the Church, whose doctrines it expounded in form and color. But the art of the Renaissance, in Italy, at least, was mostly ordered by the citizens of republics, which had much in common with the city-states of ancient Greece. The great "schools" (established regional groups of artists with their own local traditions and ideals) rose and flourished among the rich mercantile societies of the center and north, especially the dominant republics of Florence and Venice, and to a lesser degree those of Siena, Pisa, and Lucca.

As early as the fourteenth century a rebirth (renaissance) of antiquity had occurred in the form of humanism in scholarship and poetry. The merchants and banking classes, who were the patrons of Renaissance art, also poured their golden florins into the formation of libraries, which preserved in manuscript form the great works of ancient literature.

Italian art remained Gothic in architecture and sculpture and Byzantine in painting throughout most of the thirteenth century, but by the time of Petrarch in the fourteenth, Giotto had created a new pictorial style, blending elements derived from both Gothic and Byzantine sources with a fresh understanding of human life and character, a new narrative technique, and a new conception of form. Unanimously, the Italian artists of the Renaissance regarded him as the founder of their new vision. It was not until the fifteenth century that all the arts began to turn systematically to Roman antiquity (they knew nothing of the Greeks) for their inspiration, so that ancient ideals were embodied in architecture and sculpture, combined with entirely original contemporary concepts. Painting was on its own because there was little ancient painting to be seen. The gap between painting and sculpture was bridged in the work of the short-lived Masaccio (1401–1428), who for the first time achieved painted forms revealed in light proceeding from a distinct and recognizable source.

The late fifteenth century saw the beginning of ominous social changes. A new, wealthy class had gathered around the Medici family, who ruled Florence from a palace crammed with works of art. Artistic currents were divided: Gothic was dead and forgotten, but so indeed was the monumental naturalism of Masaccio and his followers. The favorite artist of Lorenzo the Magnificent was not Botticelli but Antonio Pollaiuolo, painter, sculptor, metalworker, and engraver.

Both the Gothic and the Byzantine lasted longer in Venice because of the city's trade with still-Gothic Germany and with the Byzantine Empire. Partly through its material splendor and partly through its position on lagoons in an environment of sea air, glittering water, and distant mountains, Venice moved in directions quite opposite to those of Florence—in fact, to an unprecedented understanding of color and light, brought to brilliance by such masters as Titian, Tintoretto, and Veronese.

Social and political changes transforming Italy at the close of the fifteenth century and the beginning of the sixteenth placed new demands on the artist and fostered a new style, known today as the High Renaissance. Short-lived though the style was in central

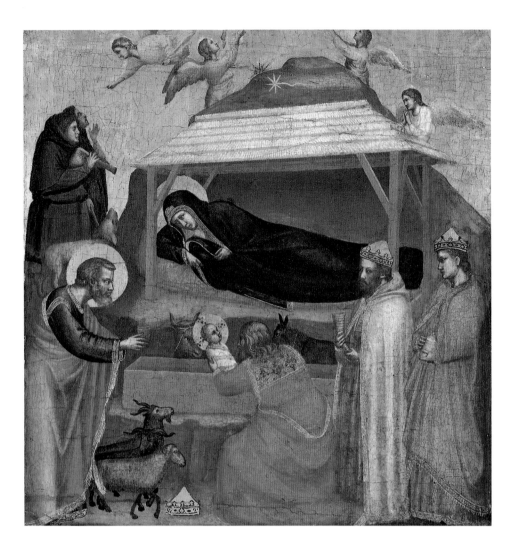

Giotto
Florentine, 1266/67–1337
THE EPIPHANY, ca. 1320

Tempera on wood, gold ground;
17¾ × 17¼ in. (45.1 × 43.8 cm)
John Stewart Kennedy Fund, 1911 (11.126.1)

Giotto of Florence was the founder of
Renaissance painting. This picture, which
shows the Adoration of the Magi in the
foreground and the Annunciation to the
Shepherds in the background, belongs to a
series of seven panels depicting the life of
Christ. When it was painted, Giotto was at
the height of his powers and enjoyed an
unparalleled reputation throughout Italy.
The clearly organized space, arranged like a
stepped stage with the stable viewed from
below, and the simplified shapes of the
figures are typical of Giotto's innovative
naturalism, as is the way in which the oldest
king has removed his crown, knelt down,
and impetuously lifted the Child from the
manger.

Italy—hardly more than twenty years—its greatest masters, Leonardo da Vinci, Michel-angelo, and Raphael, established enduring norms of grandeur, harmony, and unity.

Well before the Sack of Rome by German Lutherans and Spanish Catholic troops in 1527, the harmony of the High Renaissance social order had been threatened. Florentine independence was at an end, and the republic survived in name only. In response to these disruptions, a new style of art, known today as Mannerism, soon appeared. Mannerists rejected most of the qualities that had been essential to the High Renaissance; the strange, the novel, the unexpected were preferred to the normative, the serene.

The autocratic states of Europe, including Spain, experienced no indigenous Renaissance in the visual arts. But by the beginning of the sixteenth century, imported Italian ideas were fashionable everywhere, grafted onto native, usually Gothic forms. In its problems and solutions, the Renaissance remains intensely attractive to the late twentieth century. If the disturbed nature of Mannerism is especially accessible to our own era, the ideal perfection of the High Renaissance is a refuge, and the ceaseless experimentations of the Early Renaissance an inspiration.

The Museum's holdings in Renaissance works of art are housed in several curatorial departments, including European Paintings, European Sculpture and Decorative Arts, Arms and Armor, Drawings, Prints and Illustrated Books, and Musical Instruments. These collections have been enriched over the years by extraordinary gifts and bequests from such generous donors as Benjamin Altman, Jules Bache, George Blumenthal, Mr. and Mrs. H. O. Havemeyer, Robert Lehman, Jack and Belle Linsky, J. Pierpont Morgan, and Mr. and Mrs. Charles Wrightsman.

Simone Martini
Sienese, active by 1315, died 1344
SAINT ANDREW, ca. 1326

Tempera on wood, gold ground;
22½ × 14⅞ in. (57.2 × 37.8 cm)
Gift of George Blumenthal, 1941 (41.100.23)

The most influential Sienese painter of the
early 14th century was Simone Martini. His
Gothic style, which combined
extraordinary descriptive subtlety with
decorative beauty, spread throughout
Europe. This panel, one of five belonging to
a portable altarpiece (two companion
panels are in the Robert Lehman
Collection), is an excellent example of the
delicacy and richness of Simone's work. The
drawing of the hands is remarkably
sensitive, and the folds of the pink robe,
modeled in green, are beautifully worked.
Especially notable is the rich tooling of the
gold background and the rare, original
frame.

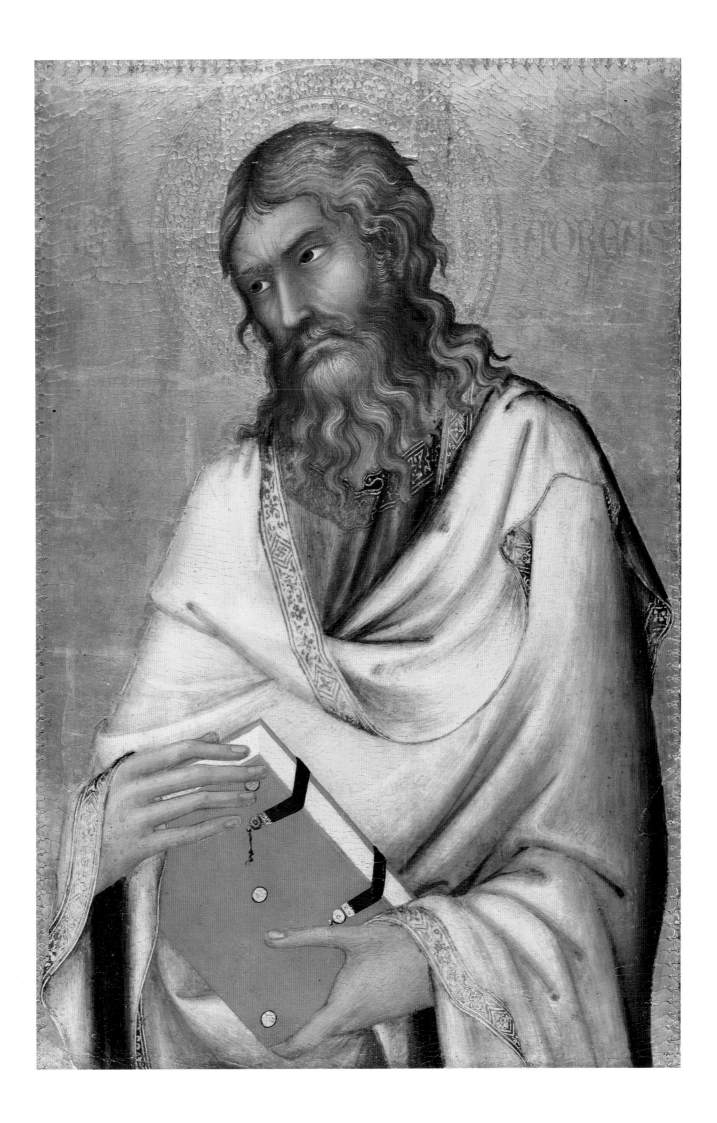

Giovanni di Paolo

Sienese, active by 1426, died 1482

THE CREATION OF THE WORLD
AND THE EXPULSION FROM
PARADISE, ca. 1445

Tempera and gold on wood; 18¼ × 20½ in.
(46.4 × 52.1 cm)
Robert Lehman Collection, 1975 (1975.1.31)

This extraordinary panel is widely admired for its brilliant colors, curious iconography, and mystical vitality. At the left, God the Father, supported by 12 blue cherubim, flies downward, pointing with his right hand at a circular *mappamondo*, which fills the lower half of the scene. The representation of earth is surrounded by concentric circles, including a green ring (for water), a blue ring (for air), a red ring (for fire), the circles of the seven planets, and the circle of the Zodiac. On the right, in a separate scene set in a meadow filled with flowers, Adam and Eve walk to the right against a line of seven trees with golden fruit. Their heads turn back toward a naked angel, who expels them from Paradise. Below them spring the four rivers of Paradise, which extend to the base of the picture.

This panel is a fragment from the predella of an altarpiece painted for the church of San Domenico in Siena and now in the Uffizi in Florence. Another panel from the same predella is also in the Museum's collection. The influence of the International Gothic style, especially French miniature painting, can be seen in the figures of the angel, Adam, and Eve, and in the details of flora and fauna.

Andrea Mantegna

Paduan, ca. 1430–1506

THE ADORATION OF THE
SHEPHERDS, ca. 1451–53

———

Tempera on canvas transferred from wood;
overall: 15¾ × 21⅞ in. (40 × 55.6 cm)
Purchase, Anonymous Gift, 1932 (32.130.2)

———

A prodigy, Andrea Mantegna established his
reputation when he was barely 20 years old.
This painting is an early work, but already
his highly individual style is evident. The
hard, precise drawing, the astonishing
clarity of even the smallest details in the
distant landscape, and the refined, pure
color are typical of his work, as are the
intensely serious expressions of the figures.
The *Adoration* seems to have been painted
for Borso d'Este, ruler of Ferrara, and the
coarse realism of the shepherds probably
reflects Flemish paintings collected by the
Este.

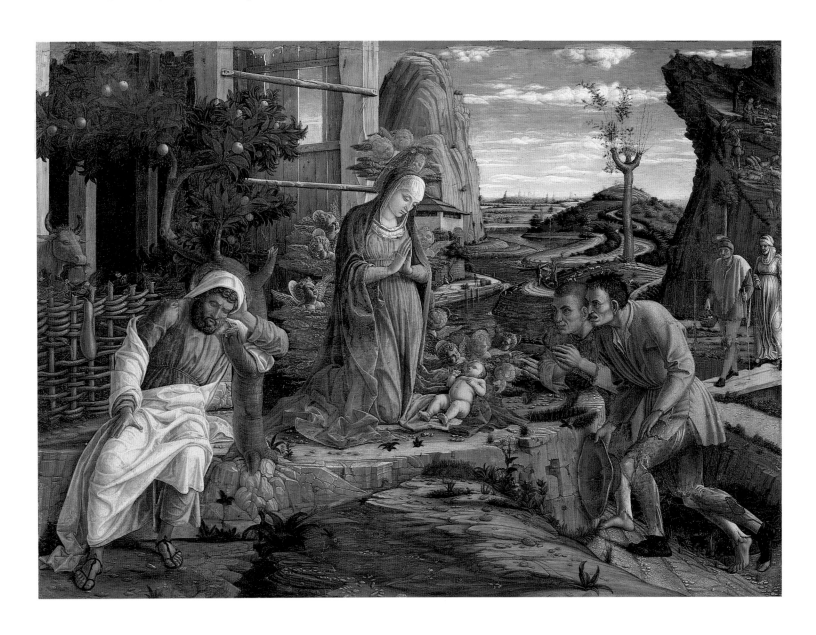

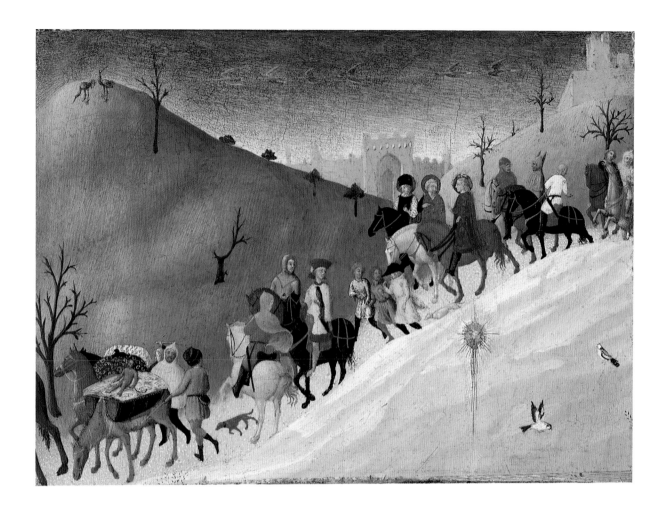

Sassetta

Sienese, active by 1423, died 1450
THE JOURNEY OF THE MAGI, ca. 1435

Tempera and gold on wood; 8½ × 11¾ in.
(21.6 × 29.9 cm)
Maitland F. Griggs Collection, Bequest of
Maitland F. Griggs, 1943 (43.98.1)

This panel showing the three magi and their
retinue on their way to Bethlehem was
originally the upper part of a small
Adoration of the Magi now in the Palazzo
Chigi-Saraceni in Siena. (The upper edge of
the stable roof is just visible along the
bottom right edge.) Sassetta was one of the
most enchanting narrative painters of the
15th century, and although this picture is
only a fragment, it is one of his most
popular works. He has imagined the magis'
journey as a contemporary pageant,
including fashionably attired figures and
courtly details such as the hunting falcon on
a man's arm and the monkey riding on the
back of a donkey. The ostriches on the hill
symbolize the miraculous birth of Christ.

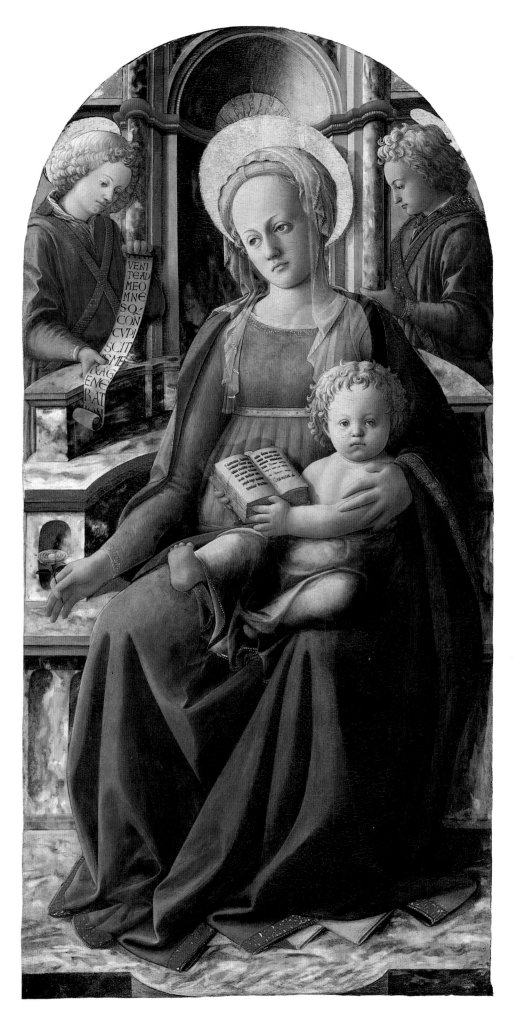

Fra Filippo Lippi
Florentine, ca. 1406–1469
MADONNA AND CHILD
ENTHRONED WITH TWO ANGELS,
ca. 1437

———

Tempera and gold on wood transferred from
wood; arched top: 48¼ × 24¾ in.
(122.6 × 62.9 cm)
The Jules Bache Collection, 1949 (49.7.9)

This early work by Filippo Lippi is the
center panel of a triptych, the wings of
which are in the Accademia Albertina in
Turin. Although made of three separate
panels, the triptych was unified by a
continuous wall and uniform lighting. The
figures and the elaborate marble throne
have a massive quality deriving from the
artist's study of the frescoes of Masaccio in
the church of Santa Maria del Carmine,
where Lippi was a monk. The rose held by
the Virgin symbolizes her purity.

Giovanni Bellini
Venetian, active by 1459, died 1516
MADONNA AND CHILD, 1480s

———

Oil on wood, 35 × 28 in. (88.9 × 71.1 cm)
Rogers Fund, 1908 (08.183.1)

Bellini was one of the great geniuses of the
Renaissance; his use of color to achieve rich,
atmospheric effects became the hallmark of
Venetian art of the Renaissance. In addition
to large altarpieces, Bellini also painted
devotional images of the Madonna and
Child for domestic settings. In spite of their
modest size and conventional theme, these
paintings invariably exhibit a remarkably
fresh, inventive approach. The Madonna in
this painting is aligned with the vertical axis
of the picture, but the rust-colored cloth of
honor and the position of the tenderly held
Child introduce a daring asymmetry. The
beautifully painted landscape,
incorporating a distant view of the Alps,
serves to balance the composition and
underscores the still, poignant mood of the
picture. The quince held by the Child is a
symbol of the Resurrection.

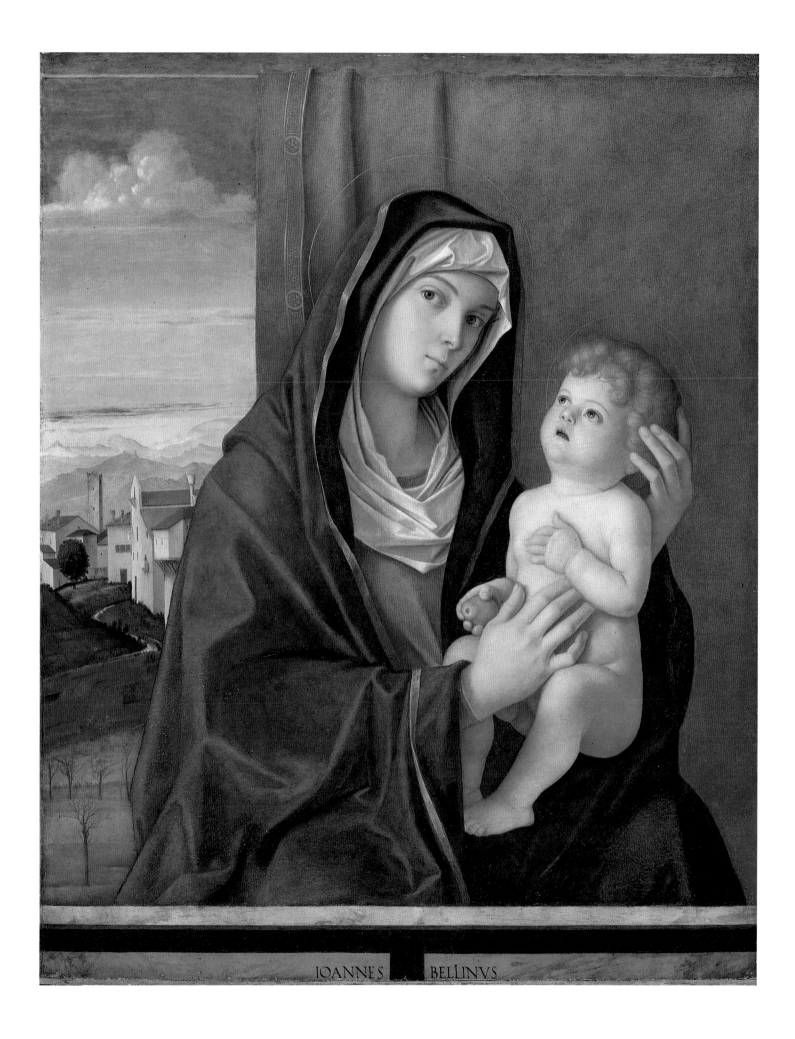

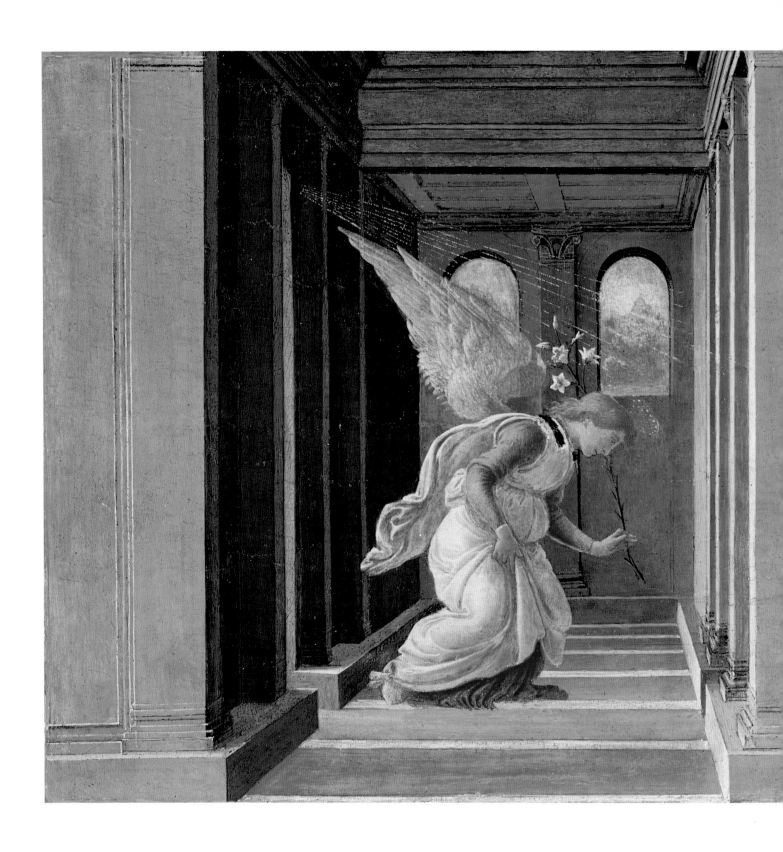

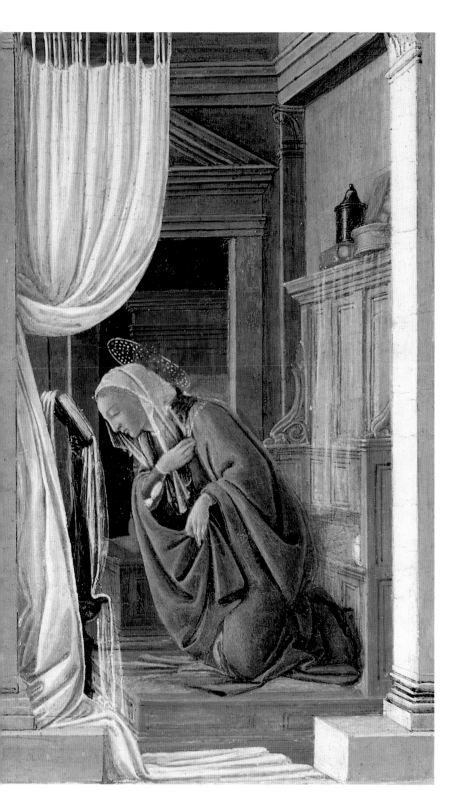

Botticelli

Florentine, 1444/45–1510

THE ANNUNCIATION, ca. 1485

Tempera and gold on wood; 7½ × 12⅜ in.
(19.1 × 31.4 cm)
Robert Lehman Collection, 1975 (1975.1.74)

This picture is one of the jewels of 15th-century Italian art, embodying the achievements that made Florence so famous and influential. The classical architectural setting is carefully rendered in linear perspective, one of the great discoveries of Florentine artists. The figures of the Virgin and the archangel Gabriel, virtually mirror images of each other, are separated by the center row of pillars, but they are subtly drawn together into a unified composition by the rays of light carrying God's message from heaven. The complex composition, as well as the lyrical quality of the drawing and the transparency of the colors, are characteristic of Botticelli's mature style.

Vittore Carpaccio

Venetian, ca. 1455–1523/26

THE MEDITATION ON THE
PASSION, ca. 1510

———

Oil and tempera on wood; 27¾ × 34⅛ in.
(70.5 × 86.7 cm)
John Stewart Kennedy Fund, 1911 (11.118)

———

Carpaccio is best known for the extensive
narrative cycles he painted for Venetian
confraternities, but he also produced a
number of individual religious works for
private collectors that are distinguished for
their haunting stillness and richly
descriptive approach. One of the most

beautiful of these paintings is this depiction
of the Old Testament figure Job and of Saint
Jerome as a hermit meditating on the body
of the dead Christ. Inscribed in Hebrew on
the marble block where Job sits are the
words "I know that my redeemer liveth."
Numerous details underscore the theme of
death and resurrection: the bones next to
Job, the crown of thorns propped up against
Christ's broken throne, the small bird that
flies upward from Christ to symbolize the
Resurrection. Even the lavishly painted
landscape carries the theme by appearing
desolate on the left and lush and open on
the right.

Antonio Pollaiuolo

Florentine, 1429–1498

BATTLE OF THE NAKED MEN,
ca. 1490?

Engraving (second state of two);
15⅝ × 23¼ in. (39.7 × 59.1 cm)
Purchase, Joseph Pulitzer Bequest, 1917
(17.50.99)

Whether a specific event is meant to be portrayed in this battle or whether the composition with its nude figures in different active poses is more in the nature of an exercise is uncertain, as is the date when the print was made and even the identity of its engraver. Nonetheless, Pollaiuolo's ambitious, large-scale composition has always fascinated viewers, and this print is a landmark in 15th-century Italian engraving.

Leonardo da Vinci

Italian, 1452–1519

STUDIES FOR A NATIVITY

———

Pen and brown ink, over preliminary
sketches in metalpoint, on pink prepared
paper, 7⅝ × 6⅜ in. (19.3 × 16.2 cm)
Rogers Fund, 1917 (17.142.1)

Leonardo left hundreds of notebooks filled
with drawings in which he explored ideas,
compositions, or inventions. His curiosity
led him to sketch and puzzle out diverse
subjects, such as running water, growing
plants, and human anatomy. The series of
sketches on this sheet show Leonardo
exploring a theme that would later emerge
as the *Madonna of the Rocks*, in which the
Virgin kneels over the infant Jesus, raising
her right hand in benediction.

Tullio Lombardo

Venetian, ca. 1465–died 1532

ADAM, 1490–95

Marble; H. 75 in. (190.5 cm)
Fletcher Fund, 1936 (36.163)

This figure, on whose base the sculptor has signed his name, belonged to the most important funerary monument of the High Renaissance in Venice, that of Doge Andrea Vendramin (died 1478). Tullio's *Adam* is clearly classicized, like the architectural framework of the tomb, which is derived from the Roman triumphal arch. The figure combines aspects of antique statues of Antinous and Bacchus, interpreted with an almost Attic simplicity. But the decorated tree trunk, the eloquent hands, and the meaningful glance are refinements on the antique. Remarkable for the purity of its marble and the smoothness of its carving, *Adam* was the first monumental classical nude to be carved since antiquity.

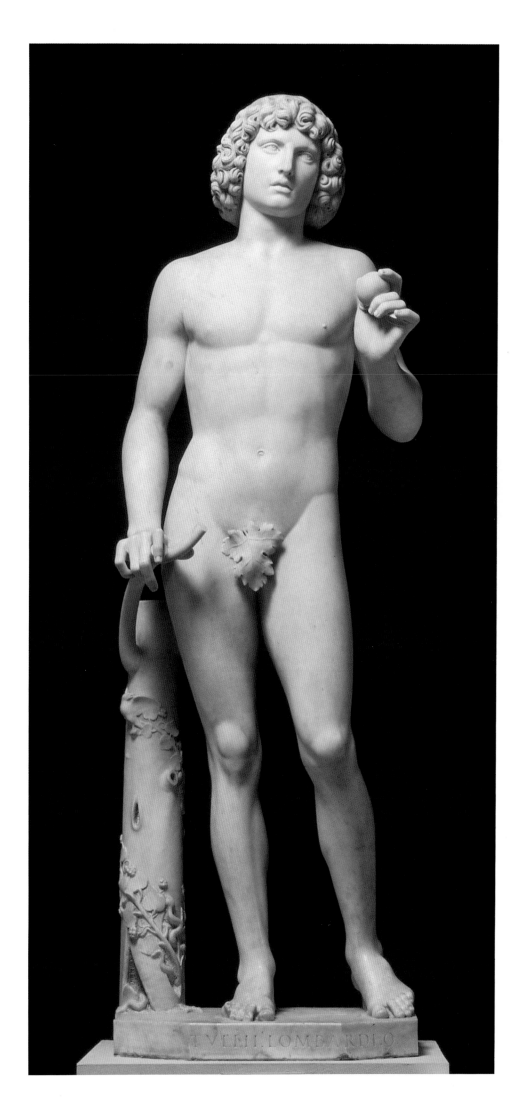

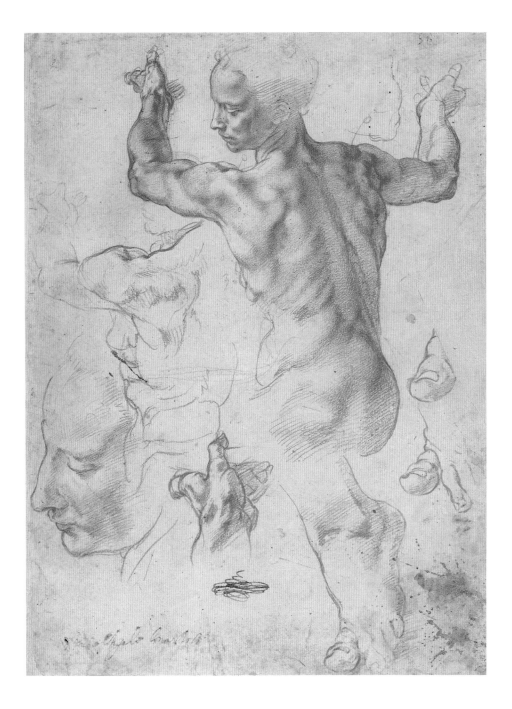

Bronzino

Florentine, 1503–1572

PORTRAIT OF A YOUNG MAN, ca. 1540

Oil on wood; 37⅝ × 29½ in.
(95.6 × 74.9 cm)
H. O. Havemeyer Collection, Bequest of
Mrs. H. O. Havemeyer, 1929 (29.100.16)

This is one of Bronzino's greatest portraits.
The self-possessed aloofness of the sitter and
the austere elegance of the palace interior
are hallmarks of the courtly style of
portraiture he created for Medicean
Florence. Although the sitter cannot be
identified, he is likely a member of
Bronzino's close circle of literary friends.
The book held by the sitter in the portrait
probably alludes to his literary interests, and
the fanciful table and chair, with their
grotesque decorations, are visual analogues
to the sorts of literary conceits enjoyed by
this cultivated society.

Michelangelo Buonarroti

Italian, 1475–1564

STUDIES FOR THE LIBYAN SIBYL,
ca. 1510

Red chalk; 11⅜ × 8⁷⁄₁₆ in. (28.9 × 21.4 cm)
Purchase, Joseph Pulitzer Bequest, 1924
(24.197.2)

Like Raphael and Leonardo, Michelangelo
typifies the concept of the Renaissance
artist. Sculptor, painter, architect,
draftsman, and poet, he redefined the
parameters of each field through his own
individual genius. Michelangelo made these
studies from a nude male model for the
figure of the Libyan Sibyl in the ceiling
frescoes of the Sistine Chapel,
commissioned in 1508 and unveiled in 1512.
Here he studies the contours of the Sibyl's
twisting back as she turns to close what will
in the fresco become a large book on the
ledge behind her. Also on the sheet are
sketches of the figure's profiled head, hands,
and feet. Although drawn on the flat surface
of a page, Michelangelo's figure has been
drawn with the force and volume of a piece
of sculpture. Through the motion of a body,
the artist expresses the human spirit.

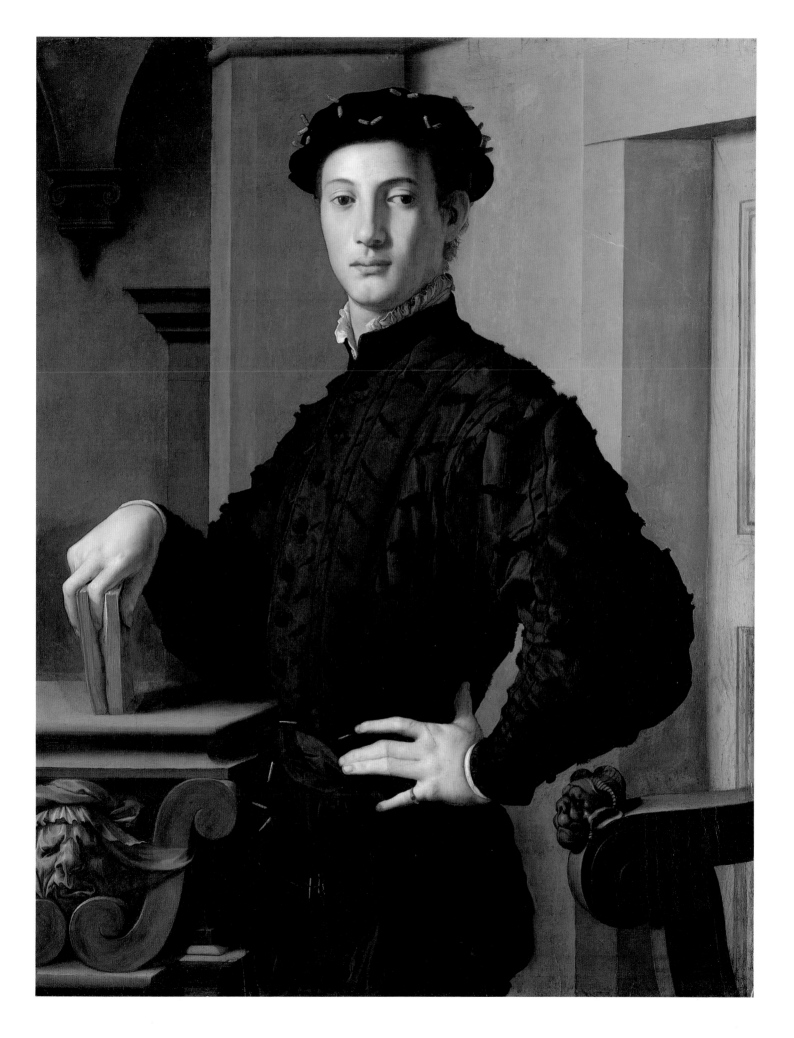

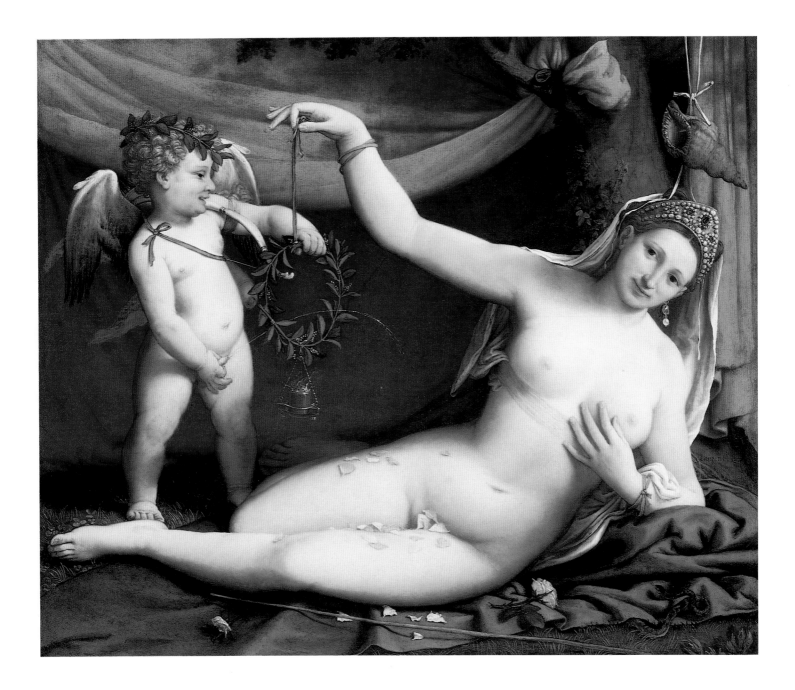

Lorenzo Lotto

Italian (Venice), ca. 1480–1556

VENUS AND CUPID

Oil on canvas; 36⅜ × 43⅞ in.
(92.4 × 111.4 cm)
Purchase, Mrs. Charles Wrightsman Gift,
1986 (1986.138)

Of the countless Renaissance paintings of
Venus and Cupid, few are as beautiful—and
certainly none is quite so startling—as this
humorous wedding picture. It is an allegory
in which the goddess of love, surrounded by
symbols of fertility and conjugal fidelity,
blesses a marriage. With her right hand
Venus raises a myrtle wreath through which
Cupid urinates, with evident delight, onto
her lap. His action may seem ludicrous to us

today, but for Lotto's contemporaries a
urinating child was an augury of good
fortune. The joyous mood and lush coloring
of this picture place it among the works that
Lotto executed at Bergamo, where he
settled from 1513 to 1526 and produced some
of his greatest altarpieces and best portraits.

(OPPOSITE)

Paolo Veronese

Venetian, 1528–1588

MARS AND VENUS UNITED BY LOVE,
ca. 1570

Oil on canvas; 81 × 63⅜ in. (205.7 × 161 cm)
John Stewart Kennedy Fund, 1910 (10.189)

This is one of the greatest works by
Veronese, whose brilliant use of color and

sensuous female figures influenced
European artists from the time of Rubens to
that of Delacroix. Together with four other
allegorical paintings by Veronese, the
picture was owned by Emperor Rudolf II in
Prague. Although generally thought to
show the goddess of love united by Cupid to
the god of war, the picture has also been
interpreted as showing Chastity
transformed by Love into Charity; the horse
restrained by an armed cupid may
symbolize restrained passion.

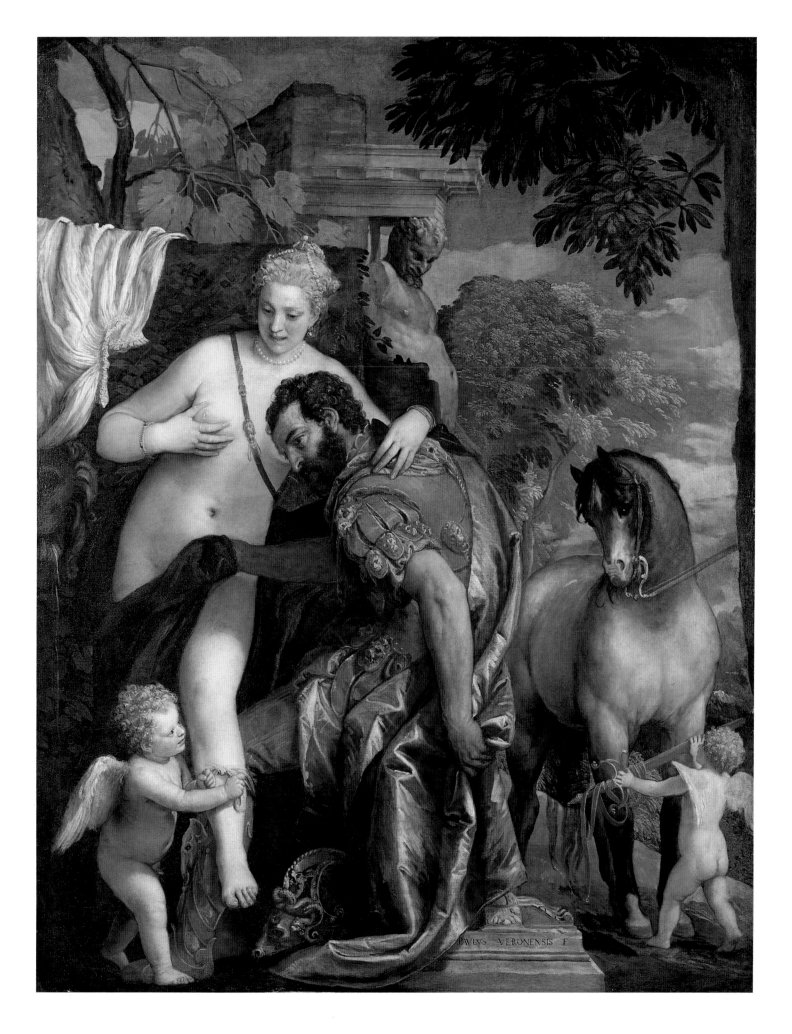

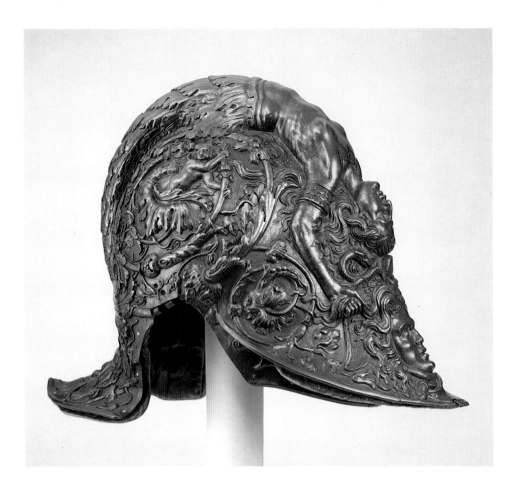

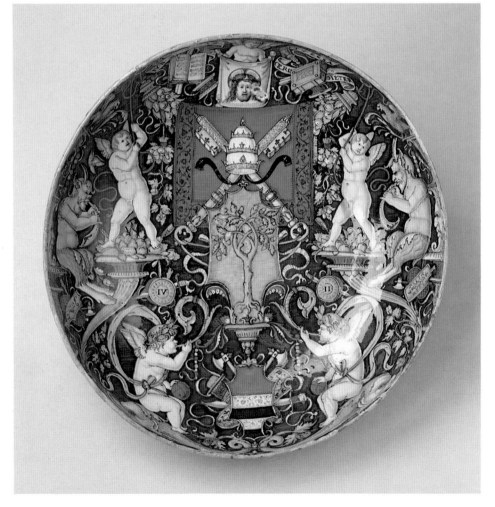

Filippo Negroli
Milanese, 1532–1551
PARADE HELMET, 1543

Steel and gold; H. 9½ in. (24.1 cm)
Gift of J. Pierpont Morgan, 1917 (17.190.1720)

This superb example of Italian Renaissance sculpture in steel was made by Filippo Negroli, the leading master of embossed armor in the antique style. The embossed ornament of acanthus scrolls inhabited by putti is inspired by classical prototypes. The reclining mermaid forming the comb of the helmet holds the head of Medusa, whose stare was reputed to turn the onlooker into stone.

Italian, 1508
BOWL

Terracotta; Diam. 12¾ in. (32.4 cm)
Robert Lehman Collection, 1975 (1975.1.1015)

Technically and artistically, this large bowl is one of the great masterpieces of Italian majolica. The center is occupied by the coat of arms of Pope Julius II crowned by symbols of papal authority, and it has been suggested that the bowl was a gift from the pope to one of his servitors, Melchiorre de Giorgio Manzoli of Bologna, whose arms appear beneath Julius's. An inscription on the back states that the bowl was made in Castel Durante by the potter Giovanni Maria in 1508, making this the first known signed piece of majolica.

Italian, ca. 1476–80
STUDY FROM THE PALACE AT GUBBIO

Intarsia of walnut, beech, rosewood, oak, and fruitwoods on walnut base
Rogers Fund, 1939 (39.153)

This is a detail of a wall from a small room that is one of the Museum's most celebrated environments: the *studiolo* intended for meditation or study in the Gubbio palace of Duke Federigo da Montefeltro. The *studiolo* walls were decorated with small pieces of wood of various sorts inlaid in patterns, a technique known as intarsia. Here the designs produce trompe-l'oeil effects, as cabinet doors appear ajar and books lie open, evidence of the great interest in linear perspective at this time.

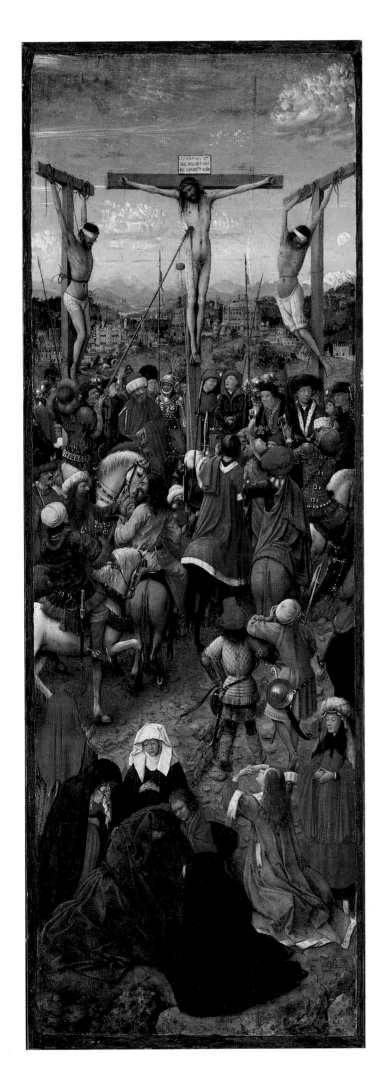
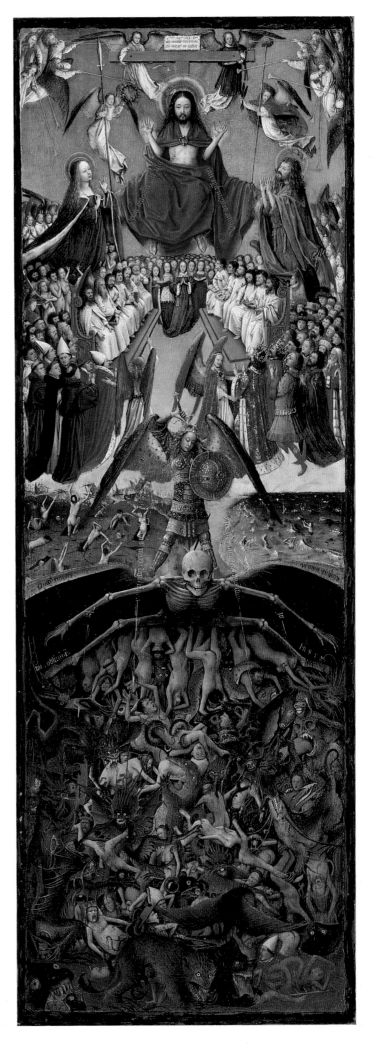

Northern Europe

 EVEN AFTER THE PERIOD of Gothic glory, a golden age of art flourished during the fifteenth and sixteenth centuries in the North, in many ways as splendid and revolutionary as the Renaissance in Italy. A true renaissance has usually been denied the Gothic North if only because the revival of the antique was not initially part of this area's development. For the Italians great art was mural painting—works to be viewed from a distance as a grand design enhancing a huge surface. Northern painting, on the other hand, was intimate and personal and had its aesthetic basis in the delicate and diminutive Book of Hours, to be scanned slowly for its intricate details, its gemlike fineness, its refined preciousness. Despite these fundamental differences it is remarkable how developments in Netherlandish art paralleled those in Italy. Indeed it is possible to discern phases in Northern painting similar to those of the Italian Renaissance.

Early in the fifteenth century, the Limbourg brothers, painters to Jean, duke of Berry, executed some of the most memorable images of the so-called International Style. In their miniatures the first signs of borrowings from Italian antiquity can be faintly detected, as in the *rinceau* borders of the *Belles Heures* of about 1410 (see page 72). Their tastes were transmitted to later Flemish painters who worked for the courts, such as Jan van Eyck, but the progressive tendency toward naturalism was exploited more by those artists who worked in the city guilds, including Robert Campin and his apprentice Rogier van der Weyden. They painted for the merchant class that was molding the economic and political life of the Low Countries into the bourgeois society that ultimately triumphed there. Later generations of Netherlandish artists were indebted both to van Eyck and Rogier. Their styles—meticulous realism, on the one hand, and rhythmic abstraction, on the other—form the poles between which subsequent styles vacillate.

Deep space and immobile figures characterized the style of many painters from the northern Netherlands, regional differences perhaps due to their isolation from the flamboyant courtly tastes of the Flemish patrons. The Netherlandish artists were especially renowned for their portraits, which were more meticulously descriptive and psychologically revealing than those in the Italian manner.

The violent social upheaval and political turmoil that followed the demise of Burgundian rule in the Netherlands, the tensions within the Church on the eve of the Reformation, and the pervasive fear of an impending apocalypse provoked a frantic spirit in the late 1400s. The collapse of medieval values can be clearly noted in the arts, but the positive features of a new culture, while more difficult to describe, were there as well. The guilds proliferated as a new class of patron—the merchant—emerged to replace the Church and its benefactors. Artists and craftsmen flocked to Antwerp from all over northern Europe to reap the profits of the new market; they introduced the eclecticism so characteristic of Antwerp's art. During these years a new art form—the print—was established. It was especially lucrative because of its attraction for middle-class patrons.

The Protestant revolution had much to do with the fate of the arts in Germany, and to a lesser extent, in the Netherlands as well. It became heretical to produce images of God and this stifled the arts in Germany, at least as far as religious imagery was concerned. But the Reformation did not occur overnight, and iconoclasm was not

(OPPOSITE)

Jan van Eyck

Netherlandish, active by 1422, died 1441

THE CRUCIFIXION and THE LAST JUDGMENT, 1425–30

———

Oil on canvas transferred from wood; each panel: 22¼ × 7¾ in. (56.5 × 19.7 cm)
Fletcher Fund, 1933 (33.92ab)

———

Jan van Eyck, one of the greatest artists of the Renaissance, appears to have been the first painter to develop the full potential of the new oil medium. Although the panels are small, the artist has managed to render the figures' emotions with great sensitivity, especially the poignant grief of the foreground group in *The Crucifixion* or the horror and misery of those in hell in *The Last Judgment*. Every detail is observed with equal interest—from the alpine landscape to the slender body of Christ. Perhaps more than any other works attributed to Jan, these pictures show him as the forerunner of realism in the North. They date from the same time as the Ghent Altarpiece (1432). The two panels may have been planned as a diptych or as wings of a triptych or tabernacle.

The raised lettering on the original frames are quotations from Isaiah on the Crucifixion and from Revelations and Deuteronomy on the Last Judgment.

(LEFT)

Detail from chasuble on page 130

universally accepted by all who joined the movement. Albrecht Dürer of Nuremberg is often regarded as the founder of the Northern Renaissance, and he, in fact, did bring the Italian revival of the antique to the North in both spirit and form. The painter of Renaissance portraits par excellence was Hans Holbein the Younger, a cosmopolitan artist who lived and worked in three international cities: Augsburg, Basel, and London.

Regional ducal powers, which had provided the patronage during the fourteenth and fifteenth centuries, gave way to international empires in the sixteenth. Through marriage the Hapsburgs had inherited the Netherlands in 1477; Henry VIII had proclaimed England free of Rome's influence, and in France Francis I was determined to establish a Renaissance court in his new capital at Fontainebleau. For Francis, who knew Italy well, there was only one source that could nourish his culture and that was Renaissance Italy. Nevertheless, the severe tenets of Gothic art still lingered in France. The court of Fontainebleau served in a sense to filter Italian art into the North.

A new Renaissance philosophy appears in the works of Pieter Bruegel the Elder, who stands out like a giant among later Netherlandish artists. He was the master of the latest styles, and it is impossible to characterize his art as medieval, Renaissance, or even Mannerist, since his works seem to encompass all these expressions. Unlike his compatriots, Bruegel did not dwell on antiquities and Renaissance masterpieces but concentrated on the landscape, especially that of the towering Alps. It seems strange indeed that in our discussion of the Renaissance in the North, what ultimately triumphs is not the image of man but the cosmic forces of nature.

(OPPOSITE)
Gerard David
Netherlandish, active by 1484, died 1523
VIRGIN AND CHILD WITH FOUR ANGELS, ca. 1505

Oil on wood; 24⅞ × 15⅜ in. (63.2 × 39.1 cm)
Gift of Mr. and Mrs. Charles Wrightsman, 1977 (1977.1.1)

The influence of Italian Renaissance art can be seen more clearly in the works of Gerard David than in those of Hans Memling, though both artists worked in Bruges for Italian patrons. Painted about 1505, this exceptionally well-preserved panel was probably commissioned by someone associated with the Carthusian monastery of Genadendal, outside the walls of Bruges and seen here in the background. The composition is based on Jan van Eyck's *Virgin and Child at the Fountain* of 1439 (Koninklijk Museum voor Schone Kunsten, Antwerp). Gerard David added a different setting with musical angels and turned the Child's head toward the viewer.

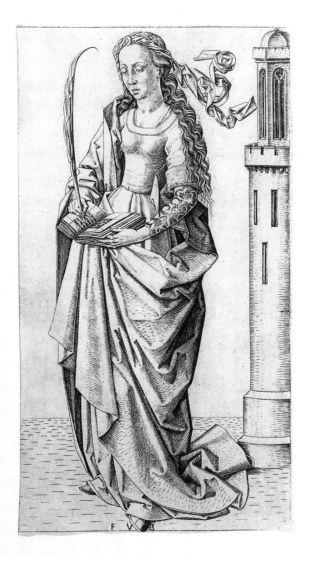

Master F.V.B.
Flemish
SAINT BARBARA, 1475–1500

Engraving; 6⁹⁄₁₆ × 3¹¹⁄₁₆ in. (16.6 × 9.2 cm)
The Elisha Whittelsey Collection, The Elisha Whittelsey Fund, 1955 (55.530)

This engraving of Saint Barbara, who was beheaded by her father for refusing to renounce Christianity, was made by an engraver known only by the initials F.V.B. (the "V.B." may stand for "van Brugge," "of Bruges"). He was one of the finest early Netherlandish engravers, and his oeuvre of about 60 prints reflects the style of such Flemish masters as Rogier van der Weyden, Dieric Bouts, and Hans Memling. In this fine example of his work, Saint Barbara, patroness of armorers and firearms, stands holding a peacock feather, a symbol of immortality, in front of the tower in which her father imprisoned her.

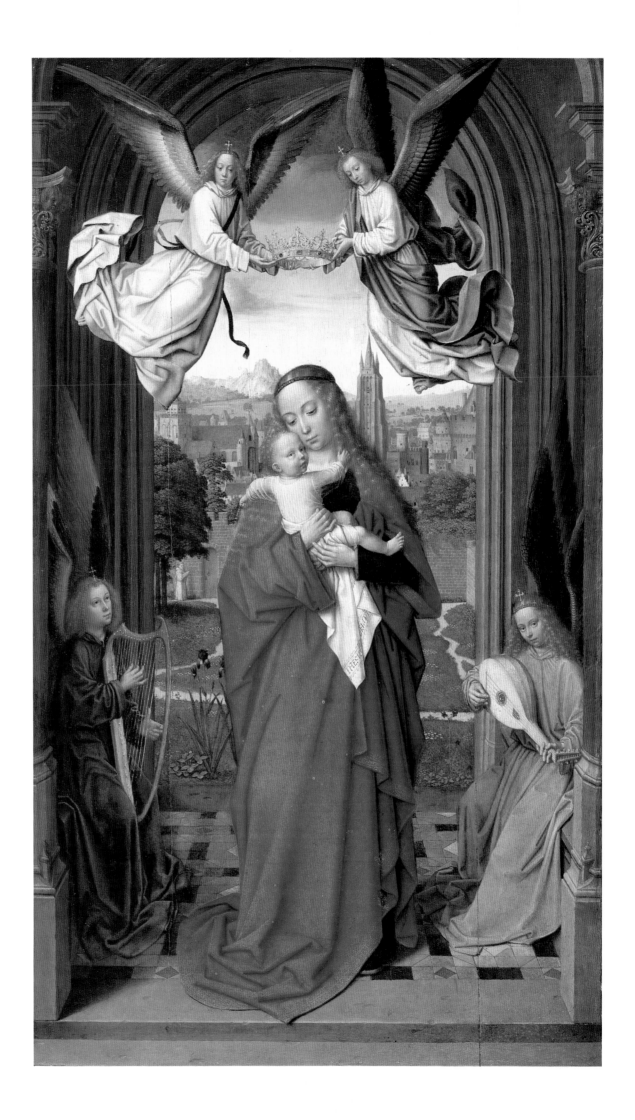

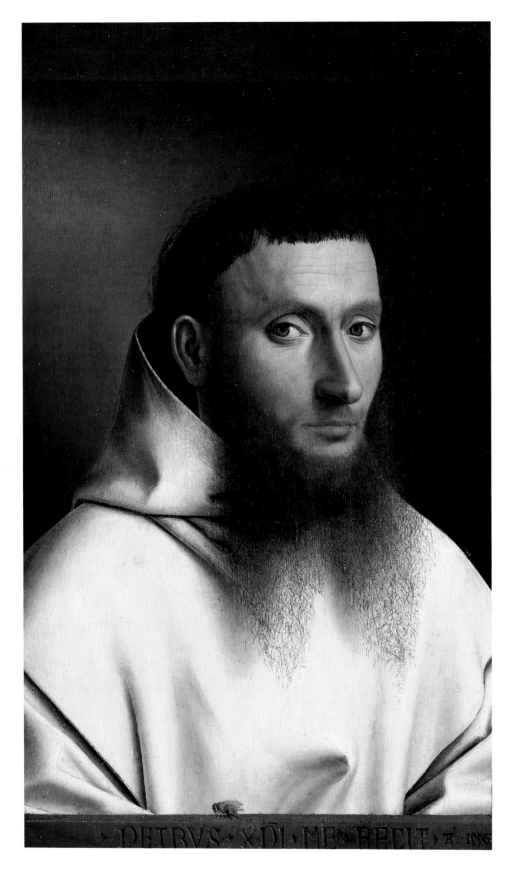

Petrus Christus
Netherlandish, active by 1444, died 1475/76
PORTRAIT OF A CARTHUSIAN, 1446

———

Oil on wood; overall: 11½ × 8½ in.
(29.2 × 21.6 cm)
The Jules Bache Collection, 1949 (49.7.19)

———

In 1444, three years after the death of Jan van
Eyck, Petrus Christus left his homeland in
the northern Netherlands to settle in
Bruges. This portrait, one of Christus's
earliest signed and dated works, shows van
Eyck's influence in the technical virtuosity
of the trompe-l'oeil fly and the carved
inscription. The sitter, once transformed
into a saint by the addition of a halo, is an
unknown lay brother of the Carthusian
order. The fly is a symbol of decay, a
reminder of man's mortality.

Rogier van der Weyden

Netherlandish, 1399/1400–1464

FRANCESCO D'ESTE, ca. 1460

Oil on wood; overall: 12½ × 8¾ in.
(31.8 × 22.2 cm)
The Friedsam Collection, Bequest of Michael
Friedsam, 1931 (32.100.43)

The work of Rogier van der Weyden, at one time an apprentice to Robert Campin, painter of the Annunciation Altarpiece (page 74), has an elegance and grace that epitomizes the finest qualities of the late Gothic style. Rogier learned much from Campin and Van Eyck, but he fashioned a world that more fittingly responded to the tastes of the upper classes. The sitter in this fine portrait is Francesco d'Este, the illegitimate son of Leonello, the duke of Ferrara, who received his military training in Brussels in 1444 and spent the rest of his life in Burgundy. The ring and hammer he holds may be emblems of office or tournament prizes. This panel was probably painted about 1460, when Francesco was close to 30. With his elongated features and introspective gaze, Francesco is the paragon of aristocratic aloofness. The Este coat-of-arms with Leonello's crest, the hooded lynx is on the back of the panel.

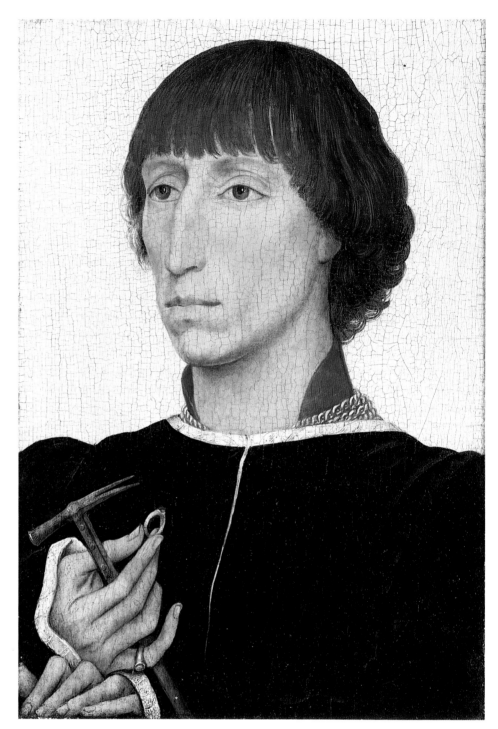

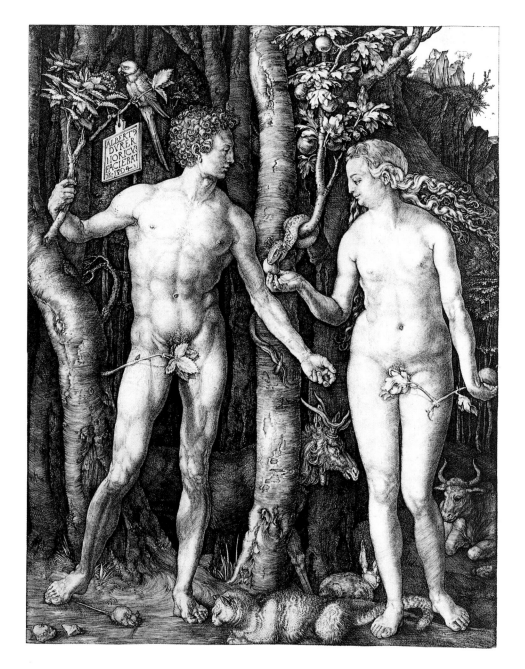

Albrecht Dürer

German, 1471–1528

VIRGIN AND CHILD WITH SAINT
ANNE, 1519

Oil on canvas; 23⅝ × 19⅝ in. (60 × 49.8 cm)
Bequest of Benjamin Altman, 1913 (14.40.633)

Saint Anne, the mother of the Virgin, was
particularly revered in Germany and was
frequently depicted in Holy Family
groupings. This painting was probably
made in 1519 (the monogram and date were
later additions), the year in which Dürer
became an ardent follower of Martin
Luther, and the emotional intensity of the
image may be a reflection of his conversion.
It owes much to the artist's two visits to
Venice, when he came under the influence
of Italian art, particularly the work of
Giovanni Bellini. The monumental masses
of the figures and the balanced composition
reveal the impact that Italian art made on
Dürer's northern Gothic style. The lifelike
baby is very different from the wizened
creatures often found in Northern
European paintings.

Albrecht Dürer

German, 1471–1528

ADAM AND EVE, 1504

Engraving (fourth state of five); 9¾ × 7⅝ in.
(24.8 × 19.4 cm)
Bequest of Ida Kammerer, in memory of her
husband, Frederic Kammerer, M.D., 1933
(33.79.9)

Throughout Dürer's life, he was
preoccupied with the study of ideal human
proportion. He struggled to portray the
perfect male and female forms, and *Adam
and Eve* is a prime example of this interest.
The figure of Adam is based on the *Apollo
Belvedere* and Eve on an antique Venus, and
indeed they stand frontally like statues, thus
somewhat blunting the significance of this
dramatic moment in human history. The
trees themselves and the animals in the
woodland setting carry rich symbolism,
alluding to the Tree of Life and the Four
Temperaments. The latter, according to
medieval belief, were in perfect equilibrium
before the Fall, but thereafter man was
susceptible to vices as one or another of the
temperaments gained dominance. The
technical brilliance of this engraving added
luster to Dürer's already widespread
reputation. He modeled the flesh of the
subjects in precise detail, using fine dots to
create such a variety of textures that the
shading virtually creates the illusion of
color.

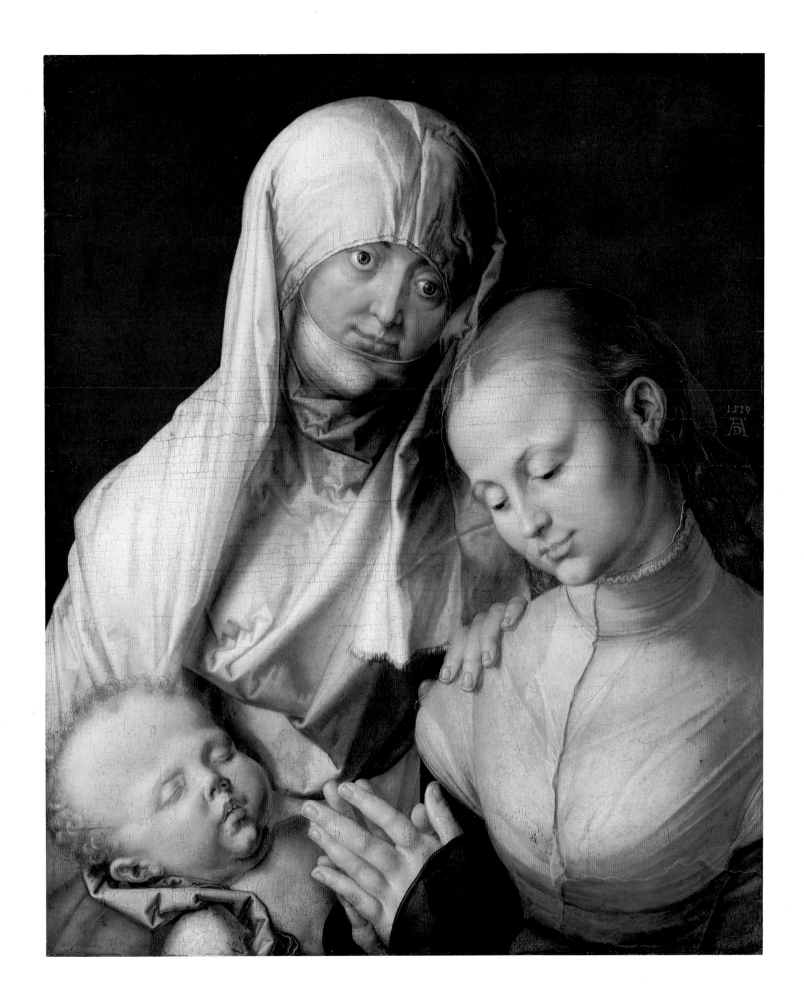

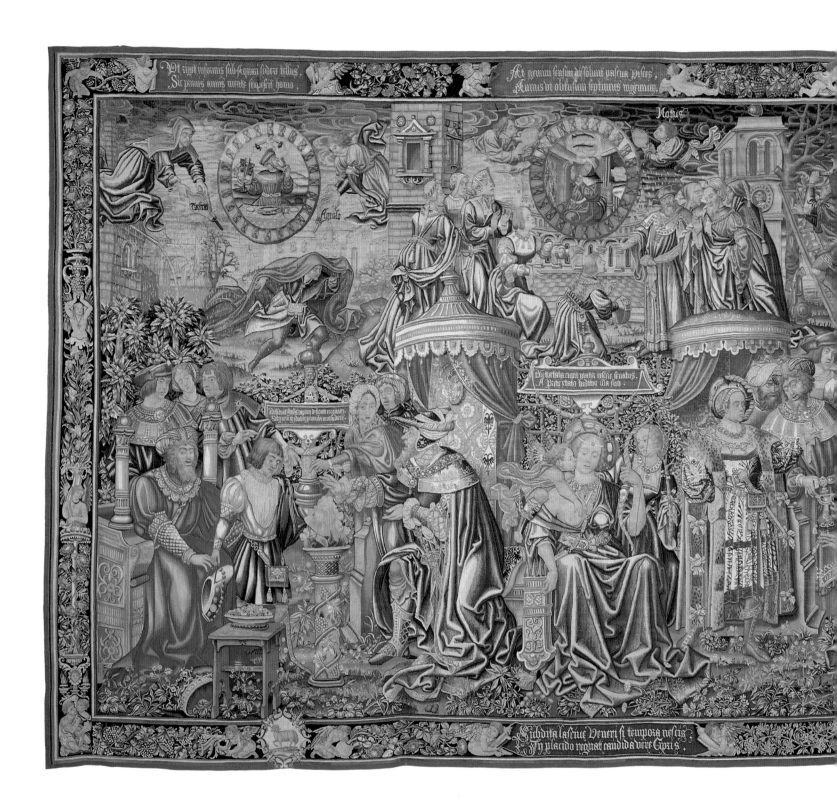

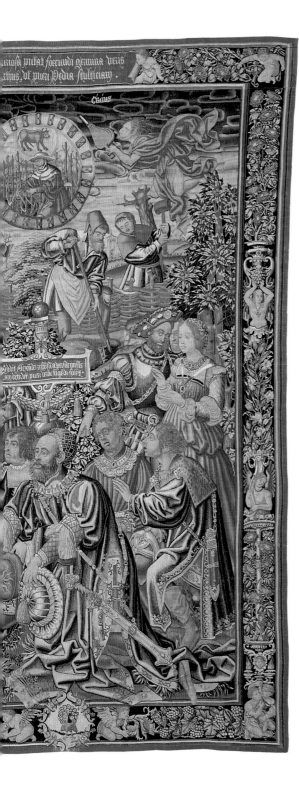

Brussels, ca. 1520–25

SPRING, FROM THE TWELVE AGES OF MAN

Wool and silk; 14 ft. 7 in. × 23 ft. 8 in. (4.45 × 7.28 m)
Gift of The Hearst Foundation, in memory of William Randolph Hearst, 1953 (53.221.1)

Tapestries, often called the murals of the north, were made to provide splendor at a distance and delightful details close at hand. This Flemish example, the first in a set of four depicting the months and the ages of man, all in the Metropolitan Museum, includes the first three months of the year and the first 18 years of life, presided over by Venus in the center. The first age, or January, on the left, has at the top, in a roundel, Janus feasting and a man running in a rainstorm; the scene below is the test of Moses, who as an infant chose hot coals rather than jewels, illustrating the lack of common sense in children under seven. At the top center, with a roundel representing February, a man sitting by a fire, is the story of the astute Roman youngster, Papirius, who kept the secrets of the Senate from his mother, exemplifying the growth of intelligence in teenagers. March, at the upper right, with men at work in a vineyard, shows below the youthful Alexander amazing some Persian envoys with his shrewd questions, demonstrating a man's maturity at 18.

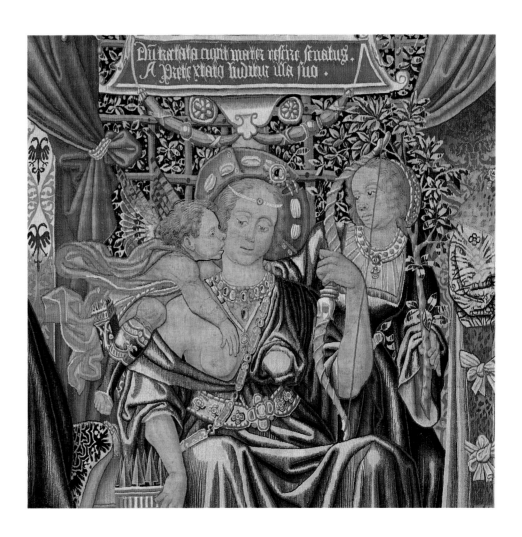

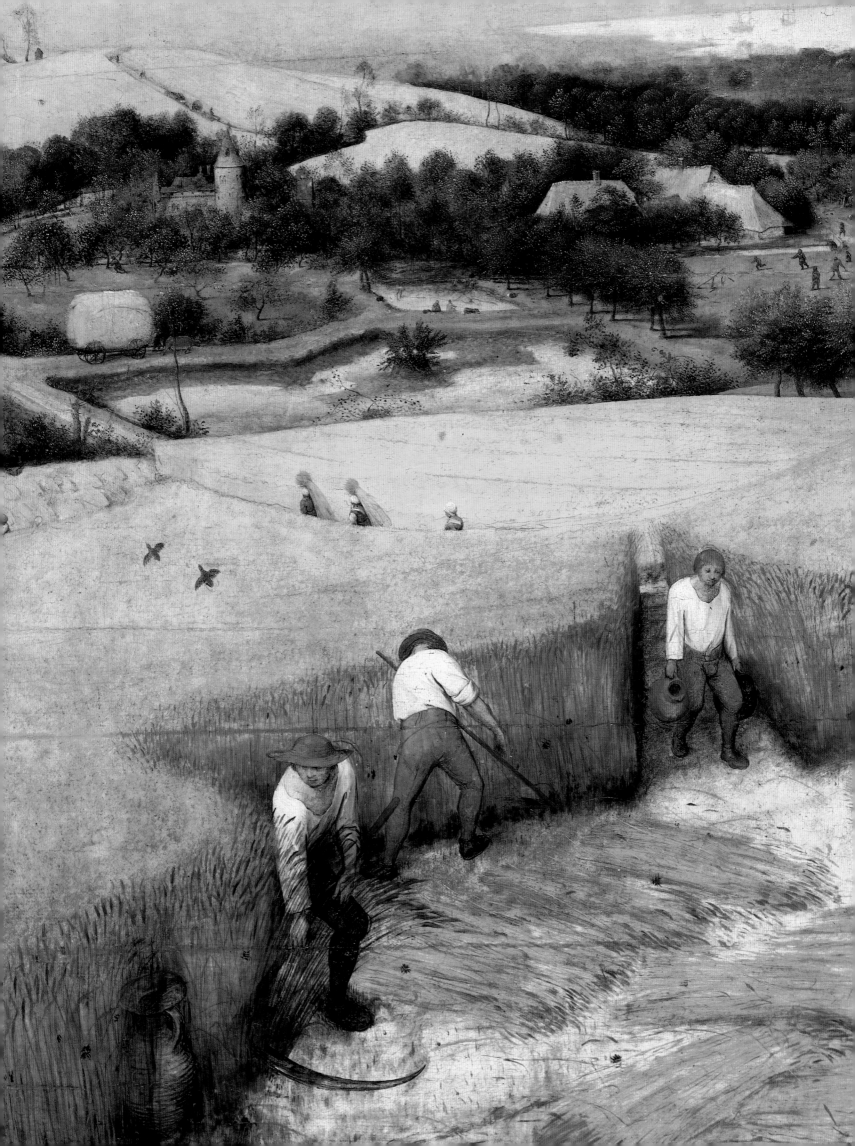

Pieter Bruegel the Elder

Netherlandish, active by 1551, died 1569

THE HARVESTERS, 1565

Oil on wood; 46½ × 63¼ in.
(118.1 × 160.7 cm)
Rogers Fund, 1919 (19.164)

Although Bruegel traveled to Italy in 1552–53, the trip had little effect on his art. Instead of classical subjects, he chose to depict peasant life, as in this picture of a wheat harvest, one of the five remaining panels from a cycle devoted to the labors of the months. The simplified forms of the harvesters convincingly convey their weight and solidity, while their familiar activities—cutting bread, eating, drinking—endow them with an everyday reality. The contorted expressions on some of the faces, as well as the pose of the exhausted man lying against the tree, suggest the hardships they endured. The figures occupy a relatively small portion of the panel in comparison with the brilliantly lit, vast landscape, reminding us that man remains subordinate to nature.

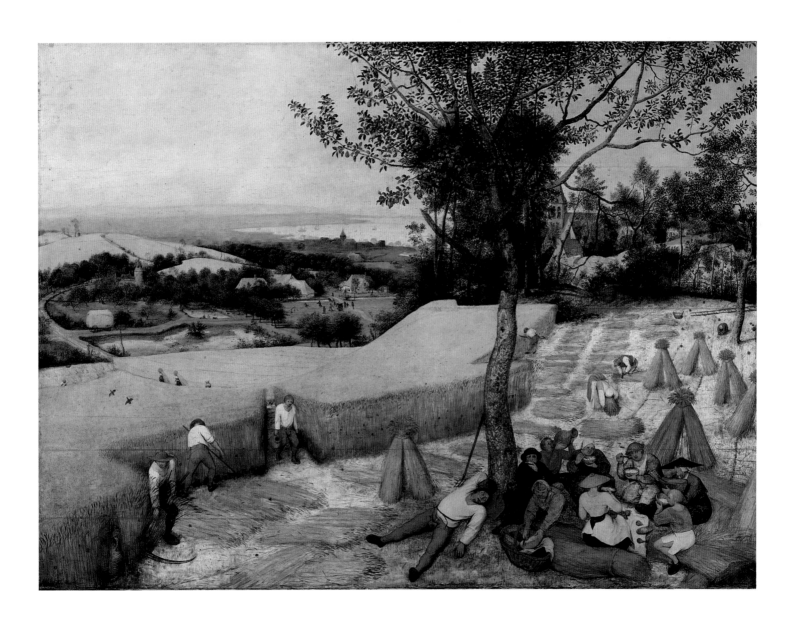

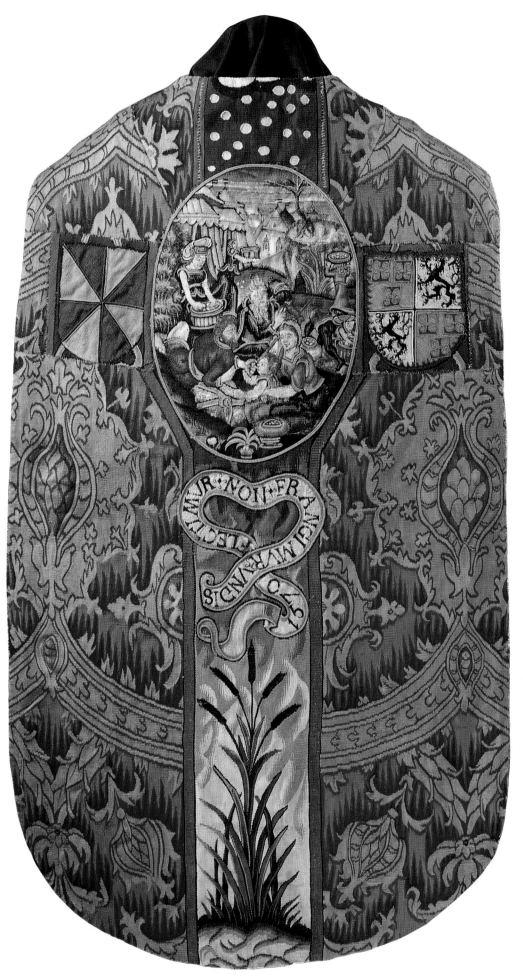

North Netherlandish, 1570
CHASUBLE

Linen, wool, and silk; 44 × 27½ in.
(111.8 × 69.9 cm)
Rogers Fund, 1954 (54.76.2)

Ecclesiastical vestments made of rich velvets and elaborate embroideries were often costly gifts to the church. In this highly unusual chasuble, which was probably used in a private chapel, the lavish effects of a pomegranate pattern in velvet and an embroidered scene of the Israelites gathering manna are imitated in tapestry. The device of reeds bent but not broken by the wind, particularly significant in politically turbulent times, is that of Johannes de Visscher van der Gheer of Culemborg; the arms are those of the same family and of the illegitimate Van Culemborch branch.

(OPPOSITE)
Lucas Cranach the Elder
German, 1472–1553
THE JUDGMENT OF PARIS, ca. 1528

Oil on wood; 40⅛ × 28 in. (101.9 × 71.1 cm)
Rogers Fund, 1928 (28.221)

Cranach was one of the most versatile artists of the Northern Renaissance, a staunch patron of the Reformation, and a close friend of Martin Luther. He painted didactic religious paintings, but he also produced his own erotic ideal of the female nude. Although his style, unlike that of Dürer, borrowed little from the Italians, he favored mythological and classical subjects and painted the story of the Judgment of Paris many times during the course of his career. Here the artist has chosen a German version of the story, in which Mercury presents the three goddesses—Juno, Venus, and Minerva—to Paris in a dream. Cranach signals Venus's victory by placing Cupid, her son, in the upper left, aiming in her direction as she points to him. The figures of the three women give the artist an opportunity to make a visual tour of the female nude from different perspectives.

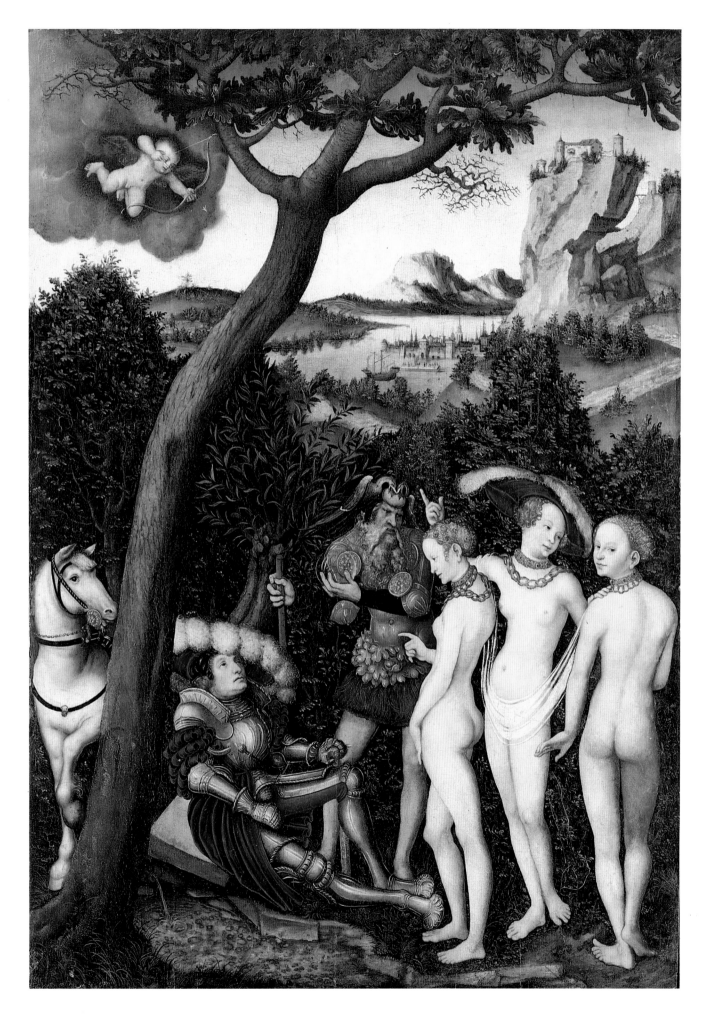

Hans Ruckers the Elder

Netherlandish, ca. 1545–1598

DOUBLE VIRGINAL, 1581

———

Wood and various other materials; W. 74¾ in.
(190 cm)
Gift of B. H. Homan, 1929 (29.90)

———

This sumptuously painted virginal, the
oldest extant work by Hans Ruckers the
Elder, head of a renowned family of Flemish
harpsichord builders, was made in Antwerp
in 1581, when Spain dominated Flanders.

Above the right keyboard are medallions of
Philip II and his fourth wife, Anne of
Austria. On the underside of the lid is a
painted scene of a garden fete; the panel
below the keyboards bears a Latin motto
meaning "Music, sweet solace of labor."
The double virginal, which anticipates the
double-manual harpsichord, consists of two
instruments. When the higher-pitched
"child" at the left is placed above the
"mother," both can be played by one
person.

(OPPOSITE)
Caspar Behaim

Austrian, active 1568–84

ASTRONOMICAL TABLE CLOCK, 1568

———

Bronze gilt, brass gilt, and steel; H. 14¼ in.
(36.2 cm)
Gift of J. Pierpont Morgan, 1917 (17.190.634)

———

Most 16th-century clocks were enclosed in
metal cases, some architectural in nature,
others engraved and embossed with designs
that rival the work of goldsmiths of the day.
The case of this clock is made of gilt bronze
with a domed top decorated in relief with a
scene of men hunting bear. The dials on the
front of the clock mark the hours of the day,
the day of the month (with saints' days), and
the position of the sun in the zodiac. A large
astrolabe dial fills most of the back of the
clock. The base is decorated with the
triumphal procession of Pluto and
Proserpina.

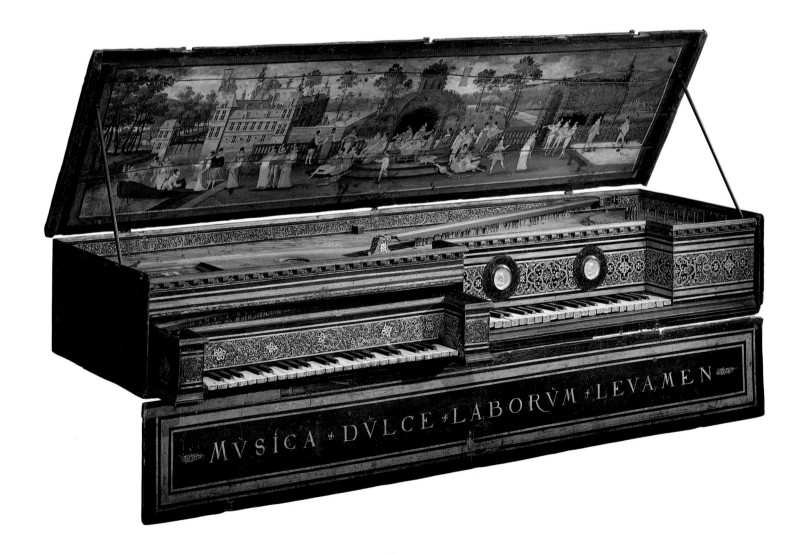

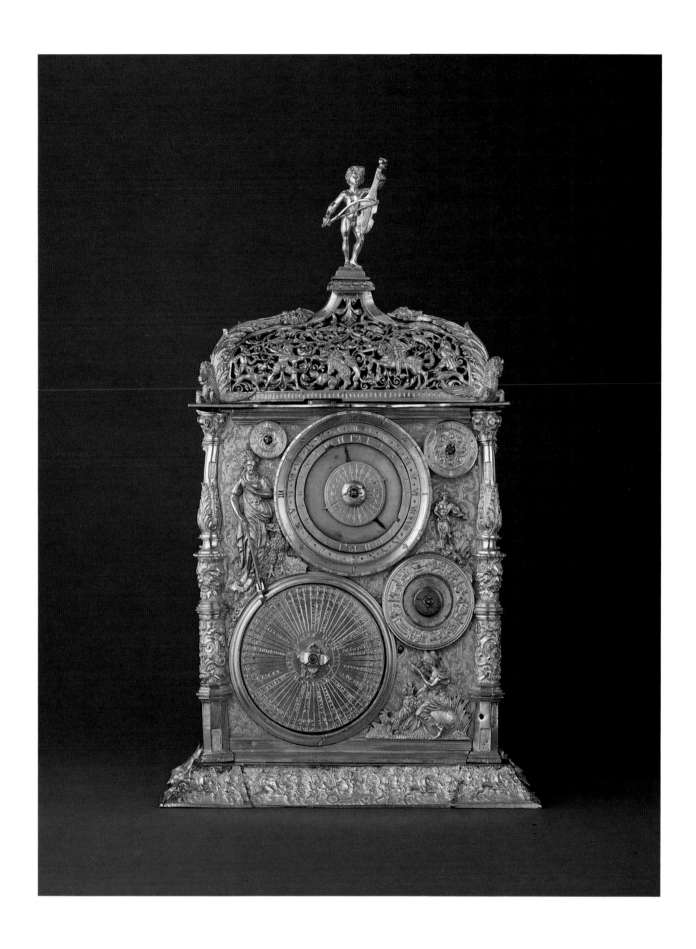

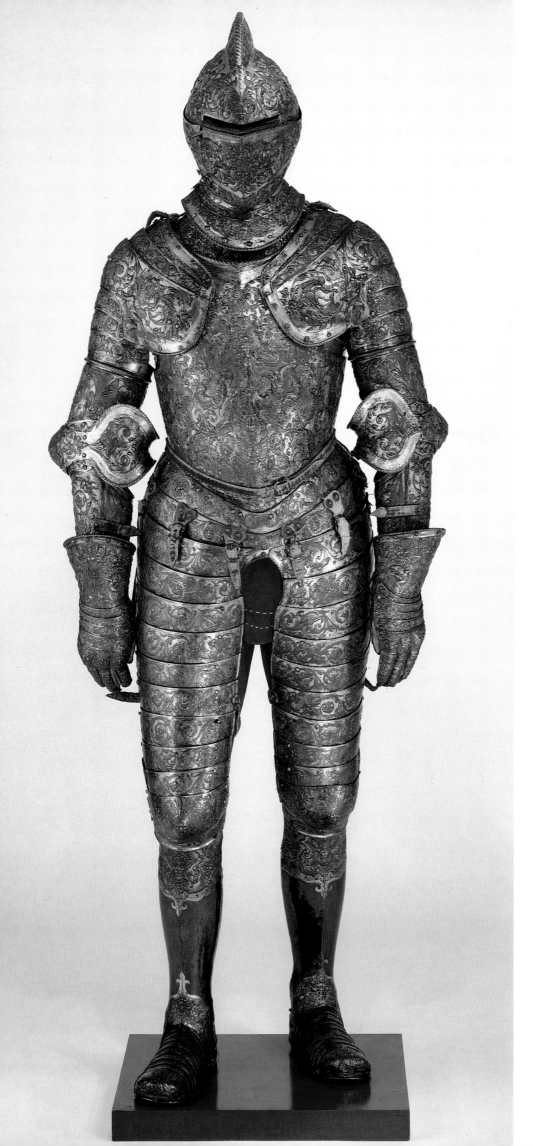

French, ca. 1555

PARADE ARMOR OF HENRY II OF
FRANCE

Steel, embossed, blued, silvered, and gilt,
leather, and velvet; H. 5 ft. 9 in. (175.4 cm)
Harris Brisbane Dick Fund, 1939 (39.121)

This sumptuous parade armor was made
for Henry II (r. 1547–59) and was meant to
be worn on state occasions amid much
pomp and pageantry. Requirements of
defense are completely subordinated here
to purposes of display. The surfaces are
embossed with dense foliate scrolls
inhabited by human figures, symbols of
Triumph and Fame, and a variety of
fabulous creatures that derive from the
Italian grotesque. The ornament is
attributed to the Parisian goldsmith and
printmaker Étienne Delaune (1518/19–1583),
one of the most original designers at the
French court.

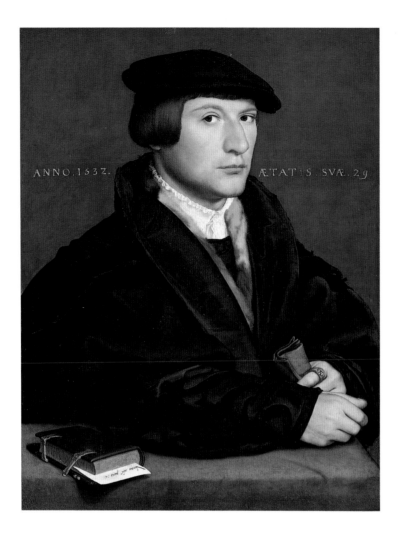

Hans Holbein the Younger

German, 1497/98–1543

PORTRAIT OF A MEMBER OF THE
WEDIGH FAMILY, 1532

Oil on wood; 16⅝ × 12¾ in. (42.2 × 32.4 cm)
Bequest of Edward S. Harkness, 1940
(50.135.4)

Hans Holbein was a true Renaissance man.
Equally at home in Basel and London, he
was a friend of the great humanists of his
day and produced works ranging from
paintings to book illustration to designs for
stained glass. This picture demonstrates
why Holbein is regarded as one of the
world's greatest portraitists. The clarity of
color, the precision of drawing, and the
crisp, explicit characterization constitute a
compelling likeness of an individual person.
The sitter is a member of a Cologne trading
family; presumably he was their
representative in England, where Holbein
found many clients among a wealthy
community of German merchants who
belonged to the Hanseatic League.

Jean Clouet

French, active by 1516, died 1541

GUILLAUME BUDÉ, ca. 1536

Oil on wood; 15⅝ × 13½ in. (39.7 × 34.3 cm)
Maria DeWitt Jesup Fund, 1946 (46.68)

Jean Clouet, who was probably from the
Netherlands, worked at the French court
from 1516 and rose to the position of chief
painter to King Francis I. His portraits were
highly praised by his contemporaries and
were notable for both their delicacy and
their force of characterization. Guillaume
Budé (1467–1540), a famous humanist, was
the founder of the Collège de France, the
first keeper of the royal library (now the
Bibliothèque Nationale), an ambassador,
and chief city magistrate of Paris. This
portrait is mentioned in Budé's manuscript
notes and is Jean Clouet's only documented
work.

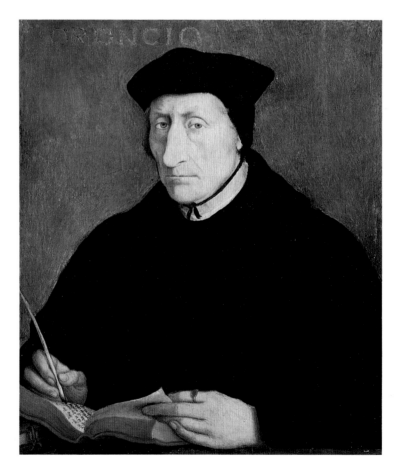

THE SEVENTEENTH CENTURY
IN EUROPE

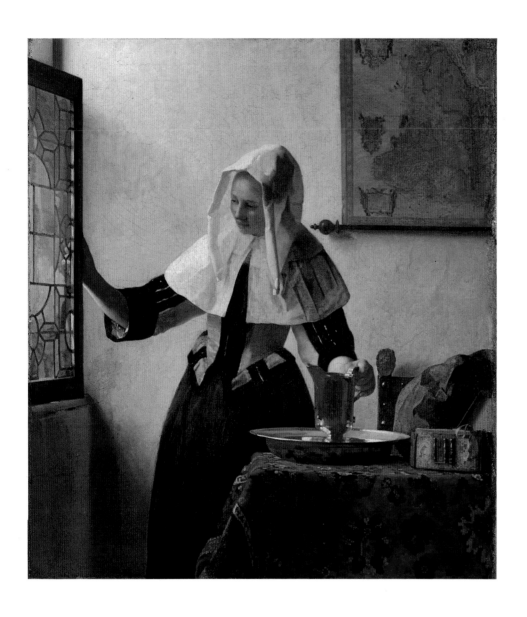

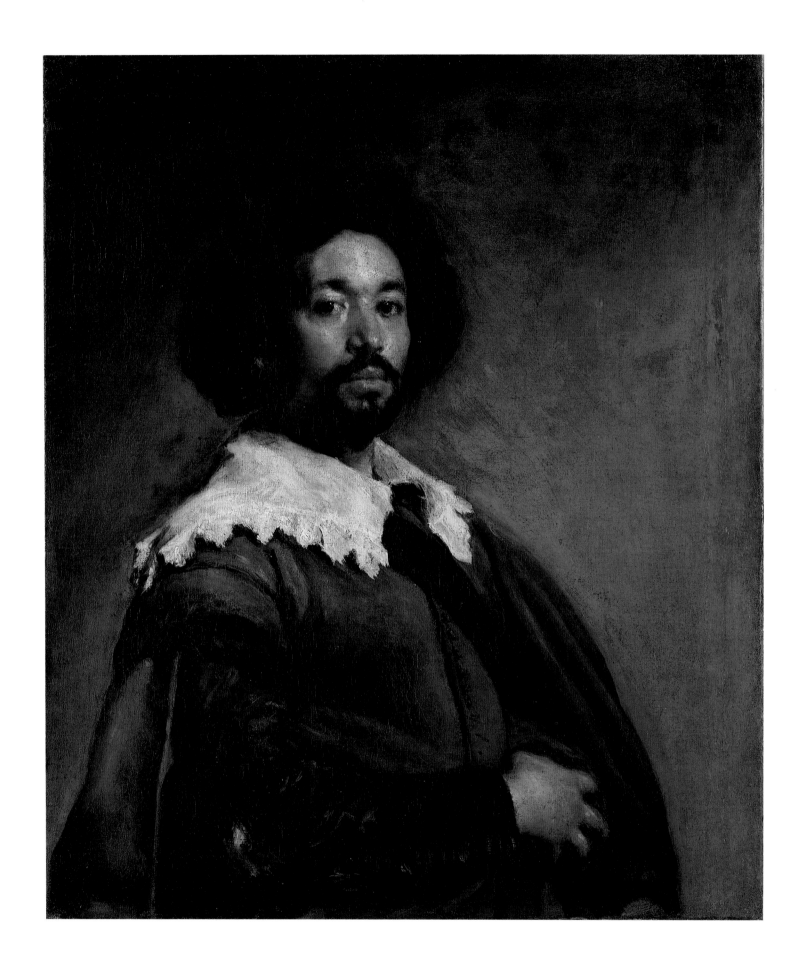

THE SEVENTEENTH CENTURY IN Europe rings with the names of the great sovereigns at whose courts power and wealth were concentrated and the arts flourished. Elizabeth I of England secured for her heirs the Protestant succession and for her country mastery of the seas; Louis XIV of France assembled his defeated vassals at Versailles; Gustavus II Adolphus and Christina of Sweden were for a time the most powerful Protestant monarchs on the Continent; Philip III and Philip IV of Spain ruled a vast empire in the New World and intrigued to maintain Hapsburg power in the Old; and Peter the Great of Russia consolidated the power of the house of Romanov and used it to push his country into the mainstream of European political, intellectual, and artistic life.

Just as the kings and queens of this period are still exemplars of glorious majesty and shrewd statesmanship, so the artists of the century remain the Old Masters of European art. In every medium the clash and complicity of the traditional Classical style and the newer Baroque vision bequeathed us a rich treasure.

As is so often the case, the art-historical designation for this period, the Age of the Baroque, is a misnomer. The Baroque was but one of the stimulating, if at times perplexing, multiplicity of styles that vied for preeminence during the seventeenth and early eighteenth centuries. The term "Baroque" was itself coined only at a later date by unsympathetic critics who wished to condemn an artistic (and literary) style that they judged eccentric and irreconcilable with the precepts of Classicism, the principal rival to Baroque style during the seventeenth century.

Baroque style occurred in as many brands as there were schools of painting in different countries and cities. By its intrinsic nature Classical style tended to be more codified. Although definitions are elusive in seventeenth-century art, it is reasonable to conclude that Baroque artists were captivated by the ceaseless flux of nature and human existence, while classicizing artists sought to express the timeless quintessences of beauty and harmony.

From about 1595 to 1760 Rome was the crossroads of Europe, an academy-without-walls to which artists from every nation came in order to improve and test themselves against the time-honored standards of ancient art as well as the best art of their contemporaries. To an unprecedented degree, wealthy and prominent people in Rome felt that patronage of the fine arts was a prerogative and almost, in fact, an obligation. The Church was the other source of patronage, as new orders and congregations, having been organized in the course of the Counter-Reformation, required suitable places of worship.

At the close of the sixteenth century both Caravaggio and Annibale Carracci undertook to reform Italian painting, and their styles had profound consequences for painting throughout Europe. Annibale proposed to re-create the High Renaissance, and to some extent he succeeded in this. Caravaggio claimed to despise the past and to rely only on nature and his eyes. He was ultimately responsible for the current of naturalism that lies at the heart of the Baroque style and that surfaces in the works of such different artists as Rubens, Ribera, Velázquez, and Rembrandt.

The seventeenth century was the Golden Age of Spanish art. An abundance of first-rank masters developed a Baroque style that accommodated both ardent mysticism and hard realism. The travels of the Flemish master Peter Paul Rubens and the service of his foremost pupil, Anthony van Dyck, in Spain and England are but two instances of the unprecedented internationalism of European art in the seventeenth and eighteenth centuries. Nicolas Poussin and Claude Lorrain, the foremost French painters, resisted entreaties to return home from Italy, and thus a considerable part of seventeenth-

(OVERLEAF)
Johannes Vermeer
Dutch, 1632–1675
YOUNG WOMAN WITH A WATER JUG, early 1660s

———

Oil on canvas; 18 × 16 in. (45.7 × 40.6 cm)
Marquand Collection, Gift of Henry G. Marquand, 1889 (89.15.21)

———

Vermeer's exquisitely balanced compositions and color schemes were ideally suited to his usual theme of domestic tranquility. At least 21 of the approximately 35 known works by Vermeer were purchased as they were painted by a single wealthy patron in Delft, Pieter van Ruijven, whose support partly explains how the artist could have devoted such technical refinement and subtle expression to his art. This canvas was the first of 13 paintings by Vermeer to arrive in America between 1887 and 1919.

(OPPOSITE)
Diego Velázquez
Spanish, 1599–1660
JUAN DE PAREJA, 1648

———

Oil on canvas; 32 × 27½ in. (81.3 × 69.9 cm)
Purchase, Fletcher Fund, Rogers Fund, and Bequest of Miss Adelaide Milton de Groot (1876-1967), by exchange, supplemented by gifts from friends of the Museum, 1971 (1971.86)

———

Exceptional powers of observation and an unprecedentedly vibrant technique make Velázquez the greatest Spanish painter of his century. As court painter to King Philip IV of Spain, Velázquez was sent in 1648 to Rome, then the center of the international art world, where he made two of his greatest portraits, one of Pope Innocent X (Doria Pamphili Gallery, Rome) and this one, of his studio assistant Juan de Pareja, a Sevillan of Moorish descent. When the picture was exhibited publicly at the Pantheon in 1650, one connoisseur remarked that while all the rest was art, this alone was truth.

(LEFT)
Detail from Savonnerie Carpet (see page 159)

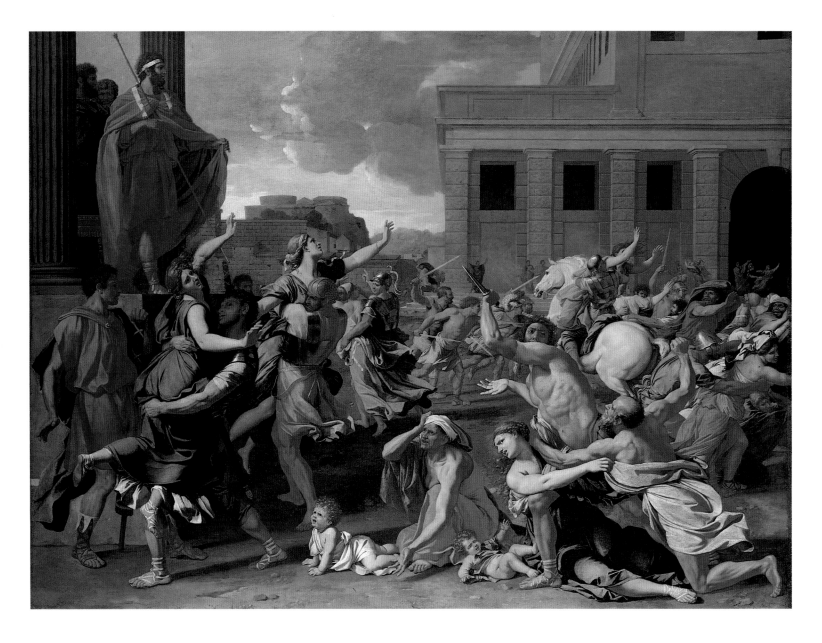

century French painting took place outside of France. In political terms Protestant Holland was odd man out in this century of absolutist monarchy. Dutch art from about 1600 to 1665 was characterized by a formation of Baroque style that had no counterpart in Europe. The differences were based in the circumstance that the United Netherlands was the only country in which patronage stemmed predominantly from the Protestant middle class. The greatest Dutch painter of the century was Rembrandt, in whose paintings and prints the Metropolitan Museum is especially rich. Vermeer was certainly the brightest light of the third quarter of the century; fewer than forty of his paintings are known and five of these are in the Metropolitan.

As befitted an age where splendor bespoke power, kings, courtiers, and burghers all insisted on furnishings appropriate to their station. Workers in stucco, wood, and marble crafted rooms of splendid proportions and exquisite detail. Goldsmiths and porcelain designers produced objects that epitomize luxury. And in France, where the Sun King demanded unparalleled splendor, the weavers at Beauvais, the porcelain factories at Sèvres, and the royal cabinetmakers at Versailles developed the *grand goût*— a style forever associated with France in its "splendid century."

Nicolas Poussin

French, 1594–1665

THE RAPE OF THE SABINE WOMEN

Oil on canvas; 60⅞ × 82⅝ in.
(154.6 × 209.9 cm)
Harris Brisbane Dick Fund, 1946 (46.160)

Although Poussin spent almost the whole of his working life in Rome, he was the greatest as well as the most influential painter of 17th-century France. His authoritative interpretations of ancient history and Greek and Roman mythology left their mark on European art down to the time of David and Ingres. Here he shows Romulus, ruler of the newly founded city of Rome, giving a prearranged signal with his cloak for the Roman soldiers to carry off the Sabine women to become their wives, thereby establishing themselves permanently in their new home. The Sabine men, who had come unarmed to what they thought would be a religious celebration, are put to flight. The subject enabled Poussin to display to the full his unsurpassed archaeological knowledge and his mastery of dramatic interpretation.

Gian Lorenzo Bernini

Italian (Rome), 1598–1680

BACCHANAL: A FAUN TEASED BY CHILDREN, 1616–17

Marble; H. 52 in. (132.1 cm)
Purchase, The Annenberg Fund, Inc. Gift, Fletcher, Rogers and Louis V. Bell Funds, and Gift of J. Pierpont Morgan, by exchange, 1976 (1976.92)

Gian Lorenzo Bernini was the heroic central figure of Italian Baroque sculpture. A prodigy of astonishing facility, he was trained in the workshop of his father, Pietro, an important pre-Baroque sculptor. During his apprenticeship, he executed a number of marble sculptures, which were recorded in his father's name. This, the most ambitious of those works, provides insights into the crucial shift in style that took place during the early 17th century. The subject is a somewhat mysterious one, having its origins in the Bacchic revels of classical and Renaissance iconography. In his portrayal of the faun, Bernini revealed what would become a lifelong interest in the rendering of emotional and spiritual exaltation.

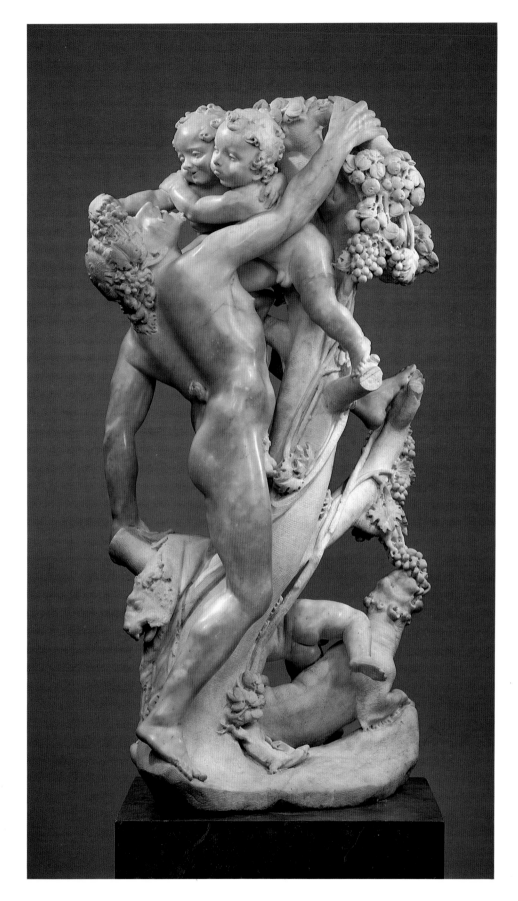

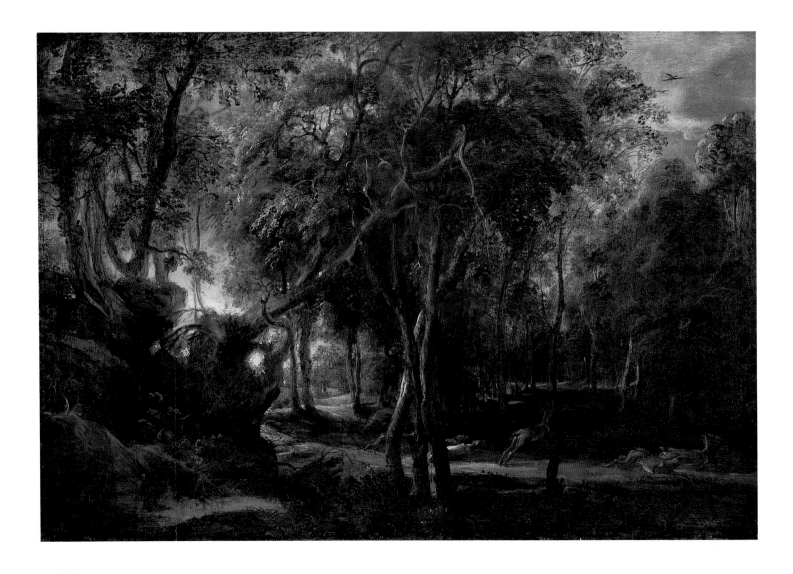

Peter Paul Rubens

Flemish, 1577–1640

A FOREST AT DAWN WITH A DEER
HUNT, ca. 1635

Oil on wood; 24½ × 35½ in.
(62.2 × 90.2 cm)
Purchase, The Annenberg Foundation, Mrs.
Charles Wrightsman, Michel David-Weill,
The Dillon Fund, Henry J. and Drue Heinz
Foundation, Lola Kramarsky, Annette de la
Renta, Mr. and Mrs. Arthur Ochs Sulzberger,
The Vincent Astor Foundation and Peter J.
Sharp Gifts; Bequests of Emma A. Sheafer
and Theodore M. Davis, by exchange; Gift of
George R. Hann, in memory of his mother,
Annie Sykes Hann, by exchange; Gifts of
George A. Hearn, George Blumenthal,
George H. and Helen M. Richard and Mrs.
George A. Stern and Bequests of Helen Hay

Whitney and John Henry Abegg and
Anonymous Bequest, by exchange,
supplemented by gifts and funds from friends
of the Museum, 1990 (1990.196)

This recently acquired painting, once
owned by Sir Joshua Reynolds, is the first
finished landscape painting by Rubens to
enter a collection in the western
hemisphere. Rubens's late landscapes were
often painted for his own pleasure and
reflect his interest in nature, Titian, and
Pieter Bruegel the Elder. Here Rubens treats
the subject as an encounter of elemental
forces—of light and darkness, life and death,
growth and decay—and gives this
essentially realistic scene a sense of myth
and metaphor.

Peter Paul Rubens

Flemish, 1577–1640

RUBENS, HIS WIFE HELENA
FOURMENT, AND THEIR SON PETER
PAUL, ca. 1639

Oil on wood; 80¼ × 62¼ in.
(203.8 × 158.1 cm)
Gift of Mr. and Mrs. Charles Wrightsman, in
honor of Sir John Pope-Hennessy, 1981
(1981.238)

Rubens married his second wife, the
exceptionally beautiful 16-year-old Helena
Fourment, in 1630, when he was 53. This
painting celebrates their marriage, and the
luminosity of the colors and the ebullient
presentation of the figures make this one of
Rubens's most magnificent achievements.
He has related his marriage to the theme of
the Garden of Love; the fountain, the
foliated trellis, and the caryatid are symbols
of fertility. The warm, intimate expression
of the painter and the gentle caress of his
hand attest to his love for Helena.

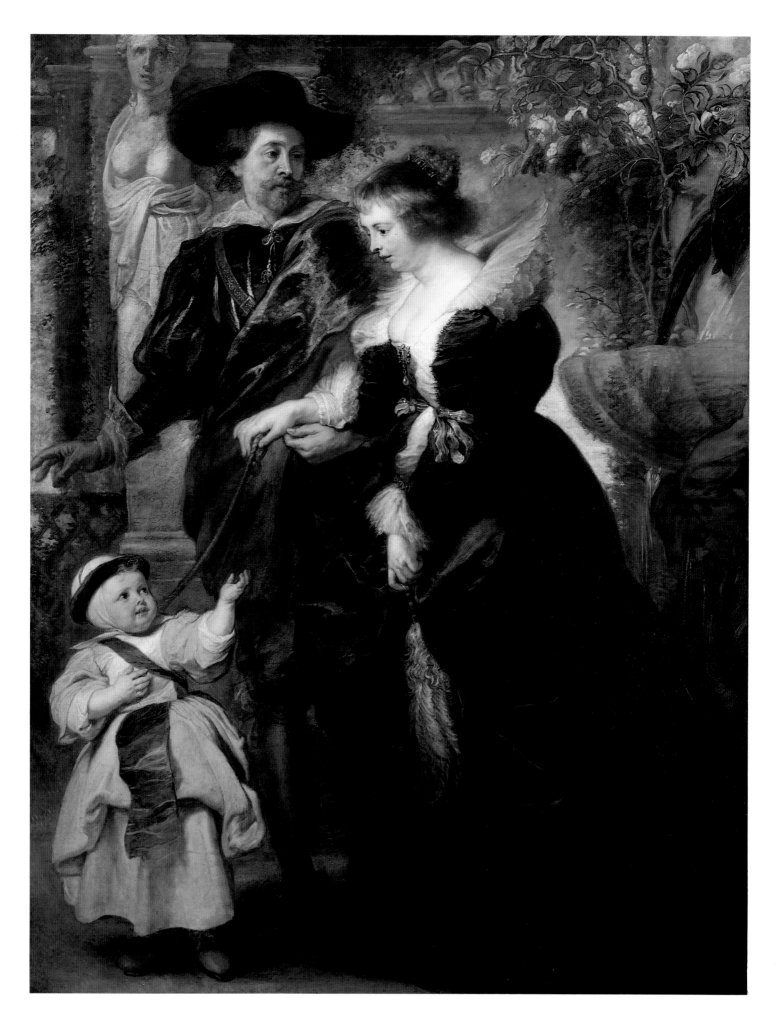

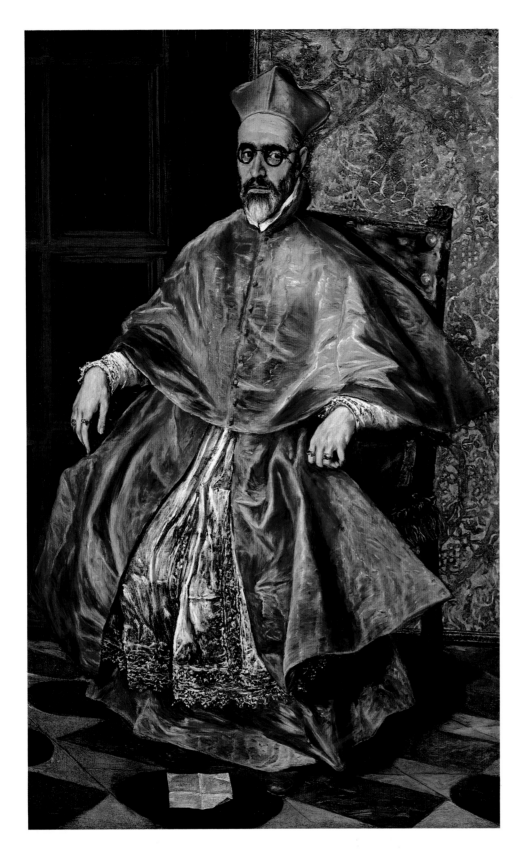

El Greco
Greek (born Crete), 1541–1614
PORTRAIT OF A CARDINAL

Oil on canvas; 67¼ × 42½ in.
(180.8 × 108 cm)
H. O. Havemeyer Collection, Bequest of Mrs.
H. O. Havemeyer, 1929 (29.100.5)

El Greco was born Domenikos
Theotokopoulos in Crete. Following his
training in Venice, possibly in the workshop
of Titian, he settled in Toledo, Spain. This is
one of El Greco's two greatest portraits.
The sitter is usually identified as Cardinal
Don Fernando Niño de Guevera, Grand
Inquisitor and, from 1601, Archbishop of
Seville. El Greco suggests the cardinal's
personality through the emphasis on his
prominent glasses, the compulsive gesture
of his left hand , the animated, nervous
brushwork, and the singular color range.

El Greco
Greek (born Crete), 1541–1614
VIEW OF TOLEDO, ca. 1597

Oil on canvas; 47¾ × 42¾ in.
(121.3 × 108.6 cm)
H. O. Havemeyer Collection, Bequest of Mrs.
H. O. Havemeyer, 1929 (29.100.6)

This painting is El Greco's highly personal
depiction of the city of Toledo, the center of
artistic, intellectual, and religious life in
16th-century Spain. A city of great antiquity,
Toledo is the see of the primate archbishop
of Spain and until 1561 was the capital of the
Spanish empire. In portraying his adopted
home, El Greco has taken considerable
liberty with the topography of the city, so
that the pastoral foreground, with the
Tagus River and Alcantara bridge, serve as a
foil for the haunting vision of the Alcazar
and cathedral tower against an eerily
stormy sky.

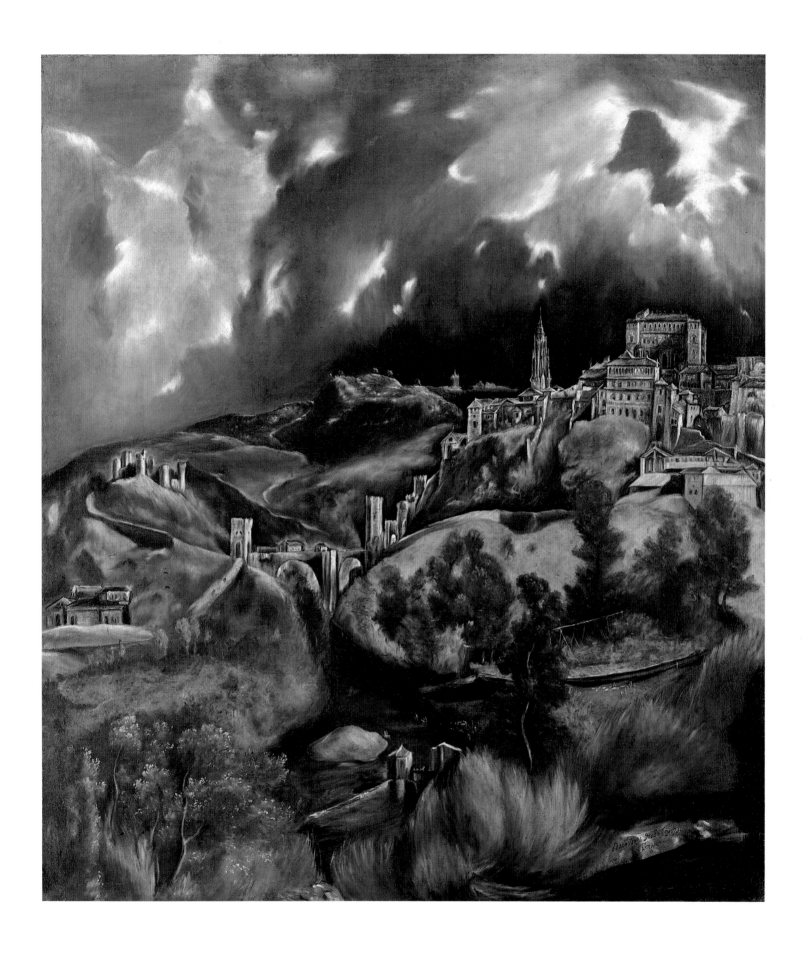

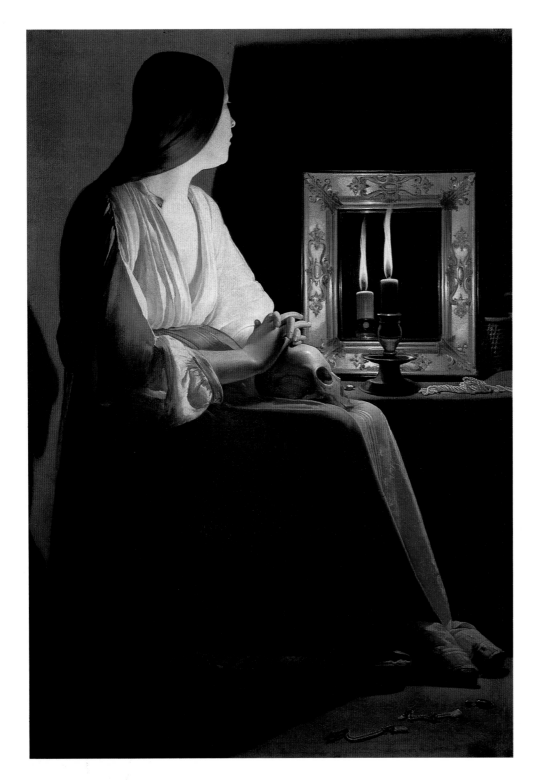

Georges de La Tour

French, 1593–1652

THE PENITENT MAGDALEN, 1638–43

Oil on canvas; 52½ × 40¼ in.
(133.4 × 102.2 cm)
Gift of Mr. and Mrs. Charles Wrightsman,
1978 (1978.517)

An artist of great brilliance and originality, Georges de La Tour was from the duchy of Lorraine in northeastern France. Early in his career he gained knowledge of contemporary Caravaggesque painting, with its emphasis on realism and dramatic effects of light and dark. This picture shows Mary Magdalen in a dark room at the dramatic moment of her conversion, her features lit by a candle flame that imparts a hauntingly spiritual quality to the work. The elaborate silver mirror, the pearls on the table, and the jewels on the floor symbolize luxury, which she has cast aside. In their place she clasps a skull, a common symbol of mortality.

Jacob van R
Dutch,

sought to express as well the majestic and incontestably supreme power of nature. In his paintings of the 1670s, like this one, flat landscape subjects are characteristic, as are the converging lines of earth and sky and the alteration of shadow and sunlight. The tiny figures who populate Ruisdael's canvases—indeed, all human activities—are ultimately dwarfed by the vast canopy of sky and immense, towering clouds. This vision of nature is impressive and powerful yet never loses its wistful, melancholic beauty.

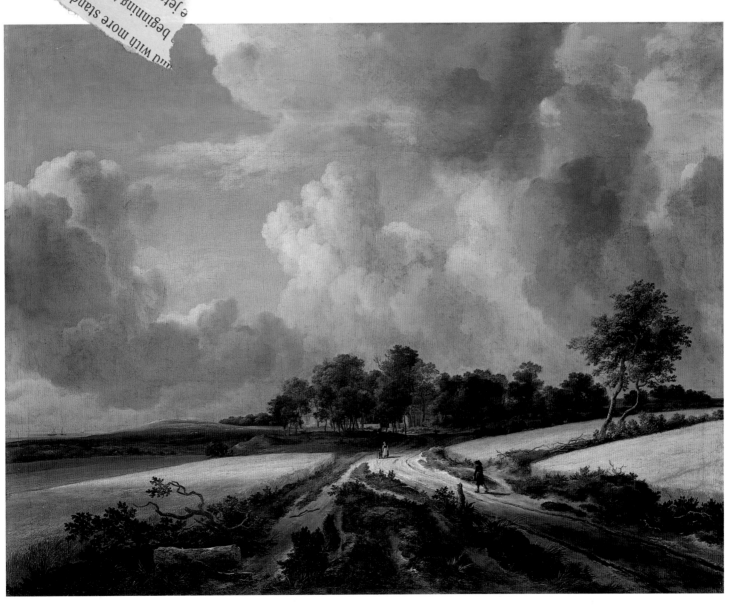

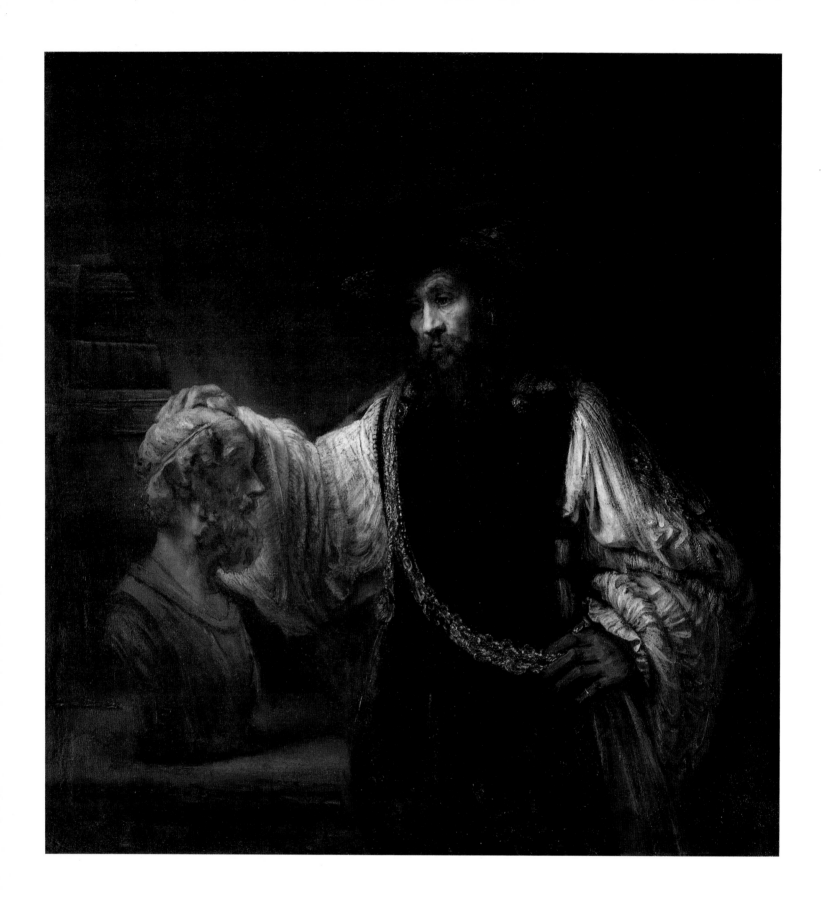

Rembrandt van Rijn

Dutch, 1606–1669

ARISTOTLE WITH A BUST OF
HOMER, 1653

Oil on canvas; 56½ × 53¾ in.
(143.5 × 136.5 cm)
Purchase, special funds and gifts of friends of
the Museum, 1961 (61.198)

This imaginary portrait, one of
Rembrandt's best-known works, was
painted for Don Antonio Ruffo, a wealthy
Sicilian nobleman and Rembrandt's only
foreign patron, who had asked Rembrandt
for a portrait of a philosopher. Rather than
choose a single figure, the enormously
inventive artist found a way to present three
of the great men of antiquity: Aristotle,
Homer, and Alexander the Great. Aristotle,
the great Greek philosopher of the fourth
century B.C., is shown in his library dressed
in the robes of a Renaissance humanist. He
rests his hand on a bust of Homer and wears
a splendid chain bearing a medallion of
Alexander the Great, who had at one time
been Aristotle's pupil. The figure of Homer
was certainly based on one of several
Hellenistic busts owned by Rembrandt; the
figure of Aristotle is reminiscent of
Rembrandt's portraits of the Jews of the
Amsterdam ghetto, whom he had often
used as models in his biblical paintings. The
solemn stillness of Aristotle's study, the
eloquence of his fingers resting on the bust
of the blind poet, and above all the brooding
mystery in his face unite to communicate
an image of deep thought.

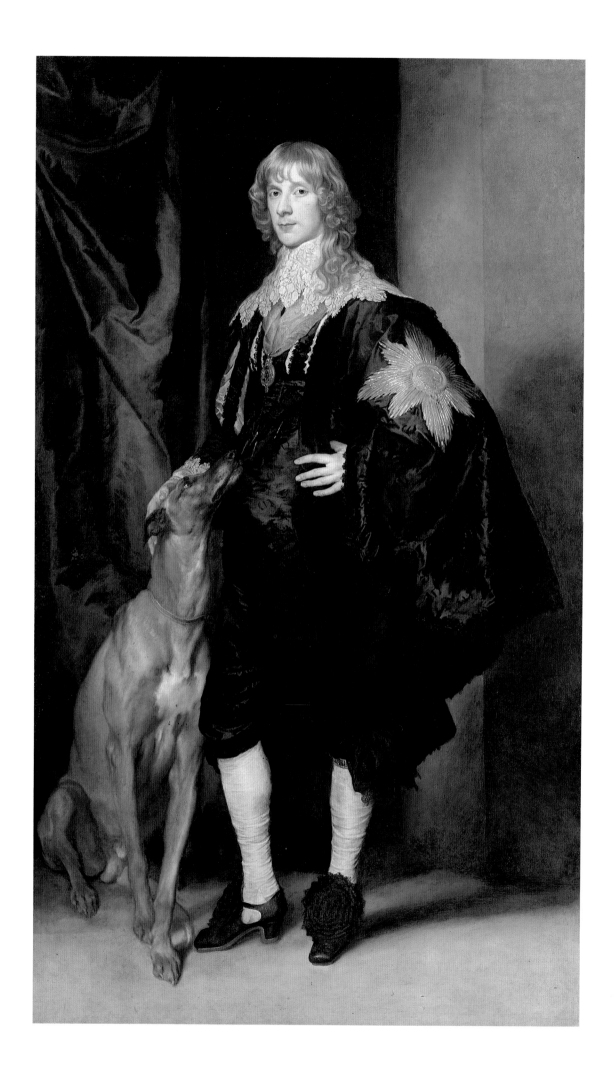

Anthony van Dyck

Flemish, 1599–1641

JAMES STUART, DUKE OF
RICHMOND AND LENNOX

Oil on canvas; 85 × 50¼ in.
(215.9 × 127.6 cm)
Marquand Collection, Gift of Henry G.
Marquand, 1889 (89.15.16)

In 1632 Van Dyck entered the service of King
Charles I of England; he was knighted the
same year. Van Dyck's portraits of Charles I
flatter a royal sitter who was actually not
very imposing. Possibly the same was true
of James Stewart (1612–1655), Charles's
cousin and protégé, depicted here.
Certainly Van Dyck has used all his skills to
give the duke elegance and a commanding
presence. The ratio of his head to his body is
one to seven, instead of one to six, the
average in life. The dog stretching its great
body against its master also emphasizes the
duke's height and aristocratic bearing. The
composition is based loosely on those used
by Titian, whose works Van Dyck had
studied during his long sojourn in Italy.

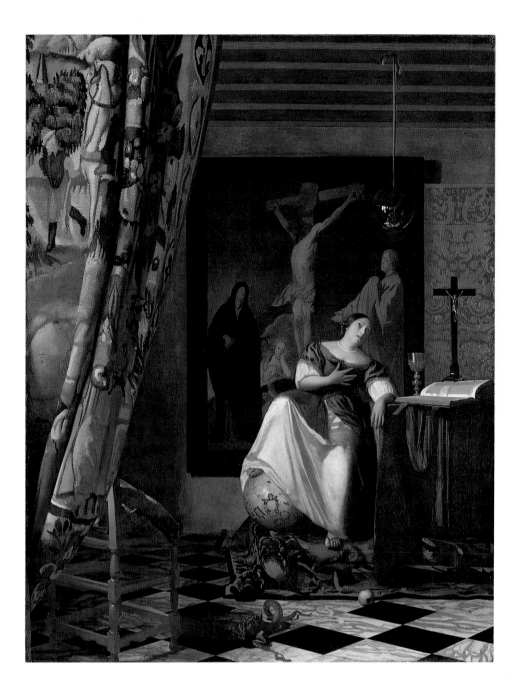

Johannes Vermeer

Dutch, 1632–1675

ALLEGORY OF THE FAITH

Oil on canvas; 45 × 35 in. (114.3 × 88.9 cm)
The Friedsam Collection, Bequest of Michael
Friedsam, 1931 (32.100.18)

An unusually large canvas for Vermeer, this
is one of the two known paintings of his that
have explicitly allegorical content. Vermeer
had converted to Catholicism at the time of
his marriage, and this work may have been
commissioned by a Catholic institution.

Northern allegories of the Catholic
faith were limited to a rather specific
iconography. The woman here is a
personification of Faith; the crushed snake
in the foreground represents the triumph
over sin. The colors worn by Faith, white
and blue, may represent the virtues of
purity and truth. Despite the subject matter,
Vermeer remains concerned with the
depiction of objects, space, and light. The
simplification and hardening of the light in
this painting are characteristic of the artist's
last style.

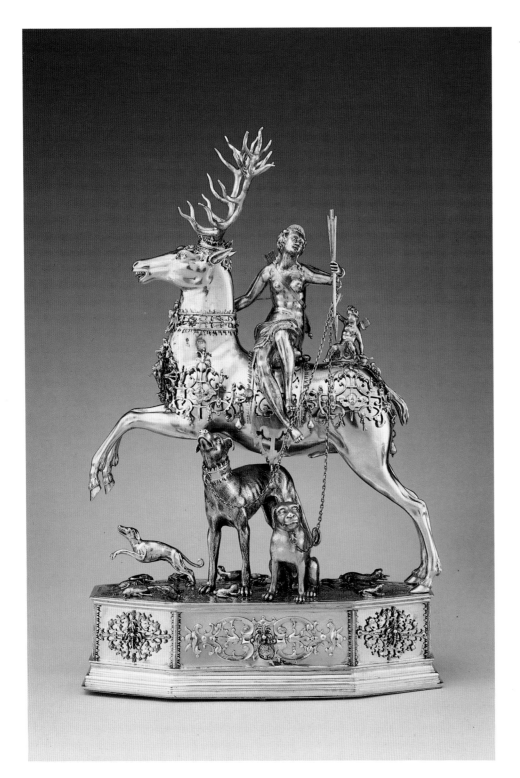

Joachim Friess
German (Augsburg), ca. 1579–1620
AUTOMATON: DIANA AND THE
STAG, ca. 1620
———
Case of silver, partly gilded and enameled,
and set with jewels; H. 14¾ in. (37.5 cm)
Gift of J. Pierpont Morgan, 1917 (17.190.746)
———
Renaissance Augsburg was, after
Nuremberg, the greatest of the German
manufacturing and commercial cities, and a
ready supply of silver enabled its guild of
goldsmiths to fashion great numbers of
richly ornamented vessels for export. This
automaton, in which the goddess Diana,
designed in a Late Mannerist style, is seated
on a hollow-bodied stag with a removable
head, functioned as a drinking vessel. A
mechanism in the base causes the
automaton to roll about on a tabletop in a
pentagonal pattern and then stop; the
person before whom it stopped would have
to drain the contents. Diana's bow and
arrow and the jewels set in the trappings of
the stag are modern replacements.

German (Dresden), 1606
PARADE RAPIER
———
Steel, gilt bronze, various jewels and pearls,
and traces of enamel; L. 48 in. (121.9 cm)
Fletcher Fund, 1970 (1970.77)
———
Israel Schuech (active ca. 1590–1610),
swordcutler to the court of Saxony,
fashioned the magnificent hilt of this rapier
for Christian II, duke of Saxony and elector
of the Holy Roman Empire. Of cast bronze,
richly gilt and formerly enameled, the
slender branches of the guard are covered
with intricate strapwork and tiny allegorical
figures and sparkle with jewels and pearls.
Such lavishly decorated sword hilts were
appreciated as masculine jewelry and
adjuncts to the prince's costume, reflecting
his taste, social status, and wealth. Although
probably never intended for use in self-
defense, the sword is mounted with a blade
by Juan Martinez (active late 16th century),
the most renowned of the celebrated
swordsmiths of Toledo.

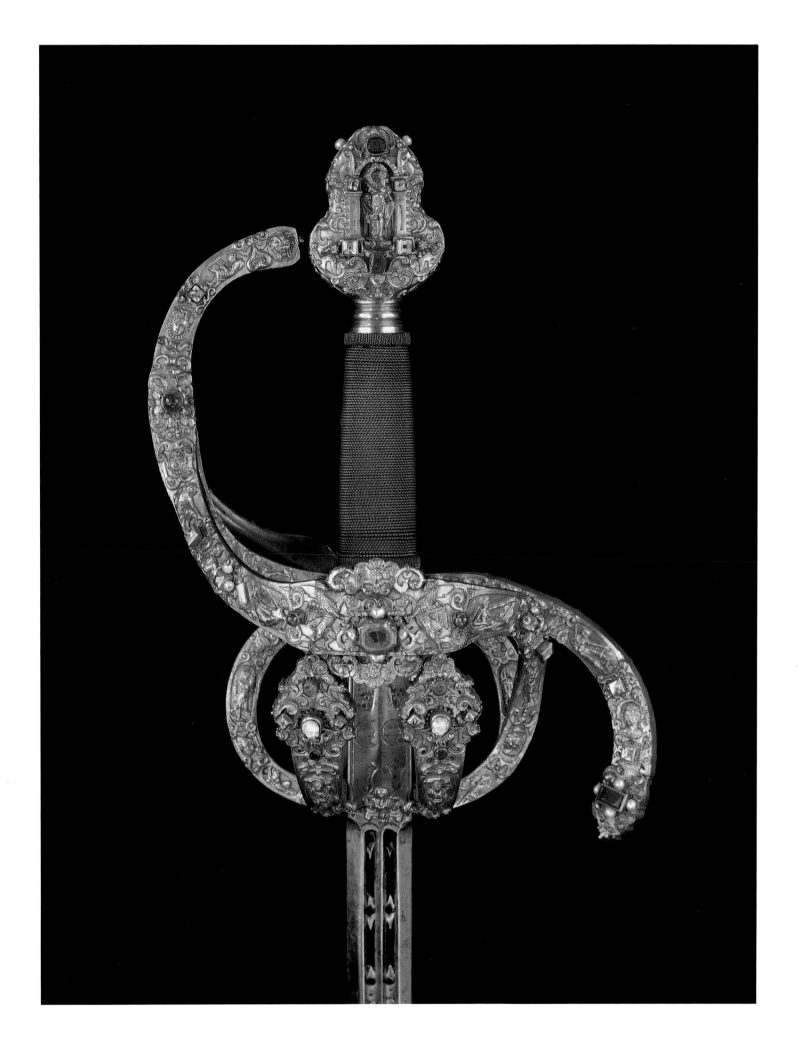

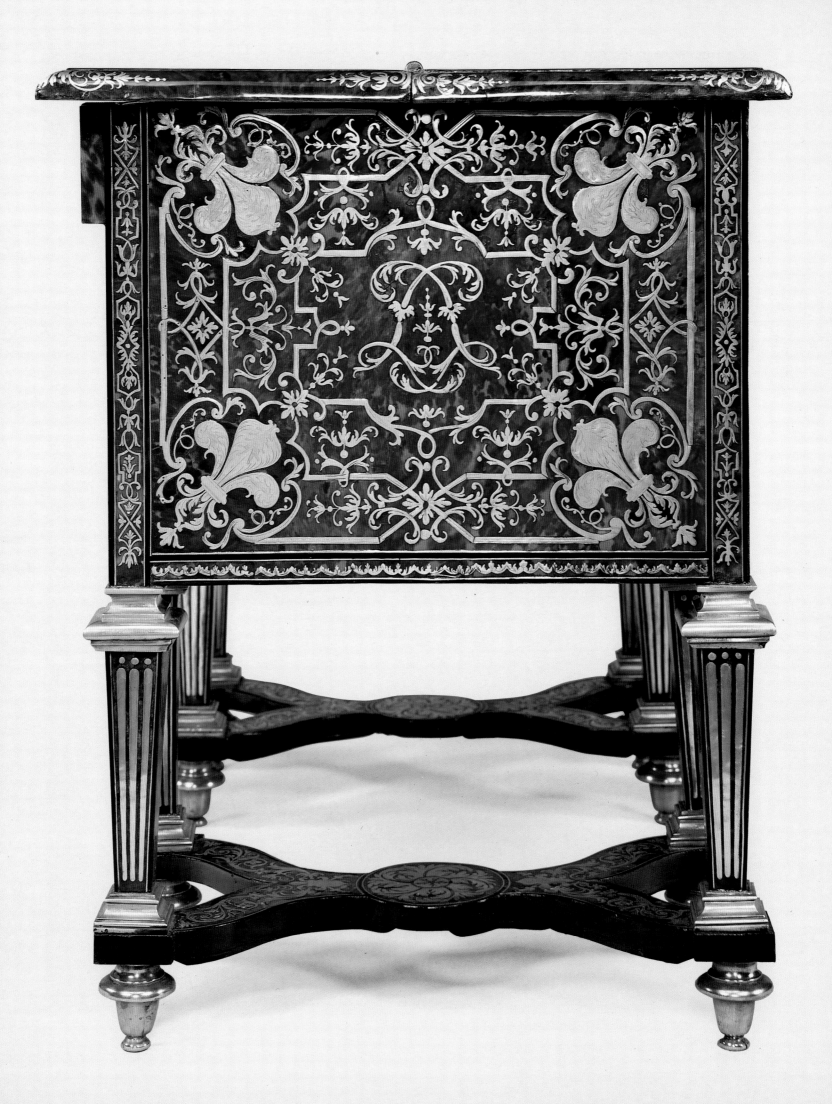

Alexandre-Jean Oppenordt
(cabinetmaker)
French, 1639–1715
SMALL DESK, 1685

Oak, pine, walnut veneered with red
tortoiseshell, engraved brass, ebony, and
Brazilian rosewood; gilt-bronze mounts;
H. 30¼ in. (76.8 cm)
Gift of Mrs. Charles Wrightsman, 1986
(1986.365.3)

This is one of a pair of desks made in 1685 for
Louis XIV's study at Versailles. Oppenordt,
the cabinetmaker, had been given a royal
appointment the previous year with the title
Ébéniste Ordinaire du Roi. Jean Berain,
Dessinateur du la Chambre du Roi, designed
and possibly engraved the elaborate brass
inlay, which depicts many of the symbols of
the Sun King. The desk belongs to a type of
furniture called *bureau brisés* (literally,
"broken desks"); the front half of the top
folds back to reveal a writing compartment
veneered with Brazilian rosewood and
fitted at the back with four drawers.

British (Norfolk), ca. 1695
FORMAL DRESS

Gray-brown striped wool embroidered with
silver-gilt wrapped thread
Rogers Fund, 1933 (33.54 ab)

This is the earliest complete European
costume in the Museum's renowned
Costume Institute, and it is considered the
finest example of its kind extant. The style
of the two-piece dress is known as a mantua,
or open robe, and petticoat, a fashion
followed with minor variations through the
end of the 18th century. The mantua is
drawn away from the front and draped at
the back to reveal the richly decorated
petticoat ornamented in an embroidery
pattern of French derivation in satin and
stem stitches. The thread of silver gilt
wound on a yellow silk core is worked
perfectly on both sides along the border of
the robe and train so that when the skirt is
draped, the beauty of the embroidery is
uninterrupted as it cascades into folds.

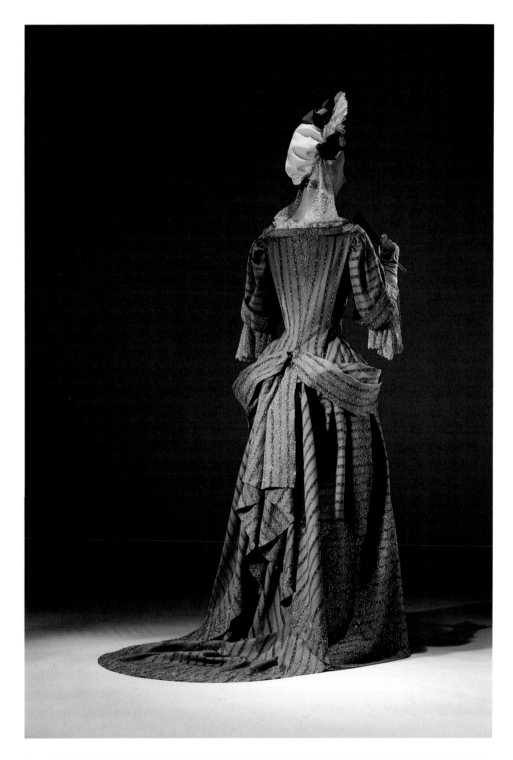

French, Paris, Savonnerie Manufactory, 1680
CARPET

Knotted and cut wool pile; 29 ft. 9¾ in. ×
10 ft. 4 in. (9.09 × 3.15 m)
Gift of Mr. and Mrs. Charles Wrightsman,
1976 (1976.155.114)

This carpet is one of a series of 92 made for
the *grande galerie* of the Louvre after designs
by Charles Lebrun (1619–1690), *premier
peintre* of Louis XIV. In 1663 he was
appointed to supervise the Savonnerie
manufactory, a carpet-weaving works near
Paris. He started the designs for the Louvre
in 1665, and the first carpets were put on the
looms in 1668. These carpets, among the
most extraordinary ever made in Europe,
have about 90 Ghiordes knots per square
inch. The carpet illustrated here, one of the
finest of the more than 50 known to have
survived from the series, was delivered in
1680. The carpets were designed to
harmonize with and echo the architecture
and decoration of the gallery. The field of
each carpet is divided into three sections: a
large central compartment and a smaller
medallion or cartouche at each end, which
framed either a landscape, as in this
example, or an imitation bas relief. Stately
acanthus scrolls, naturalistic flowers
gathered in garlands or bouquets, and
decorative motifs drawn from antiquity fill
the interstitial spaces. Emblems of royalty
are prominent on every carpet. Here three
fleurs-de-lis of France are shown
surmounted by a royal crown; in the center
are arms and trophies testifying to the
military power of the king.

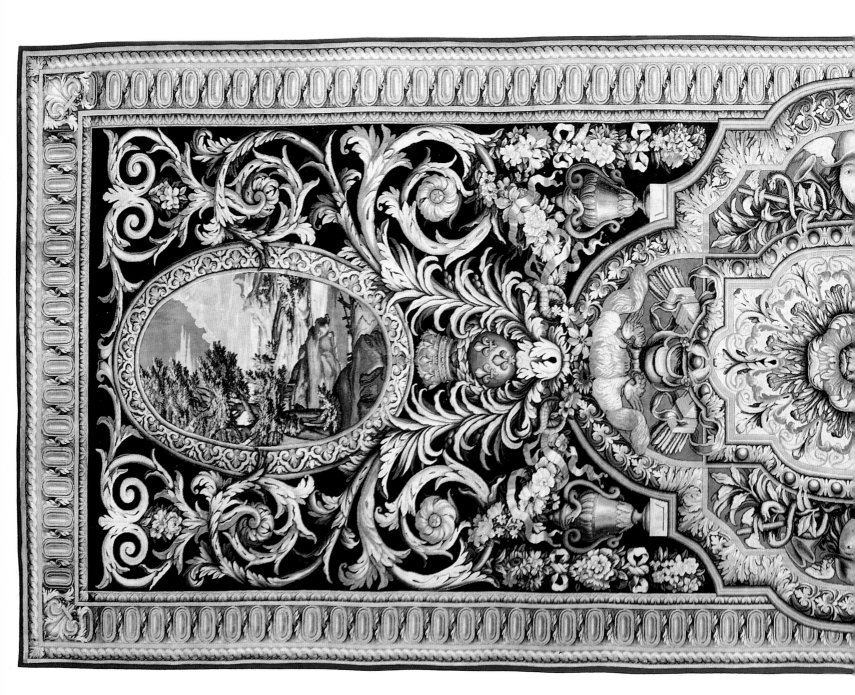

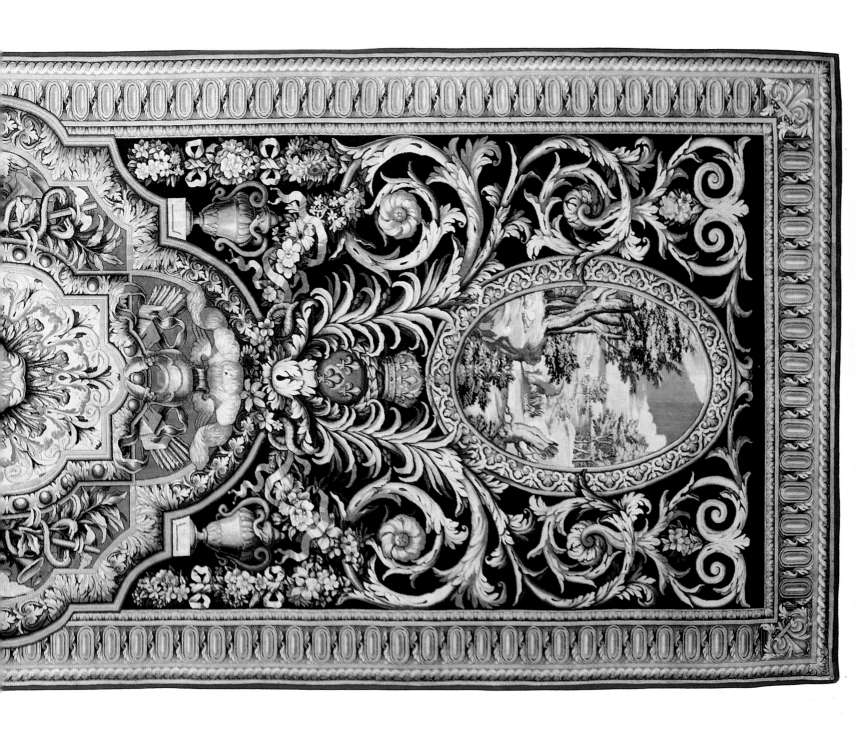

ASIA

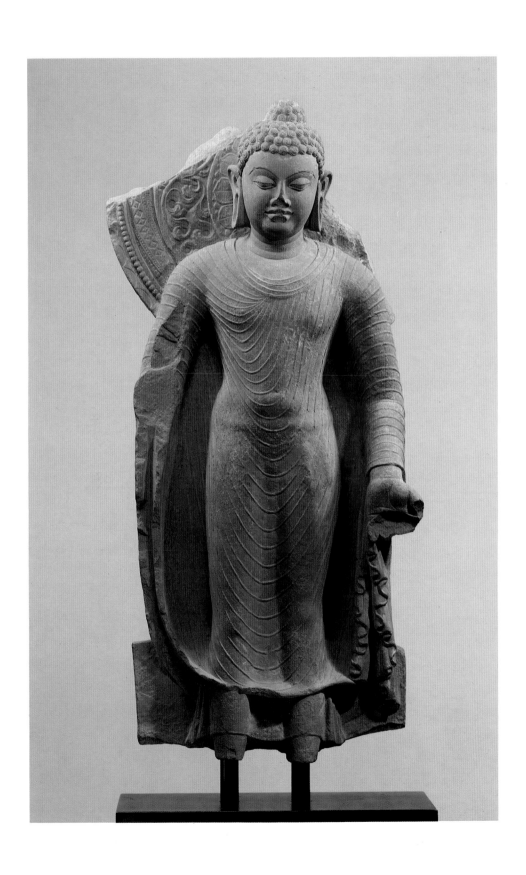

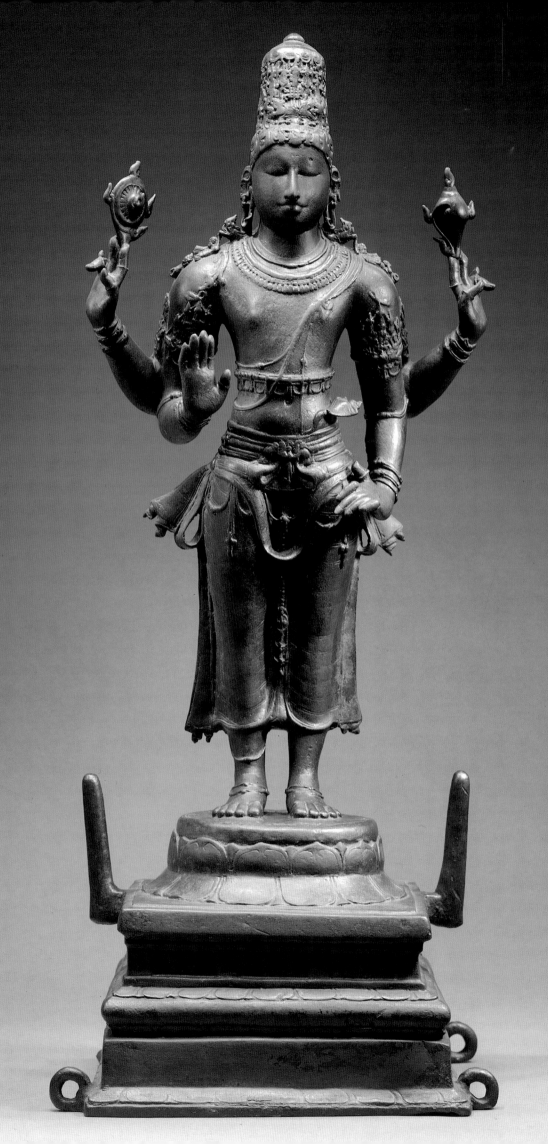

India and Southeast Asia

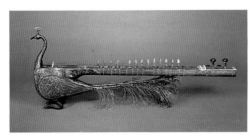

THROUGHOUT THE CENTURIES, the three great Asian civilizations—those of India, China, and Japan—have each nurtured a distinctive artistic tradition. Each has been influenced by foreign invasions, cultural or military, and each has been changed by these experiences while continuing to evolve in ways unique to itself. But throughout the social and political changes, a tradition of esteem for art and artists has been maintained in Asia and has resulted in the preservation and study of ancient art and the production of a vast library of scholarship that records the lives of artists, theories of art, and relationships between artists and patrons.

Cultural associations and influences have passed back and forth across Asia. From the fourth until the tenth century A.D., Buddhism united the area in a manner never repeated thereafter. Indeed, long after Buddhism became a dead religion in India, its birthplace, it remained a vital power in the rest of Asia. From the fourteenth century on, Islam remade the arts of India in fundamental ways, just as it had already changed Indian society. Confucianism spread from China to Japan, while Shinto remained alive only in its native Japan. With all their disparities, however, the civilizations of Asia have consistently been more closely related to each other than to the cultures of other regions. Asian religions share a veneration of mysticism and meditative philosophy and of the natural world that distinguishes Asia from any other large region of the world.

In ancient India the most esteemed art form was sculpture. Princely patrons of Buddhism and Hinduism, the dominant Indian religions until the spread of Islam, sponsored the construction of magnificent temples, which required monumental sculpture and painting as well as miniature bronze altars. Following the spread of Buddhism, places of worship were built throughout China, Japan, and Southeast Asia.

In India, as in other parts of Asia, Buddhism joined more ancient traditions of indigenous cultures. Thus, the stunning artifacts of the Indus Valley civilization of the third and second millennia B.C. incorporate some of the artistic elements found in the beginnings of Buddhist art two thousand years later. The Gupta period of India, which ran from the beginning of the fourth to the beginning of the sixth century A.D., was the classical age of Indian sculpture and painting, during which Indian traditions achieved a beautifully expressive ideal form.

Among the nations of Southeast Asia, Cambodia is especially well represented in the Metropolitan Museum. Generally speaking, Cambodian art places greater emphasis upon the abstract than does its Indian prototype, suggesting an esoteric, mystical system of thought and belief that differed from religious systems elsewhere.

(OVERLEAF)

Indian (Mathura), ca. 5th century
STANDING BUDDHA

Mottled red sandstone; H. 33⅝ in. (85.4 cm)
Purchase, Enid A. Haupt Gift, 1979 (1979.6)

This well-modeled and elegantly proportioned Buddha exemplifies the style developed in the holy city of Mathura during the Gupta period. The serene face is full, with rounded cheeks, fleshy lips, almond-shaped eyes, and high, gracefully arched eyebrows. The clinging garment, with a linear pattern of stringlike folds, reveals the body underneath. The right hand, now missing, was originally raised in the fear-allaying gesture *abhaya mudra*, and the lowered left hand holds a portion of the garment. The immutable composure and calm magnificence, characteristic of the finest early South Asian sculpture, are presented to the worshiper as the ultimate fulfillment.

(OPPOSITE)

Indian (Tamil Nadu, Tanjore region),
third quarter of 10th century
STANDING VISHNU

Bronze; H. 33¾ in. (85.7 cm)
Purchase, John D. Rockefeller 3d Gift, 1962
(62.265)

The monumental style and superb casting of this image of Vishnu exemplify the high achievement of early Chola art. Vishnu the Preserver is most commonly portrayed, as here, holding militant attributes befitting his protective role. In his upper right hand, he is holding a *chakra*, a flaming disk that was a martial implement; his upper left hand displays a conch shell, used as a trumpet in battle.

(LEFT)

Indian, 19th century
MAYURI

Wood, feathers, various other materials;
L. 44⅛ in. (112.1 cm)
The Crosby Brown Collection of Musical Instruments, 1889 (89.4.163)

A type of bowed sitar, the *mayuri* is one of many Indian musical instruments incorporating animal forms. *Mayuri* means "peacock" in Sanskrit.

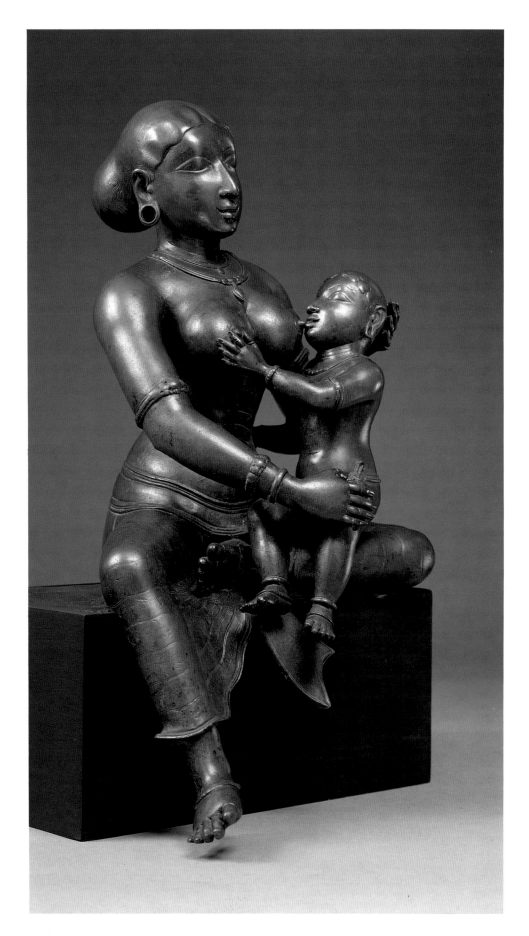

Indian (Karnataka), ca. 14th century
YASHODA AND KRISHNA

Copper; H. 13⅛ in. (33.3 cm)
Purchase, Lita Annenberg Hazen Charitable
Trust Gift, in honor of Cynthia Hazen and
Leon Bernard Polsky, 1982 (1982.220.8)

Krishna, the hero of many well-loved stories
and whose legends are related in the
Bhagavata Purana, the great Hindu epic, was
threatened as an infant by the wicked tyrant
Kamsa. His parents, in order to protect the
young god, hid him with a cowherd and his
wife, Yashoda. Depictions of Yashoda
holding her foster son are rare, especially in
sculptural form. Here she nurses the infant
god, cradling his head with one hand and
gathering him close with the other. This
statue is assuredly one of the most intimate
and tender portrayals in the history of
Indian art.

Pakistani (Gandhara region),
ca. 2nd–early 3rd century
STANDING BODHISATTVA
MAITREYA

Gray schist; H. 64¼ in. (163.2 cm)
Purchase, Lita Annenberg Hazen Charitable
Trust, 1991 (1991.75)

This large, magnificent sculpture represents
the most popular image in Gandharan art—
the bodhisattva—with the exception of
representations of the Buddha. The
bodhisattva is a being who has accumulated
sufficient merit and wisdom to attain
nirvana and escape the cycle of death and
rebirth, but chooses to remain on earth to
help others achieve salvation. Represented
in this important image is the bodhisattva
Maitreya, the messianic deity who will
become the Buddha for the next great world
age. Maitreya is identifiable by a fragment of
the sacred-water flask held in his left hand
and by his characteristic double-loop
topknot, reminiscent of the Hellenistic
krobilos worn by the *Apollo Belvedere.*
Gandharan art, created during the reign of
the Kushans, a nomadic people of Scythian
origin who became Buddhist converts,
couples Buddhist iconography and a
sculptural style markedly dependent on
Hellenistic and Roman prototypes, a
classical legacy in part of Alexander the
Great.

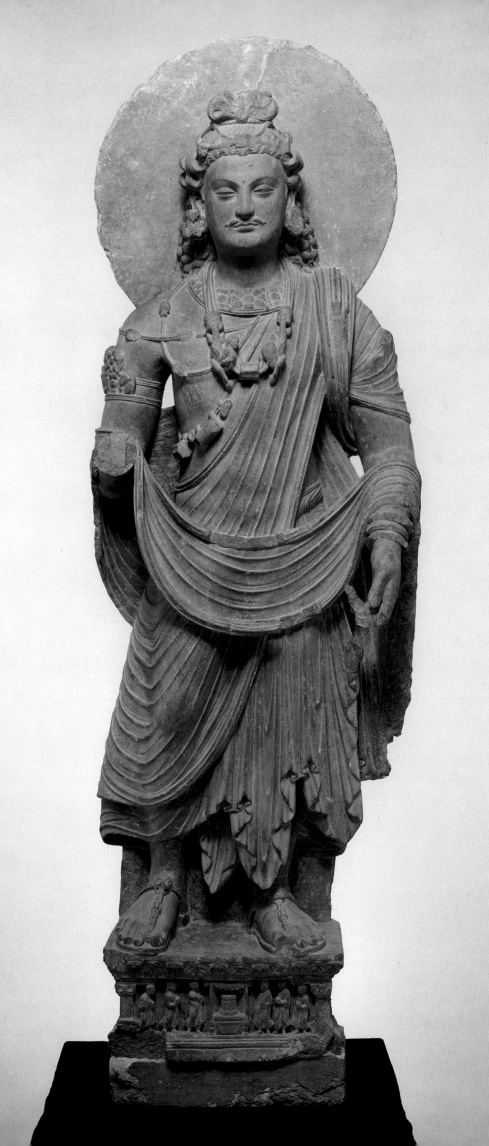

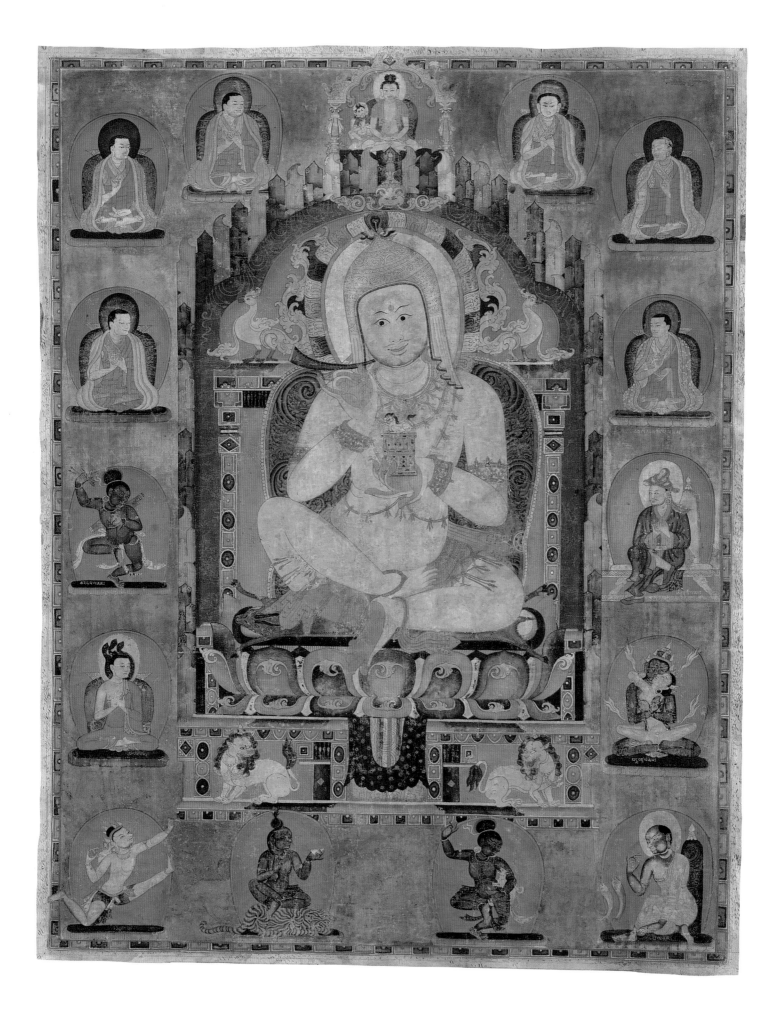

Tibetan, ca. 1300

PORTRAIT OF GREAT TEACHER
SURROUNDED BY LAMAS AND
MAHASIDDHAS

Opaque watercolor and gold on cloth;
27 × 21½ in. (68.6 × 54.6 cm)
Purchase, Friends of Asian Art Gifts, 1987
(1987.144)

The rarity, beauty, and unique iconography
of this painting make it an important
addition to the small corpus of extant early
Tibetan *thankas*, as well as one of the finest
early Tibetan works of art in the
Metropolitan's collection. The identity of
the central personage is problematic. He is
portrayed as an adept of Tantric (Esoteric)
Buddhism, balancing a magic horn with the
fingers of his raised right hand and holding
in the palm of his left hand a casket
surmounted by a snow lion, the vehicle of
the bodhisattva of divine knowledge. The
figure is seated on an elaborate throne
placed within a frame representing
mountains, and he is naked except for a
loincloth, a yellow helmet, and elaborate
jewelry—decorated with crossed
thunderbolts and small standing figures.
The inscriptions of most of the other
personages in the *thanka* allow them to be
identified as lamas of a Tibetan monastery,
or 8 of the 84 Mahasiddhas (perfected ones),
the spiritual fathers of Tantrayana
Buddhism.

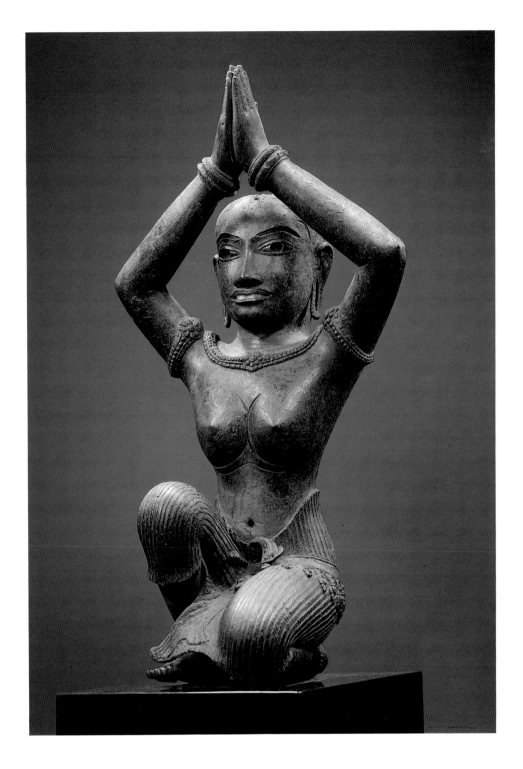

Cambodian, mid-11th century
KNEELING FEMALE DEITY

Bronze with traces of gold, inlaid with silver;
H. 17 in. (43.2 cm)
Purchase, Bequest of Joseph H. Durkee, by
exchange, 1972 (1972.147)

This sculpture of a goddess or noblewoman
ranks as one of the most important and
beautiful Khmer bronzes outside
Cambodia. Kneeling with her left leg
beneath her and her right knee raised, the
goddess lifts her hands above her head in a
gesture of adoration. She wears a pleated
sarong secured by a sash with jeweled
pendants. The left hem of the sarong is
folded over to create a frontal panel of cloth
resting between the legs and terminating in
a "fishtail" silhouette reminiscent of earlier
Khmer styles. She is wearing jeweled
armlets, bracelets, anklets, and a necklace;
her hair is arranged in vertical bands of a
quatrefoil pattern alternating with a bead
motif.

This regal beauty is superbly modeled of
soft generalized forms, with a surface made
taut as if by an inner expanding energy.
Strong but harmonious visual rhythms and
contrasts of form are established by the
sharp, diamond-shaped silhouettes of the
raised arms and the graceful arrangement
of the masses of the lower part of the body.

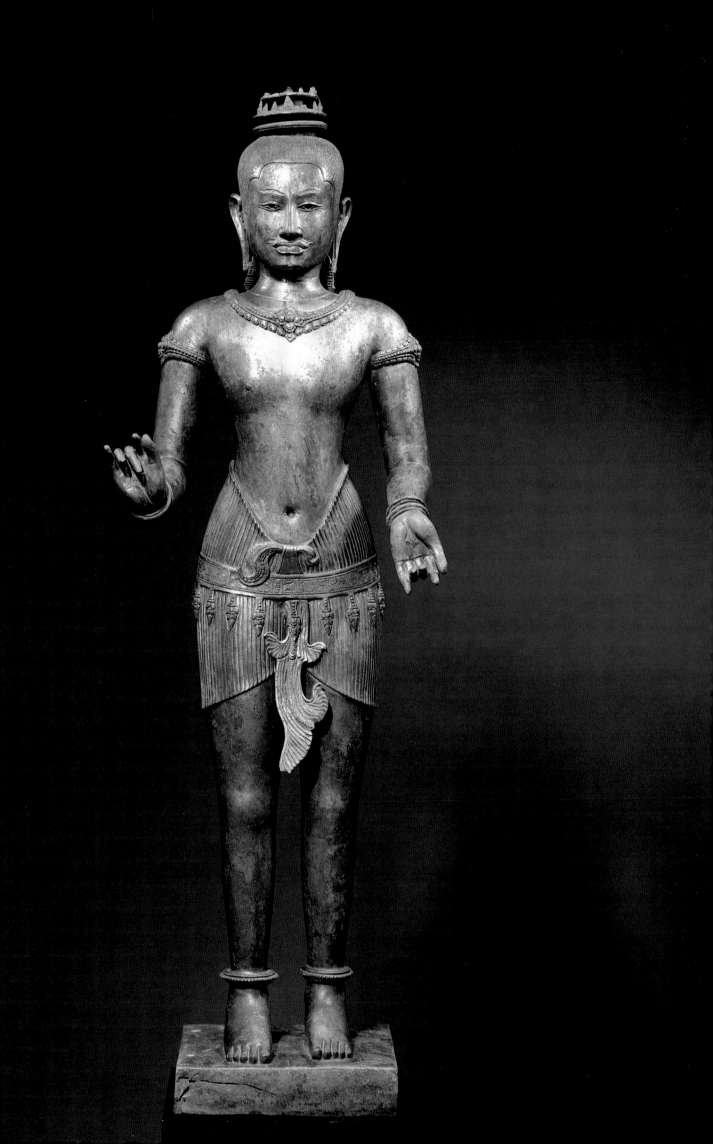

Cambodian, second half of 11th century
DEIFIED KING

———

Gilded bronze with silver inlays;
H. 41½ in. (105.4 cm)
Partial Gift of The Honorable and Mrs.
Walter H. Annenberg, 1988 (1988.355)

———

This large sculpture of a deified king sums
up the essence and spirit of royal classical
Cambodian sculpture, indeed of a whole
great civilization. The figure is of such
superb quality and possesses such magnetic
grandeur that it must be considered one of
the most important examples of the arts of
Asia in the Museum's collection. The
sculpture is in the Baphuon style (about
1010–1110), a name taken from a Cambodian
step-pyramid temple constructed at Angkor
in about 1050–66. The condition of the
image, the largest complete Cambodian
bronze sculpture known, is unparalleled.
The fingers, the bow in back, the pendant
sash-ends in front, and much of the original
gilding are intact. Only the top of the
crown, the outer perimeter of the ear
pendants—originally probably of some
semiprecious material—and the inlays of
the eyebrows, mustache, beard, and pupils,
have not survived.

(RIGHT)

Nepalese, 9th–10th century
STANDING MAITREYA

———

Gilded copper with polychrome;
H. 26 in. (66 cm)
Rogers Fund, 1982 (1982.220.12)

———

This representation of Maitreya, the
messianic bodhisattva, is an extraordinarily
radiant, elegant, and sensuous sculpture.
Not only is this one of the largest early
Nepalese bronzes in the West, but it is also
the only example of such refined elegance
combined with an almost austere economy
of surface decoration. A master sculptor
with a highly developed aesthetic sensibility
produced an image combining a deep
spiritual presence with a beautifully
arranged system of volumes. The
bodhisattva stands in a pronounced
tribhanga (thrice-bent) posture, but the
sensual exaggeration of his pose is most
unusual for Nepalese art of this early period.
In his lowered left hand Maitreya holds a
vessel; in his raised right hand he may
originally have held a rosary. He wears the
sacred thread across his chest and is adorned
with the usual jewelry of the period.

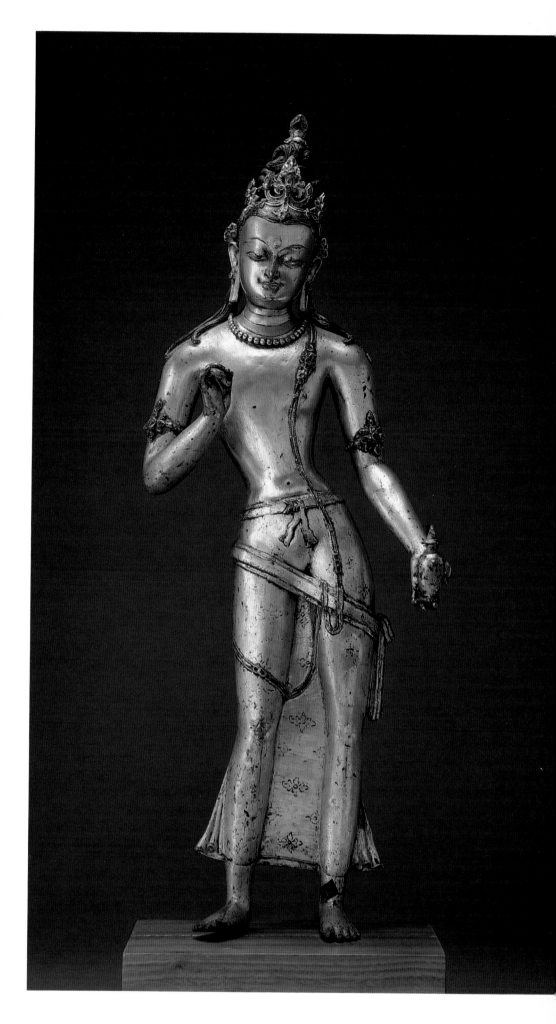

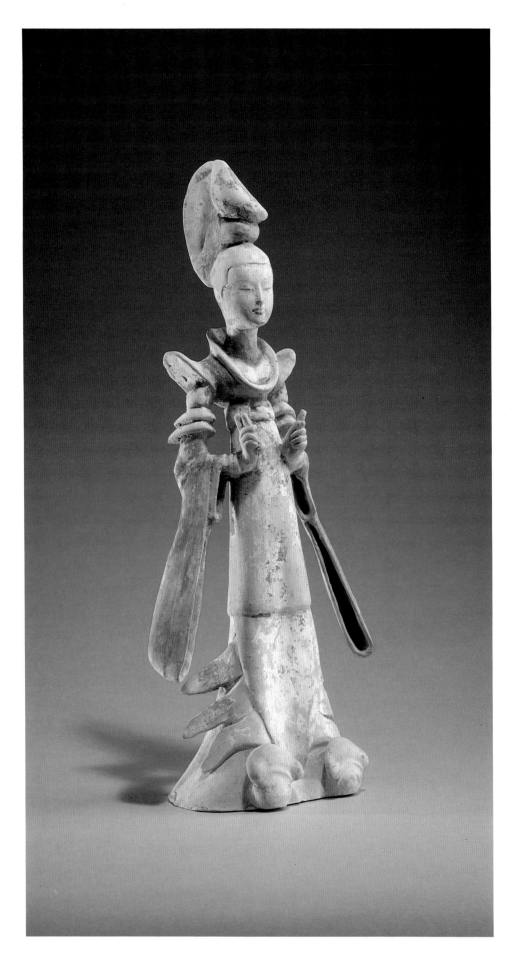

Chinese, T'ang dynasty, mid-7th century
STANDING COURT LADY

Pottery with painted decoration; H. 15⅛ in.
(38.4 cm)
Anonymous Gift, in memory of Louise G.
Dillingham, 1978 (1978.345)

The T'ang dynasty (618–906) witnessed the
beginning of the aesthetic appreciation of
ceramics as an art form. Although we have
no way of knowing whether these potters
regarded themselves as creative artists, it is
obvious to us today that many of their
creations, such as this elegant figure, are
works of art. This piece, made of pottery
with painted decoration, reflects the
aesthetic bias of the age and shows the
period's change in women's dress, makeup,
and hairstyles. In fact, the figure imparts a
distinct impression of haute couture.

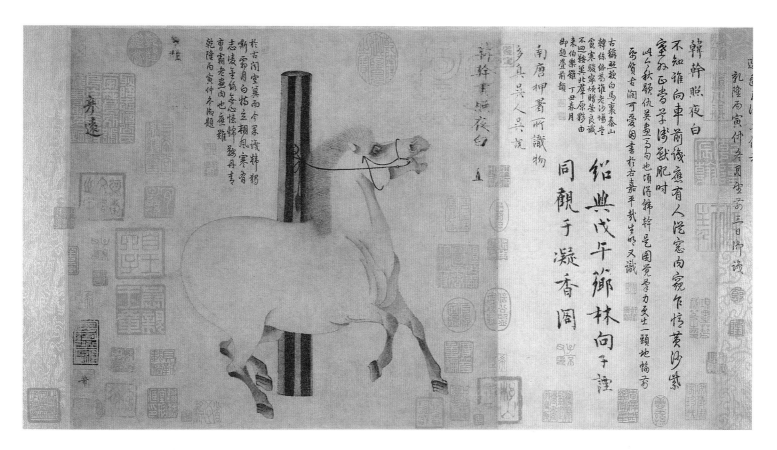

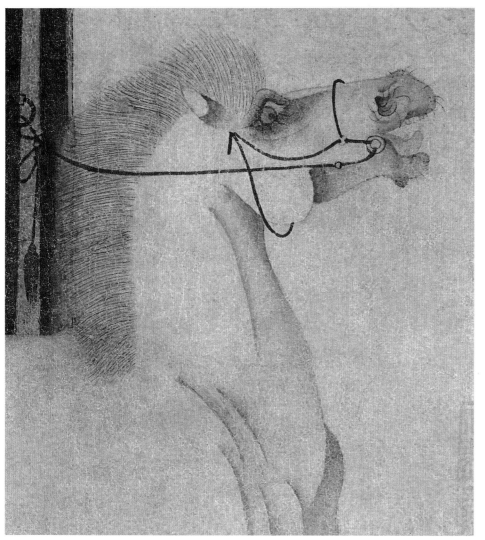

Attributed to **Han Kan**

Chinese, active 742–56

NIGHT-SHINING WHITE

Handscroll, ink on paper; 12⅛ × 13⅜ in.
(30.8 × 34 cm)
Purchase, The Dillon Fund Gift, 1977
(1977.78)

Han Kan's portrait of Night-Shining White,
a horse of the T'ang emperor Ming-huang
(r. 712–56), is one of the most revered horse
paintings in Chinese art. Recorded by
eminent critics almost continuously from
the ninth century onward, this short
handscroll has a formidable pedigree in the
form of seals and colophons of former
owners. The animal, with its wild eye,
bristling mane, flaring nostril, powerful
flanks, and nervously prancing hooves,
radiates strength and energy, even though it
is tethered. Han Kan's portrayal of Night-
Shining White is elegant for its sole reliance
on brushline and shading in ink to convey
the full-bodied strength of the steed. This
method of achieving the effects of
chiaroscuro is known as white painting, or
pai-hua.

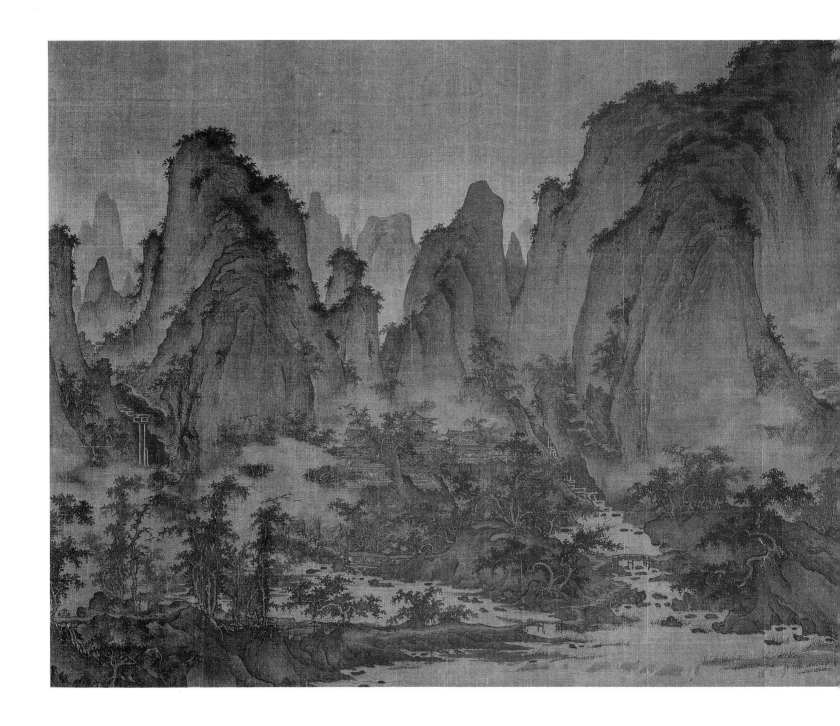

Attributed to *Ch'ü Ting*
Chinese, active ca. 1023–56
SUMMER MOUNTAINS

Handscroll, ink and light color on silk;
17¾ × 45¼ in. (45.1 × 114.9 cm)
Gift of The Dillon Fund, 1973 (1973.120.1)

The monumental landscape style came into the ascendant in Chinese painting in the first half of the tenth century, reaching its apogee around the middle of the eleventh in the Northern Sung dynasty. *Summer Mountains* depicts the vastness and multiplicity of the natural world and is, in fact, a hymn to creation itself. In this sublime handscroll a lofty range cresting in a central peak presides over the activity along a river on a summer evening. The rhythm of rising and falling peaks is accented by deep ravines, where temples and waterfalls appear half concealed by mists. Luxuriant trees harbor villages and way stations, where travelers and fishermen, concluding the day's affairs, take refreshment or put to port. The unfolding at every scale of the cosmic principles, or *li*, inherent in all things is manifest, from the wavelike undulations of the massive range to the shallow rivulets of a depleted summer stream, to precise details of masts and rigging. This depiction of detail without loss of grandeur and harmony in the whole was the unsurpassed achievement of Chinese landscape painting in the Northern Sung.

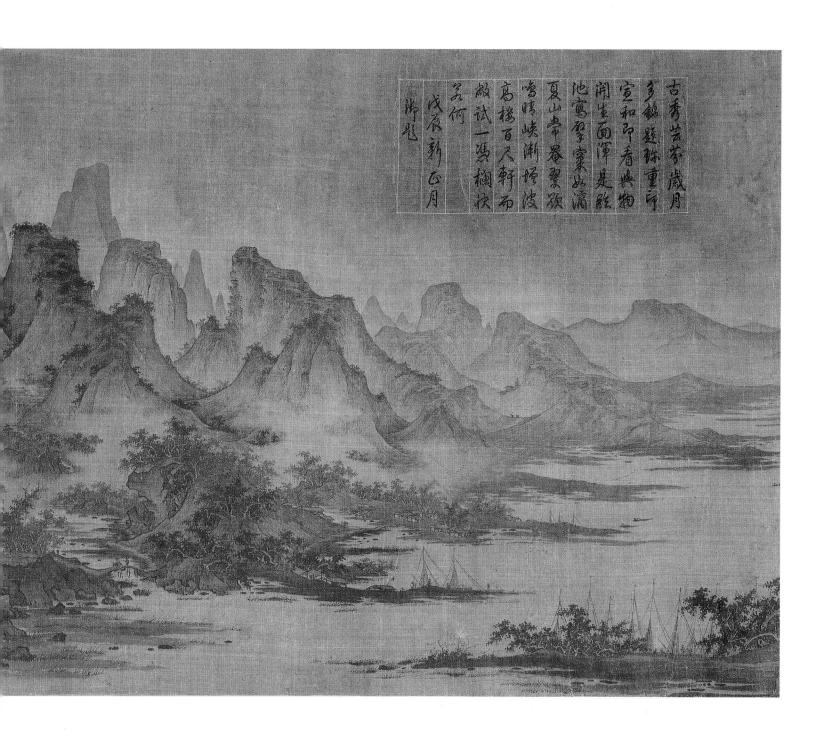

古香岩茶歲月
多錫題珠重行
宣和印香與物
開生面渾是脆
池窩翠窠如滴
夏山書番翠領
鳴晴峽漸煙波
高樓百尺軒而
敲試一隈欄快
咏何
戊辰新正月
御題

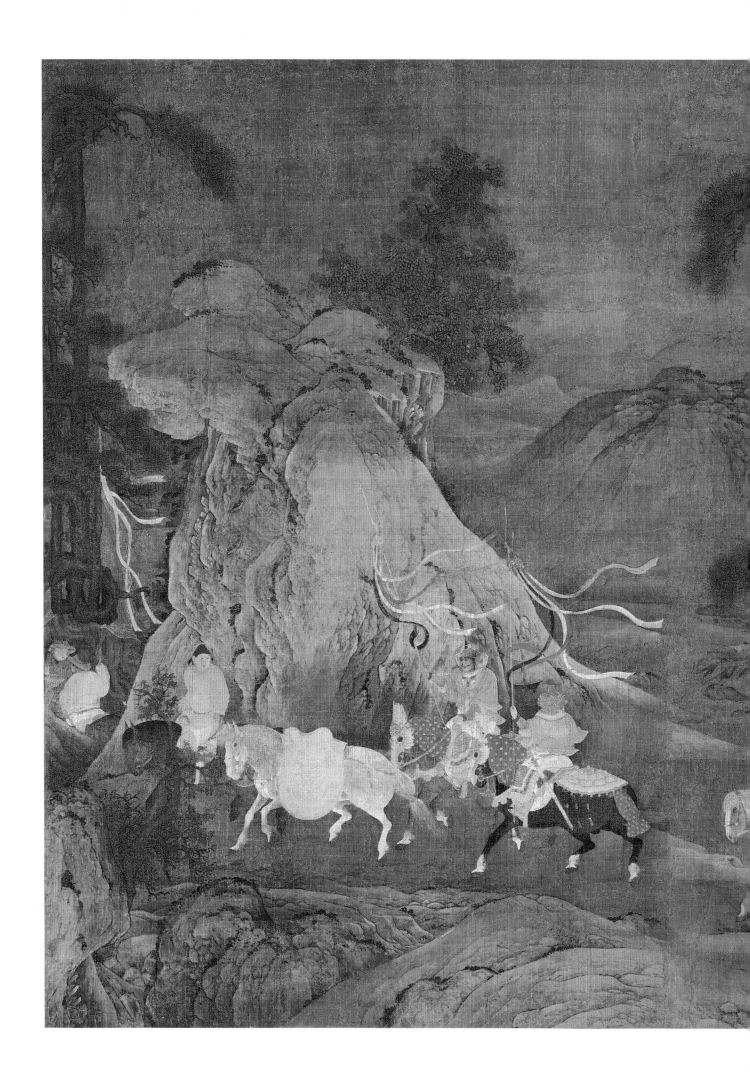

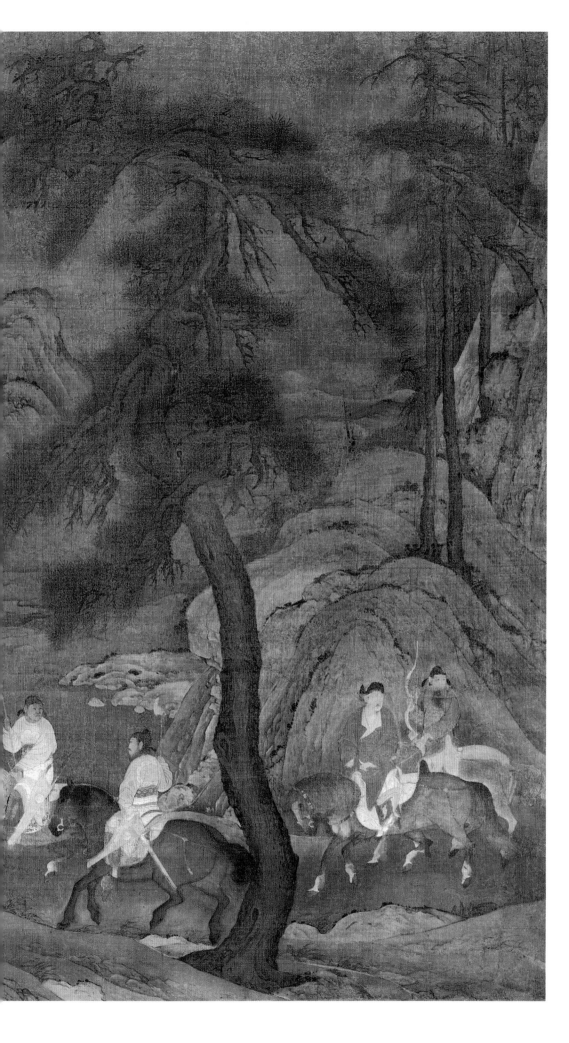

Chinese, Southern Sung dynasty,
12th century

EMPEROR MING-HUANG'S FLIGHT TO SHU

Hanging scroll: ink and color on silk;
32⅝ × 44¾ in. (82.9 × 113.7 cm)
Rogers Fund, 1941 (41.138)

Although traditionally ascribed to a Southern Sung artist, this painting may represent the continuation of the monumental landscape tradition in Northern China under the Chin tartars. The subject is the flight for safety to Shu, in Szechwan province, of the T'ang emperor Ming-huang (r. 712–56), after 33 years of able rule, following his affair with the concubine Yang Kuei-fei. During the flight, the emperor was confronted by mutinous troops who accused Yang Kuei-fei of complicity in a rebellion against him, and he was forced to assent to her execution. The painting may depict the imperial entourage moving through a somber landscape after her execution. The informally dressed imperial figure at the right appears to be Ming-huang, who seems inconsolable, but the palace guard, following the riderless horse, grins and gloats. The mountain behind the white horse glows with an ethereal luminosity created by a lighter use of ink wash and highlights of gold pigment. Touches of gold on the rocky facets and on the costumes lend regal splendor.

Chinese, Ming dynasty, 1426–35
JAR

Porcelain painted in underglaze blue;
H. 19 in. (48.3 cm)
Gift of Robert E. Tod, 1937 (37.191.1)

The design on this splendid blue-and-white jar was painted on the unfired clay body with cobalt oxide, and the piece was then glazed. When fired, the glaze was fused to the body. It was produced at the Ching-te Chen kilns in northern Kiangsi province in the 15th century after porcelain production had reached the epitome of grace and sophistication manifested in this vessel. The Metropolitan's jar is beautifully shaped and painted with a bristling dragon that combines great power with consummate fluidity of movement.

Chinese, T'ang dynasty,
ca. 9th century
FLASK

Stoneware; H. 11½ in. (29.2 cm)
Gift of Mr. and Mrs. John R. Menke, 1972
(1972. 274)

The dramatic beauty of this T'ang dynasty flask results from the splashes of contrasting color created by two layers of glaze, the lighter-colored one dripping curdlike over the dark undercoat. The variations in color produced by this dual glaze when the piece was fired range from shades of cream through gray, blue, and lavender to the dark brown of the underglaze. The unusual shape of the flask was probably based on a leather prototype. Stoneware of this kind was produced at several kilns in Northern China, including one at Huang-tao in Honan province, where this piece probably originated.

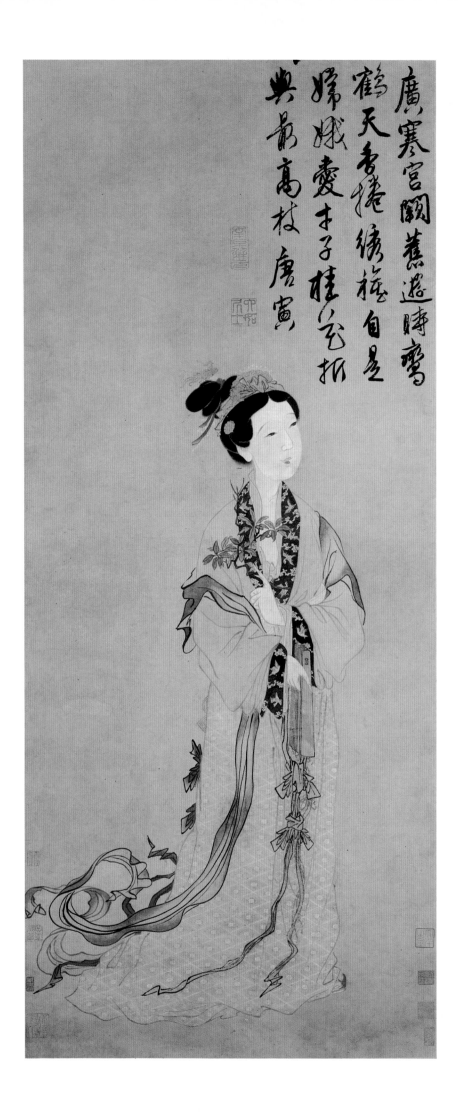

T'ang Yin
Chinese, Ming dynasty, 1470–1524
THE MOON GODDESS CH'ANG O,
ca. 1510

Hanging scroll: ink and colors on paper;
53½ × 23 in. (135.9 × 58.4 cm)
Gift of Douglas Dillon, 1981 (1981.4.2)

The moon goddess's flat, oval face and
elegant fluttering drapery reflect the Ming
emphasis on beautiful calligraphic line
rather than on three-dimensional form.
This hanging scroll, painted by the talented
scholar T'ang Yin, is a poignant reminder of
that artist's dashed dreams of success in an
official career after being involved in an
examination scandal in 1499. The goddess
holds a cassia branch in her left hand—long
a symbol of success in the autumn
examinations. T'ang Yin's poem, in bold
calligraphy, reads in part: "Ch'ang O, in love
with the gifted scholar / Presents him with
the topmost branch of the cassia tree."

Chinese, Yüan dynasty, 1206–1368
CANOPY

Silk and gold-wrapped paper strips couched
on silk gauze; 56½ × 53 in.
(143.5 × 134.6 cm)
Purchase, Amalia Lacroze de Fortabat Gift,
Louis V. Bell and Rogers Funds, and Lita
Annenberg Hazen Charitable Trust Gift, in
honor of Ambassador Walter H. Annenberg,
1988 (1988.82)

This silk gauze square, made in China
during the Yüan dynasty, was probably used
as a canopy for a shrine, being stretched
horizontally over an icon or a holy figure in
accord with Tibetan Buddhist custom. The
fine gauze and marvelously skilled
embroidery could have been produced by
Chinese artist-craftsmen in the eastern part
of the Mongol Empire for a diplomatic gift
to a great Tibetan monastery. The central
medallion of phoenixes in couched gold
circling a flaming pearl among clouds
parallels those on large stone slabs found at
the site of a Taoist temple built in 1316 in the
Yüan capital, Ta Tu (present-day Beijing).
The symmetrical vases in each corner with
their vinelike arabesques bearing small
flowers and leaves come from a different
tradition, echoing motifs from India or the
late classical world.

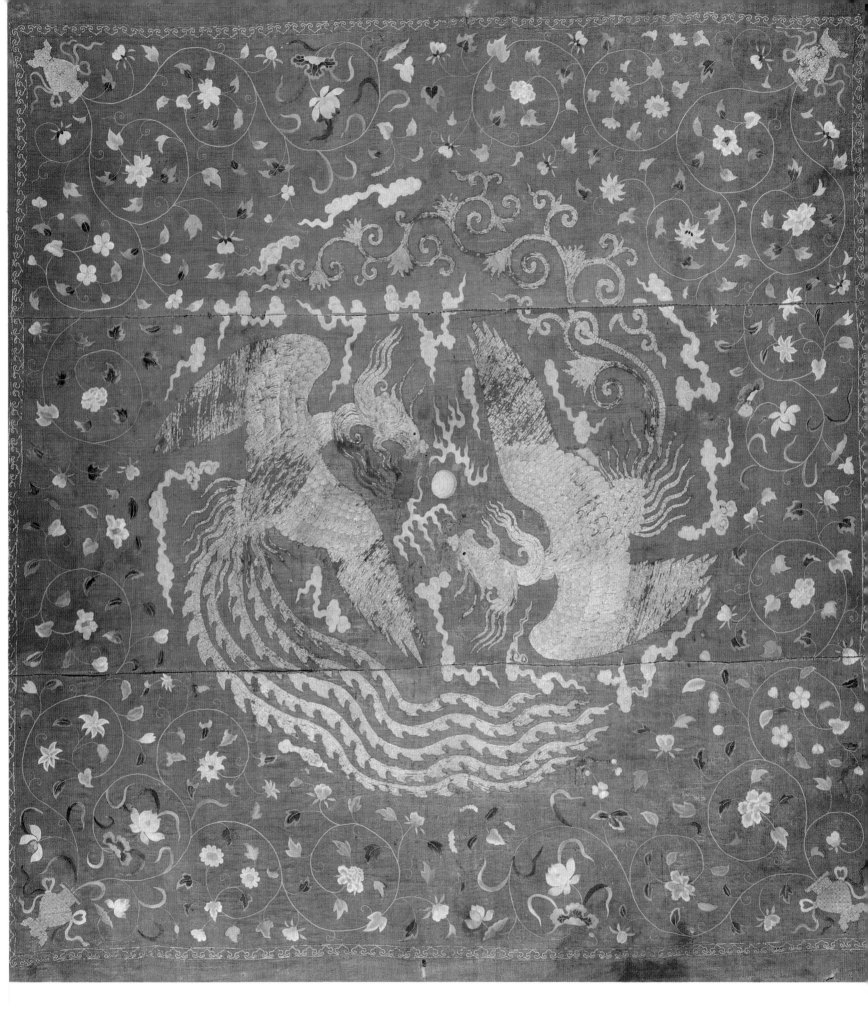

Chinese, Ch'ing dynasty, probably K'ang-hsi period, late 17th–early 18th century

THE GOD OF WEALTH IN CIVIL ASPECT

Porcelain painted in polychrome enamels on the biscuit; H. 23⅞ in. (60.6 cm)
Bequest of John D. Rockefeller, Jr., 1961
(61.200.11)

This porcelain figure of the God of Wealth in Civil Aspect sits on a gilded silver throne, his filigreed hat set with pearls, jade, and kingfisher feathers, making a truly gorgeous apparition. His elaborately fashioned robes are sumptuously embroidered with a panoply of flowers and auspicious symbols. The figure is decorated in the famille verte palette of enamels, but rather than applying them over a glaze—which would tend to fill in and blunt the sharp modeling of the features and the contours of the garments—the painter has applied them directly onto the unglazed, prefired (or biscuited) porcelain body.

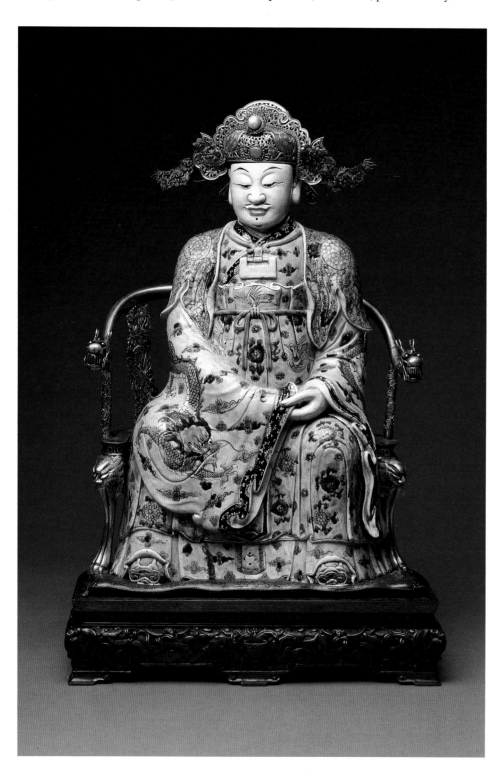

Chinese, 1981

THE ASTOR GARDEN COURT

Gift of The Vincent Astor Foundation, 1980

The Astor Garden Court, adapted from a small courtyard in a scholar's garden, called the Garden of the Master of the Fishing Nets, in Soochow, China, was assembled and dressed by 27 Chinese craftsmen and engineers in the Museum. All of its pieces, including pillars, tiles, rocks, and masonry, had first been prepared in China. Pillars throughout the court are made of *nan* wood, a rare species of broad-leafed evergreen prized for its honey-brown color, and the gray terracotta bricks and tiles used in the floor and roofs were fired in an 18th-century imperial kiln in the Soochow area, reopened for the purpose. The courtyard provides an elegant and peaceful environment for contemplation and mental repose.

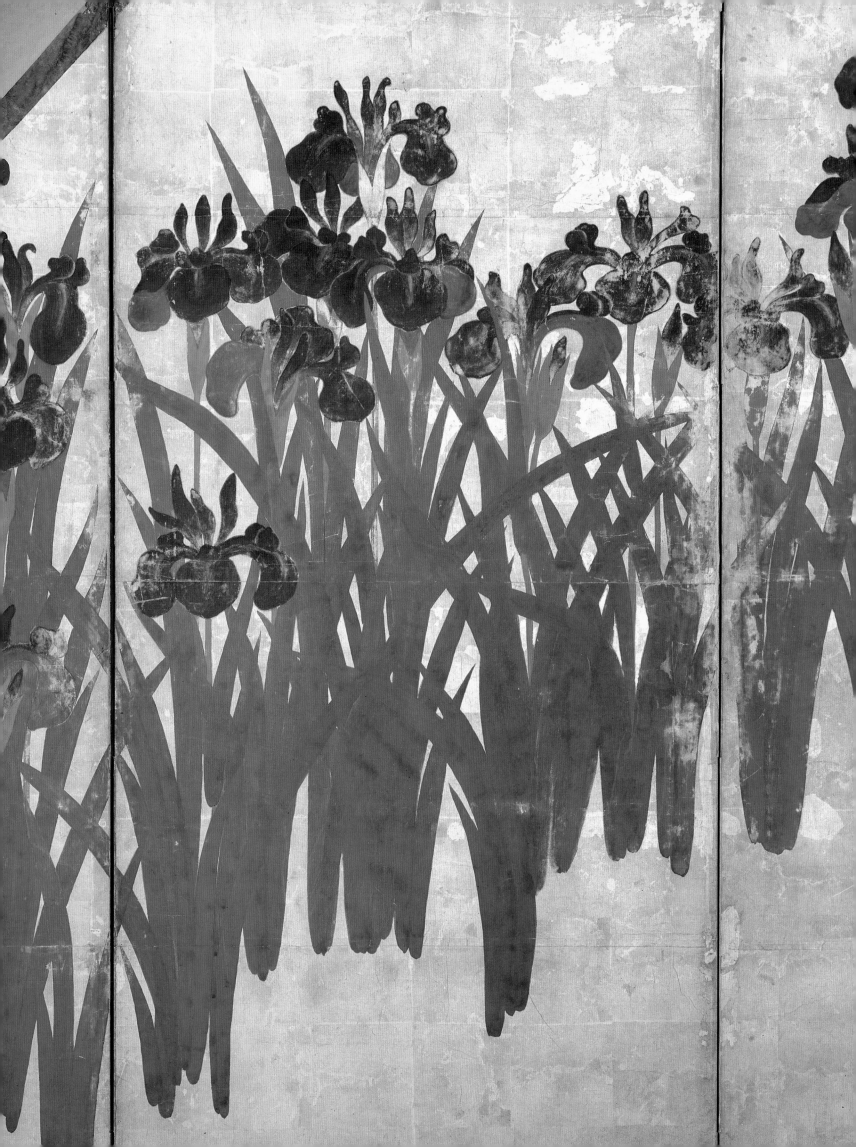

Japan

CHINA AND JAPAN WERE in constant communion throughout their histories, and an examination of early Japanese painting reveals the extent to which formative elements were imported from China. The strength of this influence, however, was tempered by the fact that Japanese artists never abandoned their own roots, but absorbed influences into the structure of their own deep-seated traditions. The highest achievements of Japanese painters can be measured in narrative handscroll painting, on the one hand, and large-scale decorative painting on the other.

Japanese decorative art, marked by exquisite craftsmanship, is perhaps the most admired in the world. Such objects as ceramics, textiles, armor, and lacquerwork employ aesthetic values to enhance appreciation and utility both. Textures play an important role, from the rough clay and cord markings of a Jōmon jar to the rich, deep, glutinous surface of a lacquer bowl. Patterns may be based on floral motifs, leaves, or natural or abstract elements. Color ranges from gold and brilliant red to pale umber and plain clay. Shapes may be functional or they may be abstract (that is, having no meaning that can now be identified); in either case shapes are aesthetically informed by nuance and subtlety, molded by the hands of an artist. "Is decorative art art?" is a question sometimes asked in the West. In Japan, decorative craftsmen are undoubtedly artists and are acknowledged as such, some even known today as Living Treasures.

Japanese painting clearly embodies this phenomenon: The most attractive achievement of post–thirteenth-century painters has been in the realm of what would, in the West, be called decorative painting. In these Japanese works the decorative qualities function not as design but as expression. Color, design, form, and relationships act directly upon the viewer to arouse emotional responses, and these responses are directly tied to the literary and human associations conveyed through them.

(OPPOSITE, BELOW)

Ogata Kōrin
Japanese, Edo period, 1658–1716
YATSUHASHI

Six-fold screen, ink, color, and gold leaf on paper; 70½ × 146¼ in. (179.1 × 371.5 cm)
Purchase, Louisa Eldridge McBurney Gift, 1953 (53.7.2)

Ogata Kōrin, one of the most important Japanese artists of the 17th century, was fascinated by irises, which he painted often in many variations and media. The Japanese word "Yatsuhashi" means Eight-Plank Bridge, and the scene refers to a passage from a tenth-century collection of poetic episodes, *Tales of Ise*, familiar to every Japanese viewer.

(LEFT)

Attributed to *Sesson Shūkei*
Japanese, 1504–1589?
GIBBONS IN A LANDSCAPE (detail)

Pair of six-panel screens: ink on paper; each screen: 62 × 137 in. (157.5 × 348 cm)
Purchase, Rogers Fund and The Vincent Astor Foundation, Mary Livingston Griggs and Mary Griggs Burke Foundation and Florence and Herbert Irving Gifts, 1992 (1992.8.1,2)

Celebrated as noble creatures in China for more than 2,000 years, gibbons were adopted by Zen Buddhism as a religious metaphor for the underlying unity of all sentient beings.

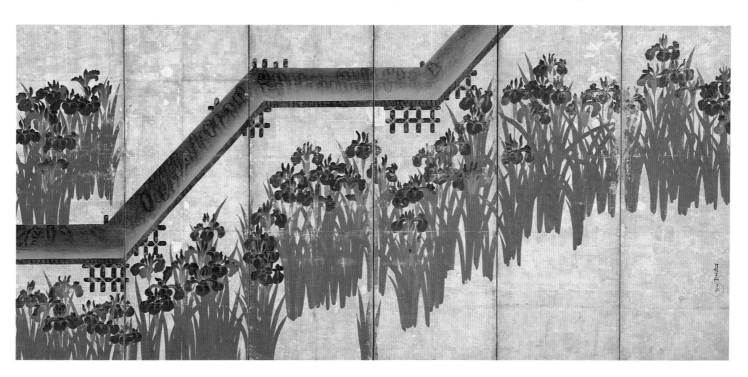

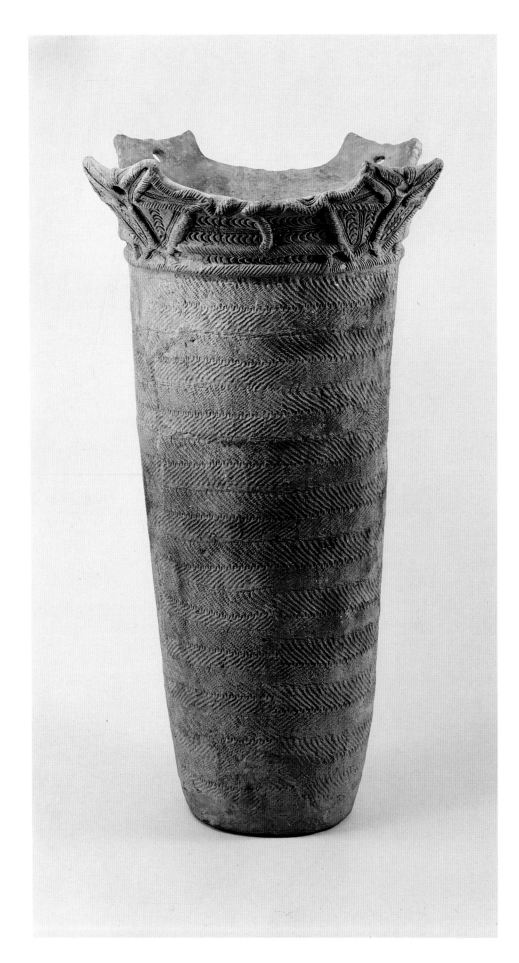

Japanese, middle Jōmon period,
ca. 3000–2000 B.C.

JŌMON JAR

Earthenware with applied, incised, and cord-marked decoration; 27½ × 16½ in.
(69.9 × 41.9 cm)
The Harry G. C. Packard Collection of Asian Art, Gift of Harry G. C. Packard and Purchase, Fletcher, Rogers, Harris Brisbane Dick and Louis V. Bell Funds, Joseph Pulitzer Bequest and The Annenberg Fund, Inc. Gift, 1975 (1975.268.182)

This earthenware food vessel, which comes from northeastern Japan, is remarkable for the fine quality of its clay and for its sophisticated decoration. The herringbone pattern on its body was produced by cords knotted together and twisted in opposite directions. Slender strips of clay were applied to create the geometric relief pattern on its flared quatrefoil rim. Sharp sticks were used to make the linear incisions. This jar is a prime example of the earliest ceramics, known as Jōmon, or "cord marked," after its distinctive textured surface decoration, produced by the earliest inhabitants of the Japanese archipelago.

Japanese, late Heian period, 12th century
FUDŌ MYŌ-Ō

Wood with color; figure without base:
H. 63¾ in. (161.9 cm)
The Harry G. C. Packard Collection of Asian Art, Gift of Harry G. C. Packard and Purchase, Fletcher, Rogers, Harris Brisbane Dick and Louis V. Bell Funds, Joseph Pulitzer Bequest and The Annenberg Fund, Inc. Gift, 1975 (1975.268.163)

This statue of Fudō, whose name means "immovable" and who is a staunch guardian of the Buddhist faith, warding off enemies of the Buddha with his word of wisdom and binding evil forces with his lasso, was the central icon of the Kuhon-ji Gomadō in Funasaka, some 20 miles northwest of Kyoto. A symbol of steadfastness in the face of temptation, Fudō is one of the most commonly depicted of the Esoteric Buddhist deities known as Myō-ō, "Kings of Brightness." Here his youthful, chubby body and his skirt and scarf are modeled with the restrained, gentle curves typical of late Heian sculpture. Fudō's hair was once painted red and his flesh dark blue-green.

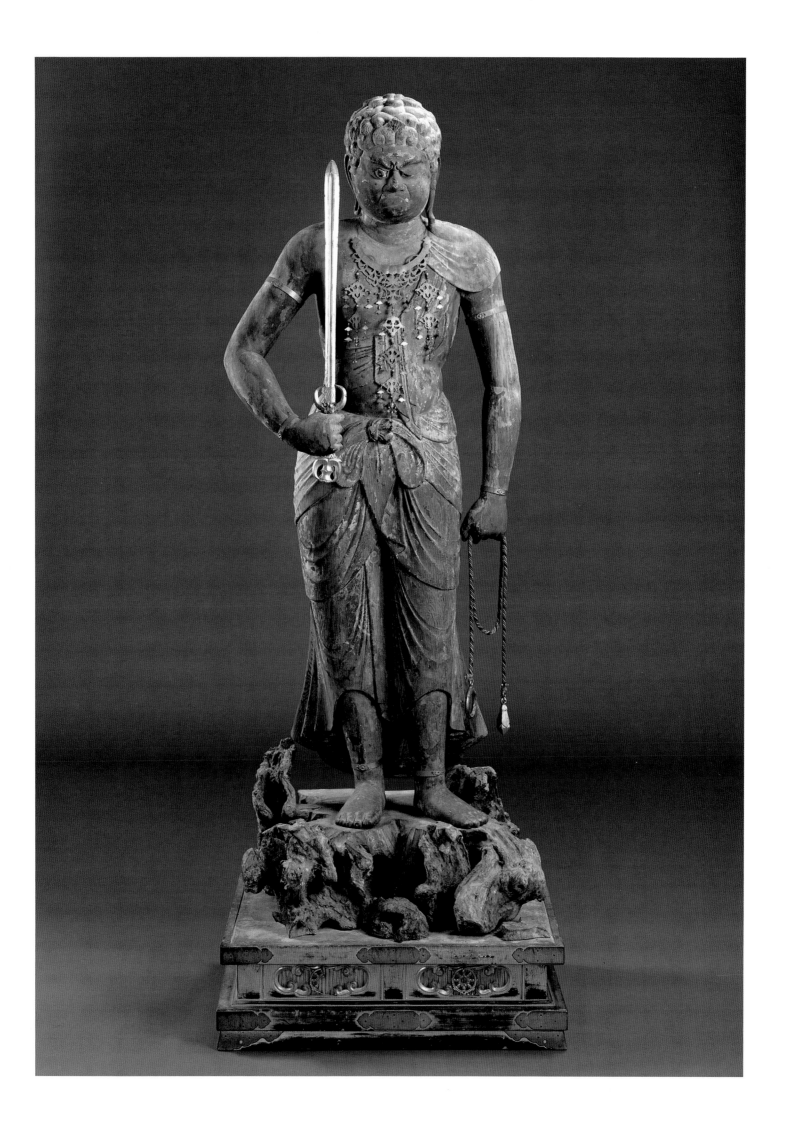

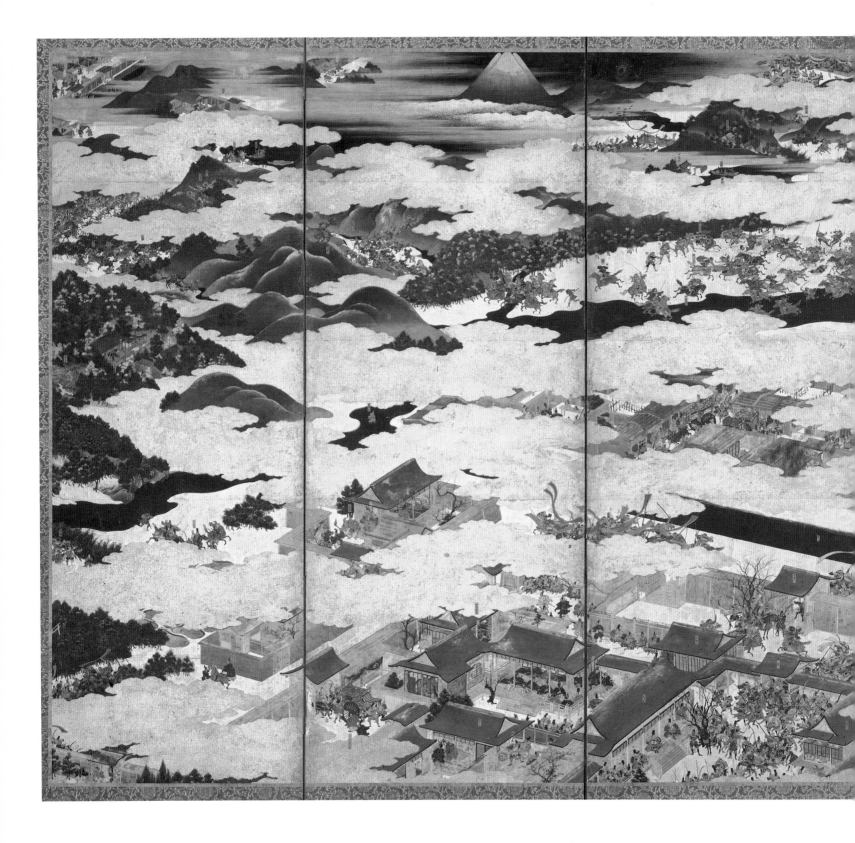

Japanese, Momoyama period, 1573–1614

BATTLE OF THE HEIJI ERA

Color and gold leaf on paper; 60⅞ × 140⅛ in.
(154.6 × 355.6 cm)
Rogers Fund, 1957 (57.156.4)

This scene comes from one of a pair of six-fold screens painted by an unknown artist of the Tosa school skilled in the traditional narrative handscroll style, depicting the bloody uprisings that occurred during the Hogen and Heiji eras in the latter half of the 12th century in Japan and which served as sources of inspiration for generations of artists. Initially, these military dramas were recounted in the form of handscrolls, but from the late 16th century they were often adapted and rearranged for use on large-

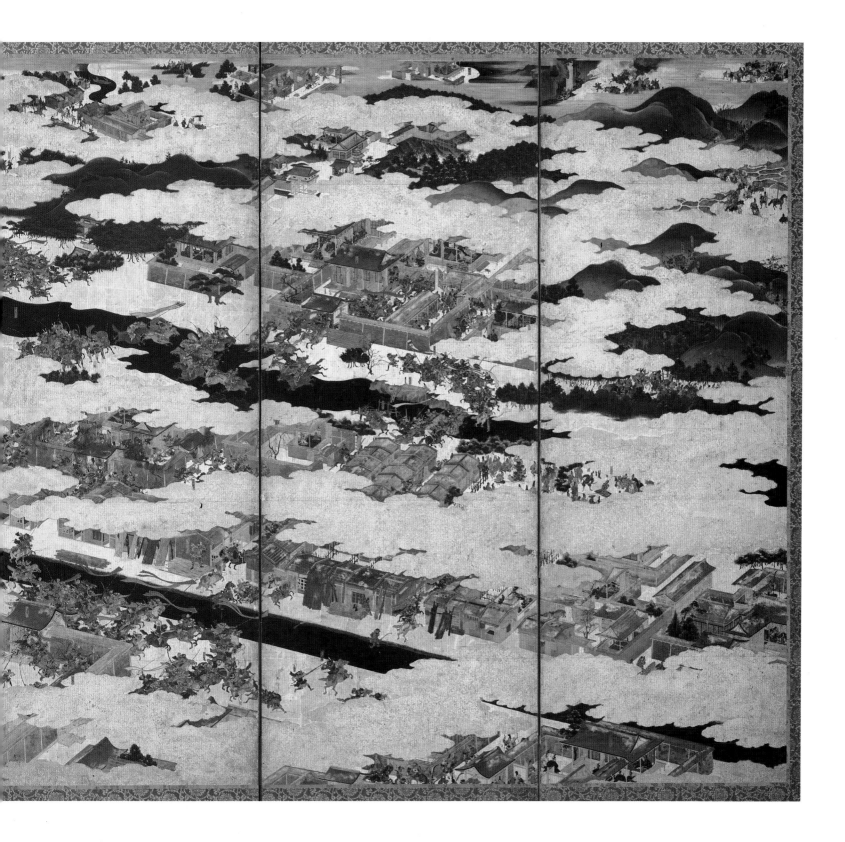

scale screens with dazzling gold grounds, as we see here.

These two screens set before us the drama of the two insurrections, scene by scene. The locale for most of the action is the capital, Kyoto, but the artist did not hesitate to switch the scene to Mount Fuji, located far to the north. The artist has distributed the actions as best fitted his artistic vision rather than placing them chronologically. The viewer gets a bird's-eye view because of the painter's technique, typical of Japanese artists, of looking from above at an oblique angle. Sliding doors and roofs of palaces are pulled back so that we can see the scenes taking place inside as well as outside.

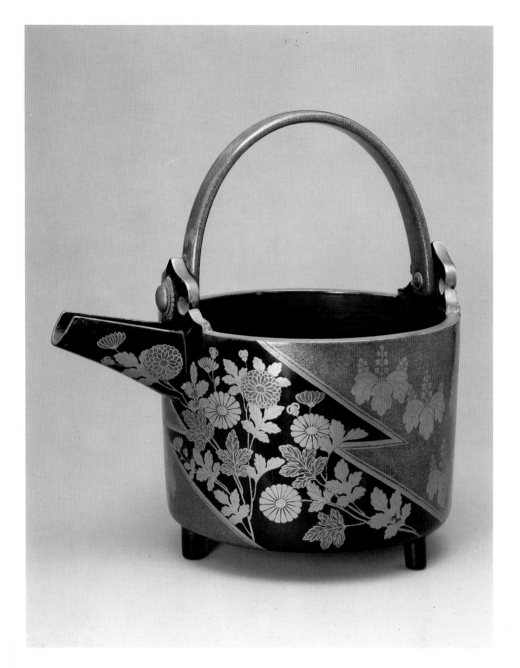

Japanese, early 14th century
ARMOR (*YOROI*)

Lacquered iron and leather, silk, stenciled leather, gilt copper; H. as mounted 37½ in. (95.3 cm)
Gift of Bashford Dean, 1914 (14.100.121)

This is a fine example of a medieval *yoroi.* This type of armor has a cuirass that wraps around the body and is closed by a separate panel (*waidate*) on the right side and by a deep, four-sided skirt. In use from around the 4th to the 14th century, *yoroi* were generally worn by warriors on horseback. The breastplate bears the image of the powerful Buddhist deity Fudō Myō-ō, whose fierce mien and attributes of calmness and inner strength were highly prized by the samurai. The helmet, long associated with this armor, dates from the middle of the 14th century.

Japanese, Momoyama period, ca. 1596
WINE CONTAINER

Kōdaji-style lacquered wood; H. 9⅞ in. (25.1 cm)
Purchase, Gift of Mrs. Russell Sage, by exchange, 1980 (1980.6)

This sake container (*chōshi*) is typical of a distinctive style of lacquer ware of the Momoyama period (1568–1615), known as Kōdaji. This name derives from that of the Kyoto temple which serves as the mausoleum of the warlord Toyotomi Hideyoshi (1536–1598). The decoration of the vessel comprises two uneven sections separated by a zigzag "lightning bolt" line. One side has a naturalistic rendering of chrysanthemums against a plain black ground, and the other has paulownia-leaf crests, more stylized, adopted by Hideyoshi. These crests are set against a ground sprinkled with gold and silver particles.

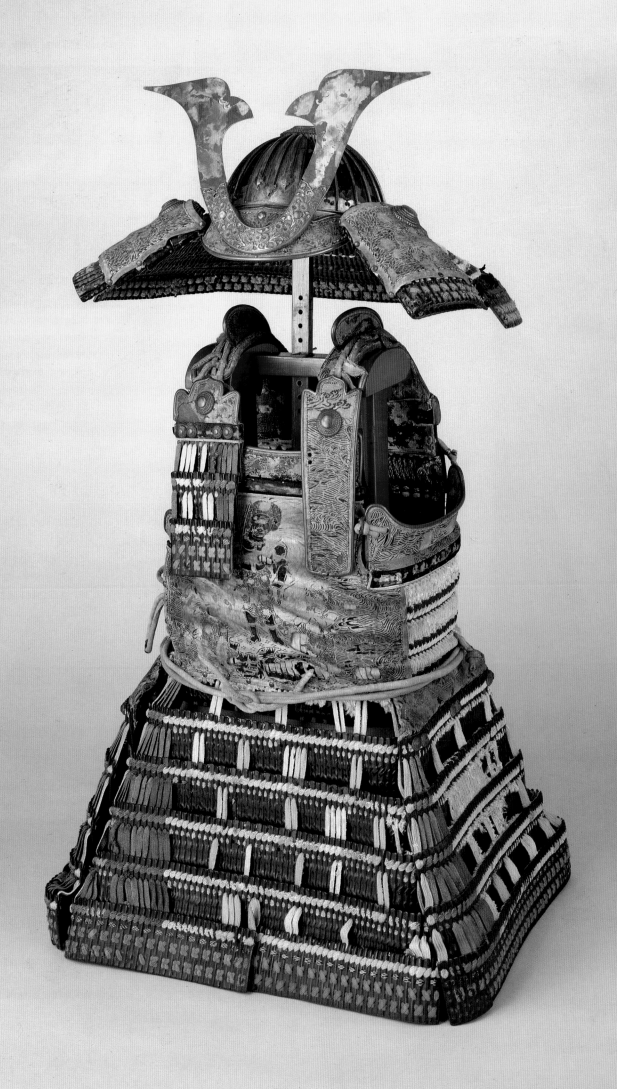

1700–1900 IN EUROPE
AND THE UNITED STATES

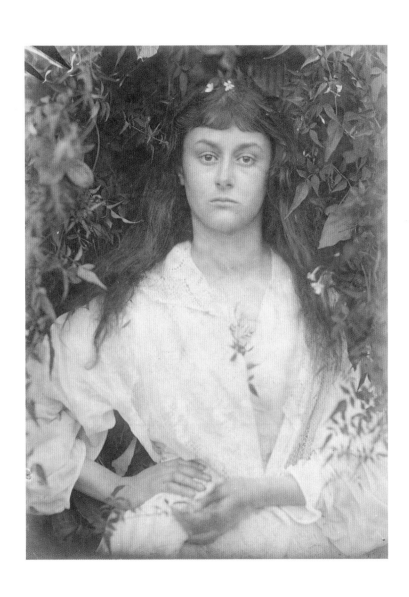

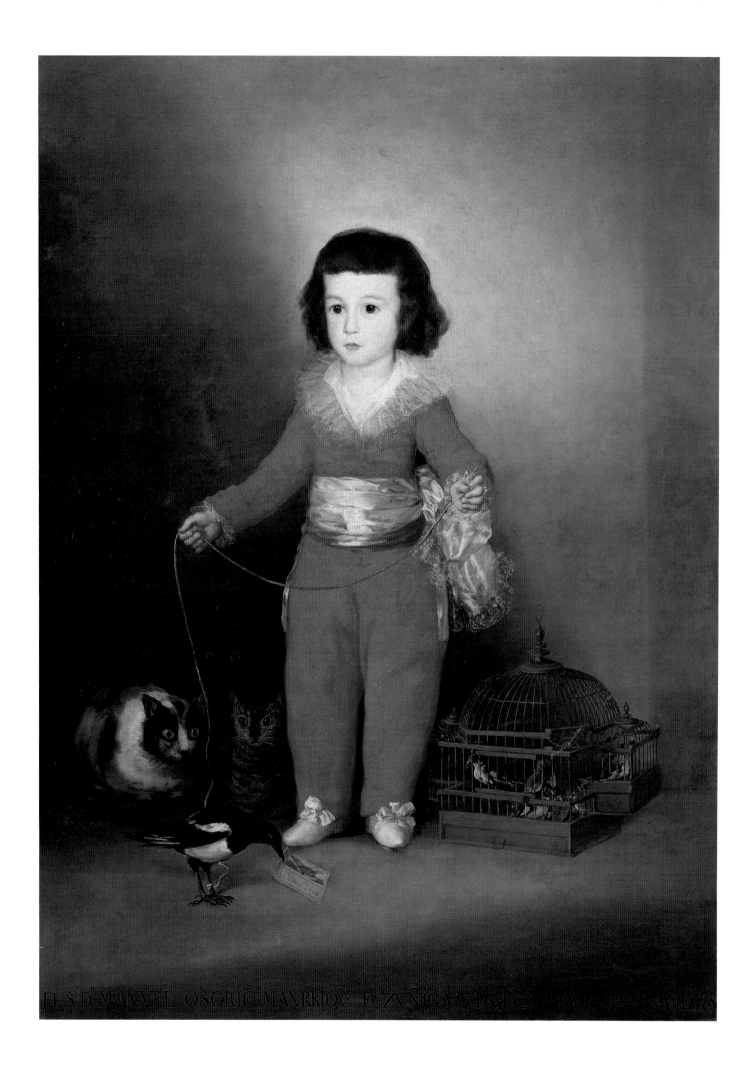

Europe

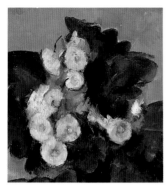

THE EIGHTEENTH CENTURY IN Europe witnessed unexpected reversals in the creative and critical fortunes of the major schools of European painting. The Golden Age of Dutch painting hardly lasted through the end of the seventeenth century; Spain never found among its native ranks a worthy successor to Velázquez until Goya appeared in the last quarter of the eighteenth century. Venice, which had not had a vigorous Baroque movement, emerged as the most admired and productive school of painting in Italy, presided over by Giovanni Battista Tiepolo. Italy in the eighteenth century continued to be the crossroads of Europe; indeed, this was the century of the Grand Tour, when no gentleman's education was complete until he had seen Rome and Venice. English lords and the princes of central Europe formed massive collections of Italian art, replacing the Roman Church as a primary employer of painters. Ultimately, however, the momentum of artistic creativity passed to France, which produced such major artists as Watteau, Chardin, Boucher, and Fragonard.

The eighteenth century is often labeled the Age of the Rococo, a reference to the brilliance of French art during this period. The term described the style of interior decoration that flowered during the reign of Louis XV, an age when art and manners were secular in outlook, an age in which royal mistresses dictated not only state policy but also artistic agendas.

The Venetian and French schools of painting were the most compelling manifestations of the sensual, pleasure-loving aspect of eighteenth-century culture. This age was split, however, as the seventeenth century had been, between the deep impulse of emotion—the Rococo—and an admiration for the intellectual attainments of classical antiquity and modern science on the other. In the second half of the eighteenth century the arts were marked by a Neoclassical style and the spirit of open-minded inquiry that was the basis of the Enlightenment.

This was an era of contradictions: unparalleled luxury and abject poverty; absolute monarchs and republican pamphleteers; unquestioned faith and reasoned skepticism; Rococo fantasy and classical purity—an epoch that witnessed the splendid waning hours of the old order and the violent birth of the modern age. The Neoclassical style initially gave artistic expression to the Revolution at its most implacable, but still-newer sensibilities were emerging that would characterize the aesthetics of the remainder of the nineteenth century: Romanticism and Realism. In England Fuseli and Blake gave expression to the brooding Romantic spirit. In Spain Goya refused to ignore the real and terrifying world and instead offered up a mirror of human capacity for brutality and compassion. In France Ingres brought classical portraiture to its apex, while Gericault and Delacroix experimented with a brilliant palette and exotic subject matter. But it was finally in the paintings of Turner and Constable in England and Corot, Rousseau, and Courbet in France that the quintessentially nineteenth-century subject emerged: nature precisely observed on site.

In 1874 a group of artists whose work had been rejected the previous year by the official French Salon organized their own exhibition in the studio of the photographer

(OVERLEAF)
Julia Margaret Cameron
British, 1815–1879
ALICE LIDDELL, 1872

Albumen silver print from glass negative; 14¼ × 10¼ in. (36.2 × 26 cm)
David Hunter McAlpin Fund, 1963 (63.545)

Born in Calcutta and educated in Paris and England, Julia Margaret Cameron became an avid photographer at the age of 48. She specialized in portraits, and her subjects included many of the great figures of Victorian arts, letters, and science. Alice Liddell, one of three daughters of Henry George Liddell, the dean of Christ Church, is best known as the model for Lewis Carroll's fictional Alice and also appears in Carroll's own photographs of children.

(OPPOSITE)
Francisco de Goya y Lucientes
Spanish, 1746–1828
DON MANUEL OSORIO MANRIQUE DE ZUÑIGA, ca. 1786

Oil on canvas; 50 × 40 in. (127 × 101.6 cm)
The Jules Bache Collection, 1949 (49.7.41)

Soon after Goya was appointed Painter to the King of Spain, Charles III, the conde de Altamira, commissioned him to paint portraits of his family, including his youngest son, Don Manuel, born in 1784. The fashionably dressed child holds a pet magpie on a string. In the background three cats stare menacingly at the bird, traditionally a symbol of the soul, which gives the painting a sinister and unsettling character. Goya apparently intended this portrait as an illustration of the frail boundaries that separate a child's world from the ever-present forces of evil.

(LEFT)
Detail from Cézanne's *Still Life with Apples and a Pot of Primroses* (see page 236)

Nadar. The group included Pissarro, Renoir, Cézanne, and Monet, whose painting *Impressionism: Sunrise*, led a prominent and hostile critic to deride the whole group as "impressionists," a name that stuck. Scorned by the French art establishment and for many years by the public as well, these artists continued to paint works that are now universally admired and acknowledged as perhaps the first true expressions of the modern spirit.

The Impressionists departed dramatically from traditional, academic painting techniques and from the romantic or rhetorical subject matter then in vogue. Instead of subjects taken from remote times and places, they chose to paint the artifacts and everyday activities of modern life. In their work nature ceased to be depicted as ideal and eternal: rather, they showed the instantaneous impression of land, sky, or water in a particular climate and at a particular time of day. Painstaking modeling and traditional perspective were abandoned in favor of short, staccato brushstrokes of color. This radical break from centuries-old tradition eventually led to new and different modes of painting both within the Impressionist circle and in the works of succeeding generations throughout Europe and the United States.

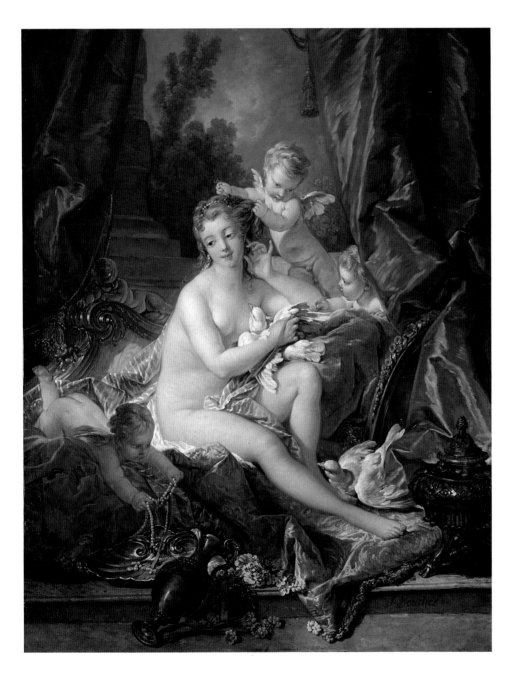

François Boucher
French, 1703–1770
THE TOILET OF VENUS, 1751

Oil on canvas; 42⅝ × 33½ in.
(108.3 × 85.1 cm)
Bequest of William K. Vanderbilt, 1920
(20.155.9)

No French painter of the 18th century was more inextricably linked to court patronage than François Boucher. This picture was commissioned as part of the decoration for Madame de Pompadour's *cabinet de toilette* at the Château de Bellevue, one of the residences built for her by Louis XV. The cupids and the doves are attributes of Venus as goddess of Love. The flowers allude to her role as patroness of gardens and the pearls to her mysterious birth from the sea. As a painter of nudes Boucher ranks with Rubens in the 17th century and Renoir in the 19th; among his contemporaries he had no equal.

Antoine Watteau

French, 1684–1721

HEAD OF A MAN

Red and black chalk; 5⅞ × 5⅛ in.
(14.9 × 13 cm)
Rogers Fund, 1937 (37.165.107)

Watteau was undoubtedly the greatest
painter of the French Rococo period. His
poignancy and intellectual perspicuity
made him unique among his peers. This
sensitively modeled head is a preparatory
study for the seated figure of Mezzetin as he
appears in the painting reproduced at the
right. The drawing is a typical example of
the draftsmanship of Watteau, who often
used a combination of red and black chalk in
his figure studies.

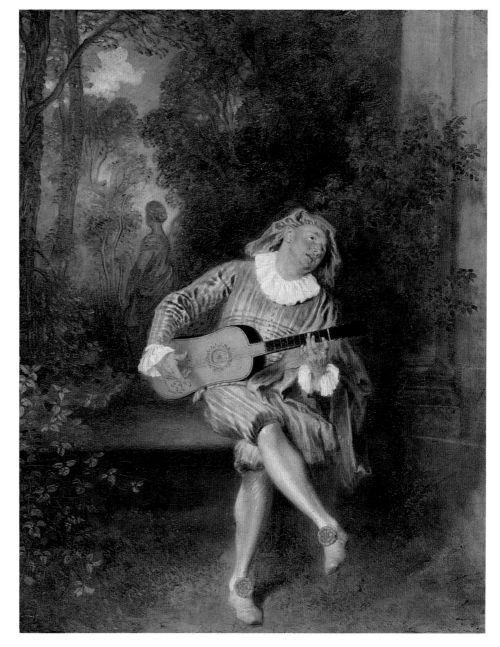

Antoine Watteau

French, 1684–1721

MEZZETIN, 1717–19

Oil on canvas; 21¾ × 17 in. (55.2 × 43.2 cm)
Munsey Fund, 1934 (34.138)

Mezzetin, a stock character of the
commedia dell'arte, the improvisational
theater form of Italian origin, was an
amorous valet who frequently engaged in
the pursuit of unrequited love. Here he is
shown playing the guitar before a garden in
which a young woman—perhaps a statue,
perhaps the painting of a statue on a stage
set—stands with her back turned,
presumably rejecting his romantic
entreaties. Such complex layering of
multiple realities was one of Watteau's
preoccupations. He delighted in the
depiction of scenes imbued with the
ambiguous relationship that existed
between stage life and real life—the world
of art and the actual world.

Jean Siméon Chardin

French, 1699–1779

THE SILVER TUREEN, ca. 1728

———

Oil on canvas; 30 × 42½ in. (76.2 × 108 cm)
Fletcher Fund, 1959 (59.9)

———

Chardin was a contemporary of Boucher, but no two artists could have been more different. Chardin invariably imbued his deceptively simple compositions with a moral and a contemptuous disregard for mere prettiness. In this still life Chardin has given ordinary objects of everyday life an aura of dignity and value. The cat creates a sense of conflict between the living and dead animals, underscoring a theme common in Chardin's genre scenes: the evanescence of life.

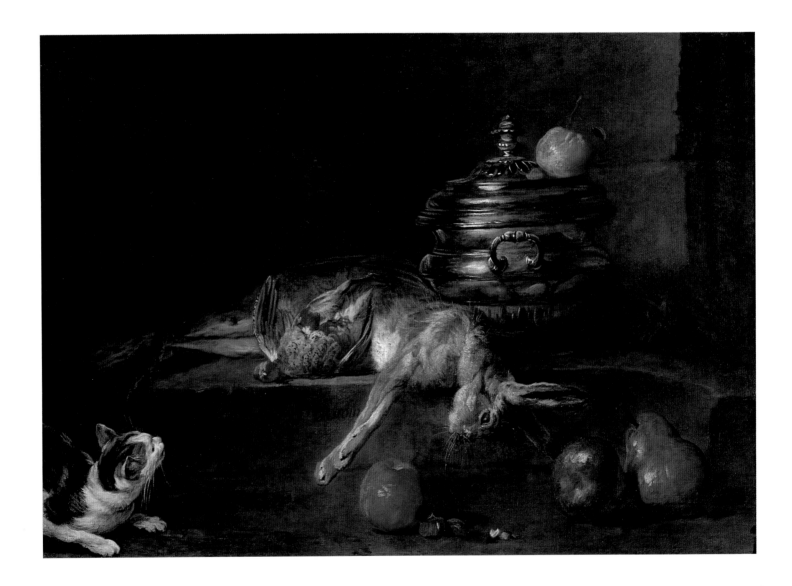

Jean Honoré Fragonard

French, 1732–1806

THE LOVE LETTER, 1770s

Oil on canvas; 32¾ × 26⅜ in. (83.2 × 67 cm)
The Jules Bache Collection, 1949 (49.7.49)

This picture exemplifies Fragonard's feeling
for color, his sensitive handling of effects of
light, and his extraordinary technical
facility. The elegant blue dress, lace cap, and
coiffure of the woman seated at her writing
table must have been the height of fashion
at the time this painting was made. The
inscription on the letter she holds has given
rise to different interpretations. It may
simply refer to her cavalier, but if it is read
Cuvillère, then the sitter would be the
daughter of François Boucher, Fragonard's
teacher. Marie Emilie Boucher, born in 1740,
was widowed in 1769 and married, in 1773,
her father's friend, the architect Charles
Étienne Gabriel Cuvillier.

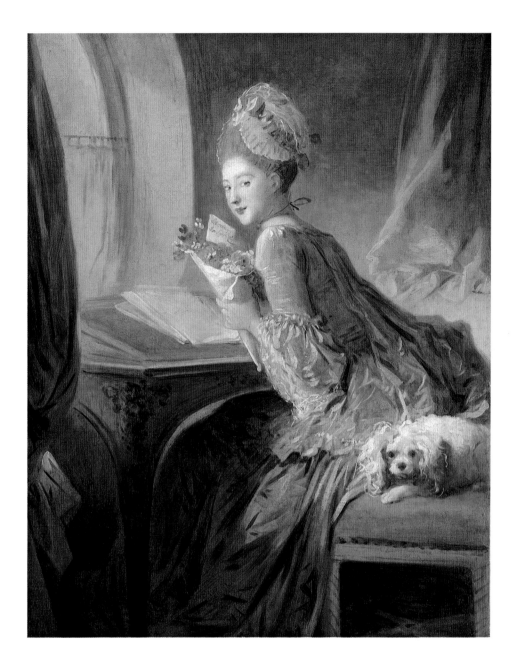

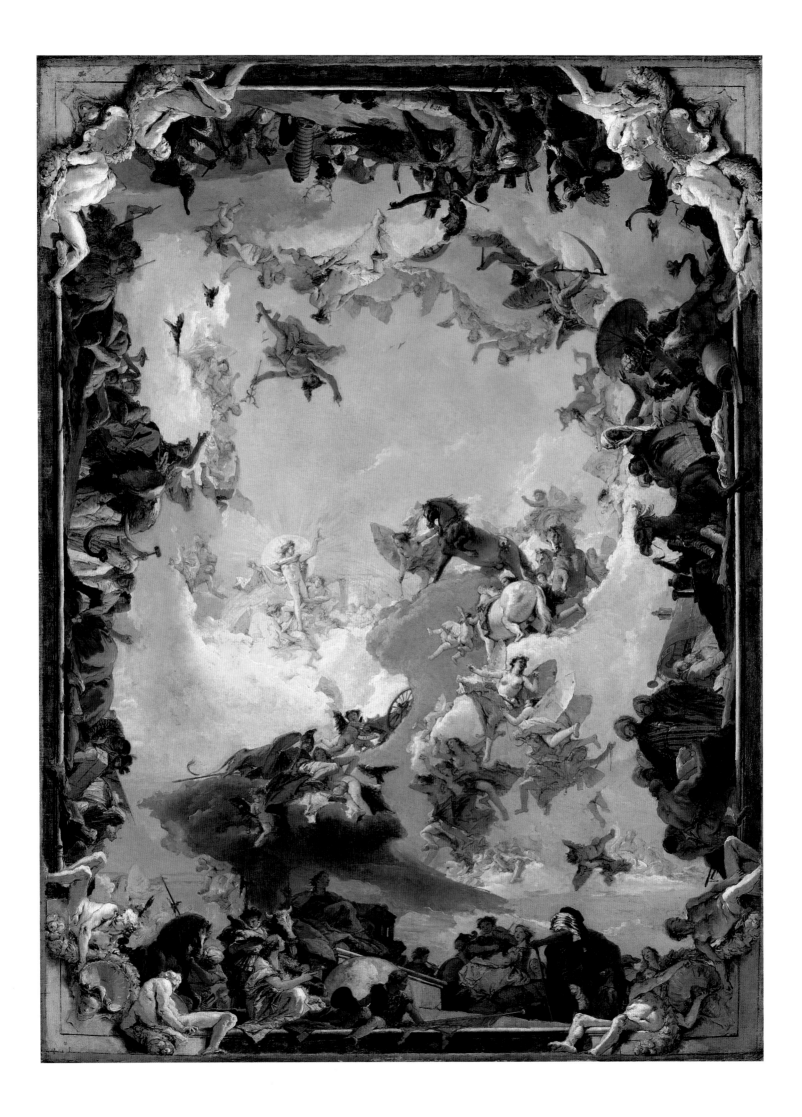

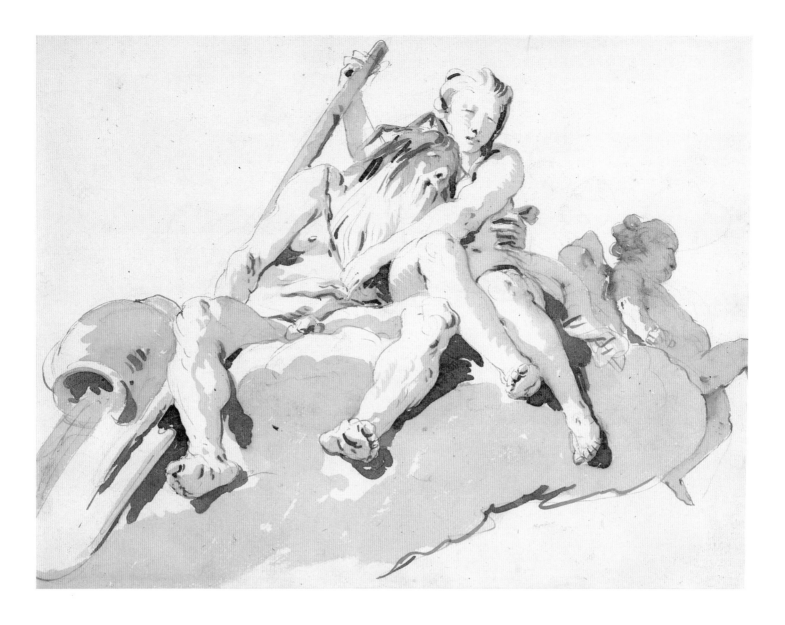

(OPPOSITE)

Giovanni Battista Tiepolo

Venetian, 1696–1770

ALLEGORY OF THE PLANETS AND
CONTINENTS, 1752

———

Oil on canvas; 73 × 54⅞ in.
(185.4 × 139.4 cm)
Gift of Mr. and Mrs. Charles Wrightsman,
1977 (1977.1.3)

———

Giovanni Battista Tiepolo was the most
famous Italian painter of the 18th century.
His greatest achievement was the
decoration of the palace of Carl Philipp von
Greiffenklau, prince-bishop of Würzburg,
carried out between 1751 and 1753. This
painting is the model presented by Tiepolo
on April 20, 1752, for the celebrated fresco
over the staircase of the palace. It shows
Apollo about to embark on his daily course
across the sky; the deities around him

symbolize the planets, and the allegorical
figures on the cornice represent the four
continents of the world. Numerous changes
were made between the model and the
fresco, but this painting shares with the
completed ceiling the feeling for airy space,
the beautiful colors, and the prodigious
inventiveness for which Tiepolo is admired.

Giovanni Battista Tiepolo

Venetian, 1696–1770

RECLINING RIVER GOD, NYMPH,
AND PUTTO, ca. 1740

———

Pen and brown ink, dark brown and lighter
brown wash, over black chalk; 9¼ × 12⅝ in.
(23.5 × 31.3 cm)
Rogers Fund, 1937 (37.165.32)

———

This drawing is one of many sketches
Tiepolo made for another important ceiling

decoration, *The Course of the Chariot of the
Sun*, in the Palazzo Clerici in Milan, painted
in 1740. The river god and nymph in this
drawing, atop a luminous cloud and bathed
in brilliant sunlight, appear without the
putto and the oar on the south cornice. A
feeling of the celestial is conveyed here
through Tiepolo's skill as a draftsman. The
golden brown color of the wash and his use
of the white of the paper to suggest the
highlights are characteristic of his drawing
technique.

British and French, 1760–71

TAPESTRY ROOM FROM CROOME
COURT, WORCESTERSHIRE

Gift of Samuel H. Kress Foundation, 1958
(58.75.1a)

George William, sixth earl of Coventry, commissioned this room jointly from his architect Robert Adam and from Jacques Neilson, head of the Gobelins Manufactory in Paris. It was the first of a series of four Gobelins Tapestry Rooms designed by Adam for English houses in the 1760s and early 1770s, which were greatly admired for the sumptuous effect of crimson ground tapestries on the walls and coverings on the furniture. The two tapestries visible in this photograph contain medallions representing *Vertumnus and Pomona as an Allegory of Earth* (left) and *Neptune Rescuing Anemone as an Allegory of Water*, after designs by François Boucher. The set of six armchairs, two settees, and pier table and mirror was carved in 1769 by the London firm of John Mayhew and William Ince. The plaster ceiling, oak floor, marble mantelpiece, carved paneling, and mahogany doors are all original to the room.

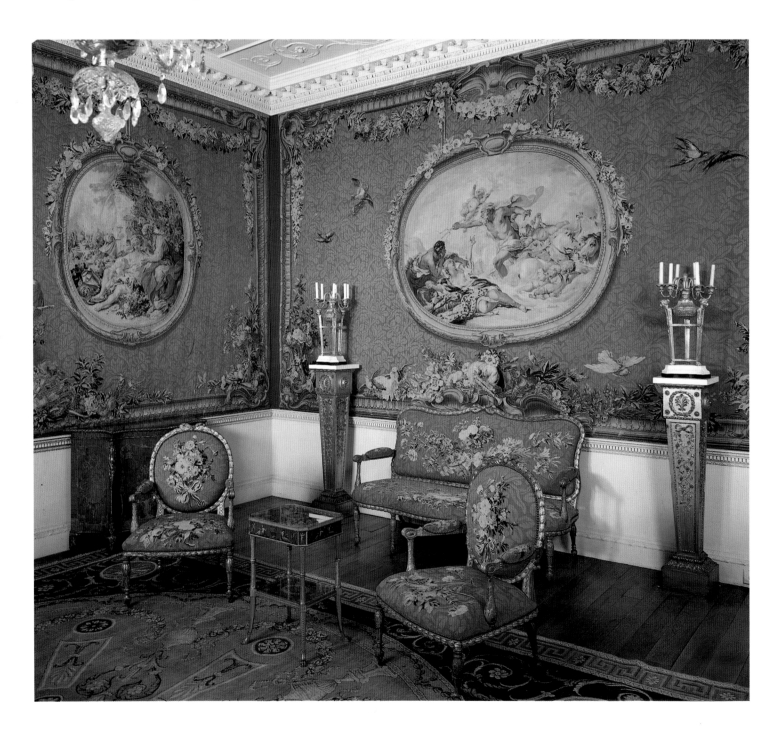

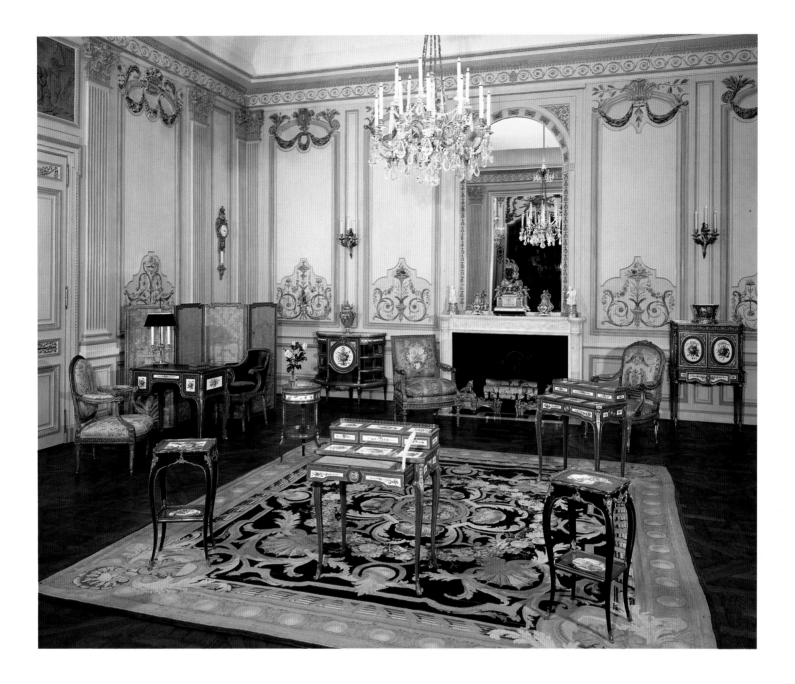

French, 18th century
SÈVRES ROOM

Purchase, Mr. and Mrs. Charles Wrightsman
Gift, 1976 (1976.91.1,2)

The Louis XVI-style paneling in this room,
part of an unidentified French room setting
of about 1770, was acquired in the third
quarter of the 19th century by a Parisian
bibliophile and collector for his house on
the Ile Saint Louis, the Hôtel Lauzun. It was
dismantled and sold in 1905, and after its
acquisition by the Museum in 1976, the
paneling was painted in a range of

naturalistic colors and combined with
elements from other sources to create the
present room. Of particular note are the
marble chimneypiece, the overmantel
mirror frame, and three *grisaille* overdoor
paintings emblematic of spring, summer,
and winter. The Museum's collection of
French furniture mounted with Sèvres
porcelain plaques, which numbers 27 pieces,
is the richest of any public institution in the
world. The inclusion of many of these in the
furnishings of this room, together with
Sèvres vases, has earned its designation as
the "Sèvres Room."

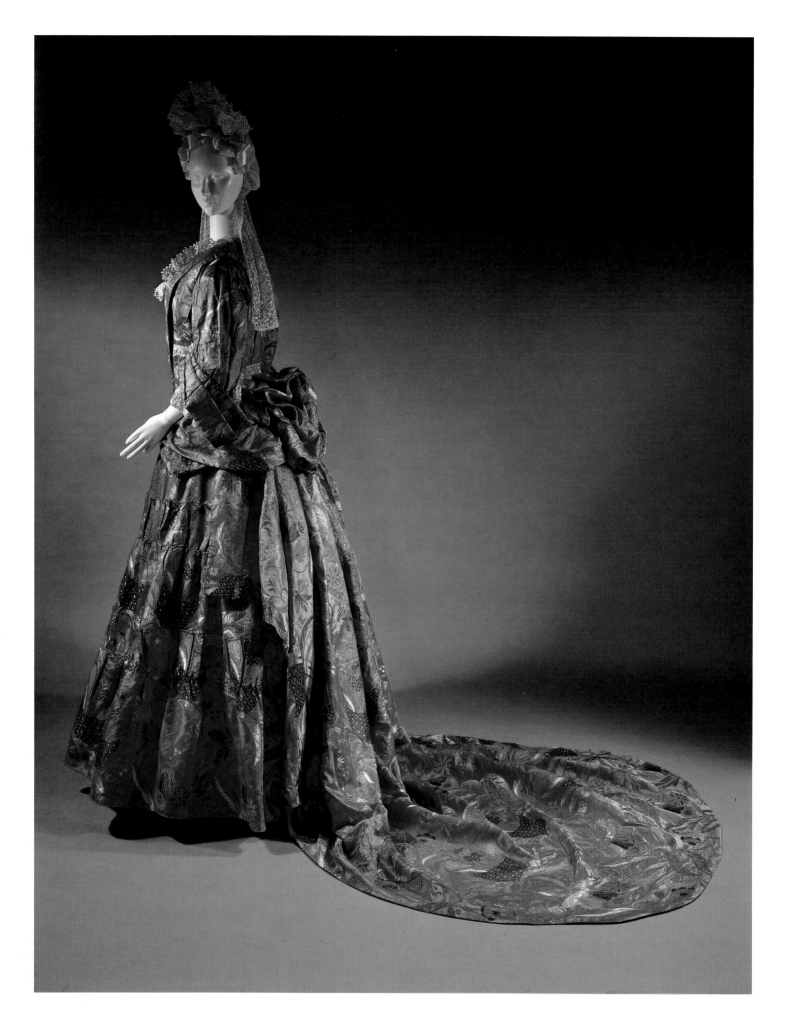

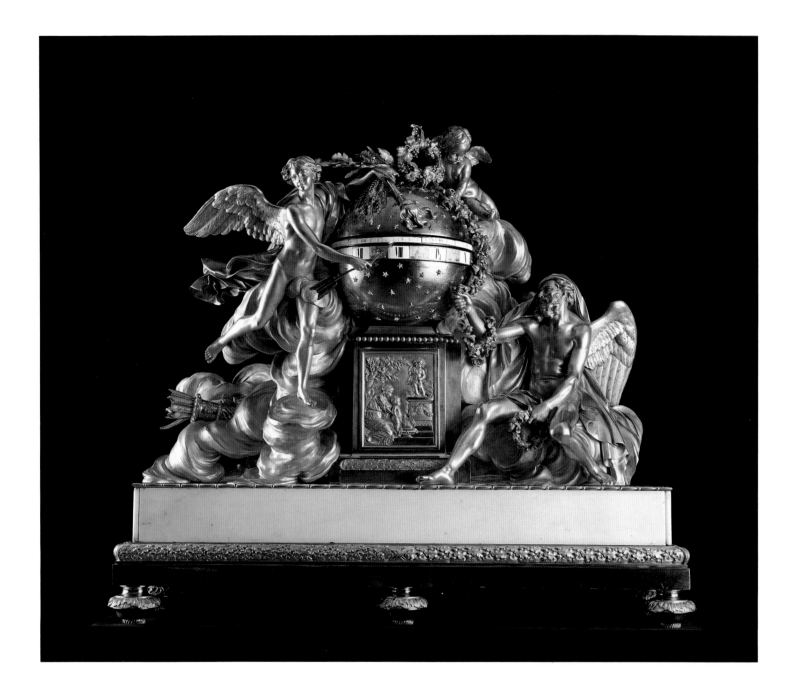

British (Derbyshire), ca. 1706–8
MANTUA AND PETTICOAT

Silk satin damask (probably French), brocaded with polychrome silk floss and two kinds of metal-wrapped thread; L. (center back) 104½ in. (265.4 cm)
Purchase, Rogers Fund, Isabel Shults Fund, and Irene Lewisohn Bequest, 1991 (1991.6.1ab)

In the 1670s the mantua first appeared as an informal gown, a welcome alternative to rigidly boned bodices and heavily pleated trained skirts open at the front over a petticoat. Louis XIV prohibited the mantua at Versailles, but it gained widespread popularity. This superb example is the earliest complete and unaltered 18th-century mantua known to exist. The fabric is one of the so-called bizarre silks, produced only between 1695 and 1720. It is remarkable to have such an expansive quantity of this rare silk survive in its original usage.

French, ca. 1775–80
MANTEL CLOCK

Case: gilt bronze, marble, and gilded copper; H. 37 in. (94 cm)
Gift of J. Pierpont Morgan, 1917 (17.190.2126)

French clock cases were often related to the sculpture and small decorative objects of the 18th century, a fashion that continued into the reign of Louis XVI, when Rococo forms and asymmetry were superseded by more formal Neoclassical structures. This clock represents a transition, being both more monumental and clearly structured than the Rococo and more playful than a true Neoclassical design. Together, the three bronze figures—Eros, a cherub, and Father Time—represent the Triumph of Love over Time.

Nicholas-Noel Boutet

French, 1761–1833

FLINTLOCK RIFLE, ca. 1800

Steel, walnut, silver, gold; L. 43½ in.
(110.5 cm)
Fletcher Fund, 1970 (1970.179.1)

Like French politics and fashion, French gunmaking set the style for the rest of Europe in the 17th and 18th centuries. This tradition continued in post-revolutionary France, where Boutet reigned as the dictator of firearms design. Named *directeur-artiste* of the new state arms factory at Versailles in 1793, Boutet oversaw not only the production of military weapons for the army but also the creation of sumptuously decorated arms for presentation to heroes and statesmen. The finely crafted gold or silver mounts are of the elegant Neoclassical style so typical of the art created during the age of Napoleon.

British (London), ca. 1840

PIANO

Wood, metal, and various other materials;
H. 37½ in. (95.3 cm)
Gift of Mrs. Henry McSweeney, 1959 (59.76)

Erard & Company, the London branch of the famous Parisian firm of harp and piano makers, built this magnificent piano for the wife of the third Baron Foley. The keys and pedals seem scarcely to have been touched, so we can surmise that this fine instrument was kept merely as an emblem of culture and status. No other piano so richly decorated is known from the period. The marquetry of dyed and natural woods, engraved ivory, mother-of-pearl, abalone, and wire illustrates many musical scenes and trophies as well as animals, grotesque figures, floral motifs, dancers, Greek gods, and the Foley arms. The decor was executed by George Henry Blake, of whom nothing is known. The mechanism, patented by Erard, is the direct ancestor of the modern grand "action," which allows great power and rapidity in technique; hence, Erard's pianos were favored by virtuosi such as Franz Liszt.

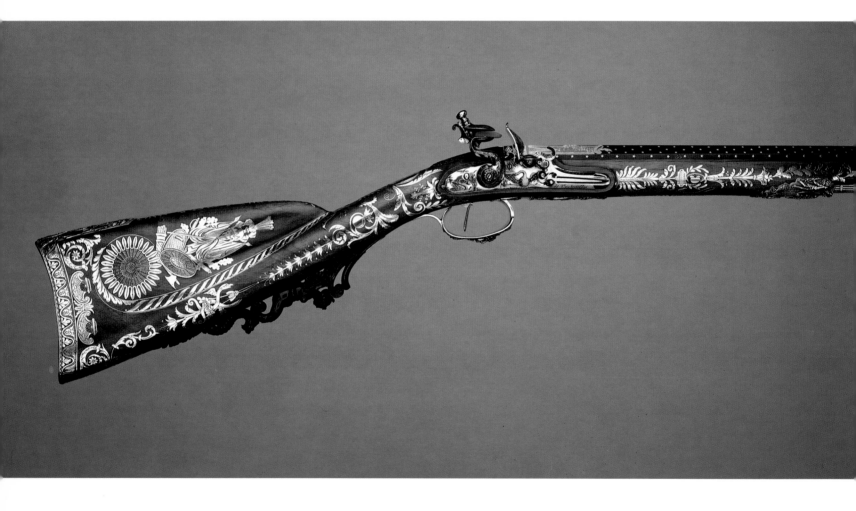

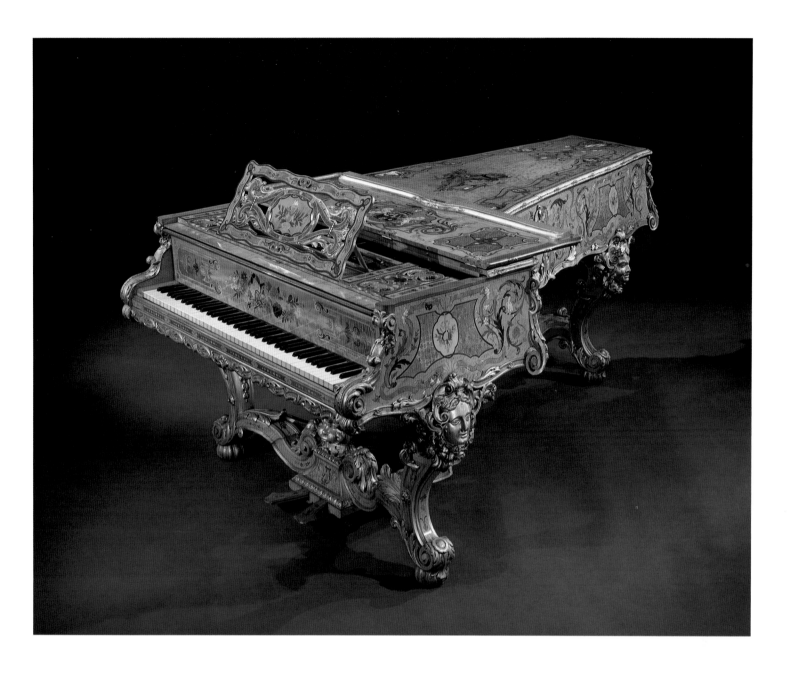

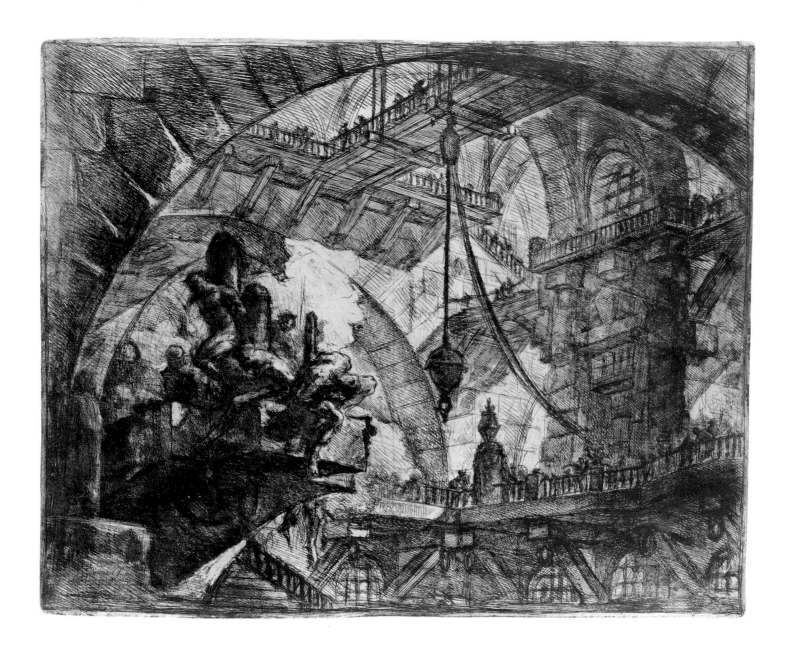

Giovanni Battista Piranesi

Italian, 1720–1778

PRISONERS ON A PROJECTING
PLATFORM, 1749–60

Etching with engraving, sulphur tint or open
bite, burnishing (first state of two);
16½ × 21¾ in. (41.9 × 55.2 cm)
Harris Brisbane Dick Fund, 1937 (37.45.3 [33])

Although a native of Venice, Piranesi went
to Rome at 20 and spent most of his life in
that ancient city that was to inspire most of
his nearly one thousand etchings. He
studied architecture, engineering, and stage
design, and his best-known series, *Carceri*
(Prisons), consisted of 14 plates depicting
stage prisons that he himself described as
"capricious inventions." The spatial and
architectural ambiguities, as well as the
dramatic use of light and form, are
characteristic of this series.

Francisco de Goya y Lucientes

Spanish, 1746–1828

THE GIANT, 1818

Aquatint with burnishing (first state);
11½ × 8¼ in. (29.2 × 21 cm)
Harris Brisbane Dick Fund, 1935 (35.42)

Goya was a fashionable and successful painter of royal portraits and tapestry cartoons when in 1799, three years after surviving a nearly fatal illness, he published a set of 80 satirical etchings called *Los Caprichos*, now the best known of his prints. He went on to produce three other sets of etchings, and at the age of 80 in Bordeaux, he took up the brand-new medium of lithography and created some of the greatest lithographs ever made. This print is not part of any series, although it was done during the period of *The Disasters of War*, between 1810 and 1820, while Spain was devastated first by the armies of Napoleon and then by famine and civil disorder. *The Giant*, of which only six impressions are known, stands out as the most monumental and powerfully sculptural single figure among his dramatic etchings. It resembles the "black paintings" that Goya painted about 1820 on the walls of his house near Madrid. *The Giant* announces not only 19th-century Impressionism but also 20th-century Surrealism and Expressionism.

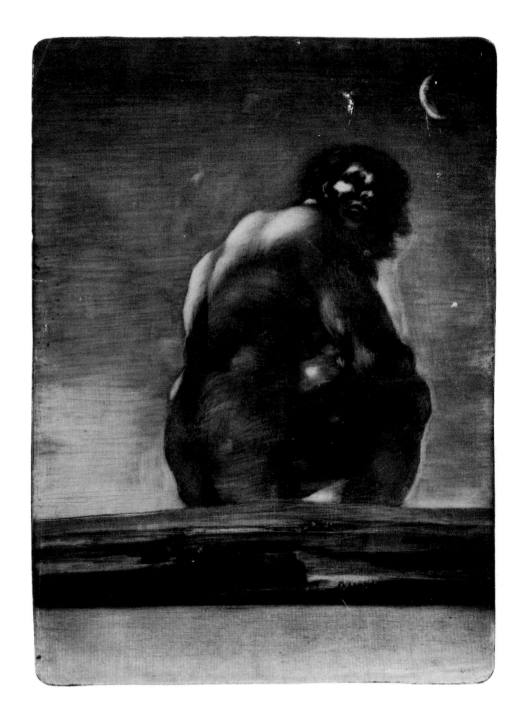

Jean-Antoine Houdon

French, 1741–1828

ROBERT FULTON, ca. 1803

Plaster; H. 27 in. (68.5 cm)
Wrightsman Fund, 1989 (1989.329)

Houdon made over 150 portrait busts of the great men and women of his age, combining psychological perception with analytical reason to bring out the individual character of each sitter. His portraits of important Americans remain definitive. He portrayed Benjamin Franklin in Paris and later visited the young United States, where he was commissioned to make busts of Thomas Jefferson and George Washington. Robert Fulton, an inventor, artist, and engineer best known for having proved the commercial practicality of the steamboat, lived in Paris from 1797 to 1806. He made his first steamboat test on the Seine in 1803 before returning to America; he also invented a submarine, the Nautilus, while still in France, although he was unable to get support from the French or American governments for its development.

Antonio Canova

Italian, 1757–1822

PERSEUS WITH THE HEAD OF
MEDUSA, 1804–6

Marble; H. 86⅝ in. (217 cm)
Fletcher Fund, 1967 (67.110.1)

Canova, the preeminent sculptor of the age of Neoclassicism, was a prodigiously talented carver of marble. In Canova's hands the stone yielded brilliant effects, both pristine and sensual, fulfilling the notions of a classical past embraced by his contemporaries. Here Perseus stands coolly triumphant, holding up the severed head of the snake-haired gorgon Medusa, the sight of which will turn anyone into stone for gazing on it. The pose vividly recalls the *Apollo Belvedere*, the work of antiquity most admired in Canova's era. The first version of the *Perseus* was acquired by Pope Pius VII as a replacement for the *Apollo* itself, which Napoleon had removed from the Vatican and shipped to the Louvre in Paris. The *Perseus* was so successful that it remained as a companion to the returned Apollo when the Congress of Vienna compelled the restitution of the Napoleonic booty. The Museum's version was purchased from Canova by the Polish countess Valeria Tarnowska.

Jean-Auguste-Dominique Ingres
French, 1780–1867

PRINCESSE DE BROGLIE, 1851–53

Oil on canvas; 47¾ × 35¾ in.
(121.3 × 90.8 cm)
Robert Lehman Collection, 1975 (1975.1.186)

Ingres was Jacques-Louis David's most celebrated pupil. His severe classical style and his meticulous working procedure epitomized the academic tradition, which he defended vehemently against the French Romantic movement, led by Eugène Delacroix. As a young man, he supported himself almost exclusively with commissioned portraits, but later in his life he hoped to renounce them for "grander things." Nevertheless, the last series of aristocratic portraits he made, between 1845 and 1853, were among the greatest achievements of his maturity.

The princesse de Broglie (1825–1860) was a great beauty and a highly respected woman, the embodiment of the best of the Second Empire aristocracy. Ingres began her portrait in 1851; after accepting the commission he wrote to a friend that it would be his last except for that of his wife. The painting completes his series of aristocratic portraits and is a supreme example of the mastery of technique, the bold use of color, and the understanding of female character for which Ingres is so justly celebrated.

Jacques-Louis David

French, 1748–1825

THE DEATH OF SOCRATES, 1787

———

Oil on canvas; 51 × 77¼ in.
(129.5 × 196.2 cm)
Wolfe Fund, Catharine Lorillard Wolfe
Collection, 1931 (31.45)

———

At the approach of the French Revolution, when Greek and Roman civic virtues were extolled as salutary antidotes to the degeneracy of the Old Regime, David triumphed at the Salon with a succession of works, including this one, that gave clear expression to the moral and philosophical principles of his time. Socrates was accused by the Athenian government of impiety and corrupting the young through his teachings; he was offered the choice of renouncing his beliefs or being sentenced to death for treason. Faithful to his convictions and obedient to the law, Socrates chose to accept his sentence. Here Socrates reaches for the cup of poisonous hemlock while he discourses on the immortality of the soul. *The Death of Socrates* became a symbol of republican virtue and was a manifesto of the Neoclassical style.

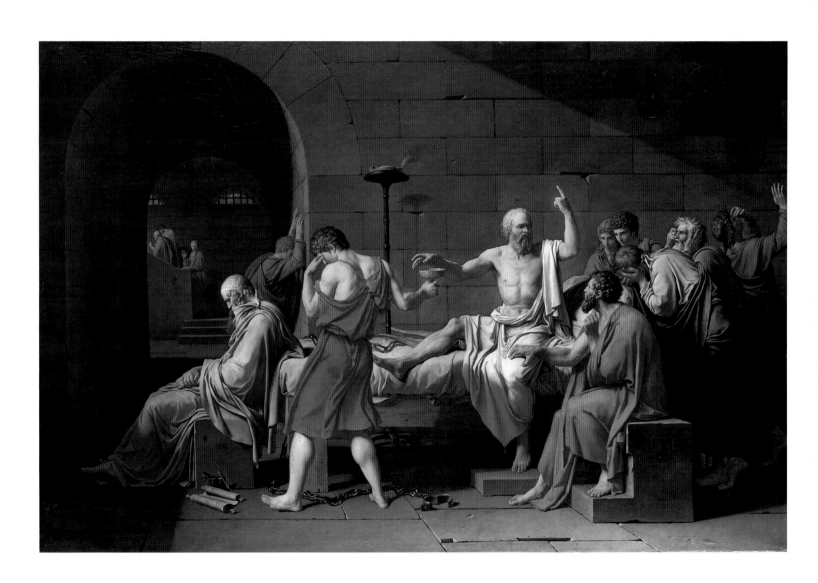

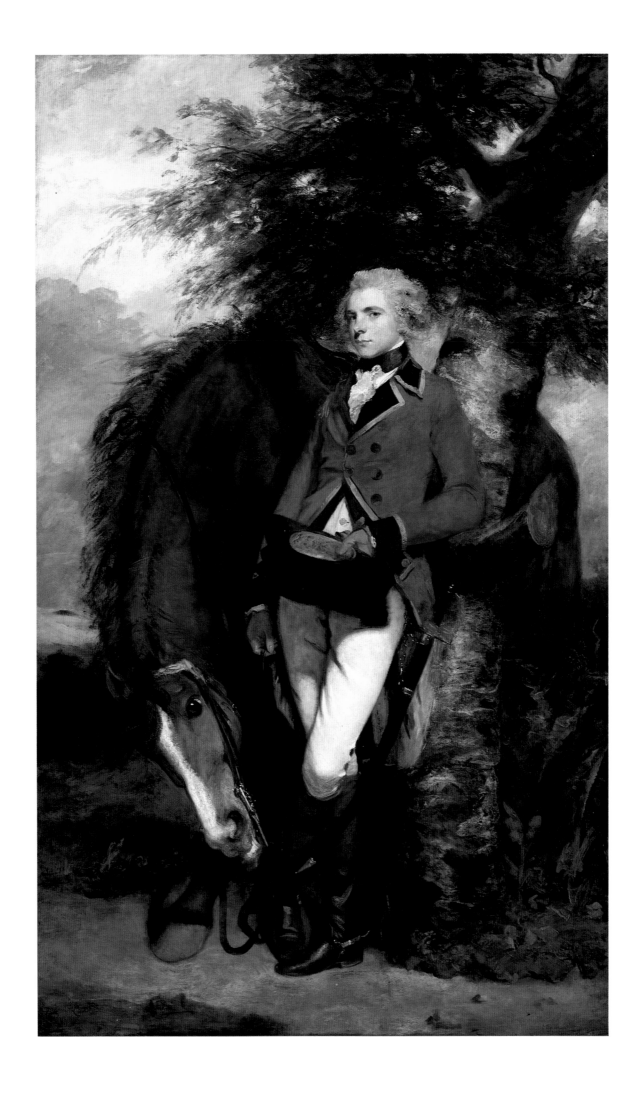

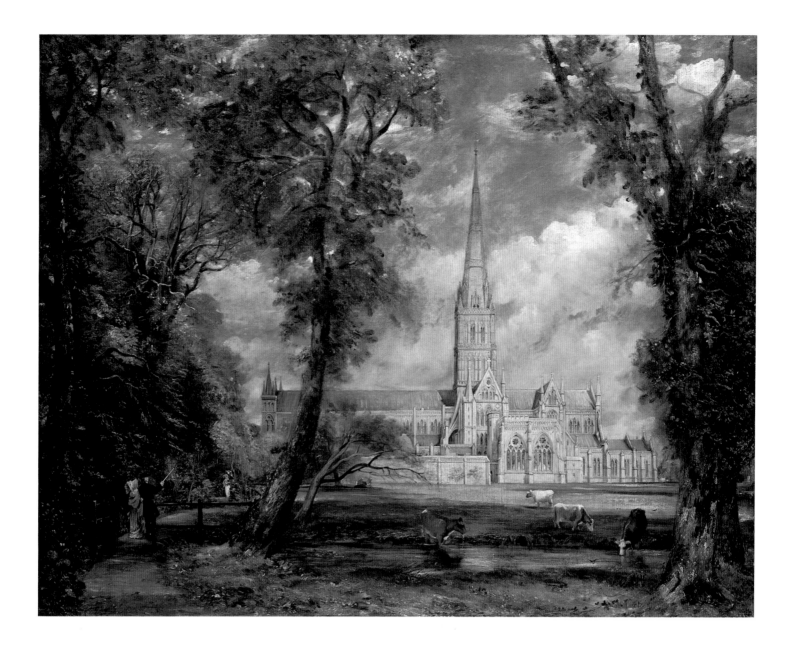

Sir Joshua Reynolds

British, 1723–1792

COLONEL GEORGE K. H.
COUSSMAKER, GRENADIER
GUARDS, 1782

Oil on canvas; 93¾ × 57¼ in.
(238.1 × 145.4 cm)
Bequest of William K. Vanderbilt, 1920
(20.155.3)

Reynolds was the first president of the Royal
Academy and the author of 15 discourses on
painting, which are classics of the theory of
art. In this dismounted equestrian portrait,
Reynolds presents Colonel Coussmaker in a
pose of casual but studied negligence, the
line of his body repeated in the curving neck
of the horse. The summer before Reynolds
painted the portrait, he traveled to Flanders
and Holland and profited by his observation
of Rubens's works, especially in the creation
of a free and painterly surface treatment.

John Constable

British, 1776–1837

SALISBURY CATHEDRAL FROM THE
BISHOP'S GROUNDS, ca. 1820

Oil on canvas; 34⅝ × 44 in.
(87.9 × 111.8 cm)
Bequest of Mary Stillman Harkness, 1950
(50.145.8)

Constable in his day was the preeminent
painter of the English landscape, and
although he never achieved the
overwhelming success of his contemporary
Turner, his naturalist's vision and novel
painting technique had far greater impact
on the history of 19th-century painting. In
1820 John Fisher, bishop of Salisbury,
commissioned Constable to paint the view
of Salisbury Cathedral now in the Victoria
and Albert Museum. The artist painted a
small replica of it in 1823 and a highly
finished variant in 1826. The first of these
pictures is in the Huntington Library and
Art Gallery, San Marino, California, and the
second is in the Frick Collection, New York.
The present picture is a full-scale sketch for
the version in the Frick. The figures on the
left are the bishop and his wife.

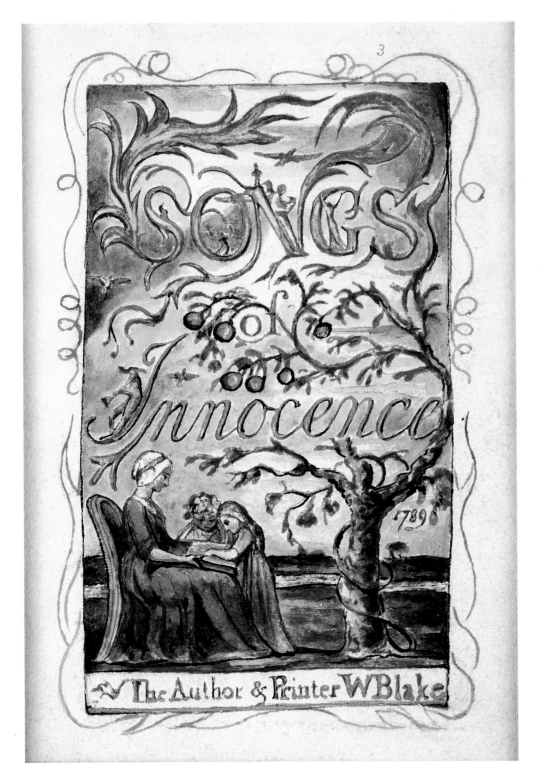

William Blake

British, 1757–1827

Title page from *Songs of Innocence*

———

Relief etching, hand-painted with watercolor
and gold; sheet: 6 × 5½ in. (15.2 × 14 cm)
Rogers Fund, 1917 (17.10.3)

———

William Blake is the only artist of his rank
who is even better known as a poet, and
some of his most pleasing works are those
he called "illuminated printing," which fuse
picture and word to form a completely
integrated and completely personal result.
Songs of Innocence, published in 1789,
comprises 31 illuminated poems; the book
was republished in 1794 with *Songs of
Experience*, with 54 plates in all. Blake's
books are similar to 15th-century
blockbooks, so called because for each page
the letters were, like the images, carved
from the block rather than printed from
movable type. Blake printed his plates in
one color only, here a bright red-brown. The
pages were then painted, perhaps by Blake
himself, in watercolors and gold, so every
copy of the book is unique. The colors and
gold are especially brilliant in this copy.
Blake kept the plates and produced these
books over a long period of time, probably
according to demand. The watermark on 12
leaves of the Metropolitan's copy includes
the date 1825, indicating that it was made in
or after that year.

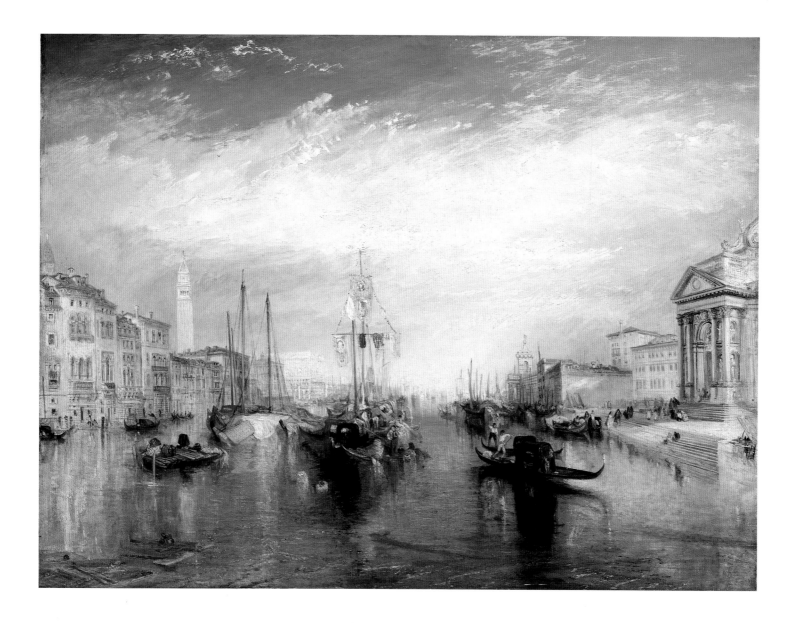

Joseph Mallord William Turner
British, 1775–1851

THE GRAND CANAL, VENICE, 1835

Oil on canvas; 36 × 48⅛ in.
(91.4 × 122.2 cm)
Bequest of Cornelius Vanderbilt, 1899 (99.31)

Turner grew from a young art student trained in executing topographical watercolors to the creator of some of the most original landscapes of his time. On his second visit to Venice, probably in September 1833, he created a series of views of the city that betray on the one hand an ardent interest in recording what he saw and, on the other, a Romantic sensibility that suffused his pictures with a sense of the grandeur of nature and of its magnificent light and color. This picture is based in part on a pencil drawing made during Turner's first trip to Venice in August 1819 and combines two viewpoints along the Grand Canal. It was shown with four other works in May 1835 at the Royal Academy, where it was well received as one of his "most agreeable works."

Honoré Daumier
French, 1808–1879
THE THIRD-CLASS CARRIAGE,
1863–65

———

Oil on canvas; 25¾ × 35½ in.
(65.4 × 90.2 cm)
H. O. Havemeyer Collection, Bequest of
Mrs. H. O. Havemeyer, 1929 (29.100.129)

In 1893 Daumier began to depict groups of
people in public conveyances and waiting
rooms, and for more than two decades he
treated these themes in lithographs,
watercolors, and oil paintings. His
characterizations of travelers document the
period in the mid-19th century when the
cities of France and their inhabitants were
undergoing the immense changes brought

about by industrialization. A lifelong social
critic, Daumier was able to infuse his
renderings of contemporary life with a
broad significance that touched on the inner
character of mankind.

(OPPOSITE)
Eugène Delacroix
French, 1798–1863
THE ABDUCTION OF REBECCA, 1846

———

Oil on canvas; 39½ × 32¼ in.
(100.3 × 81.9 cm)
Catharine Lorillard Wolfe Collection, Wolfe
Fund, 1903 (03.30)

———

As a rich source for exotic and dramatically
violent themes, the novels of Sir Walter

Scott were immensely popular with
Romantic painters. Delacroix, despite his
reservations about their literary merit,
repeatedly found inspiration in these
writings. This picture, painted in 1846 and
exhibited in the Salon of that year, illustrates
an episode from Scott's *Ivanhoe*, in which
the beautiful Rebecca is carried off by two
Saracen slaves at the command of the
Christian knight who has long coveted her.
Intense drama is created as much by the
contorted poses and compacted space as by
the artist's use of vivid color. Contemporary
critics, including Baudelaire, praised the
work's spontaneity and power.

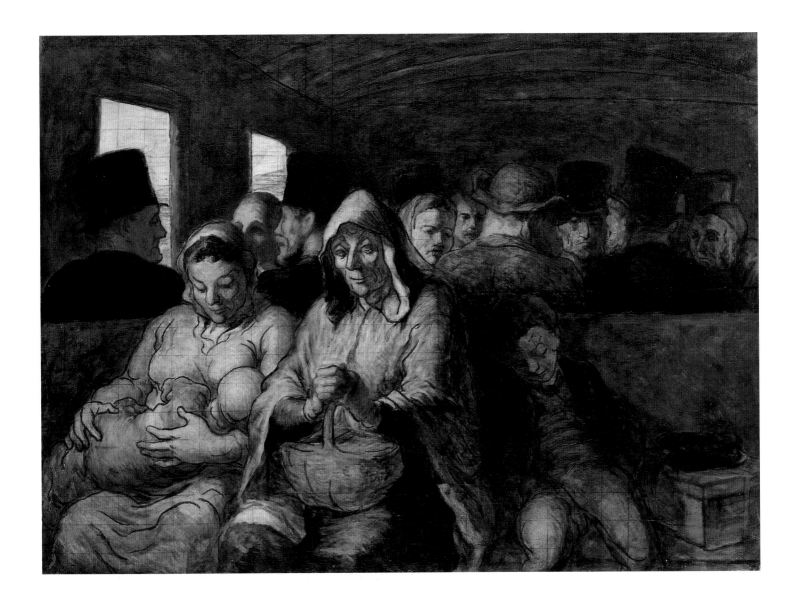

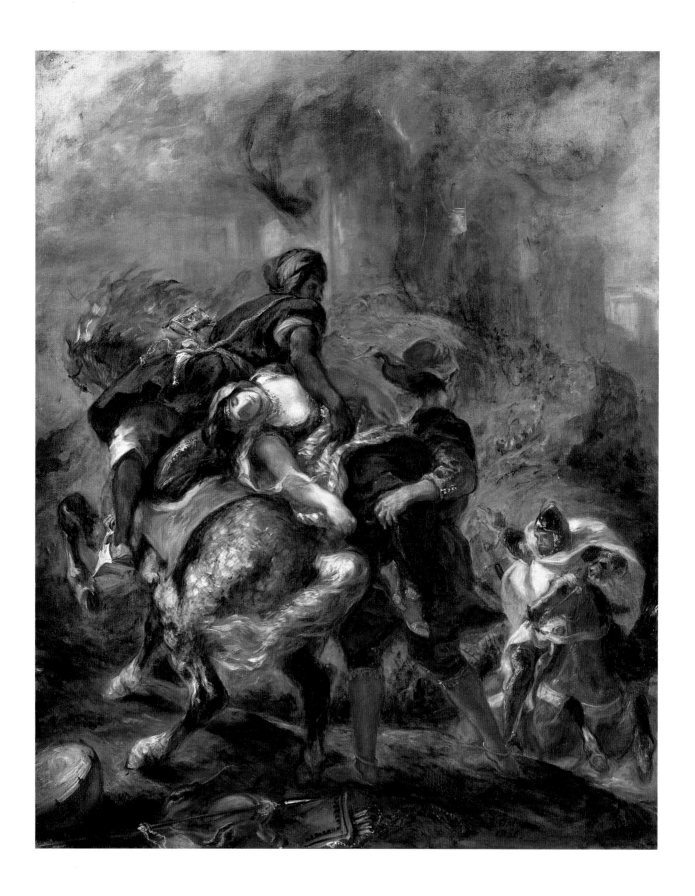

Gustave Courbet

French, 1819–1877

WOMAN WITH A PARROT, 1865–66

Oil on canvas; 51 × 77 in. (129.5 × 195.6 cm)
H. O. Havemeyer Collection, Bequest of Mrs.
H. O. Havemeyer, 1929 (29.100.57)

Like the odalisques and classical nudes made fashionable by official artists, the erotic content of Courbet's *Woman with a Parrot* appealed to Second Empire taste. Yet Courbet's mastery of flesh—his use of subtly varied pigments in the modeling of the female body—added an illusion of reality that left behind frigid academicism while it approached the sensuality of Renoir's nudes. This sense of realism was Courbet's failing, in the eyes of some contemporary critics. When the painting was shown at the Salon of 1866, critics censured the artist's "lack of taste" as well as the model's "ungainly" pose and "disheveled" hair. Nevertheless, Courbet continued to regard this as one of his great successes, and it also seems to have made quite an impression on Édouard Manet, who in 1866 painted his own version of the subject (also in the Metropolitan's collection). Paul Cézanne also must have admired the painting, for it is said that he carried a small photograph of it in his wallet.

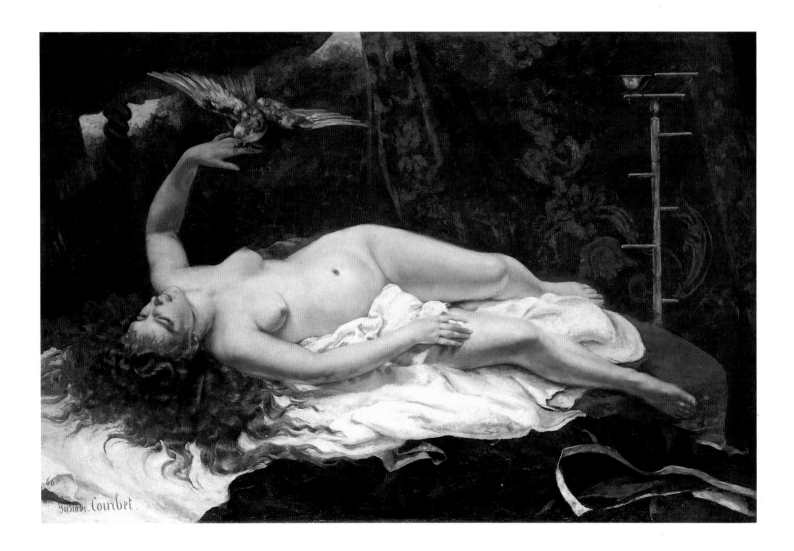

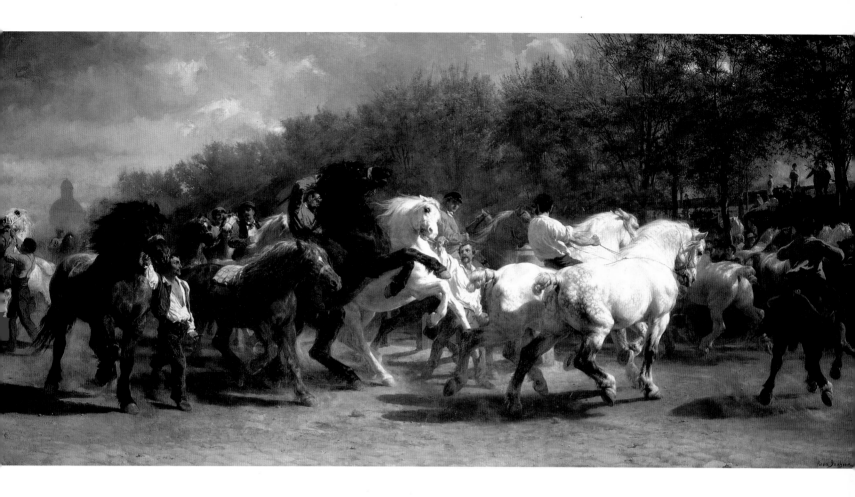

Rosa Bonheur

French, 1822–1899

THE HORSE FAIR, 1851–53

Oil on canvas; 96¼ × 199½ in.
(244.5 × 506.7 cm)
Gift of Cornelius Vanderbilt, 1887 (87.25)

When Rosa Bonheur exhibited this painting at the Salon of 1853, it was a resounding success. She was already well known for her use of movement, dramatic lighting, and fresh and direct observation, but few of her works achieved the dash and grandeur of *The Horse Fair*, and none attained the same degree of acclaim. It was vastly admired on the Continent, where it was exhibited in Paris, Ghent, and Bordeaux; subsequently, the painting was shown in England and the United States, becoming one of the best-known works of art.

The Horse Fair was preceded by numerous drawings and at least three painted studies that document the artist's exploration of various compositional solutions to the subject. Twice a week for a year and a half she went to the horse market of Paris to make sketches, dressed as a man so as not to attract attention. In arriving at the final scheme, she drew inspiration from the Parthenon frieze, from the noted animal painters Stubbs and Delacroix, and especially from Gericault. Later Bonheur referred to *The Horse Fair* as her own "Parthenon frieze." The painting was apparently retouched by the artist in 1855, repainting passages in the ground, the trees, and the sky that had been criticized for their summary execution when the painting was shown at the Salon.

Jean Baptiste Camille Corot
French, 1796–1875

VILLE-D'AVRAY

Oil on canvas; 21⅝ × 31½ in. (54.9 × 80 cm)
Catharine Lorillard Wolfe Collection,
Bequest of Catherine Lorillard Wolfe, 1887
(87.15.141)

After the mid-1840s, Corot spent most of each year in the environs of Paris, especially at the family property in Ville-d'Avray. The landscapes painted here—views of wooded glades delicately modeled in dull greens, browns, and an exquisite range of silvery grays, all veiled in misty light—won him considerable success during his lifetime. The popularity of such works as this may be related in part to the nostalgia for an arcadian past that was so much a part of contemporary French literature. Corot's late works reflect a vision of nature that combines a classicist's sense of serene order with a romantic's mood of reverie.

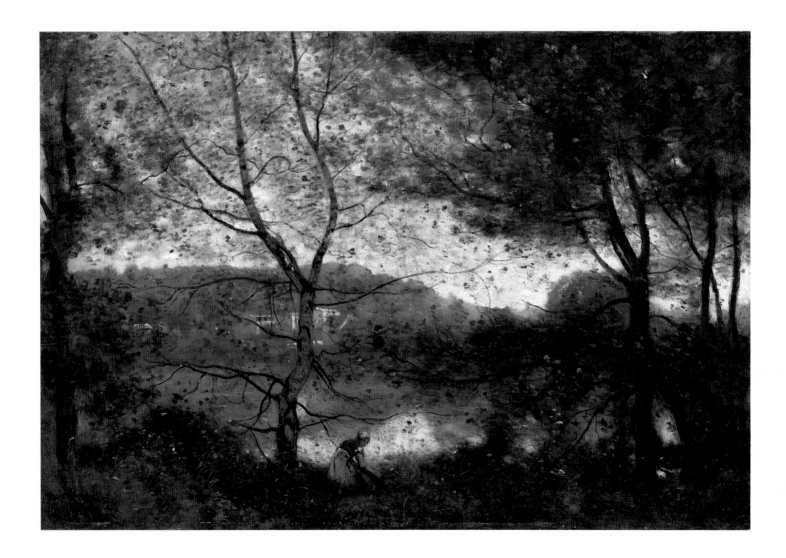

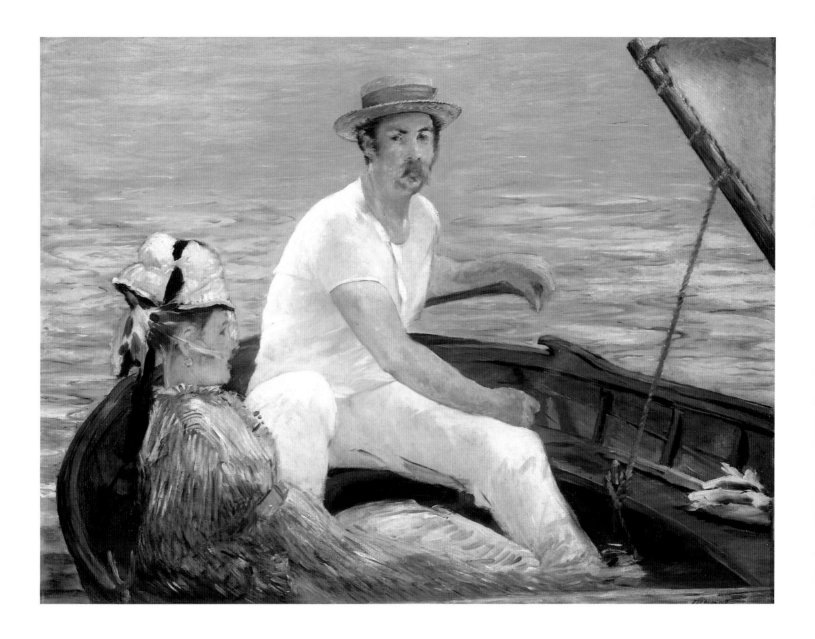

Édouard Manet

French, 1832–1883

BOATING, 1874

———

Oil on canvas; 38¼ × 51¼ in.
(97.2 × 130.2 cm)
H. O. Havemeyer Collection, Bequest of
Mrs. H. O. Havemeyer, 1929 (29.100.115)

———

Boating was painted during the summer of
1874, when Manet was working with Monet
and Renoir at Argenteuil, a village on the
Seine northwest of Paris. The influence of
the two young Impressionist painters on
Manet is evident in the subject matter—a
celebration of the everyday pleasures of the
middle class—and in the fact that Manet's
dark, Spanish palette has given way here to
high-keyed hues. The flattened
composition, in which the high viewpoint
causes the water's surface to rise up as a
backdrop, is cut off at the edges of the
canvas, reflecting Manet's interest, shared
with the Impressionists, in Japanese prints.

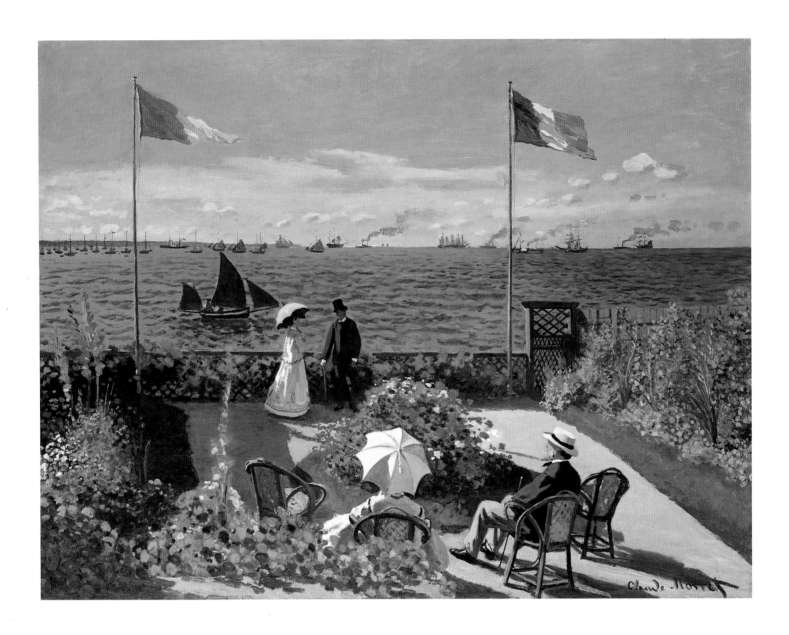

Claude Monet

French, 1840–1926

GARDEN AT SAINTE-ADRESSE, 1867

Oil on canvas; 38⅝ × 51⅛ in.
(98.1 × 129.9 cm)
Purchase, special contributions and funds
given or bequeathed by friends of the
Museum, 1967 (67.241)

A prime mover among the artists who came to be known as Impressionists, Monet spent the summer of 1867 at the French resort town of Sainte-Adresse on the English Channel. It was there that Monet painted this picture, which combines smooth, traditionally rendered areas with sparkling passages of rapid, separate brushwork and spots of pure color. Monet's father and aunt are seated in the foreground facing the sea. His cousin is seen standing with a man, possibly her father, in the middle ground. The direction of the sun tells us that it is mid-morning; the gladiolas tell us that it is mid-summer. The raised vantage point of the picture divides the composition into three horizontal registers that seem to rise parallel to the surface of the canvas rather than recede into space. The flagpoles serve to flatten the picture still further, as do the touches of red on the boat at the right. The tension between illusionism and the two-dimensional nature of the canvas remained an important characteristic of Monet's art throughout his career.

Pierre Auguste Renoir

French, 1841–1919

MADAME GEORGES CHARPENTIER
AND HER CHILDREN, 1878

Oil on canvas; 60½ × 74⅞ in.
(153.7 × 190.2 cm)
Catharine Lorillard Wolfe Collection, Wolfe
Fund, 1907 (07.122)

The publisher Georges Charpentier and his
wife, Marguerite Lemonnier, entertained
political, literary, and artistic notables on
Friday evenings, and they commissioned

Renoir to paint this beautifully composed
family portrait. Set in the small, or Japanese,
drawing room of the Charpentier's mansion
in the rue de Grenelle, Renoir depicts Mme
Charpentier with her three-year-old son,
Paul, whose godfather was Émile Zola, and
her six-year-old daughter, Georgette, who
sits on a big Newfoundland dog. Far more
elaborate than Renoir's other works of the
1870s, this painting marks the beginning of
his shift away from the classic Impressionist
style, with which he had made his
reputation only a few years before.

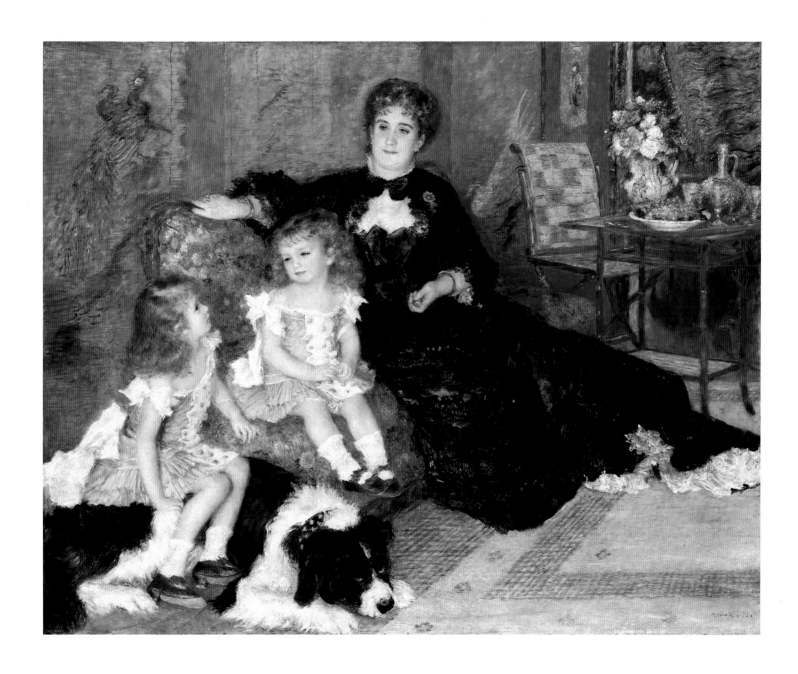

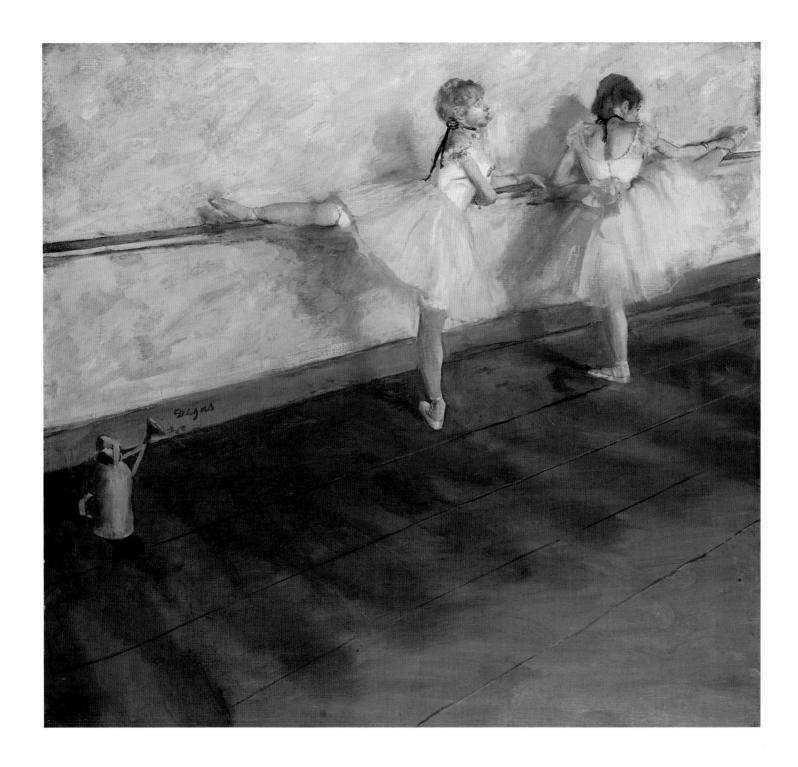

Edgar Degas

French, 1834–1917

DANCERS PRACTICING AT THE BAR,
1876–77

Oil colors mixed with turpentine on canvas;
29¾ × 32 in. (75.6 × 81.3 cm)
H. O. Havemeyer Collection, Bequest of
Mrs. H. O. Havemeyer, 1929 (29.100.34)

This painting appears to give a random
glance through an open door into a dance
studio. Far from being self-consciously
posed, the two ballerinas are spied
practicing at the bar, unaware of our
existence. Although the dancers appear to
be casually observed, the composition was
meticulously worked out. The artist's
fascination with form and structure is
reflected in the analogy between the
watering can (used to lay the dust on the
studio floor) and the dancer at the right.
The handle on the side imitates her left arm,
the handle at the top mimics her head, and
the spout approximates her right arm and
raised leg.

Edgar Degas

French, 1834–1917

LITTLE FOURTEEN-YEAR-OLD
DANCER, cast in 1922 from a sculpture
modeled ca. 1880

———

Bronze, partly tinted, with cotton skirt and
satin hair ribbon on a base of wood; H. 41¼ in.
(104.8 cm)
H. O. Havemeyer Collection, Bequest of
Mrs. H. O. Havemeyer, 1929 (29.100.370)

———

As in his painting, Degas aimed to change
the art of sculpture, turning to real life for
inspiration and experimenting with new
materials and techniques in order to gain his
desired effect. The use of everyday materials
was one of the most revolutionary aspects
of this work. While the Museum's bronze
figure wears a gauze skirt and satin hair
ribbon, the original tinted-wax sculpture
had a wax-covered linen bodice, satin
slippers, red lips, and even a horsehair wig.
The expression on the model's face is
strained, emphasizing the difficulty of her
artificial pose. When the sculpture was first
displayed in Paris at the Impressionist
exhibition of 1881, the extreme realism of
Little Dancer repelled many viewers, who
found the work brutal and coarse.

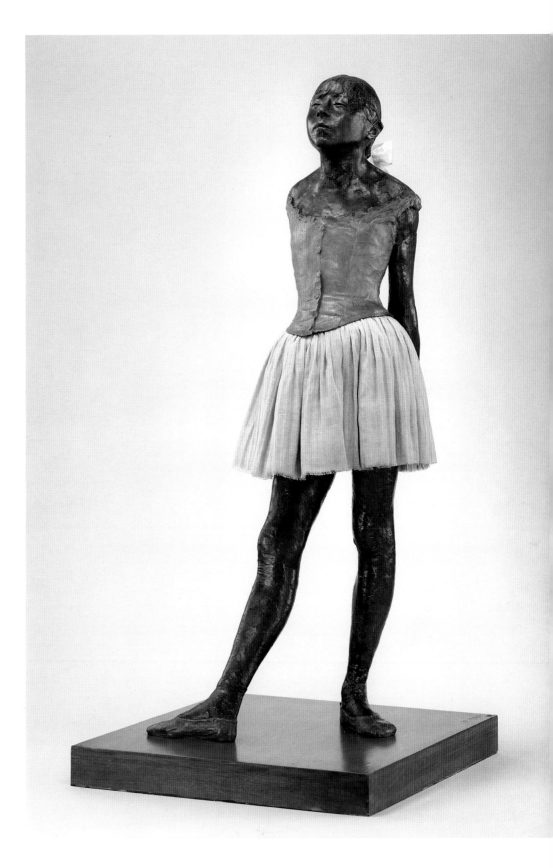

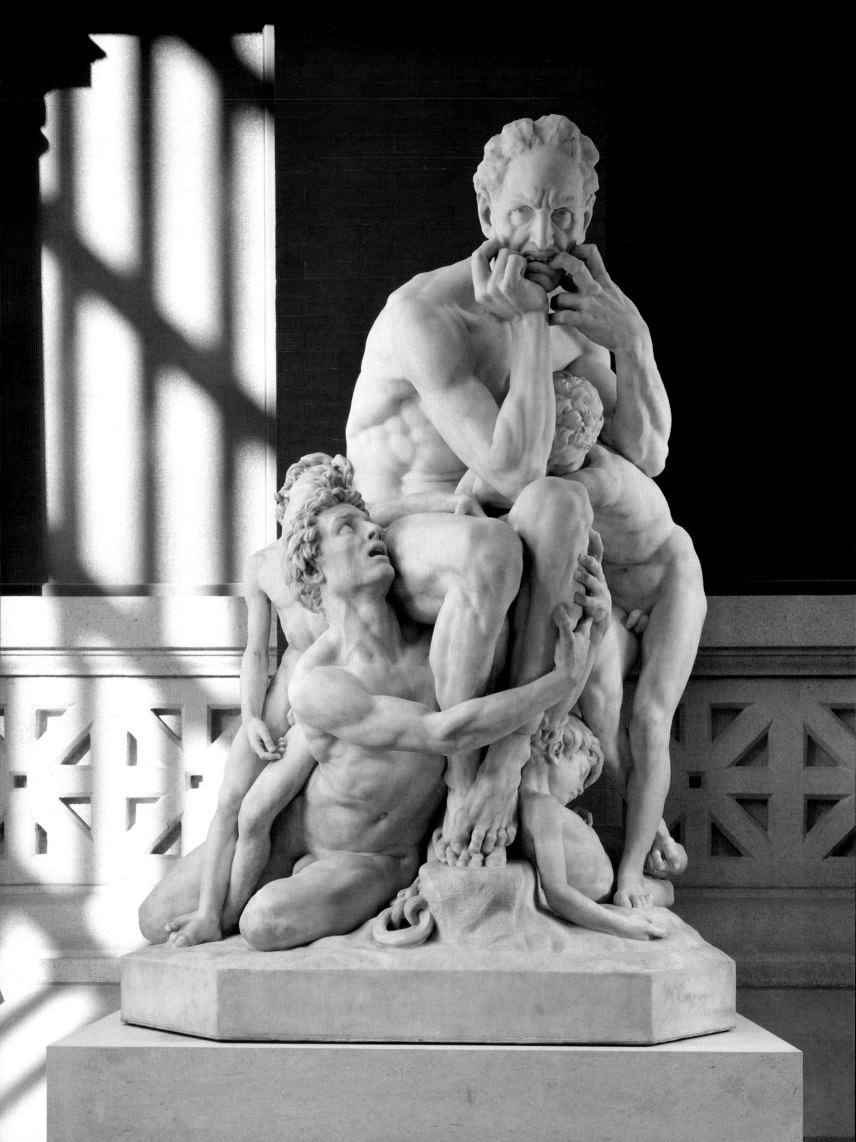

Jean Baptiste Carpeaux

French, 1827–1875

UGOLINO AND HIS SONS, carved in
1865–67 from a model of ca. 1860–61

Saint-Béat marble; H. 77 in. (195.6 cm)
Purchase, Fletcher Fund and Josephine Bay
Paul and C. Michael Paul Foundation, Inc.,
and Charles Ulrick and Josephine Bay
Foundation, Inc. Gift, 1967 (67.250)

This splendid sculpture epitomizes the
Romantic preoccupation with extreme
physical and emotional states. The subject is
taken from Dante's *Inferno*, in which a
suspected traitor, Count Ugolino della
Gherardesca, is condemned to die
imprisoned in a tower with his sons and
grandsons. Carpeaux has depicted the
moment at which the count. yielding to
hunger and despair, contemplates
cannibalism. The work, completed during
the last year of the sculptor's residence at
the French Academy in Rome, caused a
public sensation and immediately
established Carpeaux as the heir of the
French Romantic sculptors of the 1830s. He
developed a special reverence for
Michelangelo in Rome, and much of the
power of the *Ugolino* derives from *The Last
Judgment* in the Sistine Chapel.

Auguste Rodin

French, 1840–1917

ADAM, cast in 1910 or 1911 for the
Museum from a model of 1880

Bronze; H. 76¼ in. (193.7 cm)
Gift of Thomas F. Ryan, 1910 (11.173.1)

Rodin is probably the best-known sculptor
of the 19th century; in the later part of his
life he was immensely popular. Like
Carpeaux, he was deeply impressed by the
work of Michelangelo and drew on the
Sistine Chapel frescoes as a direct source of
inspiration. In the *Adam*, which shows the
first man being roused to life, Rodin
combined elements from the *Creation of
Man* in the Sistine Chapel and from the
Christ of Michelangelo's *Pietà* in the Duomo
in Florence. *Adam* was modeled originally
in 1880, and for a time Rodin intended to
incorporate the figure into the design for
The Gates of Hell, which was never
constructed. The Museum commissioned
this bronze from Rodin in 1910.

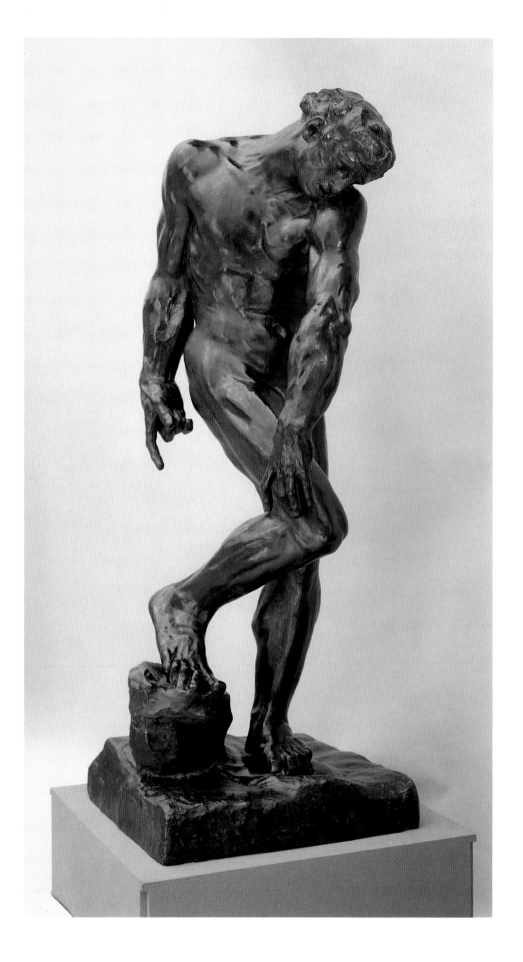

Paul Cézanne

French, 1839–1906

STILL LIFE WITH APPLES AND A
POT OF PRIMROSES

Oil on canvas; 28¾ × 36⅜ in. (73 × 92.4 cm)
Bequest of Sam A. Lewisohn, 1951 (51.112.1)

This painting, once owned by Monet, has been dated as early as 1885 and as late as 1900. Controversy about the date results in part from its quiet, almost static quality. The pattern of leaves against the background is unusual in Cézanne's work, as is the highly finished surface. With the exception of the primroses, the objects in the picture appear frequently in the artist's still lifes: the scalloped table, the cloth pinched up in sculptural folds, and the apples nested in isolated groups. When Cézanne visited Monet at Giverny in 1894, he met the critic Gustave Geffroy, to whom he explained in reference to his still lifes that he wanted to astonish Paris with an apple. He never did so during his lifetime, for his works were always considered unacceptable by Salon juries.

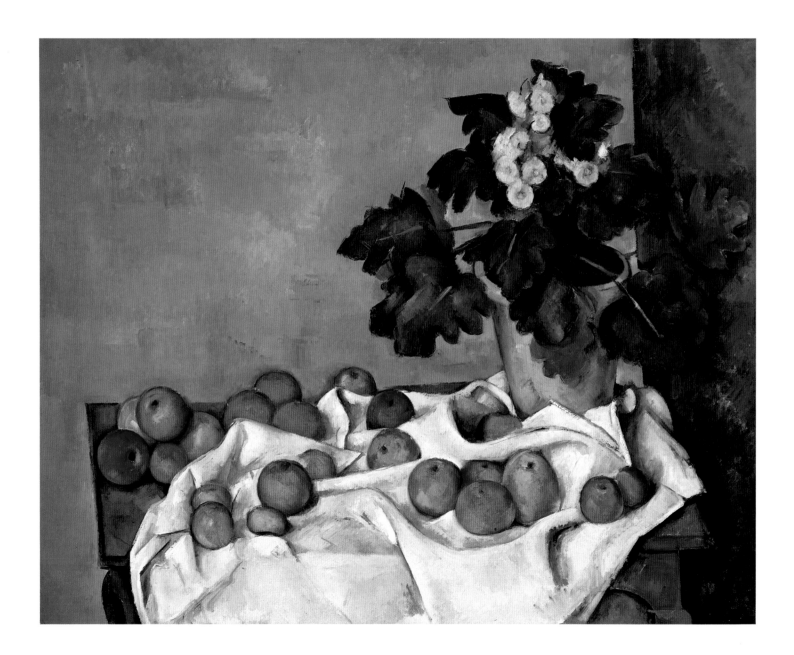

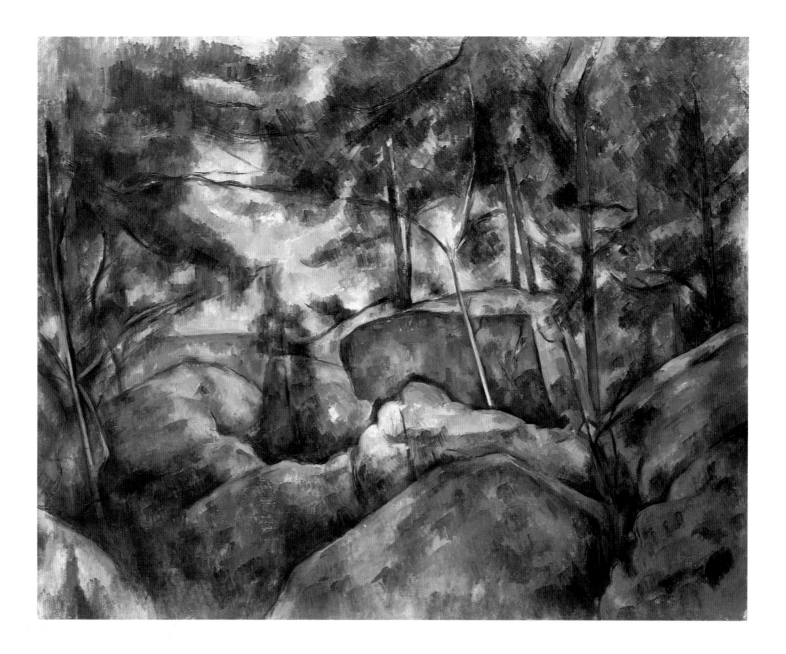

Paul Cézanne

French, 1839–1906

ROCKS IN THE FOREST, ca. 1893

Oil on canvas; 28⅞ × 36⅜ in.
(73.3 × 92.4 cm)
H. O. Havemeyer Collection, Bequest of
Mrs. H. O. Havemeyer, 1929 (29.100.194)

Cézanne exhibited with the Impressionists in 1874, and though he shared their plein-air approach, he was preoccupied by other aims. While they sought to capture the fleeting impression of a casual glance, he tried to explain the forms and patterns that build the structure of a scene. He sought to reveal the inner geometry of nature, "to make of Impressionism something solid and durable, like the art of museums." This scene showing rocks in a forest is thought to have been observed during one of Cézanne's working trips to the forest of Fontainebleau, sometime around 1893. Characteristic of his work at this time are the purplish-gray tone of the painting and the thin layers of pigment applied in a manner reminiscent of watercolor technique.

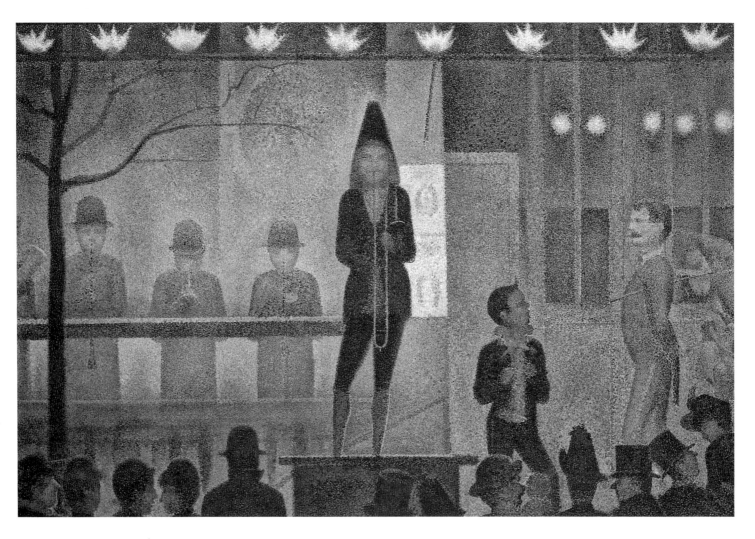

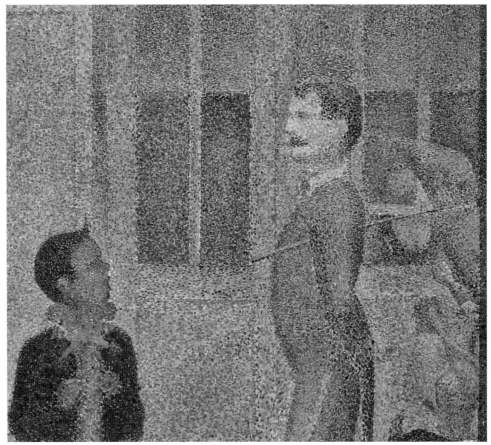

Georges-Pierre Seurat

French, 1859–1891

CIRCUS SIDESHOW, 1887–88

Oil on canvas; 39¼ × 59 in.
(99.7 × 149.9 cm)
Bequest of Stephen C. Clark, 1960 (61.101.17)

In the mid-1880s the depiction of suburban pleasures favored by the Impressionists gave way to pictures of urban entertainment, as writers, poets, and songwriters turned to acrobats, clowns, and café singers for subject matter. Seurat's interest in urban entertainment culminated in *Circus Sideshow*. The scene is a sideshow given in the evening on the street to lure passersby into purchasing tickets to the circus. But instead of being gay and festive, the performance is calm and brooding. Using a fine brush, Seurat has covered the canvas with a myriad of dark violet-blue, orange, and green dots of paint. Although his research in optics was scientific, the shadows endow the forms with mystery. Figures seem to levitate in the moody gaslight, musicians and performers are eerily geometric and alienated from the audience, and railings suggest ramps that lead nowhere. In this world where nothing is certain to the eye, Seurat implies a parity between fact and fantasy.

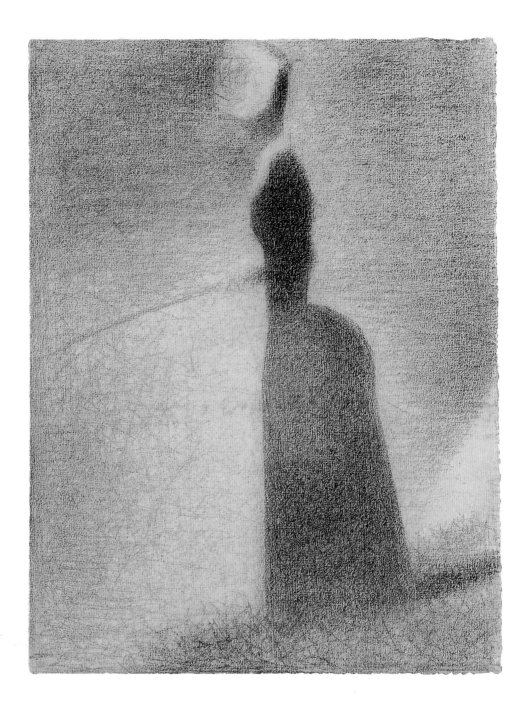

Georges-Pierre Seurat

French, 1859–1891

A WOMAN FISHING, 1884

Conté crayon on paper; 12⅛ × 9¼ in.
(30.8 × 23.5 cm)
Purchase, Joseph Pulitzer Bequest, 1951;
acquired from the The Museum of Modern Art, Lillie P. Bliss Collection (55.21.4)

Seurat's most famous painting is unquestionably *A Sunday Afternoon on La Grande Jatte* (Art Institute of Chicago), a scene of Parisians enjoying their day off on an island in the Seine. Seurat, who wanted to make the art of painting objective and systematic, completed at least 32 preparatory drawings and oil sketches for the painting, often working out individual figures in separate drawings, such as this crayon study of a woman fishing. The figure is rendered with very little interior modeling, and the contrast between her extremely thin torso and enormous bustle transforms her into an abstract shape. Her face is obscured by her fashionably tilted white hat, emphasizing Seurat's preference for the general over the individual.

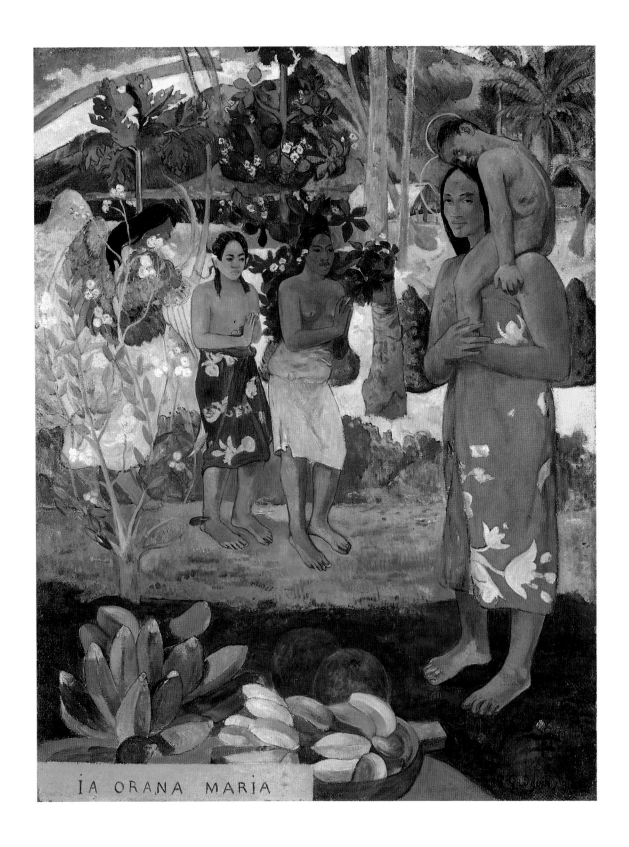

IA ORANA MARIA

Paul Gauguin

French, 1848–1903

IA ORANA MARIA (Hail Mary), 1891

Oil on canvas; 44¾ × 34½ in.
(113.7 × 87.6 cm)
Bequest of Sam A. Lewisohn, 1951 (51.112.2)

In 1883 Paul Gauguin gave up a successful career as a stockbroker to become a painter. From 1886 to about 1891 he lived in Brittany, hoping to find in native Breton culture a people close to nature, unfettered by the complications and sophistication of modern civilization. In 1891 he made his first trip to Tahiti, in search of a still more "natural" world, a kind of Polynesian Garden of Eden. The title of this work—the most important one Gauguin painted during this trip—is native dialect for "I hail thee, Mary," the angel Gabriel's first words to the Virgin Mary at the Annunciation. The only elements taken from the traditional representation of the Annunciation are the angel, the salutation, and the halos around the heads of the Virgin and Child. Everything else is Tahitian except the composition, which was adapted from a bas-relief in the Javanese temple of Borobudur, of which Gauguin owned a photograph.

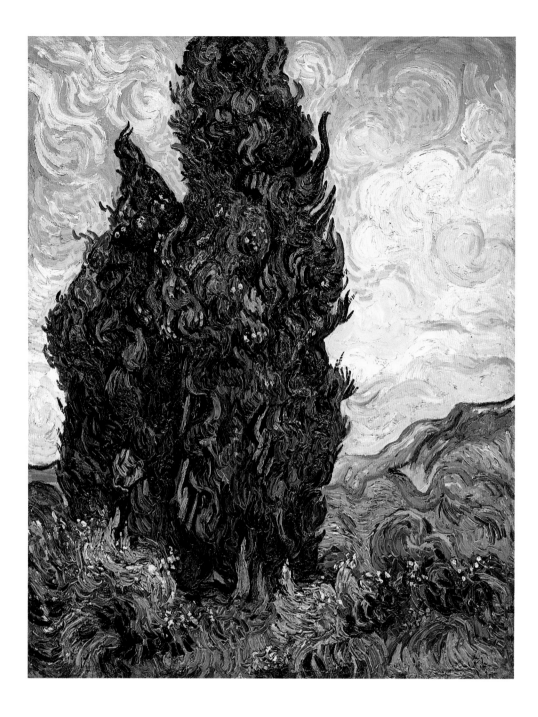

Vincent van Gogh

Dutch, 1853–1890

CYPRESSES, 1889

Oil on canvas; 36¾ × 29⅛ in. (93.4 × 74 cm)
Rogers Fund, 1949 (49.30)

Van Gogh painted *Cypresses* in June 1889, not long after the beginning of his year-long voluntary confinement at the asylum of Saint Paul in Saint-Rémy. The cypress represented a kind of perfect natural architecture in van Gogh's canon of pantheism: "It is as beautiful of line and proportion as an Egyptian obelisk." The loaded brushstrokes and the swirling, undulating forms are typical of his late work. The subject posed an extraordinary technical problem for the artist, especially with regard to realizing the deep, rich green of the trees. On June 15, 1889, he wrote to his brother, "It is a splash of black in a sunny landscape, but it is one of the most interesting black notes, and the most difficult to hit off that I can imagine."

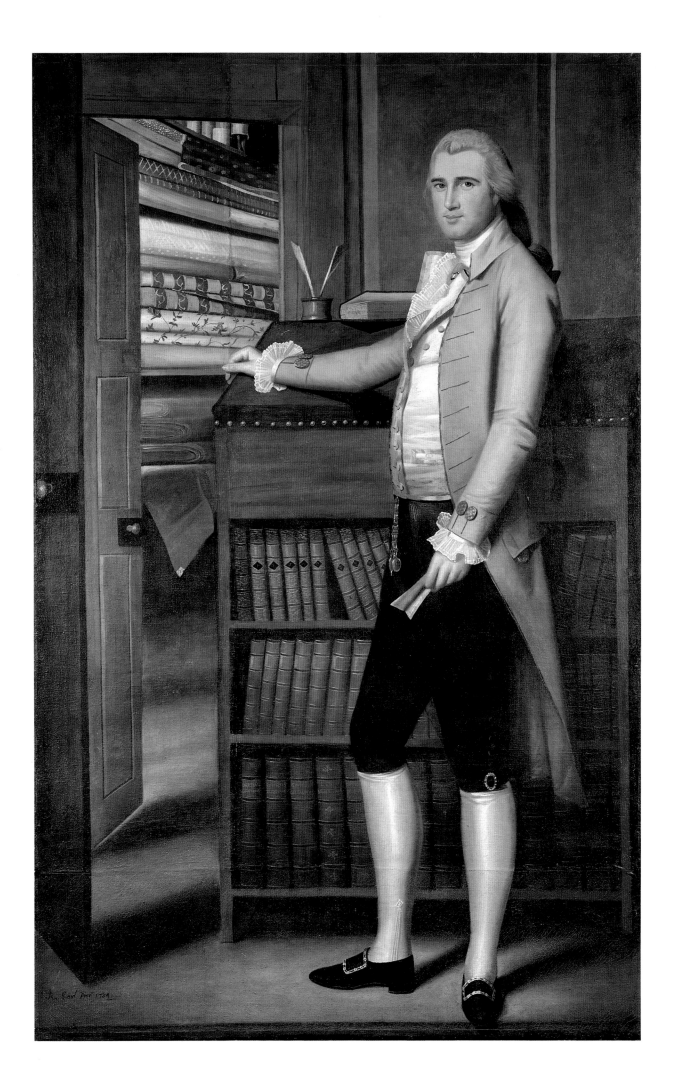

The United States of America

IN THE FIRST QUARTER of the eighteenth century the American Colonies began to develop as a provincial but highly individual society. Trade increased significantly, and large numbers of new immigrants arrived in the middle and southern Colonies. By about 1750 the Colonies were already emerging as a loosely knit group of political entities, each with its distinct social and cultural stamp and commercial capital. Power increasingly came to be wielded by a merchant elite eager to consume luxury goods but never on the scale of a hereditary nobility. American Colonials became more aware of, and willing to pay for, objects in the latest fashion. The sequence of styles that characterized English fine and decorative arts of the eighteenth century was mirrored in the American Colonies no less than in Ireland, Scotland, or India. Furniture was without a doubt the most distinctly Colonial of the decorative arts, with regional schools of cabinetmaking taking shape in Boston, Newport, New York, Philadelphia, Williamsburg, and Charleston.

The character of the American people of the mid-eighteenth century is immediately revealed in the portraits of John Singleton Copley. His works were of unquestionable quality, even by English norms, and they set the standard for Colonial America. For artists of ambition, like Copley, the career opportunities in America were simply not enough. They yearned for the museums and galleries of Europe, for the companionship of other like-minded artists, and for the chance to paint works other than portraits. Benjamin West was the first American painter to succeed in establishing himself in London, after spending three years in Italy; in time Charles Willson Peale, Gilbert Stuart, and John Trumbull would all benefit from West's hospitality.

Ironically, political independence at first had the curious effect of making American art adhere more closely to English models. The war years isolated the country artistically as well as commercially. When peace and prosperity returned, not only was there a pent-up desire for imported goods, there was an entirely new style, the Neoclassical, to assimilate. Still, the regional character of American art did not disappear during this period. America had regarded the events of the French Revolution with horror but began to warm up to its old Revolutionary War ally during Jefferson's presidency. Beginning in the early 1800s, the influence of France rivaled that of England in American art.

Neoclassicism held sway in architecture and the decorative arts until about 1840, but a peculiarly American version of European Romanticism emerged earlier in both painting and literature. Questions about America's identity—who was the new American? How big was the land and how big could it be?—were explored in the romances of James Fenimore Cooper, the genre paintings of George Caleb Bingham and William Sidney Mount, and the landscape paintings of the Hudson River School. The great natural features of a vast land became eloquent symbols in a type of painting that appeared intensely true to observed fact but was, in reality, highly idealistic and emotionally charged. This tradition began with Thomas Cole and continued with his followers, Asher B. Durand and Frederic E. Church (a member of the Metropolitan Museum's first board of trustees), who pushed the Hudson River School decisively in the direction of greater detail and greater realism.

(OPPOSITE)
Ralph Earl
1751–1801
ELIJAH BOARDMAN, 1789

Oil on canvas; 83 × 51 in. (210.8 × 129.5 cm)
Bequest of Susan W. Tyler, 1979 (1979.395)

Ralph Earl was one of the foremost American painters of the late 18th century. Elijah Boardman was a prosperous textile merchant who fought in the Revolutionary War and eventually became a United States senator. Earl has provided clues to the background and personality of the sitter by posing him in a room of his dry-goods store at a stand-up desk and bookcase. The horizontal and vertical patterns created by the bolts of cloth and the books enliven the picture. This and other Connecticut portraits represent the finest period of Earl's work, blending a straightforward realism with the polished grace that the artist acquired during his years abroad.

(LEFT)
Detail from the Album Quilt (see page 265)

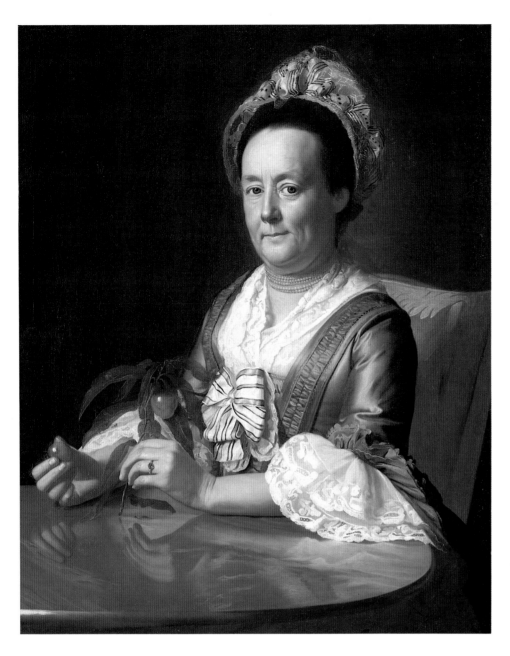

John Singleton Copley
1738–1815
MRS. JOHN WINTHROP, 1773

Oil on canvas; 35½ × 28¾ in. (90.2 × 73 cm)
Morris K. Jesup Fund, 1931 (31.109)

Copley was America's foremost painter of
the 18th century. This portrait, painted just
before he left Boston for England,
represents Copley at the height of his power
and exhibits the intensive realism that was
the principal characteristic of his work at
that time. Mrs. Winthrop (born Hannah
Fayerweather) was the wife of America's
first prominent astronomer, a professor at
Harvard University. Copley has rendered
the varying textures of her muslin cap, silk
dress, and lace cuffs with remarkable
precision; in painting the table surface upon
which she rests her hands, he demonstrated
a degree of technical competence equaled
by few of his contemporaries.

(Opposite)
James Peale
1749–1831
STILL LIFE: BALSAM APPLES AND VEGETABLES, ca. 1820s

Oil on canvas; 20¼ × 26½ in.
(51.4 × 67.3 cm)
Maria DeWitt Jesup Fund, 1939 (39.52)

Although American artists were interested
in still life in the 18th century, they did not
devote themselves to it until the 19th. James
Peale, brother of the more prominent artist
Charles Willson Peale, led in developing a
Philadelphia school of still life. This
masterpiece of the genre represents
something of a departure from James
Peale's usual work by presenting a
tempting, colorful assortment of vegetables
rather than tightly drawn pieces of fruit
falling out of a basket. In place of the
somber coloring characteristic of most of
his still lifes, Peale has adjusted his palette
and handling of paint to reproduce the rich
colors and textures of the vegetables.

The first of the major pre–Civil War revival styles that so drastically changed the look of the decorative arts was the Gothic Revival, which had appeared first in furniture, and was followed by the more exuberant Rococo Revival and Renaissance Revival styles. The traumatic experience of the Civil War made the relatively simple-minded but usually genuine sentimentalism of so much prewar American art inappropriate. As in the early decades of the nineteenth century, literature and painting first registered the changed attitudes of the post–Civil War period. In painting two major directions may be observed: a detailed and relatively blunt realism, as in Winslow Homer or Thomas Eakins, and a style veering in the direction of refinement and aestheticism, as in Leutze's patriotic if shallow *Washington Crossing the Delaware* or Whistler's elegant nocturnes. Of all the major arts of this period sculpture took the longest time, but not by many years, to move from Neoclassicism to the spirit of the new American Gilded Age.

No clearer revelation of the dilemmas posed by life in post–Civil War America exists than the decision by three of the most talented American artists—James McNeill Whistler, Mary Cassatt, and John Singer Sargent—to pursue their careers abroad as

voluntary expatriates. In London and Paris they found the sophistication, tolerance, and cultural maturity that America lacked, despite its wealth. In Europe they were also able to escape the instability of an American society increasingly divided between capitalist and laborer, native-born and immigrant, rich and poor, black and white. In the end these dilemmas would force the art of such courageous home-based realists as Eakins and Homer into introspection and disillusionment.

Since it was established over a century ago, the Metropolitan Museum has been acquiring American art, and its collections are now the most comprehensive and representative to be found anywhere. The American Wing opened in 1924, and for the first time American antiques were presented in an orderly, chronological way. In 1980 the wing was expanded in order to give an integrated and coherent representation of America's artistic past.

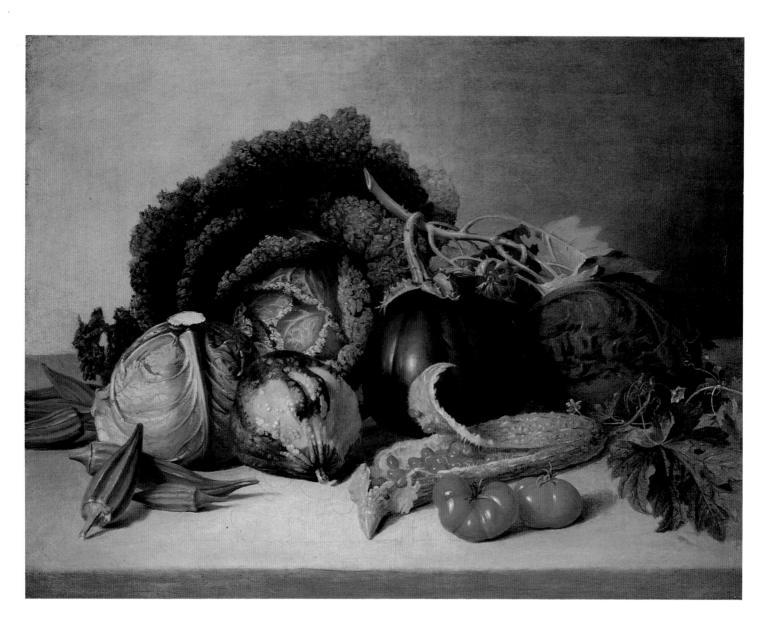

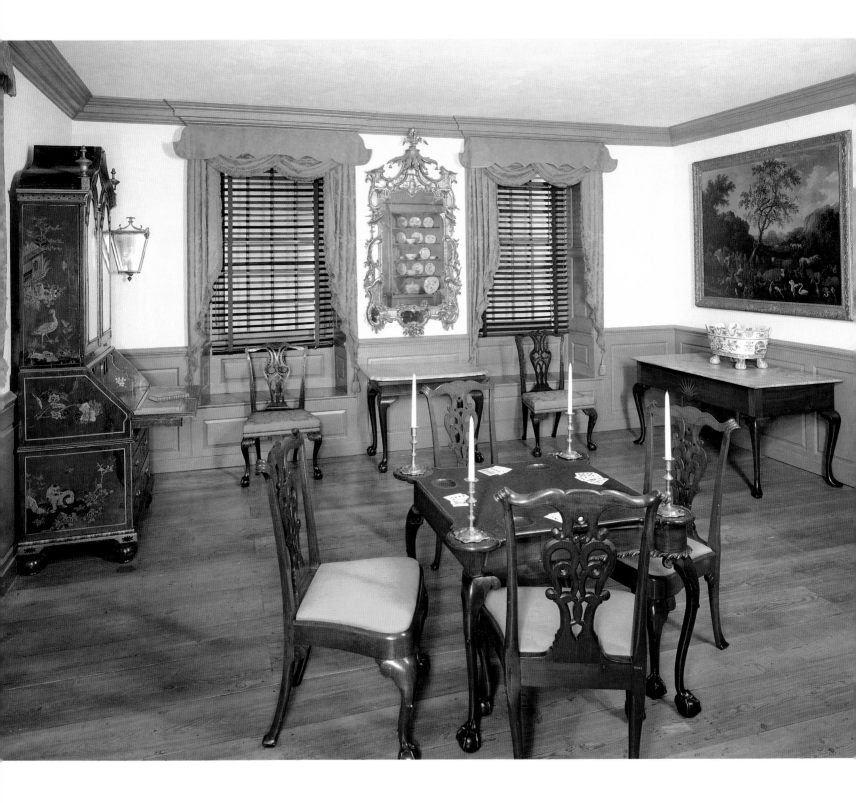

New York (Orange County), ca. 1767
VERPLANCK ROOM

Purchase, The Sylmaris Collection, Gift of
George Coe Graves, by exchange, 1940
(40.127)

Colonial cabinetmakers borrowed from
England to create an American version of
the Chippendale style, while architects

appropriated the building traditions of the
Georgian period. This room displays both
styles and demonstrates the relative
affluence and luxury Colonial gentry had
achieved by the middle of the 18th century.
This room was originally the front parlor of
a Palladian-style house in Orange County,
New York, but it is known as the Verplanck
Room because the furnishings came from

the Verplanck residence at 3 Wall Street in
Manhattan. Among the furnishings is the
only known set of New York Chippendale
parlor furniture, which includes the card
table, a settee, and the set of six matching
chairs. The upholstered pieces are covered
with a pumpkin-yellow wool damask that is
a reproduction of the original fabric.

Gilbert Stuart
1755–1828

GEORGE WASHINGTON, 1795

Oil on canvas; 30¼ × 25¼ in.
(76.8 × 64.1 cm)
Rogers Fund, 1907 (07.160)

Gilbert Stuart was a leading painter of his period and earned his livelihood by painting portraits. He enjoyed his first success in London, where he had gone at the beginning of the Revolutionary War in search of sitters; he returned to America in 1793 and painted many prominent people of his time, including the first five American presidents. Even after his exposure to British styles and techniques, he retained the straightforward realism of American art. His work is characterized by skillful drawing, excellent composition, and a sensitive use of color.

There are 22 portraits by Stuart in the Museum's collection, including 3 of George Washington. He painted the president for the first time in 1795, and the work was greeted with such enthusiasm that 39 replicas were ordered, although only 17 are known to exist. The original painting was the basis for the one seen here, which is among the earliest and finest replicas. It has been suggested that the immediacy and vitality of the president's features indicate that it was painted, at least in part, from life. Stuart's work had a strong influence on many American portrait painters of the early 19th century.

Paul Revere, Jr.

1735–1818

TEA SERVICE, ca. 1790–1800

Silver; teapot: H. 6⅛ in. (15.6 cm)
Bequest of Alphonso T. Clearwater, 1933
(33.120.543–547)

This Federal-style tea service was made by the famous Boston patriot Paul Revere. The fluted facets of its classical design, the engraved festoons, and ornamented bands are echoed in all of the pieces, including the two sugar bowls, the cream pitcher, and the teapot, which rests on a stand. The son of a Huguenot, Apollos Rivoire (who Americanized his name), Paul Revere, Jr., had many talents and is the best known of Colonial silversmiths. In addition to fashioning plates for various patrons, Revere engraved silver, made trade cards, bill heads, and copperplates for paper currency. He also engraved scenic views, portraits, and political prints.

Possibly New England, 1830–50

DISH

Pressed glass; H. 9⅛ in. (23.2 cm)
Gift of Mrs. Charles W. Green, in memory of Dr. Charles W. Green, 1951 (51.171.160)

The technique of pressing glass, a mechanical method of imitating cut glass by using a mold, was introduced in America in the late 1820s and revolutionized the glass-making industry. Molten glass often contains impurities, but these defects were disguised by elaborate lacy patterns of the molds. This rare, lacy, shell-shaped dish contains motifs culled from Classical, Gothic, and Rococo sources, a tribute to the mold-maker's talent and ingenuity.

Pennsylvania, 1865–74

POCKET FLASK

Amethyst-colored glass; H. 4¾ in. (12.1 cm)
Gift of Frederick W. Hunter, 1914 (14.74.17)

Henry William Stiegel operated the American Flint Glass Manufactory from 1765 to 1774 and was the first successful producer of glass tableware that was the equal of European imports. The diamond-daisy pattern in this amethyst-colored pocket flask was probably made by Stiegel; the pattern was not used by European glassmakers.

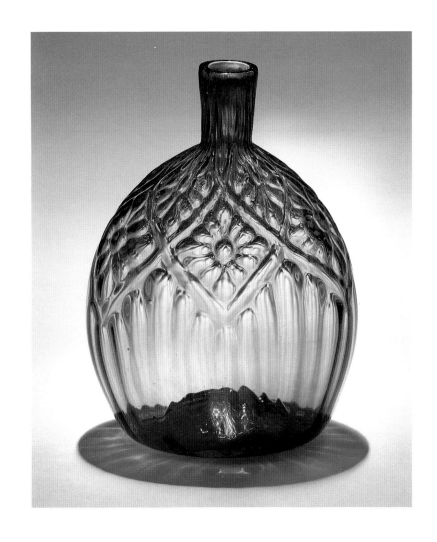

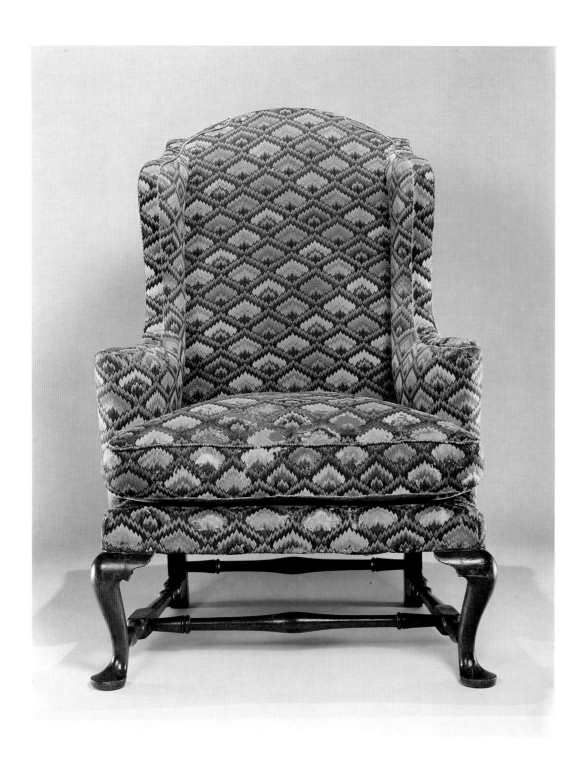

Rhode Island (Newport), 1758
EASY CHAIR

Walnut and maple; H. 46 ⅜ in. (117.8 cm)
Gift of Mrs. J. Insley Blair, 1950 (50.228.3)

This is the most extraordinary easy chair to survive from the Queen Anne Period (1720–55). In addition to its fine proportions, the chair is rare and remarkable because all of its upholstery is original. The front and sides are worked with a brightly colored diamond or flame stitch that was very popular in the 18th century, while the back is covered with a crewelwork scene that is a masterpiece in its own right. The bucolic landscape shows a shepherd with his flock, as well as deer, birds, trees, and flowers, set among stylized hills (see detail opposite). The easy chair is now known as the wing chair because of the projecting sides that served as headrests or gave protection against drafts or the heat of an open fire.

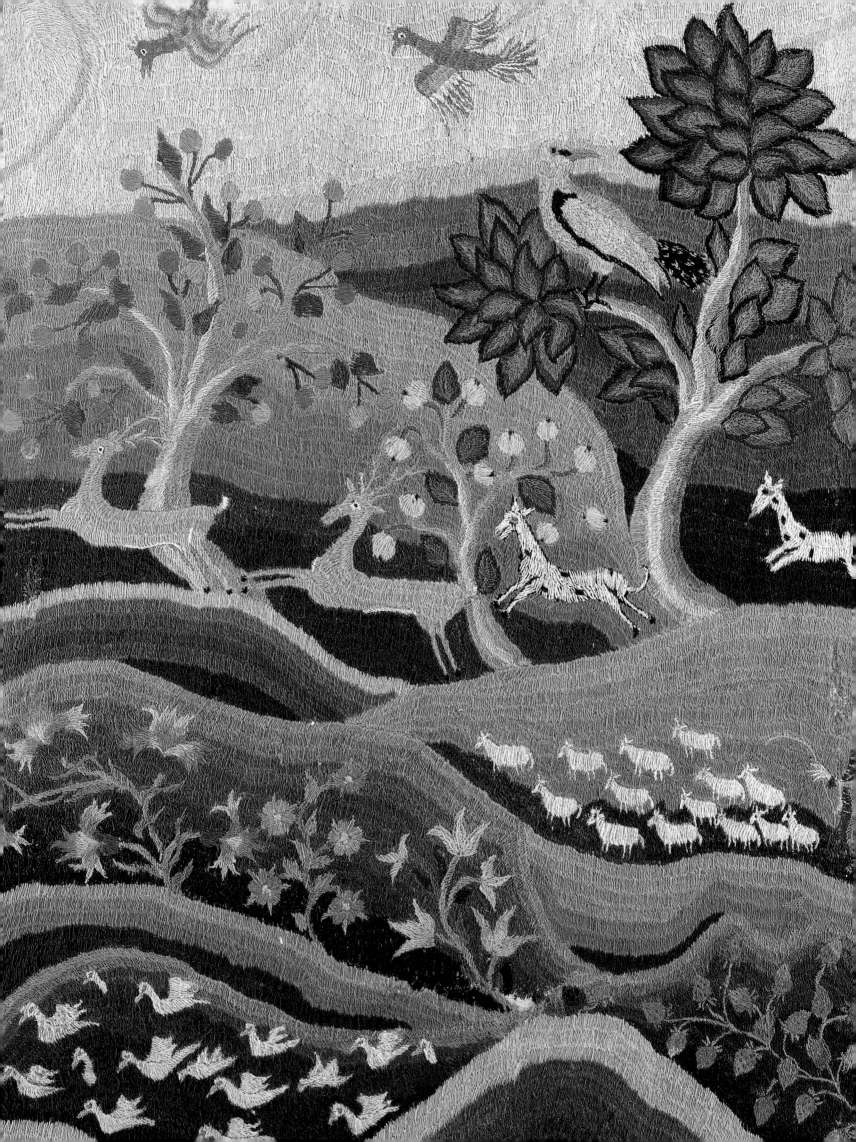

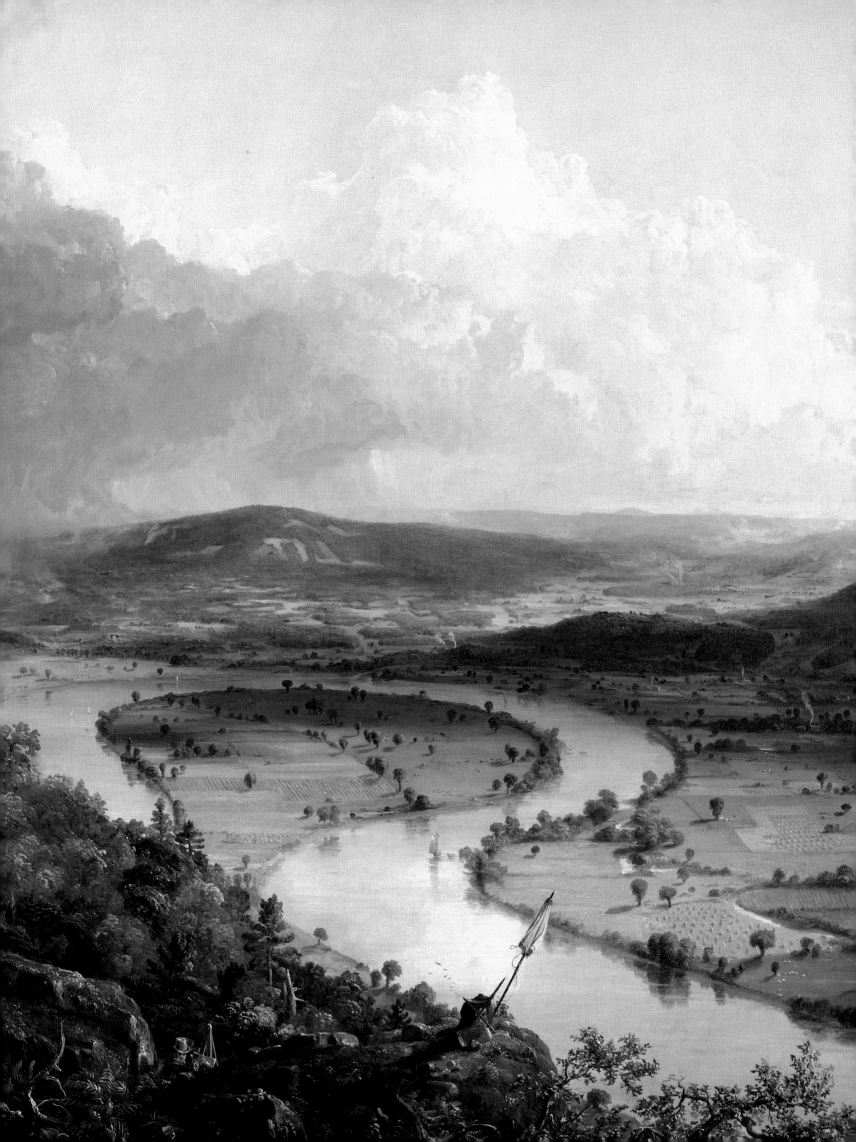

(Opposite)

Thomas Cole

1801–1848

VIEW FROM MOUNT HOLYOKE, NORTHAMPTON, MASSACHUSETTS, AFTER A THUNDERSTORM (THE OXBOW), 1836

Oil on canvas; 51½ × 76 in. (130.8 × 193 cm)
Gift of Mrs. Russell Sage, 1908 (08.228)

Known as the father of the Hudson River School of landscape painters, Thomas Cole holds a prominent place in the history of American painting, both for the quality of his own work and for the influence he exerted over a generation of painters. At once a realist and a romantic, Cole infused America's natural scenery with a sense of sublime grandeur. He was fascinated by the oxbow formation of the Connecticut River below Mount Holyoke, Massachusetts, and produced this magnificent panorama of the valley just after a thunderstorm. He depicted himself at work in the foreground (see the detail opposite).

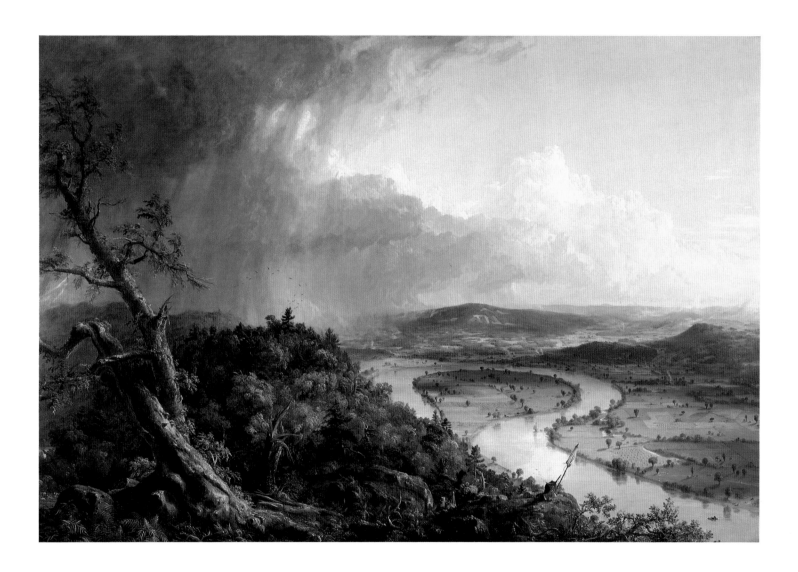

George Caleb Bingham

1811–1879

FUR TRADERS DESCENDING THE
MISSOURI, ca. 1845

Oil on canvas; 29 × 36½ in. (73.7 × 92.7 cm)
Morris K. Jesup Fund, 1933 (33.61)

Bingham was a specialist in subjects drawn
from the American countryside,
particularly life on the frontier. In this
masterpiece of American genre painting, a
unique document of river life in the
Midwest, he has depicted a moment in the
life of a French-Canadian fur trader, one of
the *voyageurs* who combined commerce
with exploration and adopted many ways of
the wild. Bingham has raised anecdote to
the level of poetic drama by setting up a
tension between the suspicious stare of the
old trader, the unconcerned reverie of his
sprawling half-Indian son, and the compact,
enigmatic silhouette of a tethered bear cub.
Parallel planes recede into the distant
background, suggesting that Bingham was
familiar with engravings of European
paintings, yet the strict formality is softened
by an exquisite luminosity.

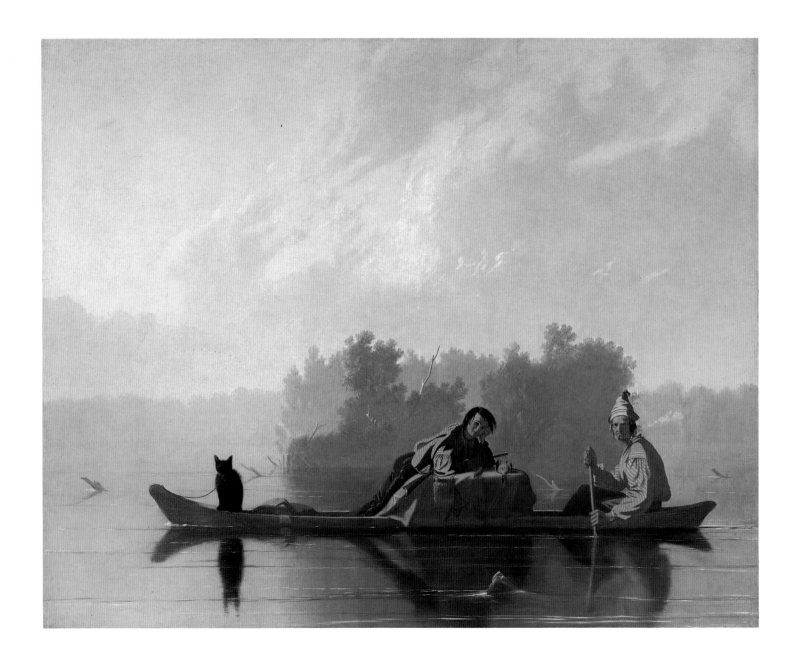

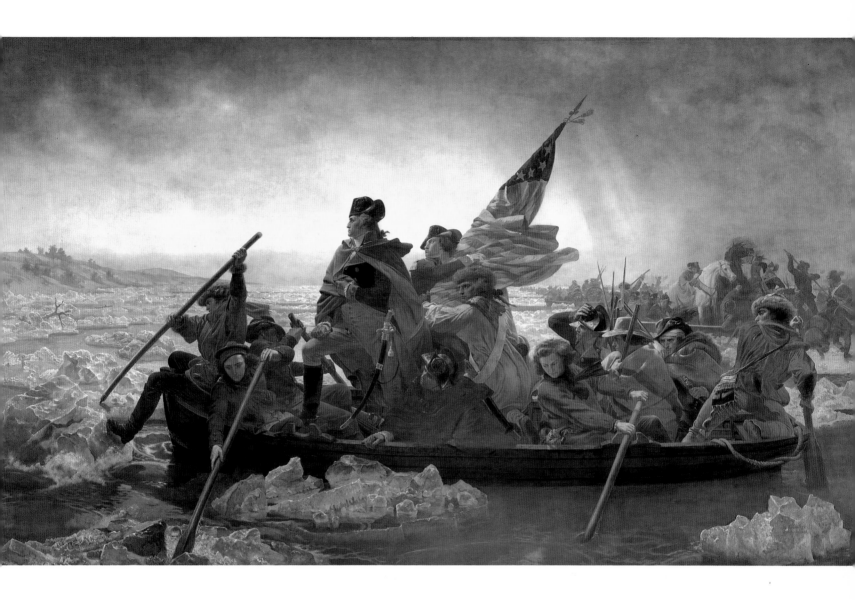

Emanuel Gottlieb Leutze

1816–1868

WASHINGTON CROSSING THE
DELAWARE, 1851

———

Oil on canvas; 149 × 255 in.
(378.5 × 647.7 cm)
Gift of John S. Kennedy, 1897 (97.34)

———

This famous event from the American
Revolution was painted by German-born
Emanuel Leutze, who spent most of his life
in the United States. He painted the first
version of this picture (destroyed in World
War II) in Düsseldorf, where a school of

Romantic painting flourished, and
immediately painted a second version—this
picture—which was sent to America and
exhibited throughout the country. A print
published in 1853 gave the painting the status
of a national monument, in spite of
numerous errors in historical detail (the
flag, for example, as depicted here was not
introduced until six months after the event).
Nevertheless, the painting captured and has
held the affection of succeeding generations
of Americans, for the drama of the episode,
despite the melodrama, rings true.

Frederic Edwin Church

1826–1900

HEART OF THE ANDES, 1859

———

Oil on canvas; 66½ × 119¼ in.
(168.9 × 302.9 cm)
Bequest of Margaret E. Dows, 1909 (09.95)

———

Frederic Church was Thomas Cole's only pupil, and as Cole was the major figure in the first generation of the Hudson River School, so Church dominated the second. He did not confine himself to views of New York and New England; in the 1850s, influenced by the great explorer Alexander von Humboldt, he traveled to South America and made sketches that were the basis of his great tropical panoramas. Church painted nature with an almost religious fervor and sense of awe. His landscapes embodied America's belief that the opening of frontiers and westward expansion were the nation's destiny. When this monumental painting was first shown to the public in 1859, in a darkened room and illuminated by hidden gaslights, it caused a sensation. In many ways, the painting carried the ideas of the Hudson River School to their culmination.

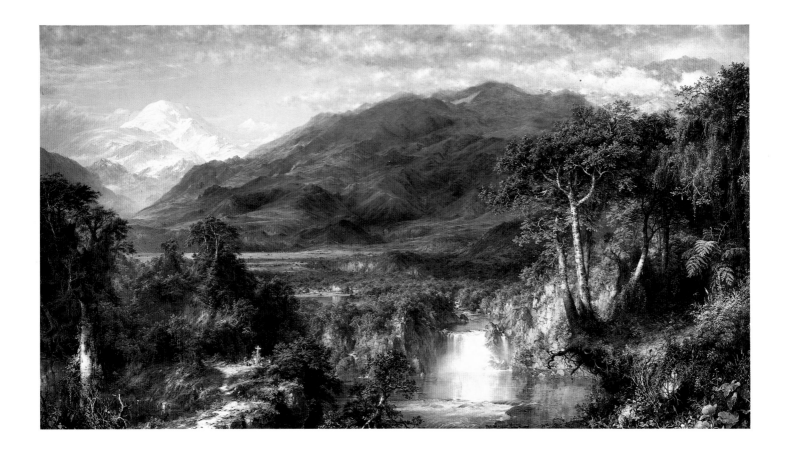

Thomas Eakins

1844–1916

MAX SCHMITT IN A SINGLE SCULL
(THE CHAMPION SINGLE SCULLS),
1871

Oil on canvas; 32½ × 46¼ in.
(82.6 × 117.5 cm)
Purchase, The Alfred N. Punnett
Endowment Fund and George D. Pratt Gift,
1934 (34.92)

Although he never achieved commercial success during his lifetime and was out of tune with the taste of his time, Thomas Eakins was arguably the finest 19th-century American painter. In this complex, haunting work, the artist's passion for sports is suffused with a lyrical response to subtle qualities of light and to the rhythmic placement of forms in deep space. A keen rower, Eakins produced several boating pictures (he himself is rowing the shell beyond Max Schmitt), but here he has been able to maintain an intellectual distance from the subject, studying the composition with great care and concentrating on the sharpness of his draftsmanship. The reflection and refraction of the water demonstrate his precise scientific observation, but here and there are freely painted passages, such as the stone house and leafy shore at the left.

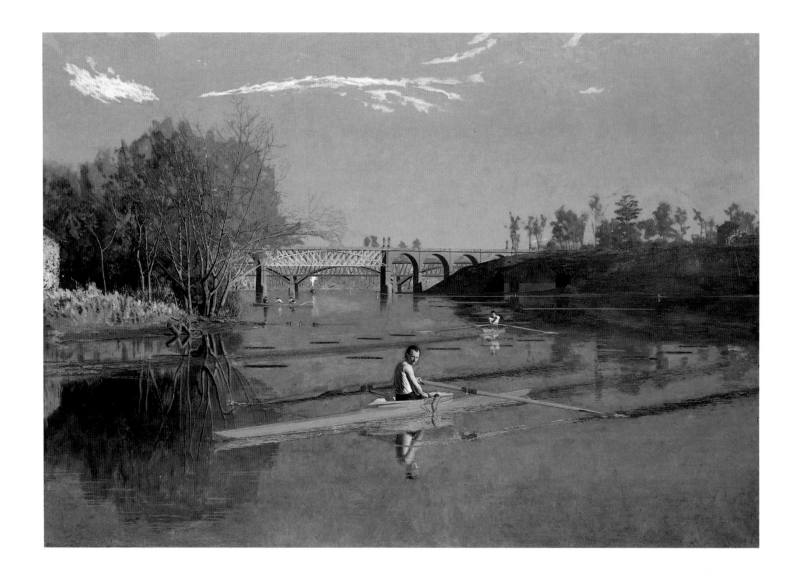

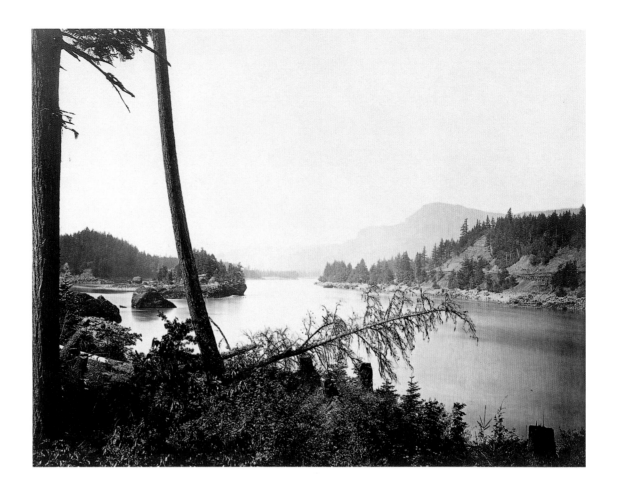

Carleton E. Watkins
1829–1916
VIEW ON THE COLUMBIA—
CASCADES, 1867

Albumen silver print from glass negative;
15¾ × 20⅝ in. (40 × 52.4 cm)
Warner Communications Inc. Purchase Fund
and Harris Brisbane Dick Fund, 1979
(1979.622)

Consummate photographer of the
American western landscape, Carleton
Watkins combined a rigorous sense of
pictorial structure with a virtuosic technical
mastery of the medium. For large-format
landscape work, such as Watkins produced
along the Columbia River in Oregon, the
physical demands of the photographic
process were great; since there was as yet no
practical means of enlarging, Watkins's
"mammoth" glass negatives had to be as
large as he wished the prints to be.
Furthermore, his glass plates had to be
coated with photosensitive emulsion,
exposed, and developed while the solution
remained humid, requiring the
photographer to transport a traveling
darkroom. So perfectly resolved are these
first commanding views of the American
West that, despite their early date, they
remain unequaled.

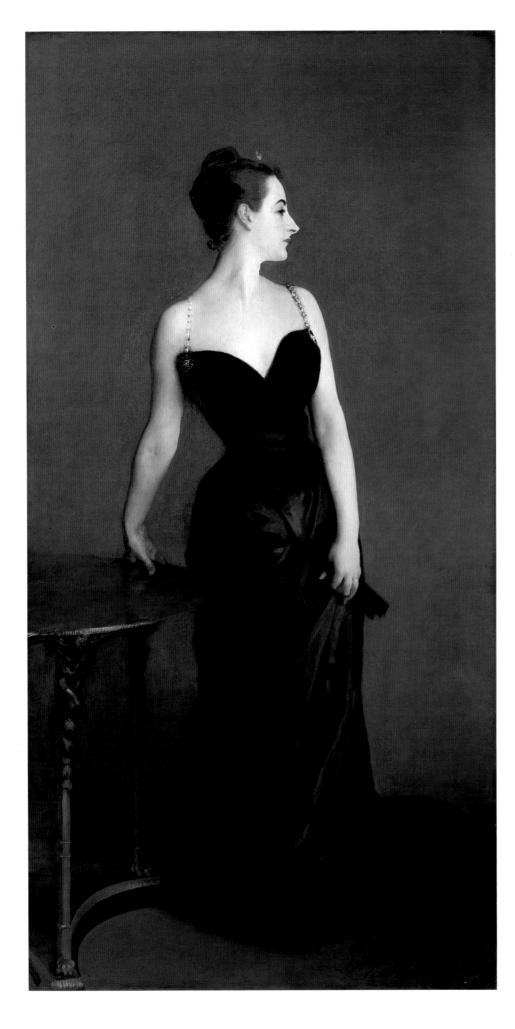

John Singer Sargent
1856–1925

MADAME X (MADAME PIERRE
GAUTREAU), 1882–84

Oil on canvas; 82⅛ × 43¼ in.
(208.6 × 109.9 cm)
Arthur Hoppock Hearn Fund, 1916 (16.53)

Mme Gautreau, born Virginia Avegno in
New Orleans in 1859 and married to a
French banker, became one of Paris's
notorious beauties during the 1880s. Sargent
was impressed by her charm and theatrical
use of makeup, and he determined to paint
her. Work was attended by numerous
delays and reworkings of the canvas, and
when it was shown at the 1884 Paris Salon, it
was given a scathing reception. Reviewers
were critical of Mme Gautreau's character,
the lavender coloring of her skin, and the
impropriety of her dress with its revealing
décolletage and the slipped strap that bared
her right shoulder (later painted over). The
portrait lacks the bravura brushwork of
many of Sargent's major paintings, partly
because of the many reworkings, but the
elegant pose and outline of the figure,
recalling his debt to Velázquez, make it one
of his most striking canvases. When he sold
it to the Museum in 1916, Sargent wrote, "I
suppose it is the best thing I have done."

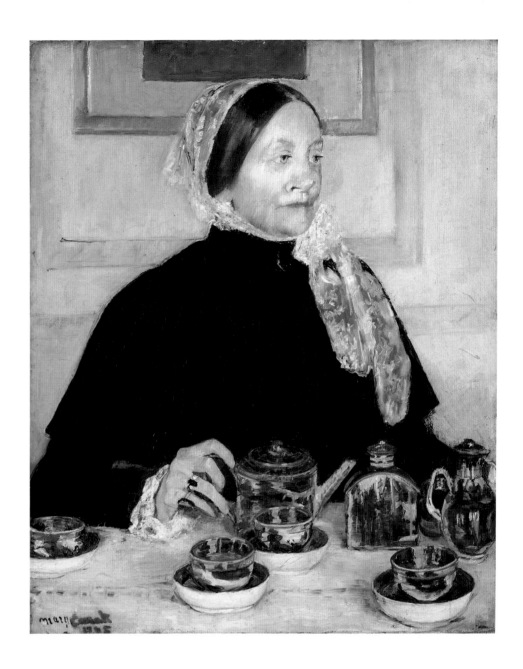

Mary Cassatt
1844–1926
LADY AT THE TEA TABLE, 1885

———

Oil on canvas; 29 × 24 in. (73.7 × 61 cm)
Gift of the artist, 1923 (23.101)

———

Mary Cassatt of Philadelphia became the only American painter to earn herself a place among the French Impressionists. Domestic scenes, especially those including women and children, were her specialty, and she used the high-key palette characteristic of Impressionism to create pictures of great naturalism and warmth but without cloying sentimentalism. Here she has portrayed her mother's cousin, Mrs. Robert Moore Riddle, in a painting that was intended to be a thank-you gift for hospitality received in London. The Riddle family found it disconcerting and unattractive, perhaps for its departure from traditional spatial relationships. The foreground and background almost merge, reflecting the artist's debt to Degas, Manet, and Japanese prints, which were charming Paris at the time. Although the painting languished in storage for 30 years and was eventually donated to the Metropolitan by the artist herself, Degas had pronounced it "la distinction même" (distinction itself).

Winslow Homer

1836–1910

NORTHEASTER, 1895

Oil on canvas; 34⅜ × 50¼ in.
(87.3 × 127.6 cm)
Gift of George A. Hearn, 1910 (10.64.5)

Homer was a man with an immensely perceptive eye and a distinctive vision, and this is one of his masterpieces. The painting captures the essence of the wind-whipped waves and rocky shore along the coast of Maine, where he spent the last part of his life portraying the constant struggle between man and the turbulent ocean. The composition here is reduced to a forceful diagonal, and the broad, sweeping brushstrokes enhance the sense of harshness and drama. Homer's openness to innovation and his ability to develop his own style probably owe much to his minimal exposure to the conservative forces of academic training.

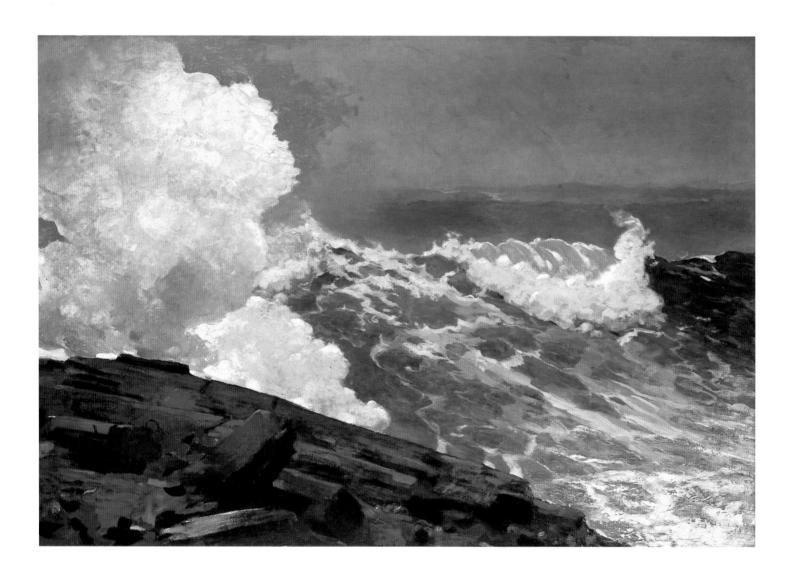

John H. Twachtman
1853–1902
ARQUES-LA-BATAILLE

Oil on canvas; 60 × 78⅞ in.
(152.4 × 200.3 cm)
Morris K. Jesup Fund, 1968 (68.52)

Most leading American artists of the late 19th century journeyed to Europe to study, usually in France. Twachtman went first to Germany, where he worked at the Munich Royal Academy, and his forceful brushstrokes, heavy application of paint, and limited, low-key palette were fashionable in German art circles of the period. Later, however, after spending a few years back in America, he went to Paris, where he painted this splendid landscape, which pictures a river scene near Dieppe on the Normandy coast, an area popular with the French Impressionists. The subdued colors and calligraphic elements show strong evidence of the influence of James McNeill Whistler and of Japanese prints. Although Twachtman never received true critical acclaim, he was respected by his fellow artists and was a founding member of a group of American Impressionist artists popularly called "The Ten."

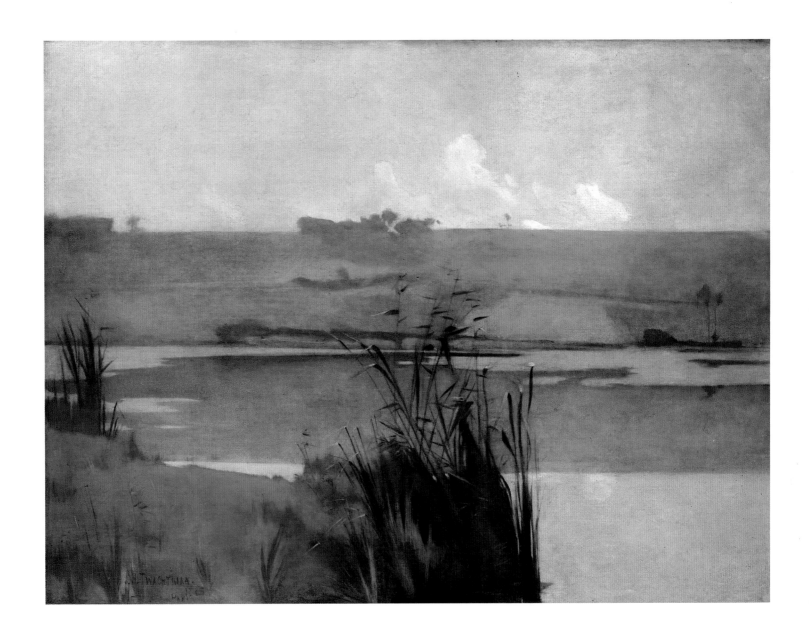

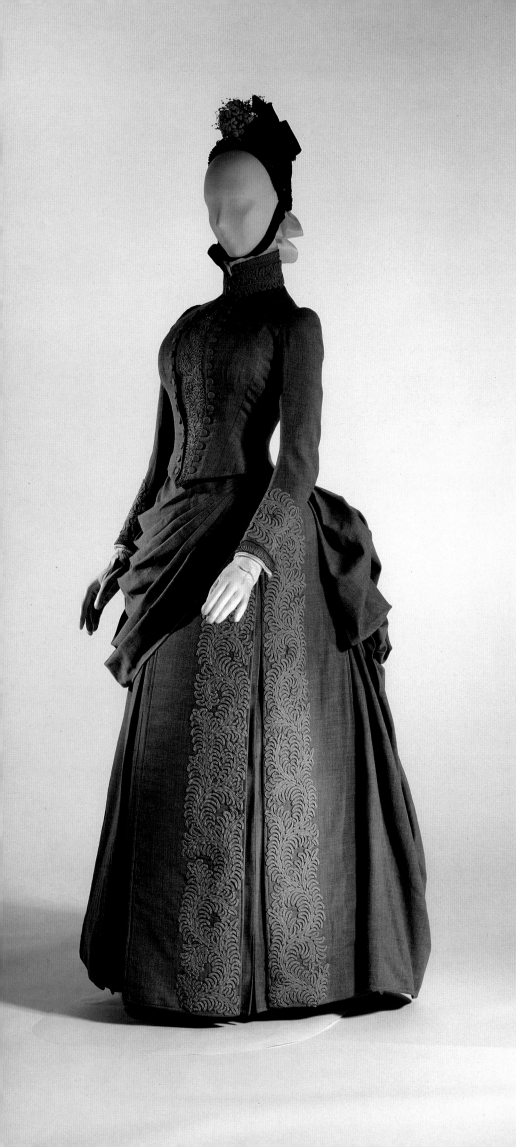

TAILORED WEDDING ENSEMBLE, 1887

Gray wool and beige passementerie
Gift of Margaret M. Flockhart, 1968
(CI. 68.53.5abd)

Louise Whitfield wore this gray wool traveling costume on April 22, 1887, when she married the great industrialist and philanthropist Andrew Carnegie. This is an excellent example of the highest quality dressmaking and construction; the fashionable late-Victorian silhouette is complemented by the graceful drapery that flows around and over the ample bustle skirt. The rose-gray passementerie is arranged in a foliate pattern on the plastron and cuffs and as a decorative panel on the skirt.

Baltimore, begun in 1846
ALBUM QUILT

Appliquéd and quilted cotton;
83⅜ in. × 85 in. (211.8 × 215.9 cm)
Bequest of Margaret Brown Potvin, 1987
(1988.134)

This beautiful quilt is one of the highlights of the Museum's fine collection of American quilts and coverlets. This is a true album quilt, since almost every block is signed and dated by a different person. Some of the blocks are decorated with motifs typically found only on Baltimore quilts, such as the central eagle and flag, while other designs, such as those that employ the cut-paper technique, can be seen on album quilts from all regions of the country. Although the quilt entered the collection with almost no known history, research has determined that the quilt blocks were given to a woman named Mary Brown Turner by friends and family in celebration of the coming birth of her child. For some reason, she never joined the blocks together, and the daughter in whose honor the blocks were made completed the quilt perhaps 20 years later.

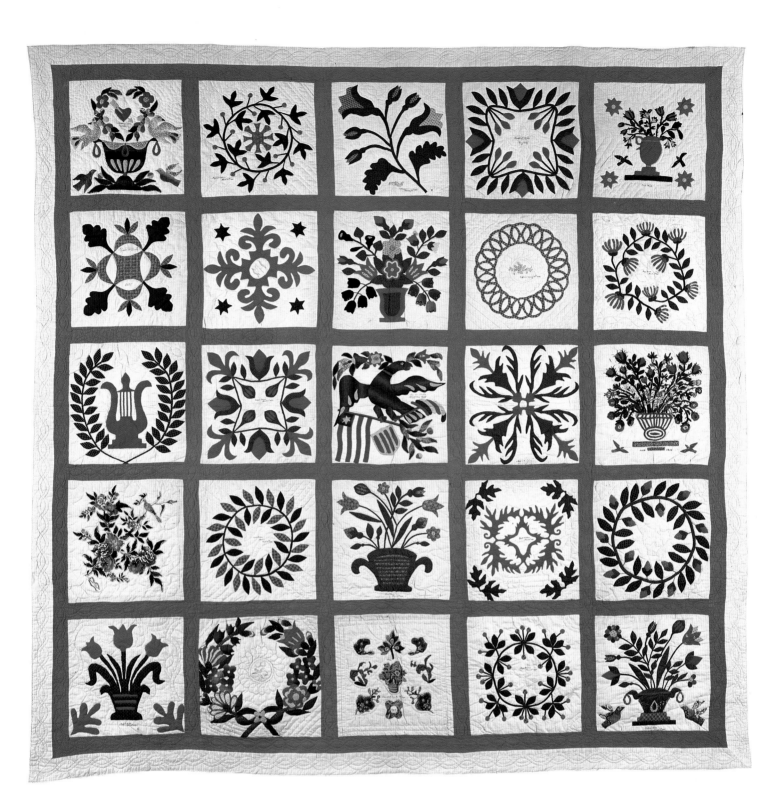

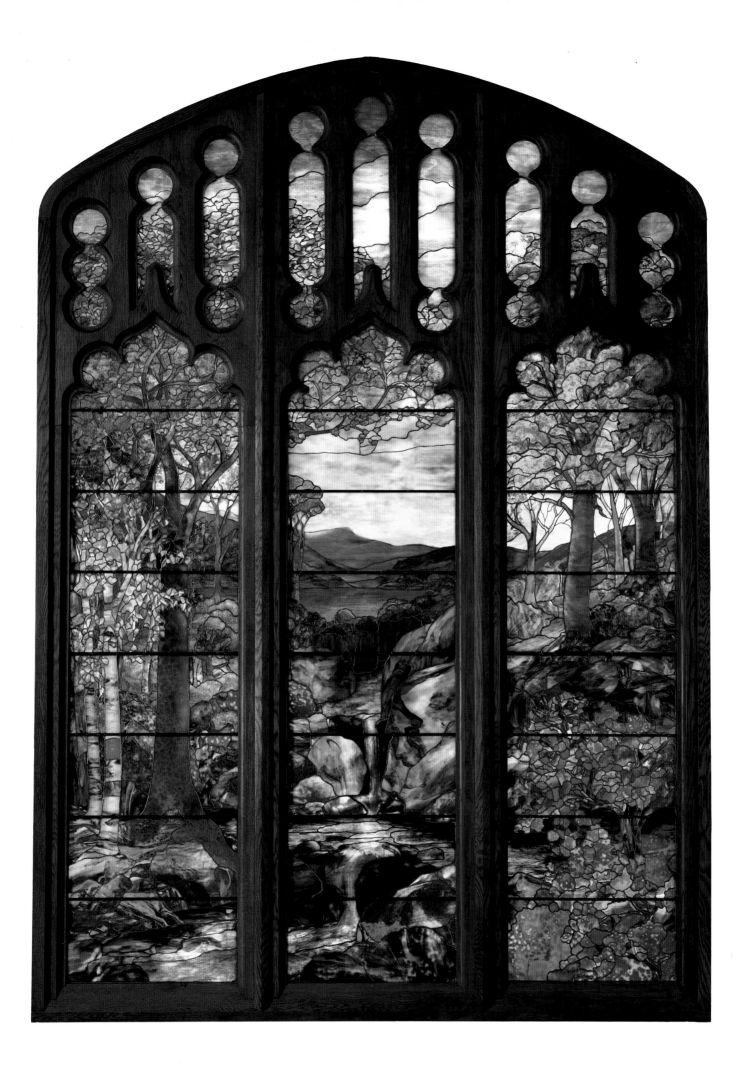

Tiffany Studios, 1902–38
AUTUMN LANDSCAPE, 1923

Stained glass; 11 × 8 ft. 6 in. (33.5 × 25.2 m)
Gift of Robert W. de Forest, 1925 (25.173)

Louis Tiffany (1848–1933), America's leading designer in the Art Nouveau style, gained international renown for his work in glass. The son of Charles L. Tiffany, founder of the well-known jewelry store, he studied landscape painting and then pursued a career in the decorative arts. He experimented with glass as early as the 1870s and achieved an astonishingly wide range of novel and colorful effects, not only with stained-glass window panels and lampshades but also with "favrile" glass, a Tiffany innovation. The Museum first acquired examples of his work in 1896.

Augustus Saint-Gaudens
1848–1907
DIANA, ca. 1894

Gilded bronze; H. (reduction)
28¼ in. (71.8 cm)
Gift of Lincoln Kirstein, 1985 (1985.353)

One of the few sculptures of nudes that Saint-Gaudens created, *Diana* was designed as a weathervane for the tower of Stanford White's Madison Square Garden, which was completed in 1890. This statuette, without the flying drapery of the original weathervane, was cast in Paris at the Gruet Foundry. Its graceful lines and silhouette rank the figure among the most beautiful and sensuous in American art and an outstanding image of the American Renaissance. The *Diana* is enhanced by the delicate chasing that defines the statuette's hair and facial features. The piece is further enhanced by a rich matte-gold patination, with which the sculptor was experimenting late in his life.

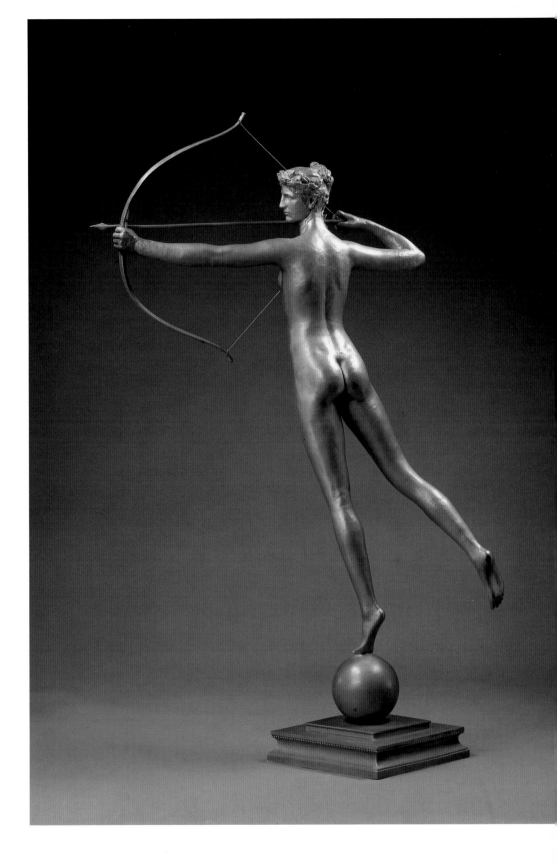

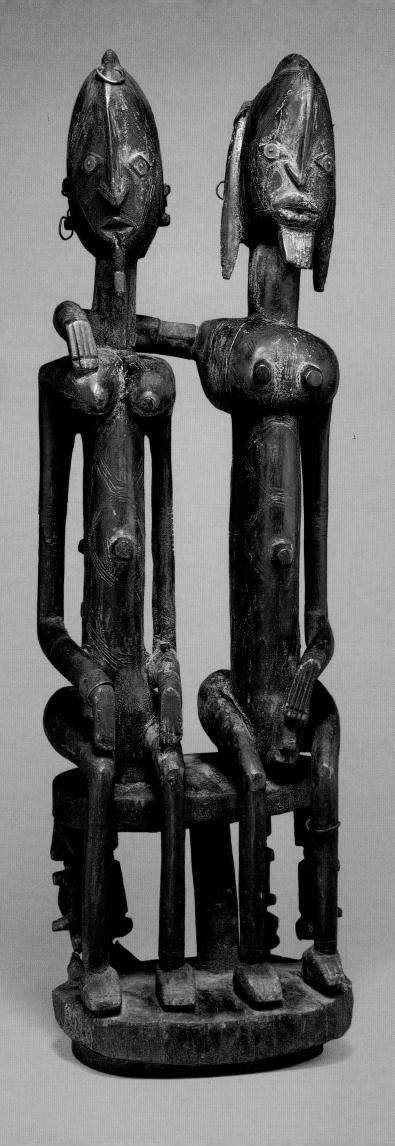

Africa

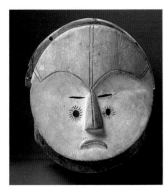

THE ART OF AFRICA is as old and as complex as any in the world. More than a million and a half years ago, the first human beings to walk erect did so in eastern Africa, and in the half-million years that followed, the population spread to most parts of the continent. Modern humans began to appear about one hundred thousand years ago, and the rude stone tools of their predecessors were gradually replaced by the more refined and efficient examples of the New Stone Age. It was during this period that the first African art appears—rock paintings of people and animals made in Namibia twenty-eight thousand years ago. By the middle of the first millennium B.C. sculptors in northern Nigeria modeled the terracotta figures that are the earliest preserved examples of sub-Saharan African sculpture.

Although the record of African sculpture begins with works of durable terracotta, most African sculpture is made of wood or other organic materials that perish quickly in a tropical climate. For this reason, most extant African wood sculpture is believed to date from only the past century or two. Objects fashioned from more resistant media, such as metal, stone, and terracotta, are therefore especially valuable as records of earlier periods. Fortunately recent archaeological work has revealed a great deal about African art, and modern scholars have also learned much from the writings of the traders, explorers, and missionaries who for the past two thousand years have come to Africa from all over the world.

Africa is so vast and its cultural contexts so varied that it may never be possible to write a single, unified history of African art. Each of the many distinct ethnic groups has a language, religion, history, and way of life all its own, and in each of these societies art plays an important but subtly different role. Most African sculpture comes from the forest and savanna areas south of the Sahara Desert, which can be divided into four broad regions: the Western Sudan and Guinea Coast areas of West Africa and the equatorial forest and southern savanna areas of Central Africa.

Although African artists rarely create art for its own sake, they do apply rigorous aesthetic standards to their work, and they value the prestige that their artistic abilities bring. Knowledge of the contexts for which African art is made is essential to an appreciation of its forms and to an understanding of its meaning.

(OVERLEAF)
Mexican, Olmec, 10th–6th century B.C.
MASK

Jade; H. 6¾ in. (17.1 cm)
Bequest of Alice K. Bache, 1977 (1977.187.33)

In the first millennium B.C., the Olmec peoples used jade and other jadelike stones of green hue for a variety of objects, from personal ornaments to figures and masks of ceremonial and/or mortuary intent. This mask is naturalistic in size, that is, big enough to cover the face, but it is not pierced for either seeing or breathing. It may have been used as part of an elaborate headdress or it could have been the burial mask of an important personage or ruler. Details of the face have a fleshy, almost lifelike quality that belies the hardness of the stone from which they were wrought.

(OPPOSITE)
Mali, Dogon people
SEATED COUPLE

Wood, metal; H. 29 in. (73.7 cm)
Gift of Lester Wunderman, 1977 (1977.394.15)

Dogon couples such as this one are usually identified as primordial ancestors, although specific field documentation is lacking. In this example, a man and a woman sit together on a single, round stool, which is supported by four figures. The man has his arm around the woman, pointing to her breasts, while with his other hand he points to his own genitals. He carries a quiver on his back, while she carries an infant on hers. These iconographic elements allude to the man's role in Dogon society as progenitor and protector, warrior and hunter, and to the woman's role as mother and nurturer. These themes are found in the sculpture of many sub-Saharan African peoples and serve to reinforce cultural stereotypes that enhance the group's social organization.

(LEFT)
Gabon, Fang people, 19th–20th century
JANUS-FACED HELMET MASK

Wood, paint; H. 11¾ in. (29.8 cm)
The Michael C. Rockefeller Memorial Collection, Bequest of Nelson A. Rockefeller, 1979 (1979.206.24)

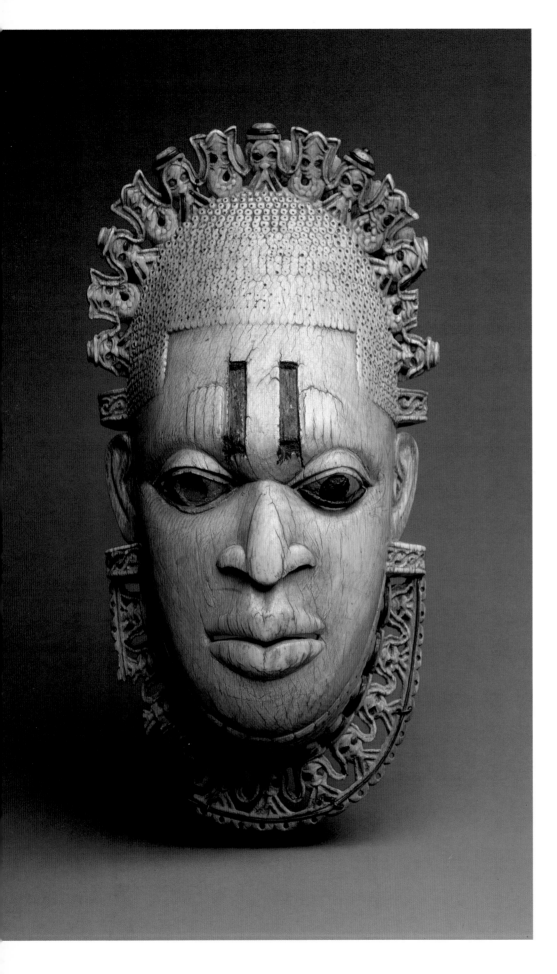

Nigerian (court of Benin), early 16th century
PENDANT MASK

Ivory, iron, and copper; H. 9⅜ in. (23.8 cm)
The Michael C. Rockefeller Memorial
Collection, Gift of Nelson A. Rockefeller,
1972 (1978.412.323)

Benin is the best documented of the early
kingdoms of tropical Africa. Portuguese
explorers who visited the court in 1485 and
other foreigners who later traveled there
compared Benin favorably with Europe.
The art of Benin is royal, created for a divine
king and his court. Vast wealth, political
stability, and the demand for an art that
reflected the power of the kingdom assured
the continuation of a 500-year tradition of
high artistic standards. The court's
preoccupation with hierarchy is reflected in
the attention to ornament—an indication of
rank. The king, or Oba, of Benin probably
wore this extraordinary mask at his hip
or on his chest during ceremonies
commemorating his deceased mother. The
flanges above and below the face are carved
with two motifs: stylized mudfish, which
evoke the king's dual nature as both human
and divine, and bearded Portuguese faces,
representing sources of the Oba's wealth
and power.

Zaire, Luba-Hemba people, late 19th century
STOOL

Wood; H. 24 in. (61 cm)
Purchase, Buckeye Trust and Charles B.
Benenson Gifts, Rogers Fund, and funds
from various donors, 1979 (1979.290)

This Luba chief's ceremonial stool was
carved by the Buli Master, one of the best-
known individual carvers of traditional
African art. Most Luba figures are full and
round, their features idealized and ageless,
but the Buli Master's sculptures have an
individuality and emotional intensity that
set them apart. Stools with caryatid figures
were among the most significant
possessions of a Luba chief, who would be
seated on such a stool during the investiture
ceremony that confirmed his right to rule.
The figures portray ancestors whose
presence provides spiritual support for the
ruler, as well as physical support of his
person.

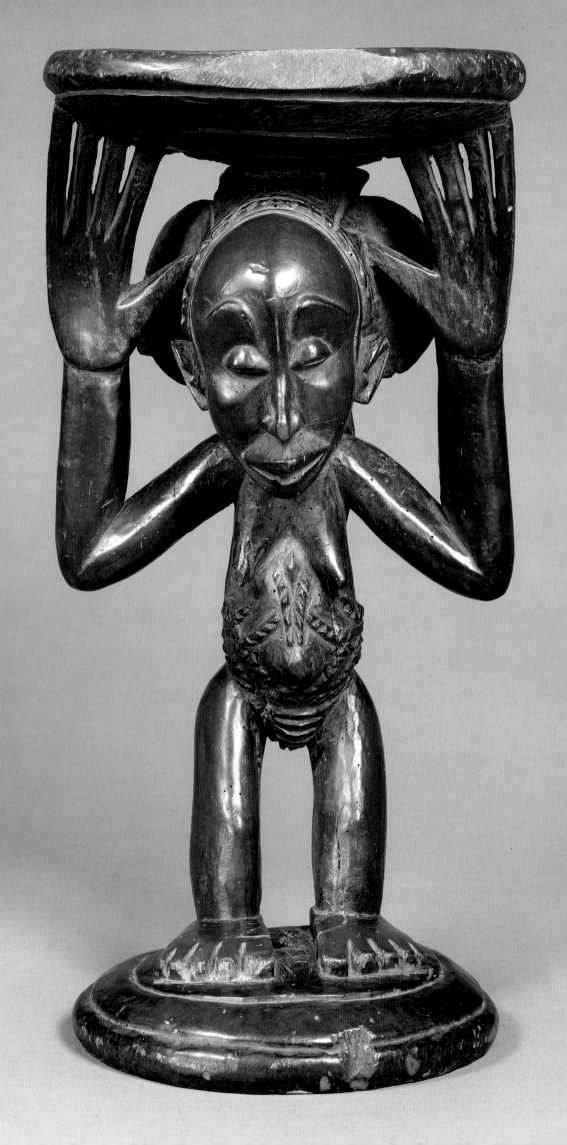

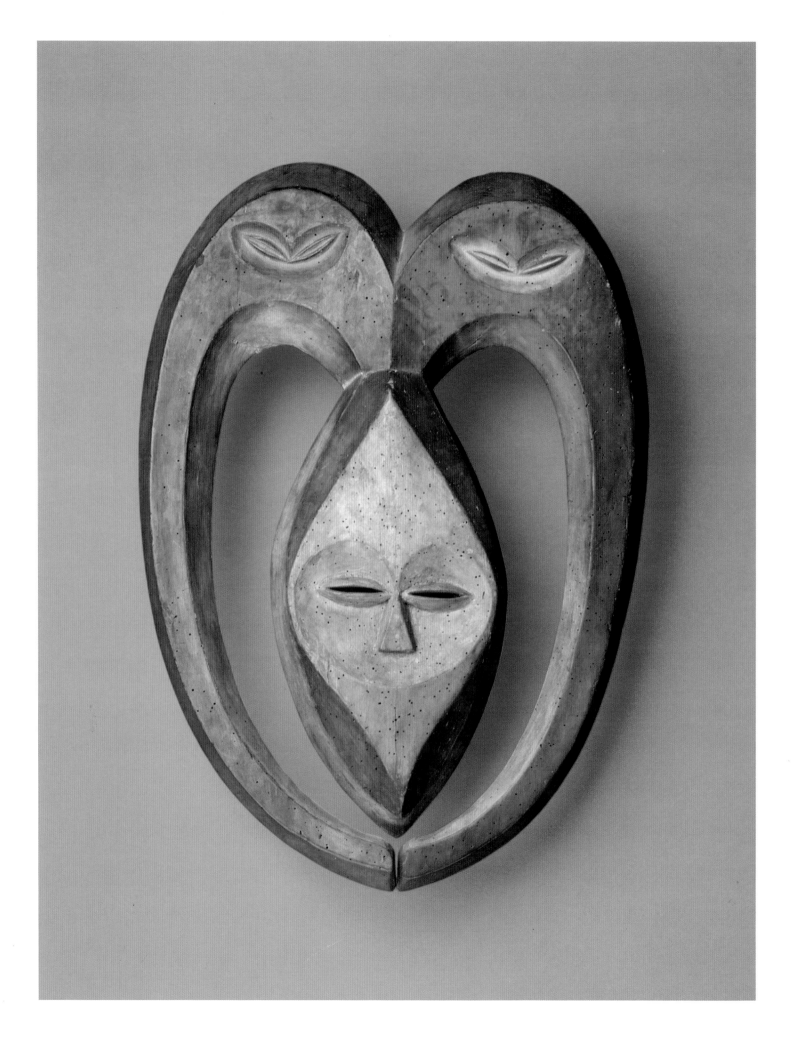

Gabon or Congo, Kwele people,
19th–20th century
FACE MASK

Wood and paint; H. 20¾ in. (52.7 cm)
The Michael C. Rockefeller Memorial
Collection, Bequest of Nelson A. Rockefeller,
1979 (1979.206.8)

Kwele masks appeared in ceremonies of the
Beete cult. Like the cults of other groups in
the western Equatorial Forest region, Beete
relied on the power of the skulls of deceased
family members to combat the negative
forces that threatened to destroy the village
with famine, disease, or war. Beete involved
making a potent medicine to be consumed
by the entire village. While the extensive
preparations for this great ceremony were
in progress, masks appeared in the village to
create the "hot" atmosphere necessary for
the medicine to be effective. These masks,
representing forest spirits and children,
would lead the villagers in dancing, creating
a sense of harmony and cooperation that
was the goal of Beete. The concave, heart-
shaped face at the center of this mask is a
feature that links Kwele masks with carving
styles of other groups in this region.

Sierra Leone, Mende people,
19th–20th century
HELMET MASK

Wood, metal; H. 15 in. (38.1 cm)
Gift of Robert and Nancy Nooter, 1982
(1982.489)

The Mende have one of the few African
masking traditions exclusively reserved for
women. The masks represent the guardian
spirit of Sande, a society responsible for the
education and moral development of
Mende women. Worn by women at
celebrations marking the end of the
initiates' training period, these masks
convey the Mende ideal of feminine beauty,
featuring an elaborate coiffure often
incorporating animal or bird imagery and a
sensuously ringed neck. This mask is
unusual because of the profusion of animal
horns that project from the coiffure, a
reference to the horns filled with protective
medicinal ingredients worn by Mende
women. The mask also features certain
male attributes, such as the beard,
suggesting that through Sande, Mende
women acquire knowledge equal to that
of men.

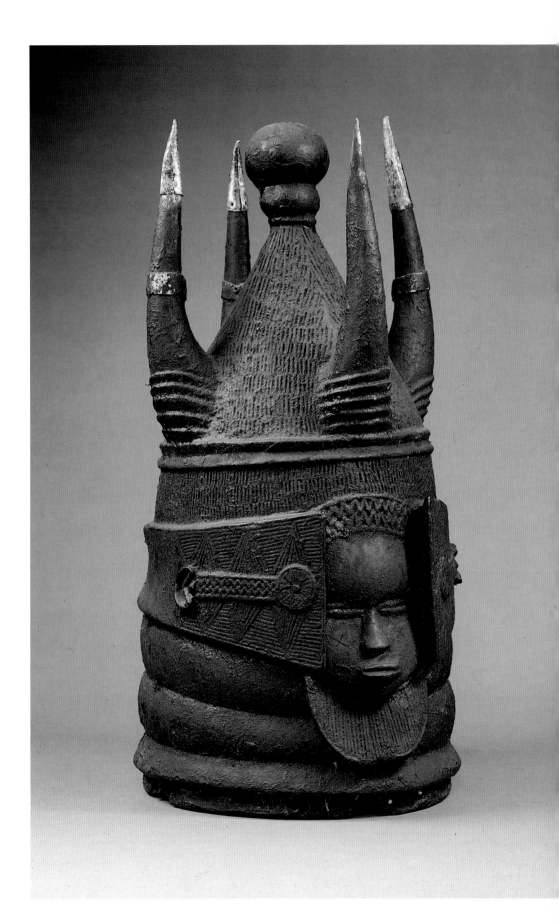

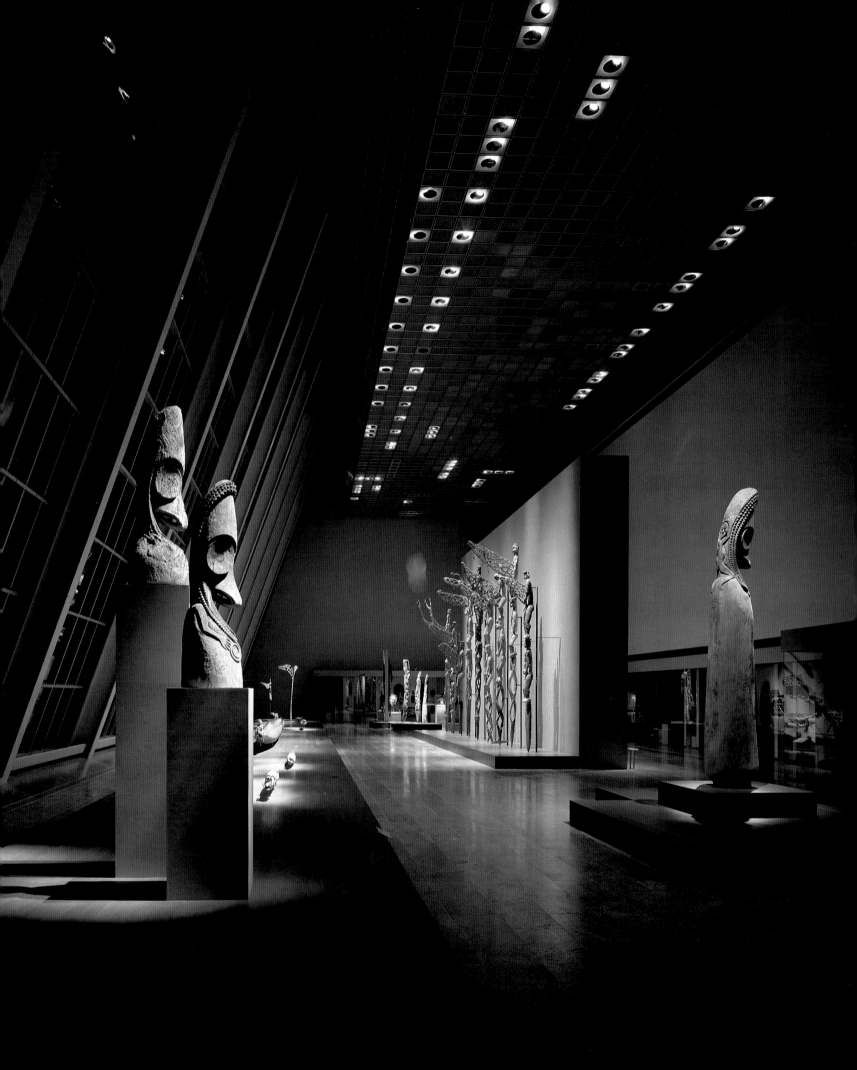

Oceania

THE SKETCHINESS OF OUR knowledge of human history in the Pacific is matched by equivalent gaps in the history of the region's art. Only faint indications of its artistic activity remain. Time and climate have not been kind to wood and barkcloth; only in New Zealand is wood sculpture of well-established antiquity known to have survived. Elsewhere the extant works are in tough materials—stone, shell, pottery—and these probably do not represent the full wealth of the actual traditions. The earliest evidence for art in the Pacific world comes from Australia, and so far works from this continent are the most copious, although their dating is often very difficult to establish.

The natural environment of the Pacific Islands is extraordinarily rich in potential imagery; apart from the overwhelming impact of its landscape, the most casual eye can find a superabundance of life, vegetable and animal, in a teeming variety of grotesque and beautiful forms. The major subject of art everywhere, however, both quantitatively and qualitatively, is the human figure. For people who lived in small groups, in environments that overmatched their physical power, and who were frequently under attack from hostile neighbors, this choice was perhaps a way to assert the fragile primacy of humanity. In accordance with this, the figure sculpture of the Pacific is never purely realistic; rather, the body is a medium for the expression of concepts.

There are many correspondences between Pacific Islands styles, but it is their multiplicity and diversity that are delightful and astonishing. The isolation of the smaller islands gave rise to local styles; in the larger areas of Melanesia and New Guinea interplay between groups influenced styles. Echoes of ancestral images abound, a form or a design recurring from one group of islands to the next.

More important to understanding of Pacific art are the area's religions—the fundamental beliefs of the islanders—and the societies these religions molded and supported. The quest for power was universal, and power could be gained through the intervention of the supernatural. The supernatural world itself was neutral; it was as likely to punish as to bless. It could kill, or it could bestow authority and fertility. These beliefs became the grand themes of Pacific Islands art, expressed in images that are not meant to edify, console, or charm.

The arts of Africa, Oceania, and the Americas are housed in the Michael C. Rockefeller Wing, which was opened in 1982. Objects assembled by the once independent Museum of Primitive Art and by Nelson A. Rockefeller, form the core of the wing's collections, which is named for Mr. Rockefeller's son, who collected many of the Asmat objects from western New Guinea that are now in the Museum.

(OPPOSITE)

VIEW OF THE MELANESIAN GALLERIES

The Michael C. Rockefeller Wing

In the foreground are several slit-gongs from Ambryn Island, New Hebrides. Behind the object at the right is the Museum's impressive collection of memorial poles (*mbis*) made by the Asmat people of west New Guinea. These carvings were made especially for ceremonies held when an Asmat village had suffered a certain number of deaths at the hands of an enemy. Ceremonial Asmat canoes can be seen behind the New Hebrides heads at the left.

(LEFT)

Detail of Solomon Islands Shield (see page 278)

New Zealand, Maori, probably 18th century
FEATHER BOX (WAKA HUIA-PAPAHOU)

Wood; H. 17⅝ in. (44.8 cm)
The Michael C. Rockefeller Memorial Collection, Purchase, Nelson A. Rockefeller Gift, 1960 (1978.412.755ab)

This wooden box with a fitted lid was used to store the prized feathers worn on the head by a Maori chief. Because the head of a chief was believed to be sacred, anything touching it could be imbued with his power and sanctity. Feather boxes like this one were carved with elaborate designs incorporating the figures of ancestors and were kept high in the rafters of the house, where they were seen from below.

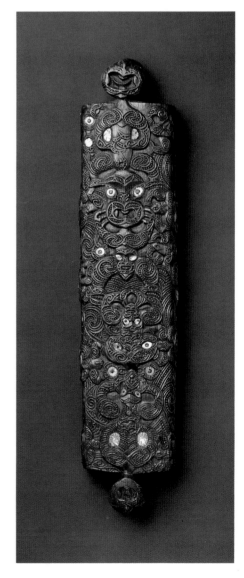

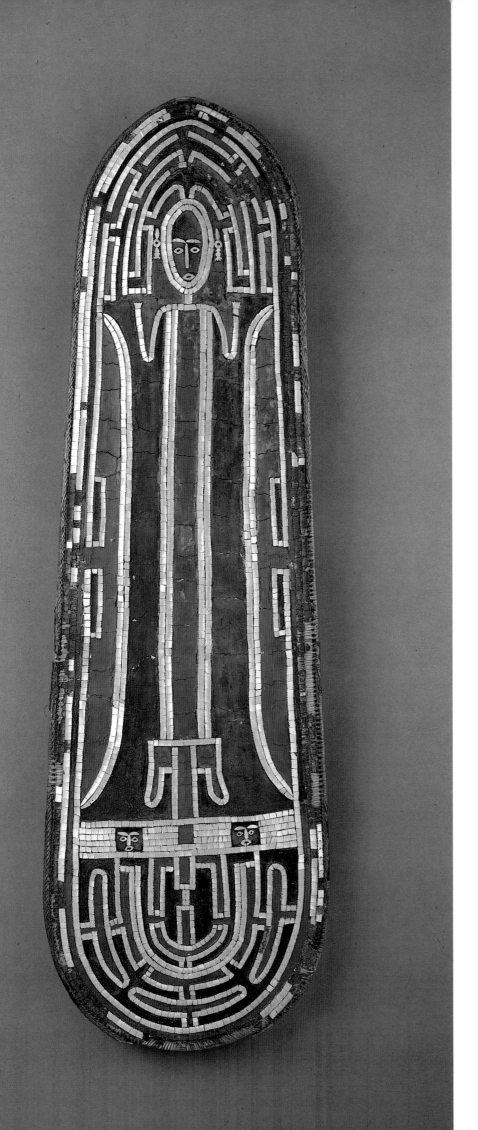

Solomon Islands (Santa Isabel Island), mid-19th century

SHIELD

Basketry, mother-of-pearl, and paint;
H. 33¼ in. (84.5 cm)
The Michael C. Rockefeller Memorial
Collection, Gift of Nelson A. Rockefeller,
1972 (1978.412.730)

The art of the Solomon Islands is most frequently seen as carved canoe decoration and architectural ornament, but a few shields—perhaps two dozen—exist that are basketry encrusted with shell pieces forming designs that represent a figure and several faces. All of the shields decorated in this manner seem to have been made in the mid-19th century, probably as ceremonial objects or status symbols for men of high rank.

Torres Strait (Mabuiag Island), 18th century
MASK

Turtle shell, clam shell, wood, feathers, sennit, resin, paint, and fiber; H. 17½ in. (44.5 cm)
The Michael C. Rockefeller Memorial
Collection, Purchase, Nelson A. Rockefeller
Gift, 1967 (1978.412.1510)

The islanders of the Torres Strait, between New Guinea and Australia, used plates of turtle shell to construct sculptures, a practice found nowhere else in the Pacific. Turtle-shell effigies in these islands were first recorded in 1606 by the Spanish explorer Diego de Prado, testimony to the antiquity of the tradition. Some masks are in human form; others represent fish or reptiles, while still others are a combination of attributes from all three.

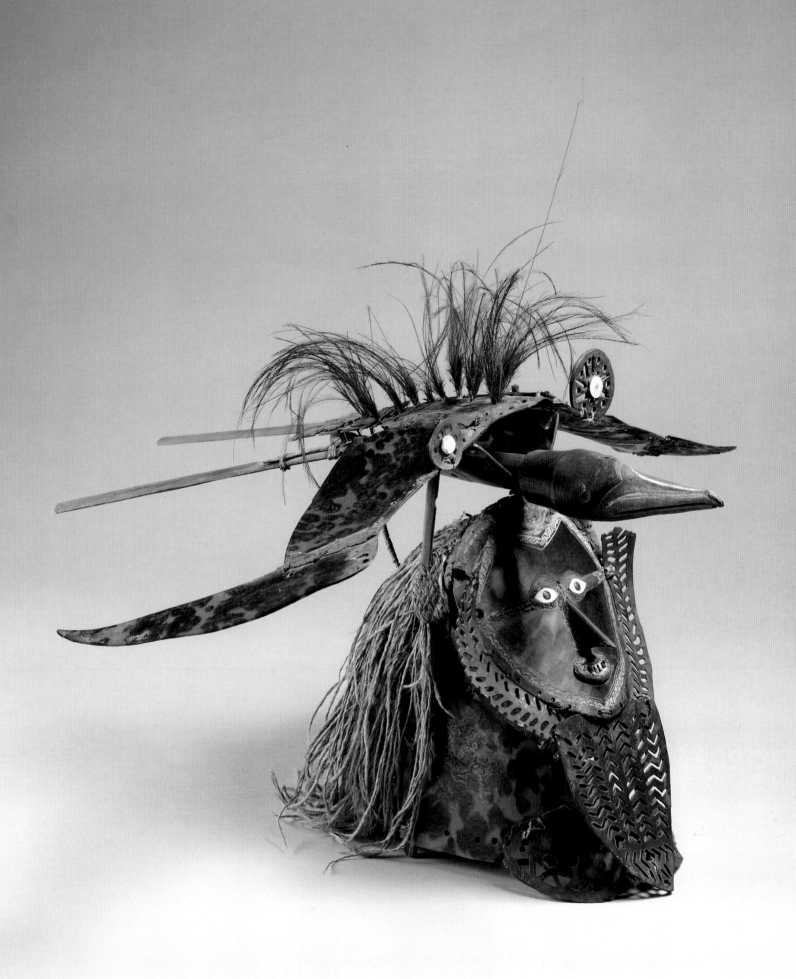

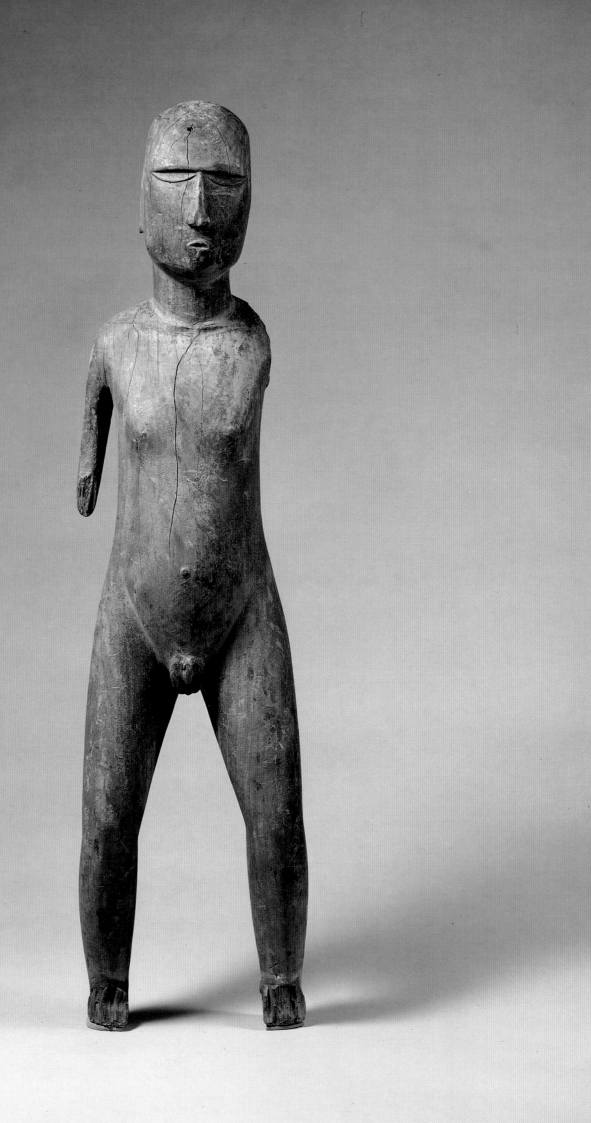

Gambier Islands (Mangareva Island),
19th century
MALE FIGURE

————

Wood; H. 38¾ in. (98.4 cm)
The Michael C. Rockefeller Memorial
Collection, Bequest of Nelson A. Rockefeller,
1979 (1979.206.1466)

————

It is not known which of the numerous
deities worshiped in the Gambier Islands is
represented by this figure, but the god most
often the subject of wood figures was Rogo,
sixth son of the mythological first
inhabitants of the island of Mangareva.
Rogo was the god of peace, agriculture, and
hospitality in all of Polynesia. On
Mangareva Island he was invoked especially
in rites connected with the cultivation of
turmeric tubers. Most of the sculpture of
this island was destroyed in April 1836 at the
instigation of missionaries. Only eight
figures survived, six of them naturalistic and
two of them highly stylized.

*Solomon Islands (Buka or northern
Bougainville),* 19th century
PADDLE

————

Wood and paint; L. 67 in. (170.2 cm)
The Michael C. Rockefeller Memorial
Collection, Purchase, Nelson A. Rockefeller
Gift, 1966 (1978.412.1491)

————

The Solomon Islanders were well known
for their highly warlike propensities, and
headhunting and slave-raiding expeditions
were frequent. The raiders traveled in huge
plank-built war canoes capable of carrying
dozens of men. Canoe paddles were
regularly decorated in extremely low relief
with representations of birds and human-
shaped figures called *kokorra*. Although they
are ubiquitous in the art of the area,
practically nothing is known of significance
about the *kokorra*, but it seems likely that
they had supernatural importance.

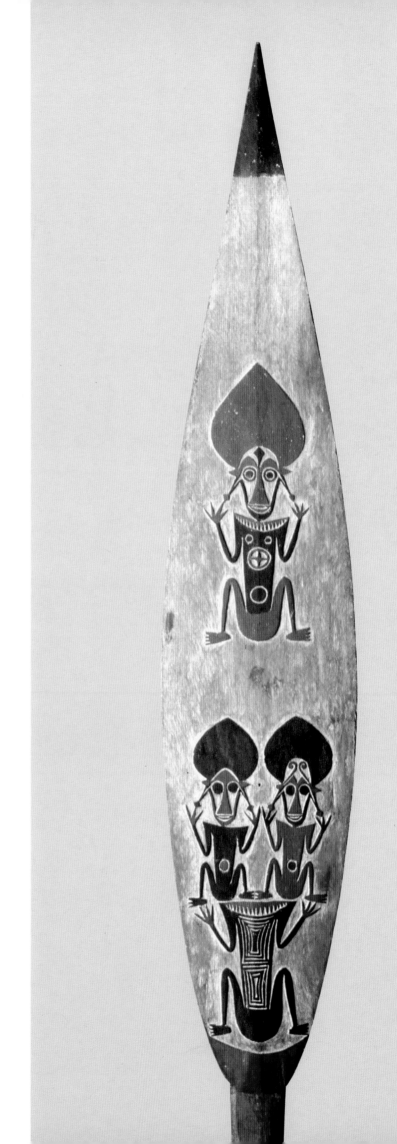

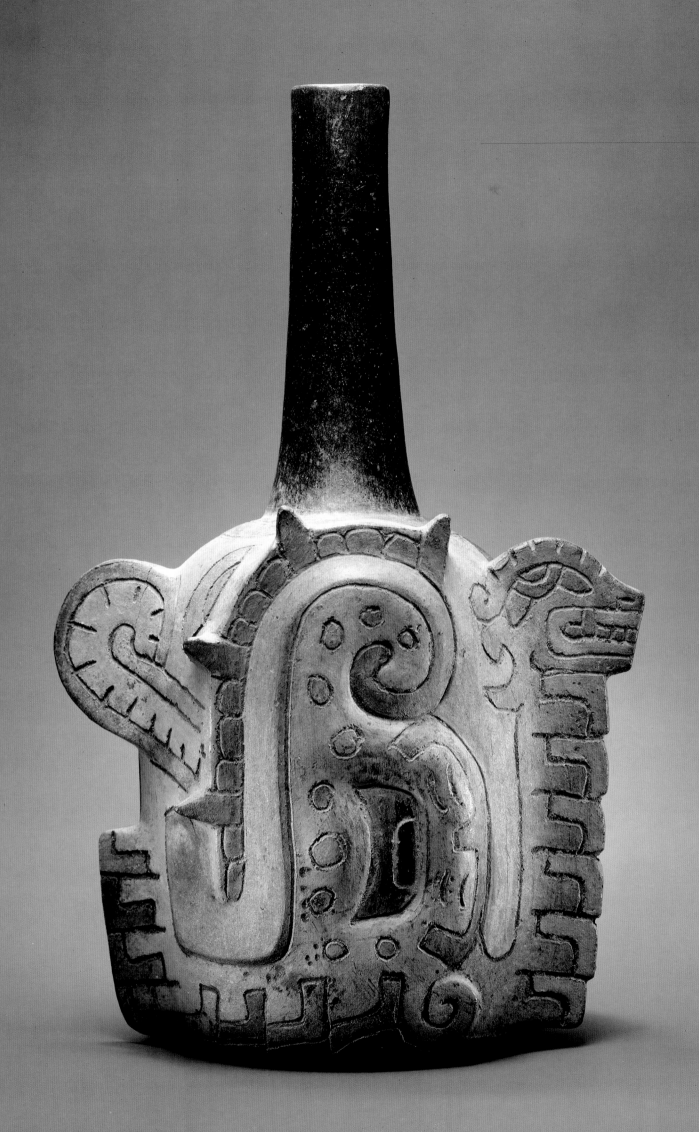

Precolumbian America

THE EARLY CIVILIZATIONS OF the two American continents flourished into greatness between the late second millennium B.C. and the middle of the second millennium A.D. The most successful of these civilizations were those of Mesoamerica—the area composed primarily of modern-day Mexico and Guatemala—and the South American region of Peru. It is here that the first great American art was made, in Mesoamerica by the Olmec peoples and in Peru by the peoples of Chavin. The Aztecs and the Incas were to dominate these respective lands many centuries later, ruling them in the early sixteenth century when the Old World began the invasion of the New. The conquerors were the first Europeans to see the art of ancient America, an art referred to today as Precolumbian (literally, "before Columbus"). It produced awe and astonishment among them, and in Europe, where many precious objects were sent, it intrigued kings and popes and inspired curiosity among the learned. By the end of the sixteenth century, however, interest in the Indian kingdoms of the Western Hemisphere had waned, and it was not until the nineteenth century that it was rekindled.

The peoples of Precolumbian America were many and varied, and their art was equally multifaceted. It was made to serve a wide variety of functions in materials that range from the precious to the humble, in shapes of tradition and invention, and in dimensions that are monumental or the size of a thumbnail. Today these differences and diversities are a challenge to the modern viewer, as heretofore little-known peoples, places, histories, beliefs, and objects are accessible to those who are interested, and to pursue them is to be rewarded with revelations of a new world.

Many common aesthetic features of Mesoamerican civilizations originated in about 1000 B.C. among the Olmecs, a politically powerful and artistically gifted people who lived in the coastal swamps of the Gulf of Mexico. They formalized concepts upon which significant achievements in Mesoamerican art and architecture were made, achievements substantially elaborated by all later peoples. In Peru the clear antecedents to the region's artistic accomplishments were present on the north-central Pacific coast by the late second millennium B.C. A significant development of this time was the beginning of metallurgy, when gold was first worked in Peru. American gold objects would be, two millennia later, major factors in attracting Europeans to the New World.

Innumerable American civilizations and peoples existed other than those of Mexico and Peru. The Taino peoples of the islands of the Greater Antilles, for instance, produced works of art of distinctive imagery, and areas of Costa Rica, Panama, and Colombia are known for the production of elaborately worked gold objects.

The Chavin era in Peru, dated to the middle centuries of the first millennium B.C. and named for a temple complex near Chavin de Huantar, was one of the most artistically and intellectually inventive in the history of ancient South America. Many extant Chavin objects come from tombs in the coastal valleys of Chicama, Moche, and Jequetepeque. Chavin ceramic vessels— fired to mute tones of gray, black, and tan— are sculptural in form and have pleasingly finished surfaces, some highly polished, others painted with dusty, matte-textured paints. Chavin iconography is extremely complex, and considerable emphasis is placed on feline forms, probably a reference to the jaguar, the most impressive wildcat of the Americas. An incised and modeled feline head in profile can be seen on this tall, well-preserved bottle.

There is a great deal of stylistic variety among the Precolumbian gold objects of the Andes, reflecting the diversity of ancient cultural traditions. This piece, from a plateau that extends from southern Colombia into Ecuador, shows components of the styles from each area, especially the Colombian tendency toward abstraction. Human and animal shapes have been completely eliminated, and what remains is a pendant that is line itself and looks like the work of some ancient calligrapher.

Colombian (Tairona), 10th–16th century
MASKED-FIGURE PENDANT

Tumbaga; H. 5¼ in. (13.3 cm)
Jan Mitchell and Sons Collection, Partial and
Promised Gift of Jan Mitchell, 1991
(1991.419.31)

This impressive pendant is of the type
known as *caciques* in Colombia. Meaning
"chieftain," the word has been applied to
the elaborate pendants as a mark of respect.
Caciques pendants always have huge
headdresses, and this example has a large
bat mask with a prominent muzzle. It
stands with its hands on its hips and holds
double-spiral objects in its hands. The
object was cast in a gold-copper alloy, called
tumbaga, by the lost-wax technique.

Mexican, Aztec,
second half of 15th–early 16th century
AZTEC STANDARD BEARER

Laminated sandstone; H. 25 in. (63.5 cm)
Harris Brisbane Dick Fund, 1962 (62.47)

Aztec temple-pyramids were the last in a
sequence of similar structures that were
built in Mesoamerica over a period of about
2,000 years. The pyramidal platforms
on which the temples sat changed
configuration over the centuries, and during
Aztec times they became mighty twin
pyramids, or "towers," as the Spaniards
called them. Wide flights of stairs led from
the plaza floors to the high platforms that
supported the temple buildings and large
incense burners and/or figures of standard
bearers. This standard bearer comes from
Castillo de Teayo, an Aztec enclave in
northern Veracruz, and it combines
cosmopolitan Aztec stylistic features with
the use of sandstone, a local Veracruz
material.

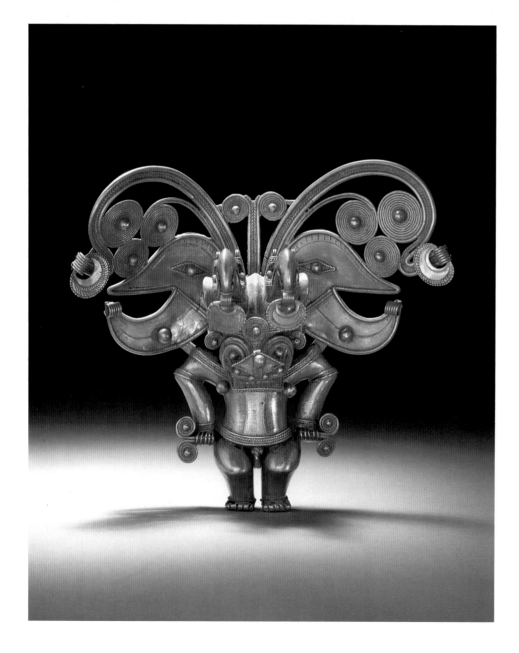

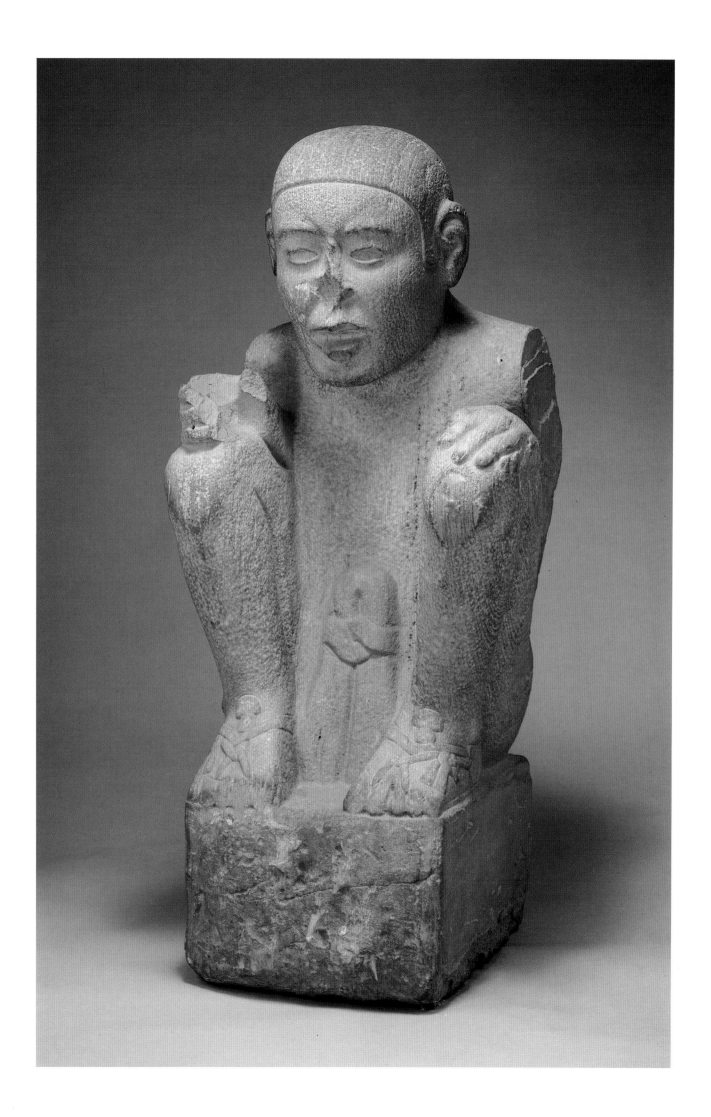

THE TWENTIETH CENTURY

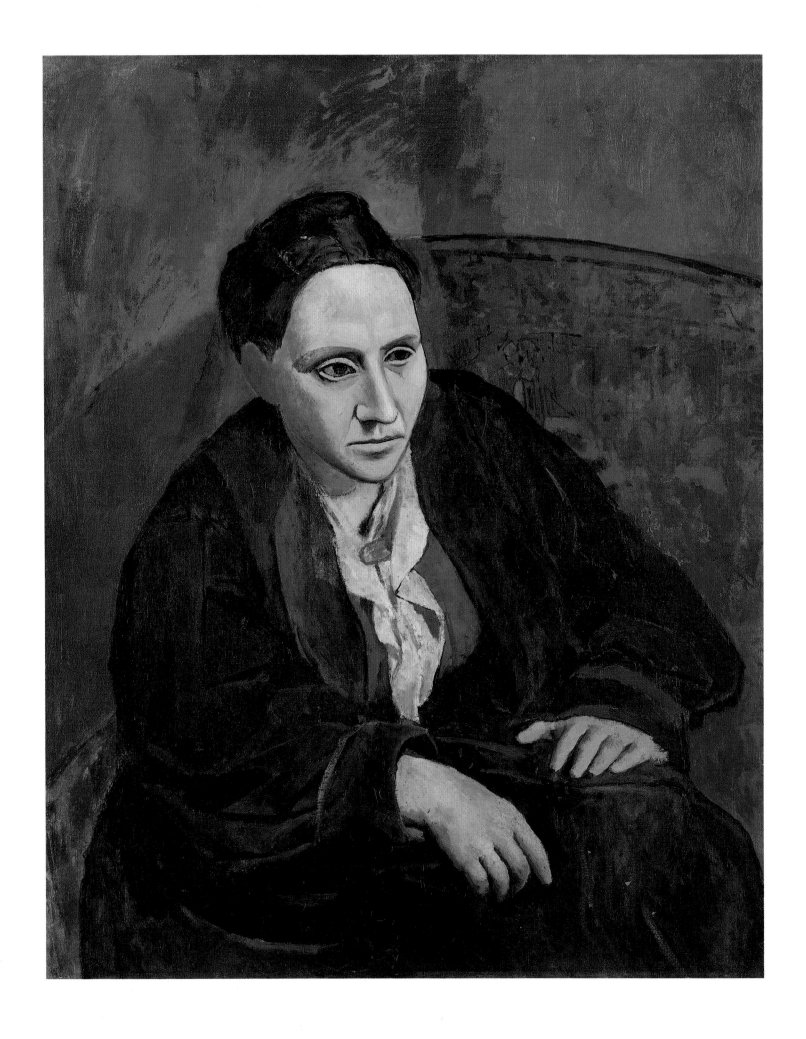

THE EARLY DECADES OF the twentieth century witnessed the rise and fall of numerous schools of art—Fauvism, Cubism, Surrealism, and others. The history of modern art in both Europe and America is, however, most eloquently written in the works of individual artists whose technical, intellectual, emotional, and aesthetic innovations speak of and for their times.

Since its founding in 1870 the Metropolitan Museum has been concerned with the art of its own time as well as that of the past. This involvement with contemporary art was strengthened early in the twentieth century with the establishment of two funds by the trustee George A. Hearn for the purpose of acquiring paintings by living American artists. Modern European painting is less conspicuously represented at the Museum, although masterpieces by Renoir and Cézanne were purchased as early as 1907 and 1913, and the acquisition of several important collections has immeasurably enriched the Museum's holdings in this area.

Avant-garde modernism in American painting began when a handful of artists—most of them associated with the photographer Alfred Stieglitz and his Gallery 291—started to emulate advanced Parisian art of the early 1900s. In 1913 the Armory Show presented an exhaustive survey of works by Futurists, Dadaists, and Cubists. Assembled for the first time in America, these works outraged critics but astounded artists. Following the outbreak of World War I, many important European modernists arrived in America, but by the time of the Great Depression, a strong American reaction to modernism had emerged in realist art, emphasizing what artists saw as truly and typically American.

In the 1930s and early 1940s it seemed that American native realism would dominate painting indefinitely, but events proved otherwise. Interest in modernism had not died but had simply gone underground. In 1936 a group of artists formed the American Abstract Artists, which contributed to the emergence of Abstract Expressionism in the 1940s. Also of major importance was the arrival of a wave of European masters seeking to escape World War II.

The selection of works in this chapter suggests that by the middle of the twentieth century national distinctions in art had ceased to have much meaning. Willem de Kooning, born in Rotterdam, was twenty-two years old in 1926 when he arrived in Hoboken, New Jersey. Pablo Picasso, a Spaniard, lived and worked most of his life in France. Balthus, born in Paris of Silesian parents, was raised in Berlin and Geneva, worked in France and Italy, and now resides in Switzerland.

When the Lila Acheson Wallace Wing for 20th Century Art opened in 1987, the Museum's collection of modern design was given a permanent exhibition space, along with paintings and sculpture of Europe and America. For the first time, the extent and richness of the Museum's modern-design holdings—perhaps the most comprehensive collection in the western hemisphere—were apparent to the public. As with modern American painting, the Museum began to acquire fine objects soon after they were made, a tradition that continues today on an international scale.

(OVERLEAF)
David Smith
American, 1906–1965
BECCA, 1965

Stainless steel; H. 113¼ in. (287.7 cm)
Bequest of Miss Adelaide Milton de Groot (1876–1967), by exchange, 1972 (1972.127)

David Smith was unquestionably one of the most influential and innovative American sculptors of the 20th century. This fine example of his late work, named for one of his two daughters, is two-dimensional in orientation, intended to be seen from the front. The diagonal elements at the top give the piece a joyous lift, and the burnished scribbles—resembling brushstrokes—over the entire work are both expressive and playful. The artist has been able to maintain the stamp of his individual identity, in spite of his use of modern industrial materials.

(OPPOSITE)
Pablo Picasso
Spanish, 1881–1973
GERTRUDE STEIN, 1906

Oil on canvas; 39⅜ × 32 in. (100 × 81.3 cm)
Bequest of Gertrude Stein, 1946 (47.106)

The American writer Gertrude Stein was one of Picasso's earliest patrons, and he began working on this portrait of her when he was 24 years old. She posed for him on some 90 occasions, but he had great difficulty with the head. After a trip to Spain in the fall of 1906, nearly a year after he started the portrait, he painted in a new head. The masklike face with its heavy-lidded eyes reflects Picasso's recent encounter with Iberian sculpture. It is said that in response to the observation that Stein, who was then 32 years old, bore little resemblance to the portrait, Picasso replied simply, "She will."

(LEFT)
Pablo Picasso
Spanish, 1881–1973
THE FARMER'S WIFE, 1908

Charcoal on Ingres paper, 24¾ × 19 in. (62.9 × 48.3 cm)
Purchase, Gift of Mr. and Mrs. Nate B. Spingold and Joseph Pulitzer Bequest, by exchange, and Van Day Truex Fund, 1984 (1984.5.1)

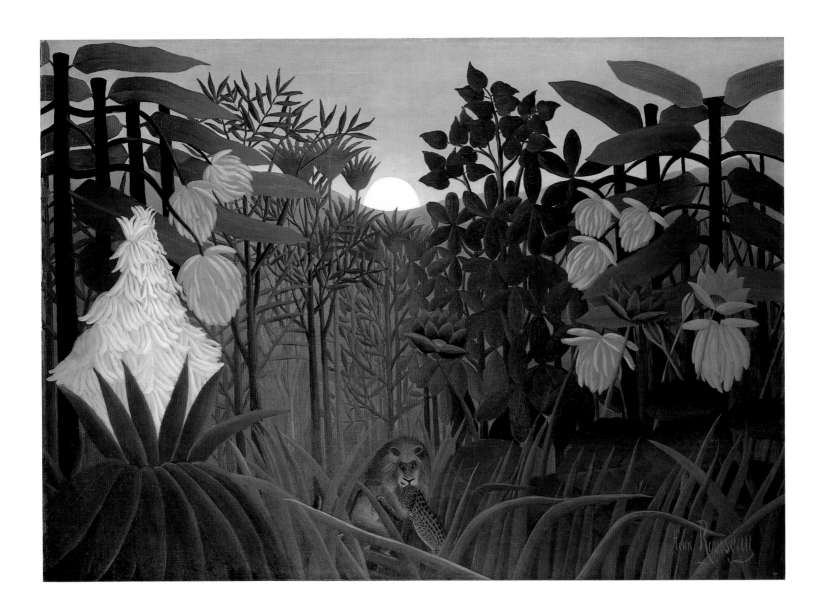

Henri Rousseau *("Le Douanier")*
French, 1844–1910
THE REPAST OF THE LION, 1907

Oil on canvas; 44¾ × 63 in. (113.7 × 160 cm)
Bequest of Sam A. Lewisohn, 1951 (51.112.5)

Rousseau was a self-taught artist whose first exhibition was held in Paris in 1886, when he was 42. Both Picasso and Gertrude Stein were among his early admirers. Rousseau began to paint imaginary scenes set in the jungle by 1891; this picture showing a lion devouring a jaguar was probably first exhibited at the Salon d'Automne in 1907. The artist's unique vision, his intuitive sense of design and color, and his precise, profuse use of detail combine to render this mysterious, exotic world authentic. The vegetation is evidently inspired by his visits to the Jardin des Plantes in Paris, but he has disregarded their actual sizes in inventing forests that dwarf the figures of natives and animals. His animals are based on photographs in a children's book owned by his daughter.

Henri Matisse

French, 1869–1954

NASTURTIUMS WITH "DANCE," 1912

Oil on canvas; 75½ × 45⅜ in.
(191.8 × 115.3 cm)
Bequest of Scofield Thayer, 1982 (1984.433.16)

This painting is Matisse's second version of
the subject (the first is in the Pushkin
Museum in Moscow). It was exhibited at
the 1913 Armory Show in New York,
Chicago, and Boston, one of the first
Matisses to be viewed by a large American
audience. The composition, a view of
Matisse's studio in Issy-les-Moulineaux,
southwest of Paris, was painted in 1912,
when the artist returned to France after a
long stay in Morocco. In the left foreground
is a wooden armchair with a striped
cushion; behind it and to the right is a tripod
table, intended for sculpture but supporting
a vase of nasturtiums. Occupying the
entire background is a section of Matisse's
large painting *Dance I* of 1909 (now in
the Museum of Modern Art, New York),
which was standing on the studio floor
at the time. Matisse repeated this device
of incorporating his own works in his
compositions many times. This version
of *Nasturtiums with "Dance"* is freer than
the first; the tones are paler but more
luminous and the varied colors are
masterfully combined, proving Matisse's
status as one of the greatest colorists of all
time. When asked by John Rewald why he
painted a second version, Matisse answered,
"Because such a thing is quite natural. The
conception is not the same. Here I was
carried away by color."

Roger de La Fresnaye

French, 1885–1925

ARTILLERY, 1911

Oil on canvas, 51¼ × 62¾ in.
(130.2 × 159.4 cm)
Anonymous Gift, 1991 (1991.397)

La Fresnaye could often have observed such military reviews near Les Invalides, in Paris. Here, artillery officers on horseback accompany an ammunition wagon carrying sliders and pulling a field gun. Holding a tricolor aloft, a band in red and blue infantry uniforms marches in the background. Considered the artist's masterpiece, *Artillery* evokes patriotic fervor, motion, and sound. Painting it during the year he became associated with Cubism, La

Fresnaye reduced all forms to their geometric core and aligned them along a rigorous diagonal axis. Completed three years before the outbreak of World War I, the picture also appears prophetic.

Marsden Hartley

American, 1877–1943

PORTRAIT OF A GERMAN
OFFICER, 1914

Oil on canvas; 68¼ × 41⅜ in.
(173.4 × 105.1 cm)
Alfred Stieglitz Collection, 1949 (49.70.42)

Hartley painted his best work during the first years of World War I while living in Berlin, a time when the city was filled with avant-garde artists from all over the world. During this period he produced a series of portraits of German officers, intensely powerful canvases that reflect not only his revulsion at the horrors of the war but also his fascination with the energy and pageantry that accompanied the war's devastation. This painting shows Hartley's assimilation of both Cubism and German Expressionism. The artist denied that the objects in the painting have any special meaning, but the banners, medals, and insignia evoke a collective psychological and physical portrait of the officer. There are also specific references to Hartley's close friend Karl von Freyburg, a young cavalry officer who had recently been killed in action.

Georg
French,
THE G

Oil and
(190.5 ×
Partial g
of Willi

The yea
transitic
who, w
Cubism
Braque
in the a
began t
naturali
of the fc
still-life
Small R
Braque
greens,
promin
is comp
plane, a
the arra
newspa
fragmei
pattern
techniq
Picasso
at least
1921 anc
earliest
Salon d

Jacques V...
French, 1875...
THE DINI...

Oil on canv...
Purchase, C...
Thannhaus...

Cubism wa...
artists, Geo...
Almost con...
assimilated...

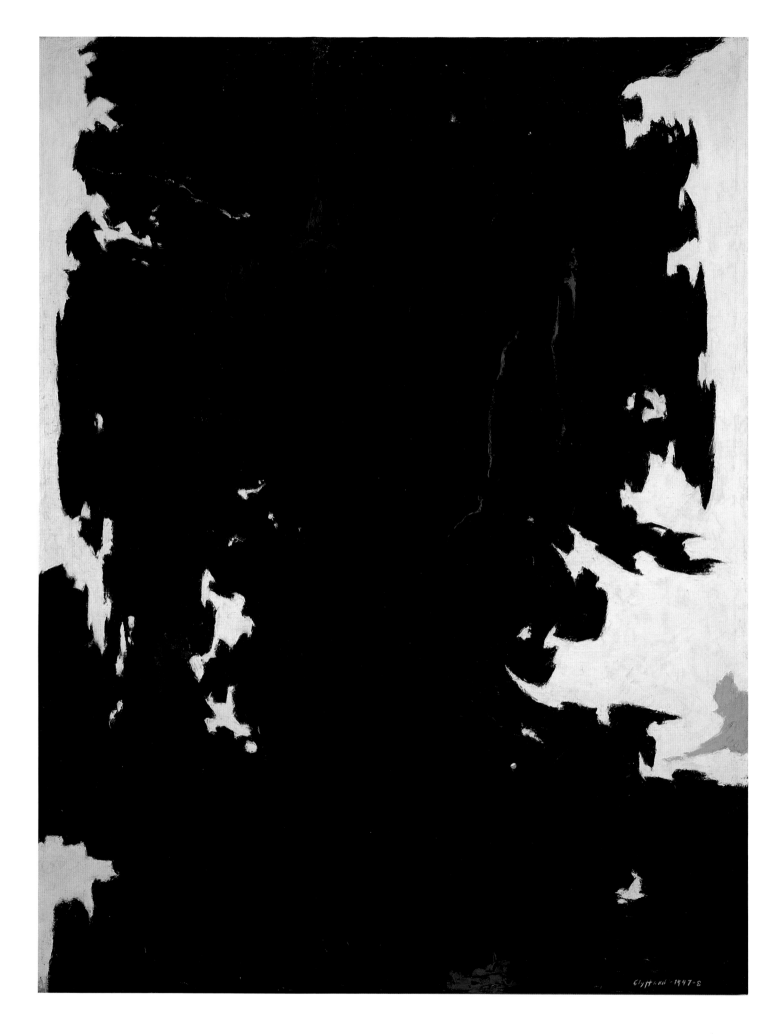

Clyfford Still
American, 1904–1980
UNTITLED, 1946

Oil on canvas; 61¾ × 44½ in.
(156.8 × 113 cm)
George A. Hearn Fund and Arthur Hoppock
Hearn Fund, 1977 (1977.174)

Still, another major figure in the New York
School, developed his style in the late 1940s
on the West Coast. This is an early example
of the color-field abstractions for which he is
known. All vestiges of traditional
composition have been banished and the
viewer is denied entry into deep space in
this emphatically frontal work.

Willem de Kooning
American (born The Netherlands), 1904
ATTIC, 1949

Oil, enamel, and newspaper transfer on
canvas; 61⅞ × 81 in. (157.2 × 205.7 cm)
The MURIEL KALLIS STEINBERG NEWMAN
Collection, Jointly owned by The
Metropolitan Museum of Art and Muriel
Kallis Newman, in honor of her son, Glenn
David Steinberg, 1982 (1982.16.3)

This energetic painting was made during a
period when de Kooning, one of the leading
gestural Abstract Expressionists, eliminated
color from his work. Constant revisions and
overpainting are evident here; the artist put
newspaper over the wet surface to help the
paint dry more quickly and this left traces of
newspaper transfer. The angular, thrusting
forms collide with curvilinear shapes to
produce a high-pitched, expressive picture.

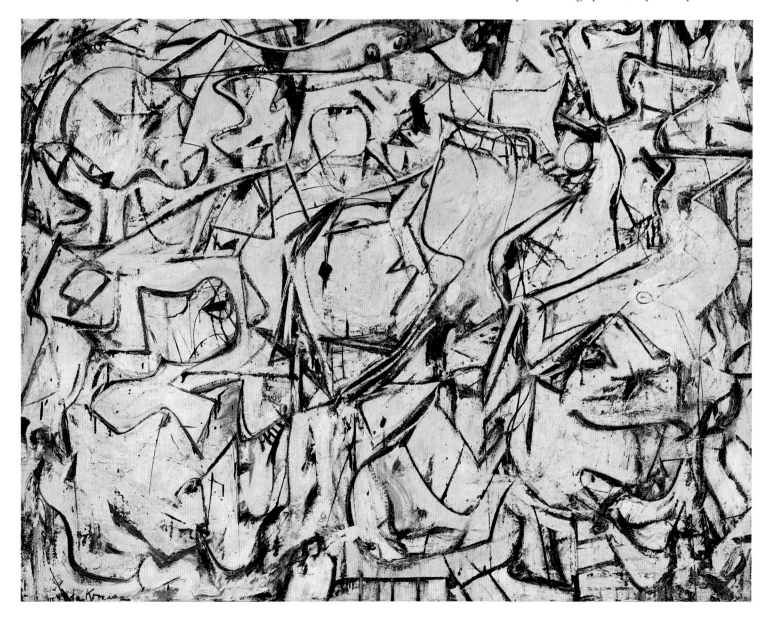

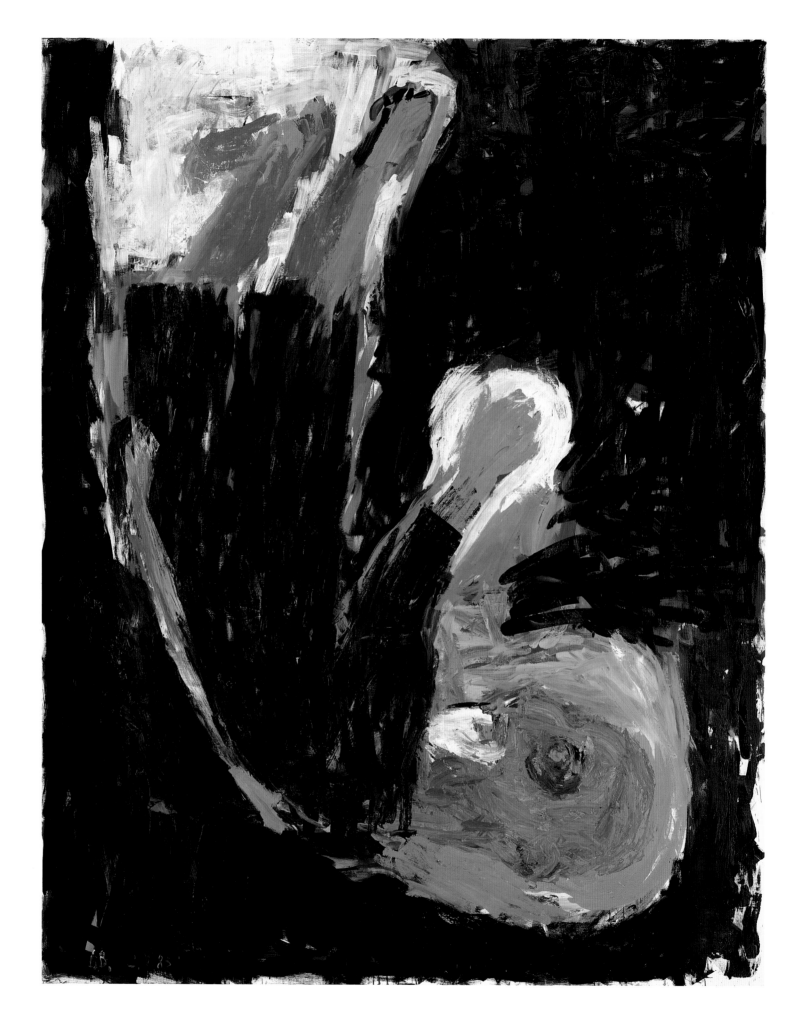

Jackson

American

AUTUM

1950

Oil on ca

(266.7 ×

George A

Pollock,

and mem

known fo

continue

than 40 y

Along w

Kooning

Rothko,

techniqu

insufficie

to conve

Pollock s

many cu

Pasiphaë

Lesson. A

Pollock

techniqu

fundame

express.

rejected

matter,

painting

example

Georg Baselitz

German, born 1938

MAN OF FAITH, 1983

Oil on canvas; 97½ × 78 in.
(247.7 × 198.1 cm)
Gift of Barbara and Eugene Schwartz, 1985
(1985.450.1)

Since 1969 the paintings of Georg Baselitz
have depicted figures upside down. The
artist intends to focus our immediate
attention not on the narrative subject but
on the process of painting itself—on the
textural qualities of the oil medium, the
vivid contrasts of color, and the violent,
agitated brushwork. In *Man of Faith* Baselitz
produces a simple, disturbing image on a
grand scale (the canvas is over eight feet
tall). A falling man, dressed in what appear
to be clerical robes, is bent over in prayer. Is
Baselitz making some reference to the
apostle Peter, who was crucified upside
down? The figure's fetuslike position is
surrounded by a jagged halo of energized
paint that heightens the sensation of rapid
descent. The artist's coarse style of painting
is equally stark and direct, and together
subject and technique achieve what he has
called "aggressive harmony."

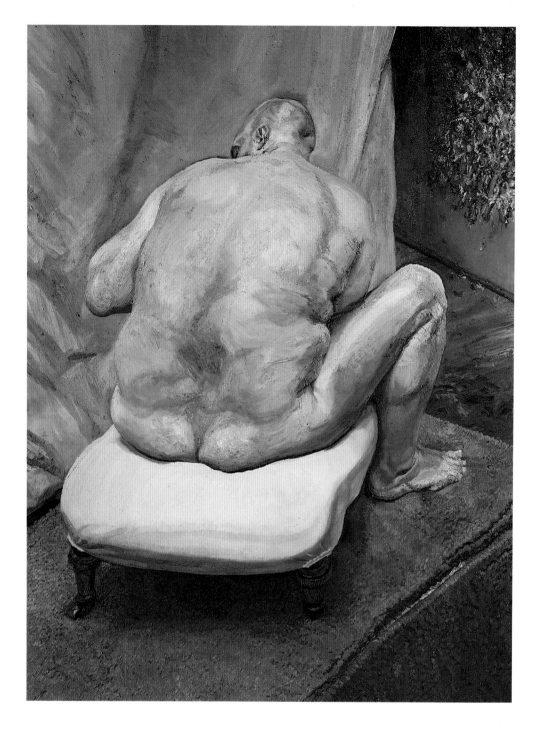

Lucien Freud

British, born 1923

BACK VIEW OF NUDE (LEIGH),
1991–92

Oil on canvas, 72 × 54 in. (182.9 × 137.2 cm)
Purchase, Lila Acheson Wallace Gift, 1993
(1993.71)

For almost half a century Lucien Freud has
concentrated on depicting the human figure
and face. This astonishing picture, among
Freud's largest, portrays a subject frankly
not beautiful. An enormous man, a broken
giant, is posed in the artist's attic studio.
Head shaven, he is nude, and with his back
turned he sits on a cloth-covered stool
placed on a model's red-carpeted stand. The
model is Leigh Bower, a somewhat
notorious London theatrical personality.
With stark truthfulness the artist records
the model's physical features, and his
manipulation of paint to describe different
textures is virtuosic. The rendition of flesh,
here beaten by time and abuse, is
extraordinary. Skin, the membrane that
clothes the human form, is the essential
subject of this still life. One is reminded of
the terrifying single figures imagine by de
Kooning, who once said, "Flesh is the
reason why oil painting was developed."

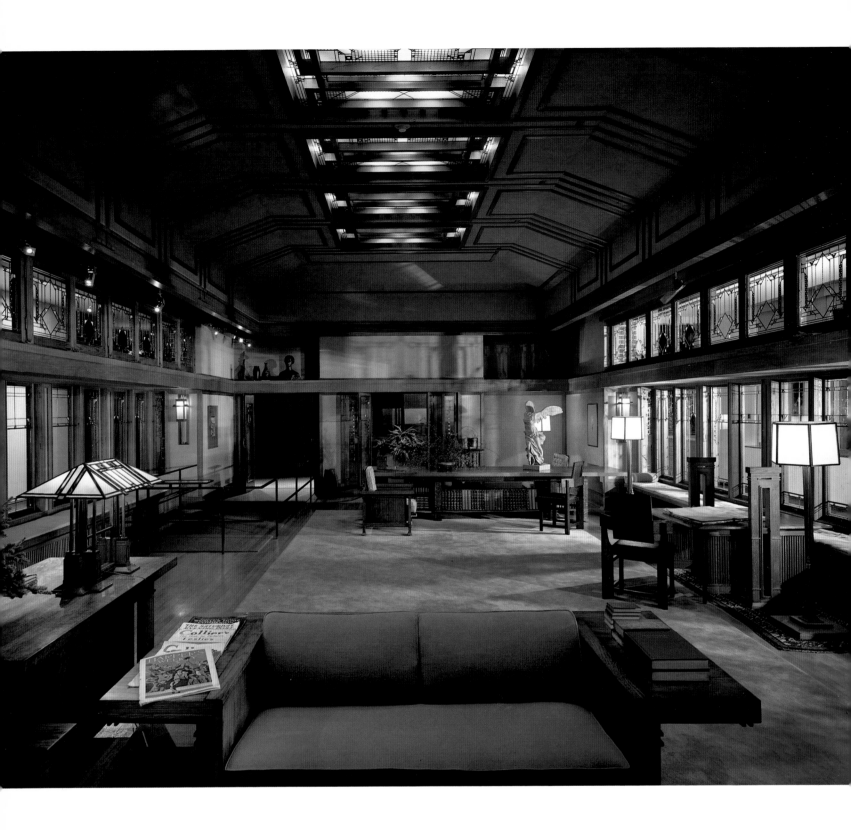

Frank Lloyd Wright

American, 1867–1959

LIVING ROOM FROM THE
FRANCIS W. LITTLE HOUSE, 1912–14

Purchase, Emily Crane Chadbourne Bequest,
1972 (1972.60.1)

Frank Lloyd Wright was one of the most
original and influential architects of the 20th
century. The house from which this room

comes was built in Wayzata, Minnesota,
and represents an extension of the
architect's earlier Prairie Style houses,
where he first developed his concept of total
design for his interiors. Characteristically,
the room has a strong architectural quality
in its finishes and furnishings. A wonderful
harmony is achieved in the combination
of the ocher plaster walls, the natural oak
flooring and trim, the bricks in the fireplace

(a repetition of the exterior brickwork),
and the electroplated copper finish of the
leaded windows. The oak furniture, all
designed by the architect, was conceived as
an integral part of the composition, and its
arrangement faithfully reflects Wright's
original plan. His antipathy for the
eclecticism of Victorian interiors and his
preference for Japanese aesthetics are also
evident in the design.

Josef Hoffmann
Austrian (born Czechoslovakia), 1870–1956

BOWL, ca. 1920

Silver; H. 7½ in. (19.1 cm)
Gift of Jennifer Johnson Gregg, 1976
(1976.415)

Josef Hoffmann cofounded the Wiener Werkstätte in 1903 with the purpose of bringing together artists and craftsmen to raise the level of applied arts in Austria. The Wiener Werkstätte style followed an independent course, changing from the rigorous geometry of early works to a baroque extravagance that proved popular in the 1920s. Hoffmann was affected by this decorative exuberance and abandoned the puritanical grids of his early work, but this bowl shows the master retaining his rational control of proportion. The surface shimmers, the handles loop in sweeping curves, and the base and lip are flared, but this is a subtle and refined piece.

Edward J. Steichen
American (born Luxembourg), 1879–1973
THE FLATIRON, 1904

Gum bichromate over platinum print (1909);
18⅞ × 15⅛ in. (47.9 × 38.4 cm)
Alfred Stieglitz Collection, 1933 (33.43.39)

The imposing height and dynamic shape of
the Flatiron Building, constructed in 1902 on
Madison Square, made it a favorite subject
for photographers at the turn of the century.
Edward Steichen's three large prints of *The
Flatiron* in the Museum's collection, each a
different color, together form the
quintessential chromatic study of twilight in
a modern urban setting. The moody,
painterly effects of this photograph were
achieved by adding color to a platinum print
with layers of pigment suspended in a light-
sensitive solution of gum arabic and
potassium bichromate. Clearly indebted in
its flattened composition to the Japanese
woodcuts that were then in vogue, and in its
coloristic effect to the *Nocturnes* of Whistler,
this picture is a prime example of the efforts
of photographers in the circle of Alfred
Stieglitz to represent their experience of the
world in ways that melded photography's
verisimilitude with current artistic visions.

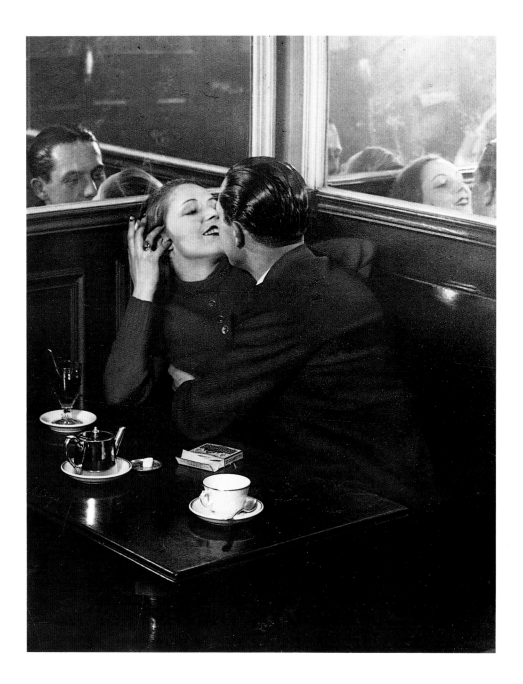

Brassaï (Gyula Halász)
French (born Transylvania), 1899–1984
COUPLE D'AMOUREUX DANS UN
PETIT CAFÉ, QUARTIER ITALIE, 1932

Gelatin silver print, 1970; 11⅛ × 8⅝ in.
(28.3 × 22.7 cm)
Warner Communications Inc. Purchase
Fund, 1980 (1980.1023.5)

Born in Brasso, Transylvania, Gyula Halász
took the name of his birthplace as a
pseudonym in 1932, when he had lived in
Paris for six years working as an illustrator
and correspondent for Hungarian and
German newspapers. In 1929, after
accompanying the expatriate Hungarian
photographer André Kertész on
assignment, Brassaï decided to take up
photography himself. In this photograph
Brassaï's compositional skill is evident in the
way he has framed his subjects, each lover's
gaze reflected in a mirror. Such artifice and
formal elegance, rather than the harsh
realities of photographic realism, was of
supreme importance to him. Indeed, this
and many of his photographs were staged,
leading to a complicity between
photographer and subject that adds to the
picture's sophistication and playfulness.

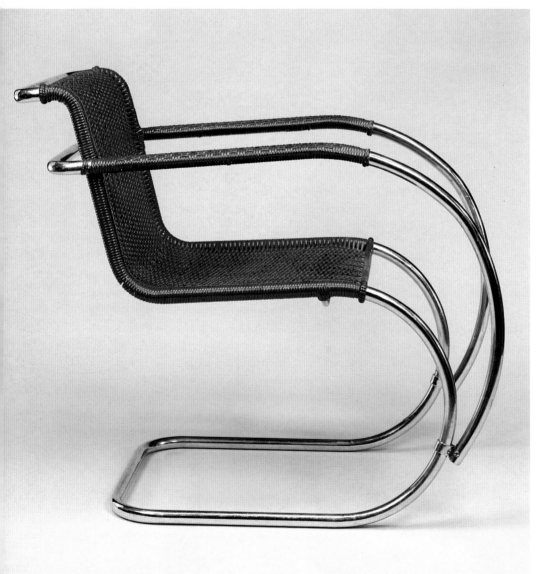

Mario Bellini
Italian, born 1935
TEA AND COFFEE SERVICE
(prototype), 1980

Cleto Munari (manufacturer)
Silverplate, rose quartz, and lapis lazuli;
coffee pot: H. 7½ in. (19.1 cm)
Gift of Cleto Munari, 1988,
(1988.191.6), Gift of Cleto Munari, 1990
(1990.96.1ab–4ab)

This service reveals Bellini's strong
architectural background with all its
elements reduced to minimal classical
geometry. But the abstract severity is offset
by the richness of the materials, and the
overall effect is monumental.

Ludwig Mies van der Rohe
American (born Germany), 1886–1969
"MR" ARMCHAIR, 1927

Chrome-plated steel and painted cane,
H. 31½ in. (80 cm)
Purchase, Theodore R. Gamble, Jr. Gift, in
honor of his mother, Mrs. Theodore Robert
Gamble, 1980 (1980.351)

Architect Mies van der Rohe's well-known
philosophy of "less is more" is evident in
this extremely graceful, elegant chair. His
superb sense of proportion and his unerring
instinct for what to leave out of a piece have
made his furniture some of the most
enduring of the 20th century.

Jacques Fath
French, 1912–1954
EVENING GOWN, 1947

Pink silk satin
Gift of Richard Martin, 1993 (1993.55)

French couturier Jacques Fath became
famous in the post–World War II years for
his beautifully articulated tailoring and
extravagant evening wear. In 1947, the year
of Christian Dior's New Look, Fath
examined that silhouette's foundation, the
waist-cinching corset, and externalized it.
This elegant evening gown, which
combines pink—a color of twentieth-
century lingerie—with traditional lacing,
exemplifies Fath's accomplishment. Its
structure is a literal equivalent of the
hourglass look of the late 1940s, here given
deeper historical resonance.

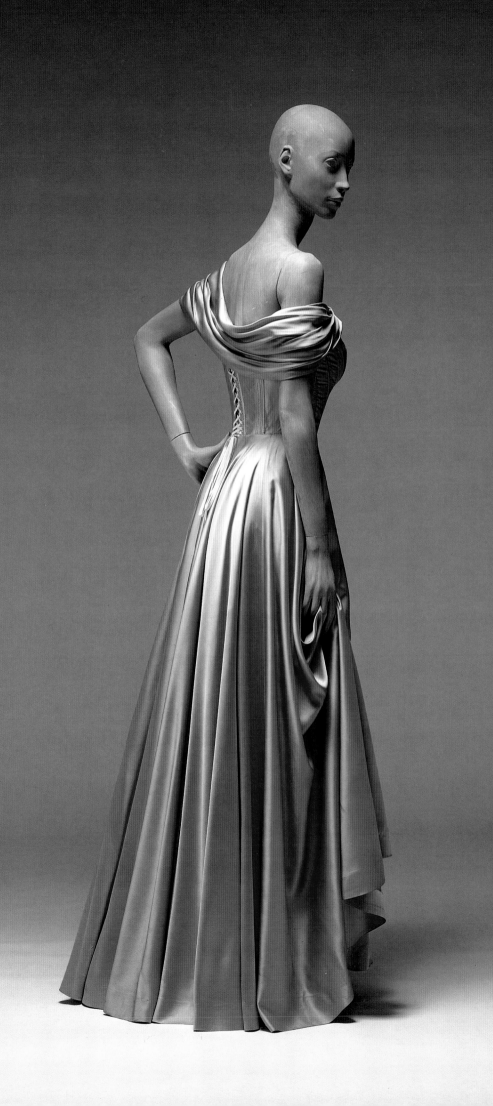

Index